THE ART OF STAR WARS

EPISODE II ATTACK OF THE CLONES™

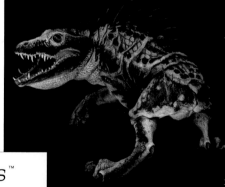

SITH CHARACTER & FINAL PAINTED MASSIFF MODEL
conceptual designs

1	Dermot Power
2	Michael Patrick Murnane (sculpt)
	& Robert E. Barnes
	(sculpt & paints)

Star Wars: Episode II Attack of the Clones

Dedication & Acknowledgments

To George Lucas, Rick McCallum, and Doug Chiang and all the artists and modelers of the Episode II art department.

And to my nephew Joey, a plucky Padawan himself.

My thanks to Steve Saffel, editor of this book at Ballantine, for booking me on this wonderful flight into the *Star Wars* universe—I hope readers enjoy the sights as much as I have! My thanks also to Lucasfilm and Lucy Autrey Wilson. Special appreciation goes to Sue Rostoni for providing me with background on the story points for Episode II—her vast knowledge of the *Star Wars* universe would put a Jedi archivist to shame.

And I propose a special victory parade through Theed for Lucasfilmer Iain Morris, who selected and laid out this art, a huge challenge as there were several thousand drawings and paintings and models from which to choose. It was a brilliant idea to organize the art to follow the narrative arc of the storyline, thus allowing readers to not only appreciate the beautiful artwork (and the wonders of the creative process) but to use this book as a visual roadmap through the story *and* the universe. It was a delight to work within the grand design Iain created.

Finally, the achievment of this book truly belongs to the talented artists whose work it documents. Here's a salute to the *Attack of the Clones* artists who shared their insights for this book: Robert E. Barnes, Carol Bauman, Doug Chiang, Ryan Church, John Duncan, Marc Gabbana, John Goodson, Kurt Kaufman, Iain McCaig, Michael Patrick Murnane, Edwin Natividad, Dermot Power, Jay Shuster, R. Kim Smith, and Erik Tiemens.

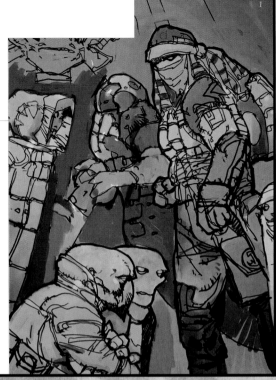

A Del Rey Book
Published by The Ballantine Publishing Group
Copyright © 2002 by Lucasfilm Ltd. & ® or ™ where indicated.
All Rights Reserved. Used Under Authorization.
All rights reserved under International and Pan-American Copyright Convention. Published in the United States by the Ballantine Publishing Group, a division of Random House, Inc., New York, and simultaneously in Canada by Random House of Canada Limited, Toronto. Del Rey is a registered trademark and the Del Rey colophon is a trademark of Random House, Inc.

Lucasfilm Ltd. would like to thank:
Troy Alders, Robert E. Barnes, Scott Carter, Stacy Cheregotis, Doug Chiang, Fay David, Fred Dodnick, Matthew Gallagher, Giles Hancock, Aaron Henderson, Ardees Rabang Jundis, Alvin D. Lopez, Rick McCallum, Wendy Menara, Ryan Mendoza, Sylvain Michaelis, Tina Mills, Iain R. Morris, Joanne Osterburg, Howard Roffman, Sue Rostoni, Steve Saffel, Lucy Autrey Wilson, and of course, George Lucas.

www.starwars.com
www.starwarskids.com
www.delreydigital.com

Library of Congress Catalog Card Number: 2002101663

ISBN 0-345-44074-9

Graciously edited by Sue Rostoni (Lucasfilm) & Steve Saffel (Del Rey)

Gorgeously produced by Fred Dodnick (Del Rey) whose contribution to the STAR WARS universe was both delightful and immeasurable

Models photographed by Robert E. Barnes, Scott Carter, & Giles Hancock

Manufactured in the United States of America

First Edition: April 2002
10 9 8 7 6 5 4 3 2 1

Design by Iain R. Morris (Lucasfilm)

LUCAS BOOKS

DEL REY
Ballantine Books
New York

THE ART OF STAR WARS

Written by
Mark Cotta Vaz

EPISODE II ATTACK OF THE CLONES™

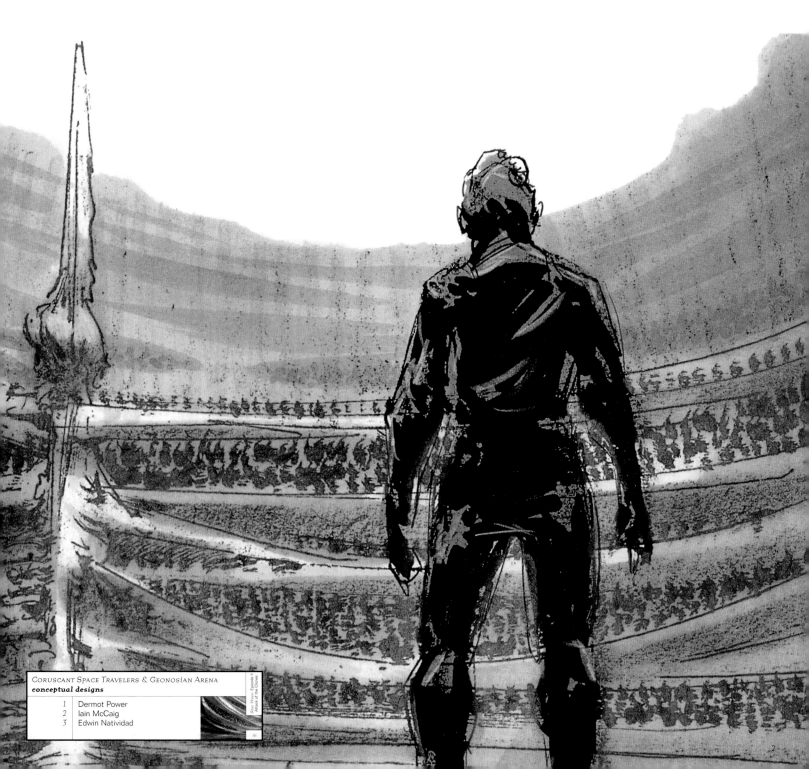

CORUSCANT SPACE TRAVELERS & GEONOSIAN ARENA
conceptual designs

1 Dermot Power
2 Iain McCaig
3 Edwin Natividad

Star Wars: Episode II
Attack of the Clones

iii

Digital technology is radically changing the way that films are made. That excites me as a filmmaker, because it vastly expands the palette I have to tell the stories that I want to tell.

Episode II takes advantage of the tools of digital filmmaking more than any film before it. It was shot digitally, edited digitally, its visual and sound effects were produced digitally, and in many cases it will even be projected digitally in theaters. And, of particular relevance to this book, a good part of the film was designed digitally.

In the new world of digital filmmaking, traditional design is giving way to a broader concept of previsualization, the first step in translating the written word into the visual medium of the screen. A script is at best a description. Previsualization is a moving, visual blueprint of what the filmmaker is trying to do. The issue of design and previsualization in films has always been very important, especially with films that involve places and things that no one has ever seen before. Traditionally, preproduction begins with concept art and storyboards—two-dimensional expressions of a three-dimensional world—and these tools were certainly used in designing Episode II. Animatics, three-dimensional animated sequences, become moving storyboards from which we can more accurately stage action sequences. With Episode II, digital production paintings rich with color, mood, and lighting details were done over the animatic films and bluescreen images, bringing the footage alive as a rough version of finished shots.

This way the entire process stays in the digital realm. Using these tools, we can now completely revisualize an entire film, working out sequences, lighting, sets, and action digitally. We are extremely precise in this previsual stage, experimenting with color schemes and lighting until the shot is locked. There may be a hundred different people working on a particular shot, and they have to know exactly what I am looking for. The more precise I can be in conveying that vision, the better the final product will be. In one sense, we actually produced two movies in making Episode II—the conceptual animatic movie and the final cut.

I look back at the stunning conceptual paintings of Ralph McQuarrie and the amazing pen-and-ink designs of Joe Johnston, now more than a quarter-century old, and realize that Episode IV: *A New Hope* might never have been made had it not been for their pioneering artistry. Today, I look through the pages of this book at the digital paintings of Erik Tiemens and Ryan Church and the animatic storyboards created by the Episode II art department and cannot help feeling that we are at the dawn of a new era in filmmaking.

GEORGE LUCAS | *January 2002, Skywalker Ranch*

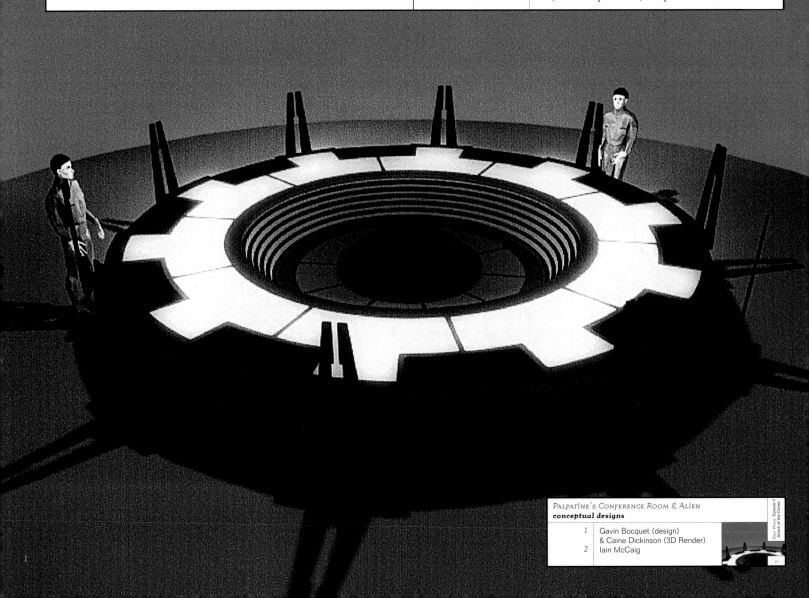

PALPATINE'S CONFERENCE ROOM & ALIEN
conceptual designs

1 Gavin Bocquet (design)
 & Caine Dickinson (3D Render)
2 Iain McCaig

INTRODUCTION

Once upon a time, there was a storybook America where magic awaited in every cloud-shrouded mountain peak and sheltered glen.

Skywalker Ranch has that aura of enchantment, a refuge designed by George Lucas where he might create the stuff that dreams are made of. And any journey to the place named for the famed Jedi Knight from the original *Star Wars* trilogy does indeed evoke the mystique of crossing over and leaving behind the world of dull reality.

A country road winds past miles of rolling hills and fenced-off fields. At a tree-shaded turnoff, a gate opens into a secluded valley where nestled buildings make it seem as if you've time-traveled back to a nineteenth-century ranch. It is here that a team of concept artists and model makers have created designs for the second episode in the planned trilogy of *Star Wars* prequels, from planets down to the smallest belt buckle.

The art department has had its Ranch domain since January 1995, when work began on Episode I *The Phantom Menace*. Approved designs are shared across divisions. Gavin Bocquet's production design department uses approved concept paintings to create new designs to realize the nuts and bolts of physical sets. Computer graphics artists digitally enhance those sets or create the illusion of life through computer-generated characters. And costume designer Trisha Biggar uses concept artists' paintings as references for wardrobe, as well as pushing these concepts farther, creating new designs.

Erik Tiemens and Ryan Church, veterans of ILM's new digital features division, developed shot designs that could be plugged directly into the final visual-effects production. "We were brought on to work with the animatics department as the link between the concept stuff and the final work of the effects guys at ILM," Church explained. "We also had the chance to explore some sequences and design from the ground up. But at first we were previsualizing look, mood, and color schemes."

Their work ranged from a series of paintings exploring the intensity of dying sunrays over a lakeside retreat on Naboo [pages vi–vii, images 1–5] to the dangerous domain of an assembly-line droid factory and such establishing shots as a climactic conflagration of gigantic ships burning amid a raging ground battle. "We were deciding what the shots would look like," Tiemens added. "The animatics guys were figuring out the movement and camera fly-through, but they didn't have time to render 3D lighting and create establishing shots. Our paintings are intended to be a valuable template in planning out the digitally created backgrounds that'd be in the film."

While some shot designs were crafted with traditional means (such as the Naboo sunset shots, created in acrylic gouache), Tiemens and Church usually painted in the computer with Photoshop or Painter software, which allowed for integrating live-action footage shot during principal photography (the "plate," in effects lingo). The resulting template paintings could be used by the animatics department to plot sequences, be printed out as reference for other ILM departments, and even be cut into the rough production footage as a "placeholder" for digital matte paintings and computer-generated environments.

Their paintings kept everyone involved on the same page during the production process, creating a link between Lucas's artistic concepts and ILM's masterfully finished shots. As producer Rick McCallum summed up the work of Tiemens and Church: "Before their shot design we had a big movie—now we have an *epic* movie!"

The production crew conjured new worlds, each a dramatic study in contrast: Kamino, a water planet of continual storms, and Geonosis, an arid world of dramatic stalagmitic rock formations. But the art department would also deal with a different aesthetic, a darker universe than the one seen in *The Phantom Menace*.

The new storyline, set ten years after the events of *The Phantom Menace* with its elegant visions of sunlit Coruscant skyscrapers and shimmering waterfalls cascading down the cliffs of Theed, revisits a galaxy that has been preparing for war. On orders they believe came from the Jedi, the Kaminoans have been creating a secret army of clone troopers, while the Geonosians maintain their own hidden factory where Battle Droids are mass-produced for the mysterious Count Dooku, a former Jedi Knight. The look of Episode II foreshadows such pre-ordained dark turns as the fall of the Republic and the transformation of Jedi Padawan Anakin Skywalker into Darth Vader.

Darker motifs, symbolic of darker themes, were as subtle as Lucas's request that the Jedi Temple towers rise up into smoggy skies. "That smog effect not only provided great atmosphere for lighting, but also set the mood," concept designer Doug Chiang revealed. "A storm is brewing, and the bright world seen in Episode I is becoming darker."

The art department's designs also subtly reflected the chronological linkup of the prequels with the original trilogy, as the sunset years of the Republic give way to the battered, "used universe" look of the Galactic Civil War era. "The tech-

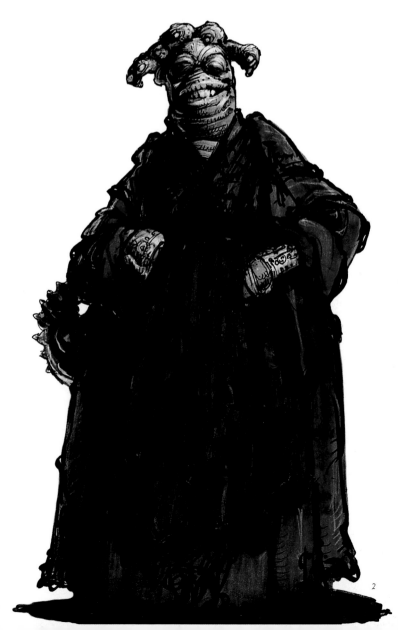

nology in Episode I, things like the Queen's ship, was radically different from the original films," concept modeler John Goodson noted. "With Episode II, we're starting to cross that line; some of the original shapes are showing up. The theme of Episode II is definitely an integration of the [prequels] into the original films." Indeed, in the new production the clone troopers of Kamino establish the prototypes for the future Imperial stormtroopers. Bounty hunter Boba Fett is introduced and the Tatooine moisture farm, where Owen and his future wife Beru Lars will eventually raise Luke Skywalker, is visited.

Still in place was the system developed for Episode I by which all the individual sketches, concept paintings, maquettes, and final models—several thousand pieces produced during the production phase—evolved through the gauntlet of approvals it took for any particular character, costume, vehicle, or environment to reach the goal of a ready-for-production final. Concept art that stayed in play literally bore Lucas's stamp of approval, from the rubber-stamped "OK" to the coveted, and rarely awarded, "Fabulouso" designation given to particularly superlative designs. The art department still maintained a tongue-in-cheek "Wall of Shame" on which they tacked rejected concept art—a sad but inevitable consequence of a process in which even the grandest ideas sometimes don't make it to the big screen.

But even the Wall of Shame acted as a resource from which a previously rejected piece might be plucked by Lucas and reworked. In fact, in his method of creative exploration, everything remained in play. Thus, many designs that hadn't made it into *The Phantom Menace* were brought back to life for *Attack of the Clones*, including early concepts for the Neimoidians that became the rock-dwelling Geonosians, and a fantastical solar sailing ship originally imagined for Padmé, which was transformed into Count Dooku's Solar Sailer.

Through this mix-and-match method, environments and characters transformed and evolved, switching around bits and pieces of different architecture, and even body parts. Early drawings for the film's prototypal stormtroopers ultimately became a new character, bounty hunter Zam Wesell. The

stormtrooper outfits themselves evolved as part classic trooper, part Boba Fett's Mandalorian armor. The final design was crafted to anticipate the next-generation trooper suits.

Lucas even considered, and sometimes discarded, the most fantastical possibilities. McCaig recalled discussions about *computer-generating* Padmé's wardrobe. "These computer costumes would come off her bare skin, starting as a tattoo and then billowing out. In computer graphics [CG], the costumes could have been a material you'd never seen before. It could have been very strange. This was like the idea George had on Episode I, where the gravity of different planets would have physically affected Jar Jar Binks. Brilliant idea, but it would have cost a ton of money, and not added to the story."

McCaig, who shared costume design assignments with art department recruit Dermot Power, recalled the method behind the madness from *The Phantom Menace*, when Lucas personally directed him to imagine a character that embodied his "worst nightmare"—instructions that evolved into Sith villain Darth Maul. "George casts his artists as carefully as he casts his actors," McCaig noted. "Then he wants to see how you react to a line like: 'It's your worst nightmare.' One of George's great talents is [to have you] lay out a table full of different ideas in front of him and he chooses the few things that fit into his universe."

Feedback from Lucas was usually reserved for Friday group meetings, wherein each artist brought in their work of the preceding week for the ultimate show-and-tell. Even when Lucas began shooting principal photography in Australia, Friday meetings remained sacrosanct, conducted via conference calls and images sent electronically.

One element in abundance in *The Phantom Menace* was missing from the new production—time. While *The Phantom Menace* concept art department worked for nearly four years, the *Attack of the Clones* production schedule allowed for only three years, shorter by an entire year.

For Episode II there was no drawn-out ramping up with personnel, as had been the case during the first prequel's long concept period. A core fifteen-person team was hired and working by September 1999. "We were fully staffed and up and running from day one," Chiang explained. "We still didn't have a script, but George spelled out the different environments, characters, and vehicles he wanted. George constantly revised the script throughout production, but by January 2000 there was a first draft, so the design department's focus shifted to

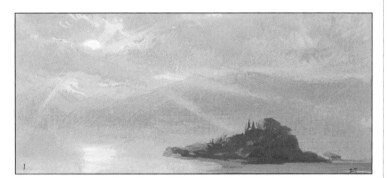

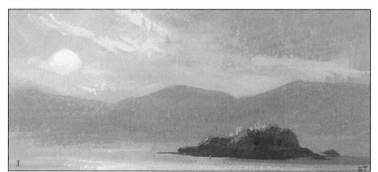

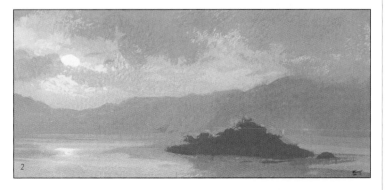

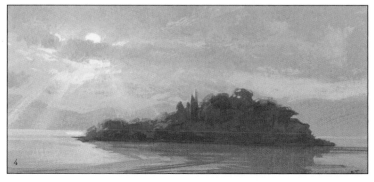

the sets Gavin Bocquet would need to build for George to shoot by June [2000]."

The digital animatics group, a part of the Episode I art department charged with creating low-resolution but sophisticated 3D storyboards, was spun off into a separate department. In Episode I, sequences were designed in thumbnail sketches and turned into storyboards, which then went to animatics. For Episode II, blocked-out sequences went directly to animatics with minimal storyboards.

Another streamlined aspect of the production appeared in the coordination among McCaig and Power and costume designer Trisha Biggar. McCaig noted that, for Episode I, Biggar hadn't even come on board when his costume designs were finished. This time, the costume designer was aboard from the start. "Trisha is such a genius at what she does that she took my designs from Episode I and *made* them work," McCaig recalled. "Often, when the baton gets passed in filmmaking, designs can be ignored, and Trisha didn't do that. This production was a true collaboration among Trisha, Dermot, and myself."

It also helped tremendously that the design team, many of them Episode I veterans, was already skilled at navigating the *Star Wars* universe. "Everyone in the art department is so good," Kurt Kaufman noted, "I think a lot of our inspiration came from each other."

There was the "Motor City" contingent: Jay Shuster, Marc Gabbana, Kurt Kaufman, and Edwin Natividad, all schooled in Detroit automotive and industrial design. There were concept artists from ILM, the Lucasfilm effects house, including Natividad, an Episode I veteran adept at exotic environments, Warren Fu, "the wildcard guy" able to take on a variety of assignments, and McCaig, another Episode I veteran. There were new recruits, notably Dermot Power, a London-based artist known for his work in the famous British comics publication *2000 AD*. ILM model-shop staffers included Robert E. Barnes, Carol Bauman, John Duncan, R. Kim Smith, Michael Patrick Murnane, and John Goodson. And there was "conceptual researcher" David Craig, whose weekly visits provided invaluable reference materials.

For modelers, the tight time schedule meant that characters and vehicles often had to be molded at the same time sketch art was being produced, so that some concepts were almost completely explored and developed in clay and other materials. There was only one drawback to being a model maker at the Ranch. As John Duncan explained: "You can't use a table

saw or a laser cutter at the Ranch; it'd be like building models in your folks' living room and getting chips and plastic all over the nice carpeting. We'd go down to ILM to work with the big tools and take the big pieces back to the Ranch for assembly."

"It's an elaborate form of storyboarding where we can see, in broad strokes, what the composition and feeling of a scene should be with as much information as possible—the elements in a shot, the lighting scheme, and the color palette," Chiang noted. "Once George sees that it's working within the cut, the information is passed on to ILM, which refines the shot design even more. I think this is a taste of moviemaking to come, where preproduction, production, and postproduction merge and become one process."

Technology aside, Erik Tiemens echoed a creative mantra for the concept designers: "Whatever tools get the job done." For the Episode II art department, the dominant tools were gray markers and blue pencils, foam, and clay. Some, like Edwin Natividad and Dermot Power, liked to start small, then blow up images on a copying machine, adding finer details with each iteration. Power, who usually worked back home in London, surprised his colleagues when it was revealed that *all* his painterly sketches had been created digitally, using a pen and Wacom tablet to draw images on a monitor, and that he'd been exclusively using computers to create art for five years.

Fay David, art department coordinator, took care the artists' needs. "She did a remarkable job," noted producer Rick McCallum. "Her expert coordination allowed them to do their best work. She's the person who kept things running, who made it happen."

This book follows the sometimes circuitous pathways of the imagination that led to the visions of Episode II. What follows is a fraction of the concept art that was produced, but it provides an illustrated road map through the universe, a graphic representation of the story.

The tale begins at a tense time for the Republic. Padmé Amidala fears that the separatist movement being led by Count Dooku will ignite war; she's leading the opposition against the creation of an army to assist the overwhelmed Jedi. Even as her Senatorial spacecraft from Naboo lands on Coruscant, assassins await her. And the galactic guardians cloistered in the Jedi Temple are feeling the creeping fear—the growing power of the dark side.

MARK COTTA VAZ *September 2001*

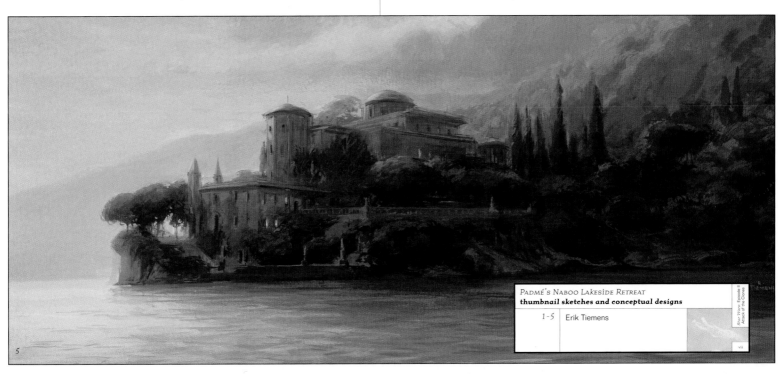

PADMÉ'S NABOO LAKESIDE RETREAT
thumbnail sketches and conceptual designs

1-5	Erik Tiemens

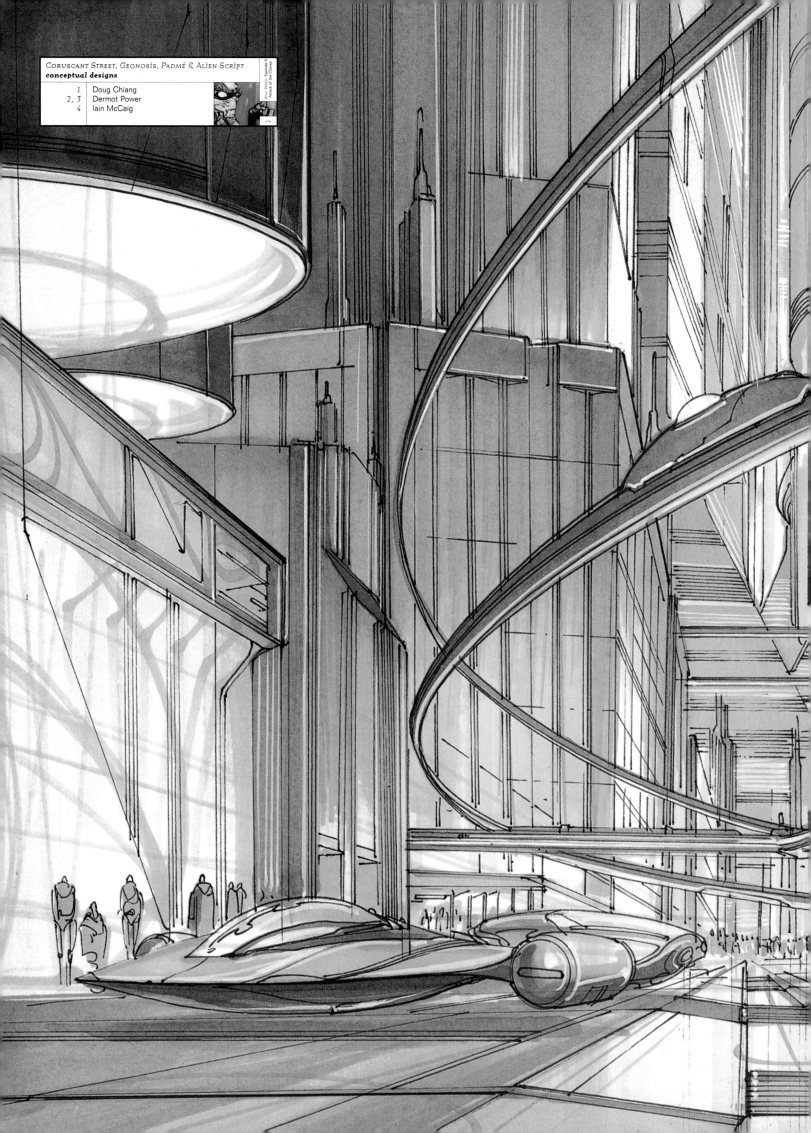

CORUSCANT STREET, GEONOSIS, PADMÉ & ALIEN SCRIPT
conceptual designs

1 Doug Chiang
2, 3 Dermot Power
4 Iain McCaig

Star Wars : Episode II
Attack of the Clones

viii

Star Wars: Episode II
Attack of the Clones

ix

CONTENTS

10
The Art

186
The Script

1

CORUSCANT
conceptual design

1 Ryan Church

scene/s:
001/003

10

It's been ten years since the Trade Federation sought to block trade routes to outlying star systems. It took the leadership of Naboo Queen Amidala, the Jedi skill of Qui-Gon Jinn and his apprentice Obi-Wan Kenobi, the Gungan army of Naboo—and the pluck of a boy named Anakin

Skywalker—to thwart the scheme. During a battle that ranged from the plains of Naboo to an orbiting Trade Federation battleship, Obi-Wan struck down the Sith villain Darth Maul, but only after his Master was felled by Maul's slashing double lightsaber. Qui-Gon, with his dying breath, made Obi-Wan promise to take on young Anakin Skywalker as a Padawan learner and train him in Jedi ways.

The crisis, though resolved, exposed the corrupt, impotent heart of the Republic Senate, and revealed the crumbling foundations of the once flourishing

Republic. Now, ten years later, an ominous power flows into the vacuum, with Coruscant itself fated to become the seat of the evil Empire.

Coruscant was never seen in the original trilogy, although pioneer *Star Wars* concept artist Ralph McQuarrie prepared artwork for *Return of the Jedi* illustrating Lucas's vision of the mighty city planet and center of galactic power. Movie audiences got a glimpse of the legendary place in 1997 when new footage prepared for the Trilogy Special Edition release of *Return of the Jedi* showed cheering throngs pouring into Coruscant Plaza to celebrate the Empire's final defeat.

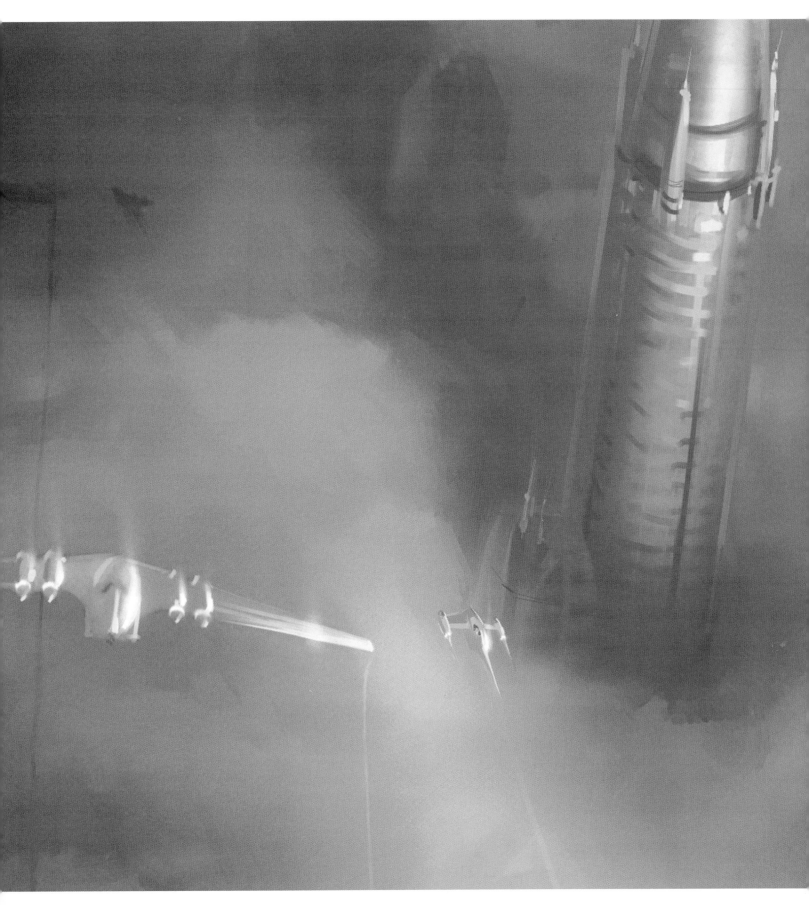

In Episode I *The Phantom Menace*, audiences finally arrived at Coruscant, navigating crowded airspace in Queen Amidala's glittering ship. Audiences saw the Jedi Temple and entered the Jedi Council, sat in on a heated session of the Republic Senate, and even looked out over a gloomy district—originally imagined as an industrial area—from the balcony where the mysterious Darth Sidious and his Sith assassin Darth Maul were plotting.

Coruscant is fully explored in *Attack of the Clones*, with scenes shifting from what Kurt Kaufman dubbed "the giant skyscraper look" to districts never before imagined. The very structures of this mighty megalopolis illustrate the planet's hierarchical social order, with the rich and powerful occupying the rarefied heights while the "lower" classes are settled deep in the foundations. There, on street-level Coruscant, we find a claustrophobic world of rough nightclub districts and industrial warehouse zones, a place of shadows, intrigue, and danger.

"We were going down to street level to see a Coruscant we'd never seen before. George threw down the gauntlet when he said it'd have to look better than BLADE RUNNER."
—Doug Chiang

Blade Runner, with its apocalyptic vision of a future Los Angeles choked with layers of technology and shrouded in an atmosphere of doom, has been a seminal reference since its 1982 release. But that dark city would be dwarfed by Coruscant's teeming metropolis.

Deep into what was called Coruscant's dark "underbelly," the city delivers a sensory assault, the very walls fitted with screens transmitting a constant electronic bombardment of images. Adding to the claustrophobic feeling are the massive foundations of structures as tall as hundreds of Empire State Buildings laid end to end. "The aesthetic I began with was the thought of what was holding these gigantic buildings up at ground level," Edwin Natividad mused. "In my early drawings, I thought of big bolts that might be anchoring these structures. I even thought of people dwelling in these bolts, like vagrants under bridges."

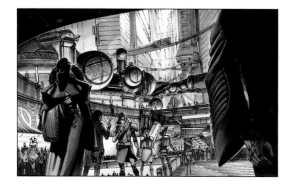

"The first drawing Doug asked me to do was the bottom of Coruscant. A lot of sunlight doesn't reach the bottom, so we wanted to echo the look of a dark, foreboding environment."
—Marc Gabbana

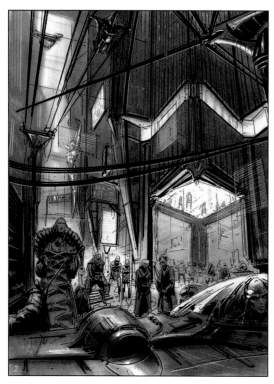

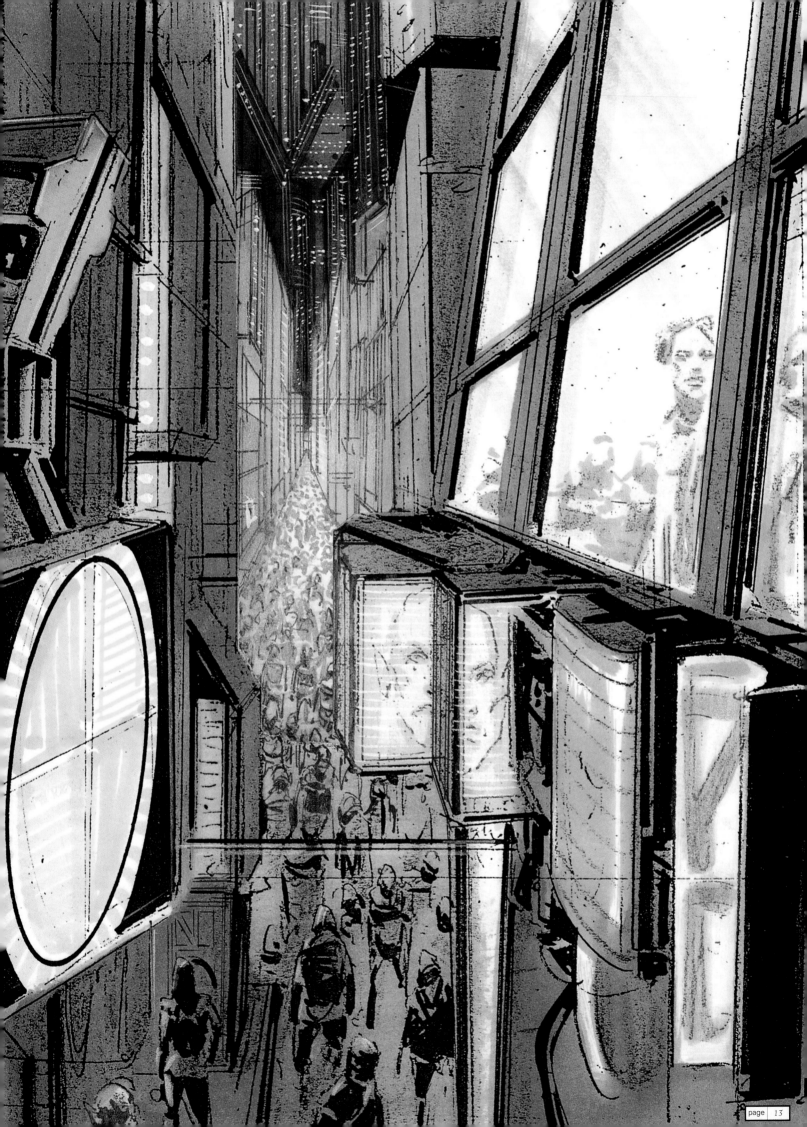

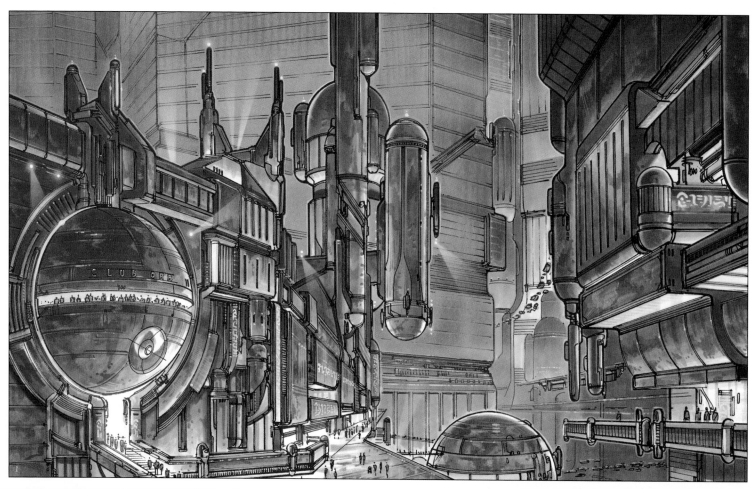

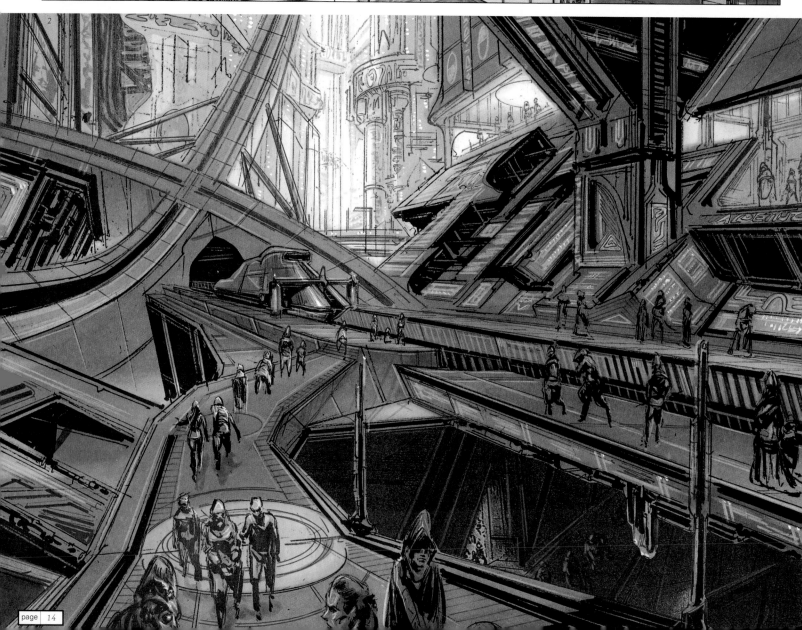

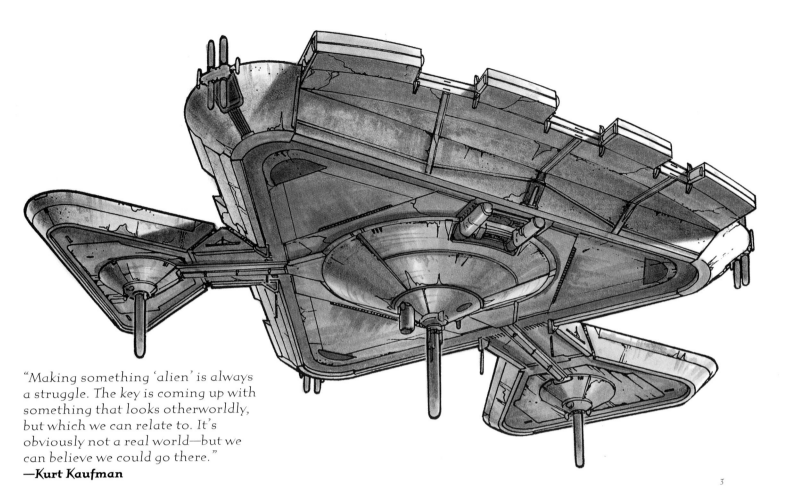

"Making something 'alien' is always a struggle. The key is coming up with something that looks otherworldly, but which we can relate to. It's obviously not a real world—but we can believe we could go there."
—**Kurt Kaufman**

3

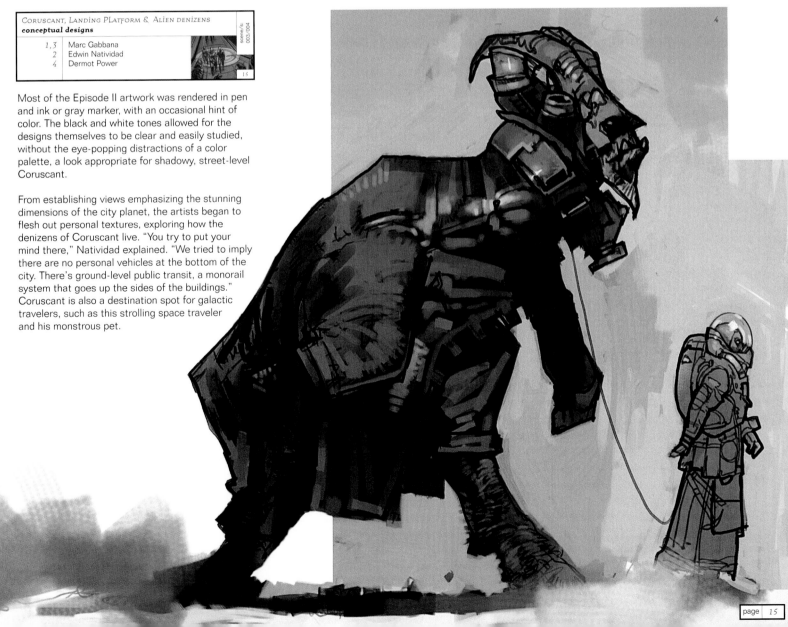

CORUSCANT, LANDING PLATFORM & ALIEN DENIZENS		scene/s:
conceptual designs		003/004
1,3	Marc Gabbana	
2	Edwin Natividad	
4	Dermot Power	15

4

Most of the Episode II artwork was rendered in pen and ink or gray marker, with an occasional hint of color. The black and white tones allowed for the designs themselves to be clear and easily studied, without the eye-popping distractions of a color palette, a look appropriate for shadowy, street-level Coruscant.

From establishing views emphasizing the stunning dimensions of the city planet, the artists began to flesh out personal textures, exploring how the denizens of Coruscant live. "You try to put your mind there," Natividad explained. "We tried to imply there are no personal vehicles at the bottom of the city. There's ground-level public transit, a monorail system that goes up the sides of the buildings." Coruscant is also a destination spot for galactic travelers, such as this strolling space traveler and his monstrous pet.

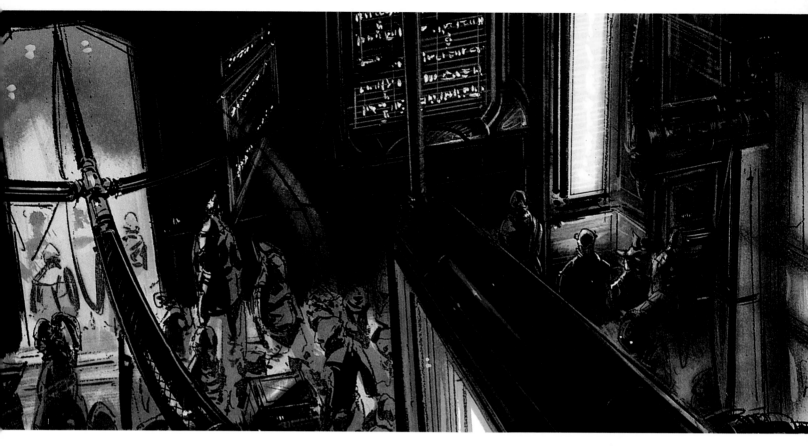

CORUSCANT STREET EXTERIORS & COSTUMES
conceptual designs

1	Edwin Natividad
2-6	Dermot Power
7,8	Jay Shuster

scene/s: 003/004

16

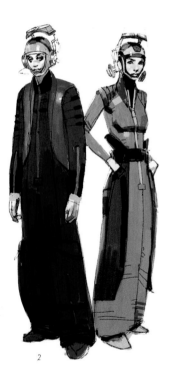

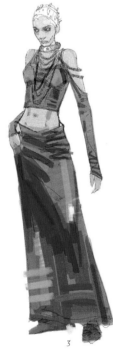

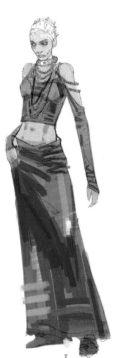

2

3

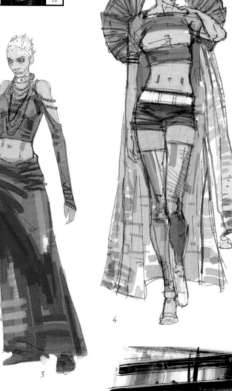

4

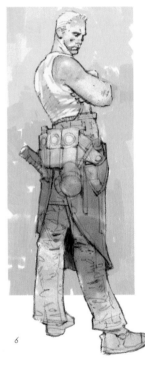

5

6

The concept artists let their imaginations take a
walk on the wild side down in the mean streets of
Coruscant, where the populace reflects the edgy
mood of the surrounding megalopolis. Edwin
Natividad's sketches of the denizens were inspired
by the rough-trade and criminal elements found in
the seedier sections of any big city. The alluring
female pictured here [4] characterizes another
aspect of nightlife in the bowels of the city:
"Decadent," Natividad summed up.

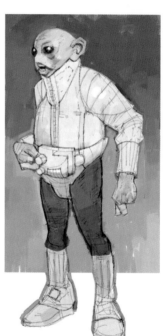

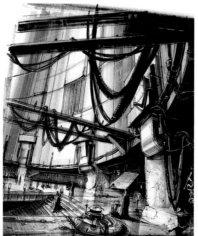

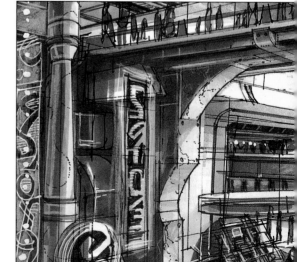

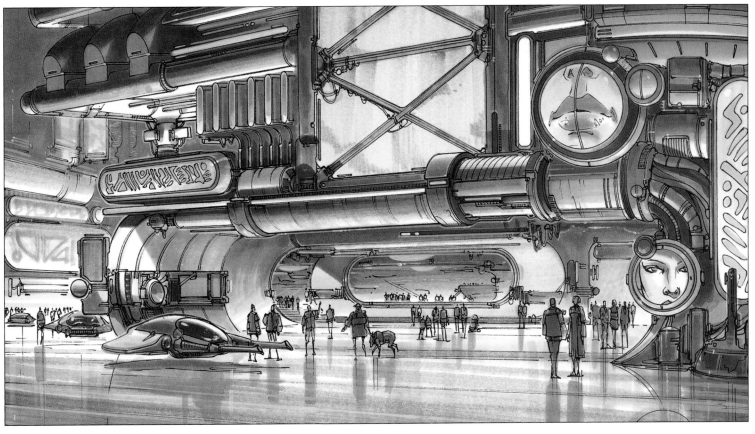

CORUSCANT STREET EXTERIORS & COSTUMES
conceptual designs

		scene/s: 003/004
1	Marc Gabbana	
2	Doug Chiang	
3	Dermot Power	
4	Iain McCaig	17

Coruscant is a melting pot of alien species and cultures, fashions, architectural styles. It's a magnet for wide-eyed visitors and the ambitious, starstruck artists and huddled immigrants praying for a fresh start—the Big Apple of the galaxy. Such a place must have its amusements, and they're to be found in the area that the art department labeled the "entertainment district," one of the key areas explored in the film.

In this image [page 17, 1] Marc Gabbana, who drew many of the district's nightclubs and bars, used pockets of open air amid the concrete and steel canyons for scale and contrast, picturing streets slick with rain and buildings buzzing with "advertising balls." The concept of a ceaseless bombardment of advertising was further developed into a final idea of floating spheres and holographic billboards.

"I don't think most productions have had the lack of ego that we had on this show. Most films have a hierarcy of production, but our concept artists have a lot of autonomy and worked directly with George."
—**Iain McCaig**

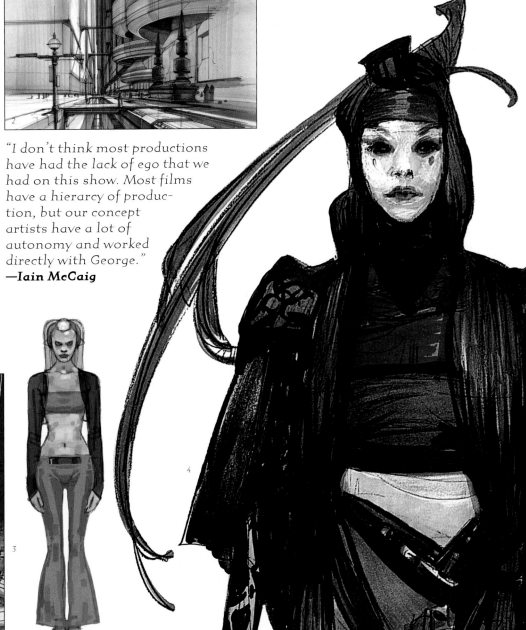

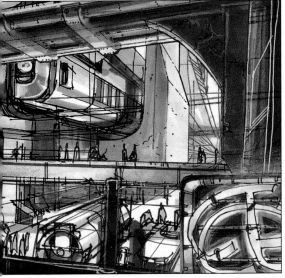

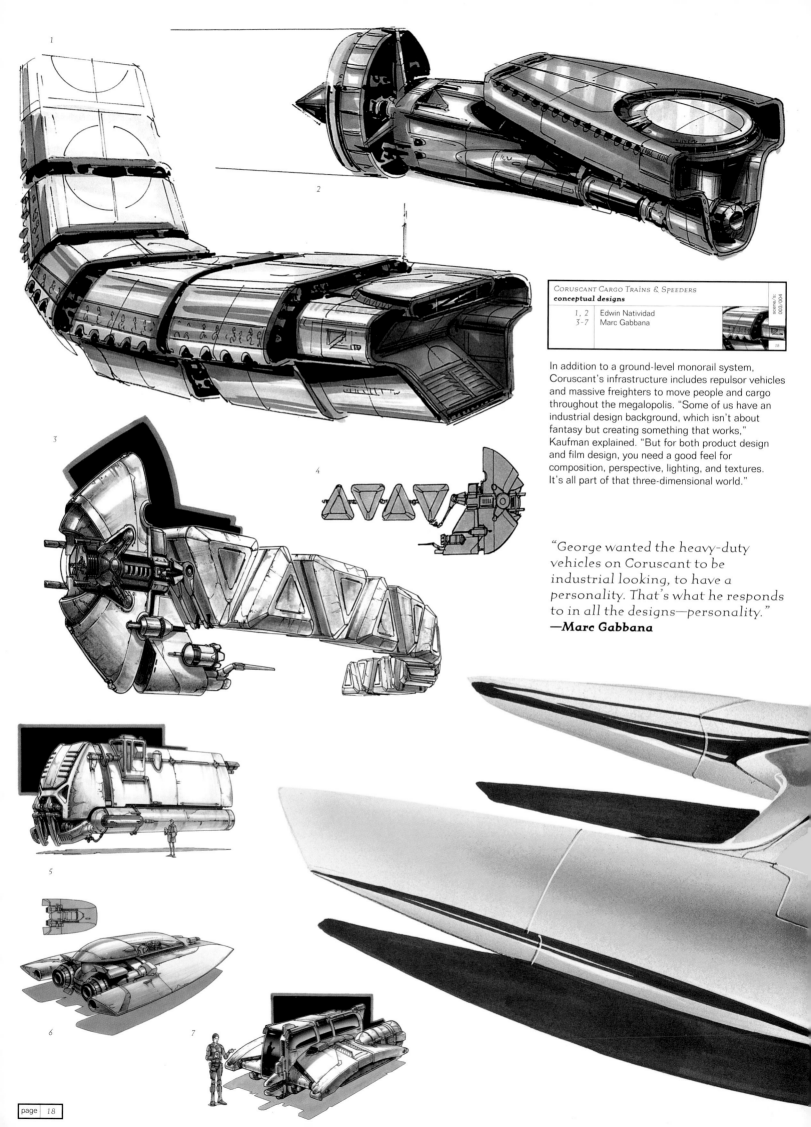

1

2

3

4

5

6

7

CORUSCANT CARGO TRAINS & SPEEDERS
conceptual designs

| 1, 2 | Edwin Natividad |
| 3 - 7 | Marc Gabbana |

scene/s:
003/004

18

In addition to a ground-level monorail system, Coruscant's infrastructure includes repulsor vehicles and massive freighters to move people and cargo throughout the megalopolis. "Some of us have an industrial design background, which isn't about fantasy but creating something that works," Kaufman explained. "But for both product design and film design, you need a good feel for composition, perspective, lighting, and textures. It's all part of that three-dimensional world."

"George wanted the heavy-duty vehicles on Coruscant to be industrial looking, to have a personality. That's what he responds to in all the designs—personality."
—Marc Gabbana

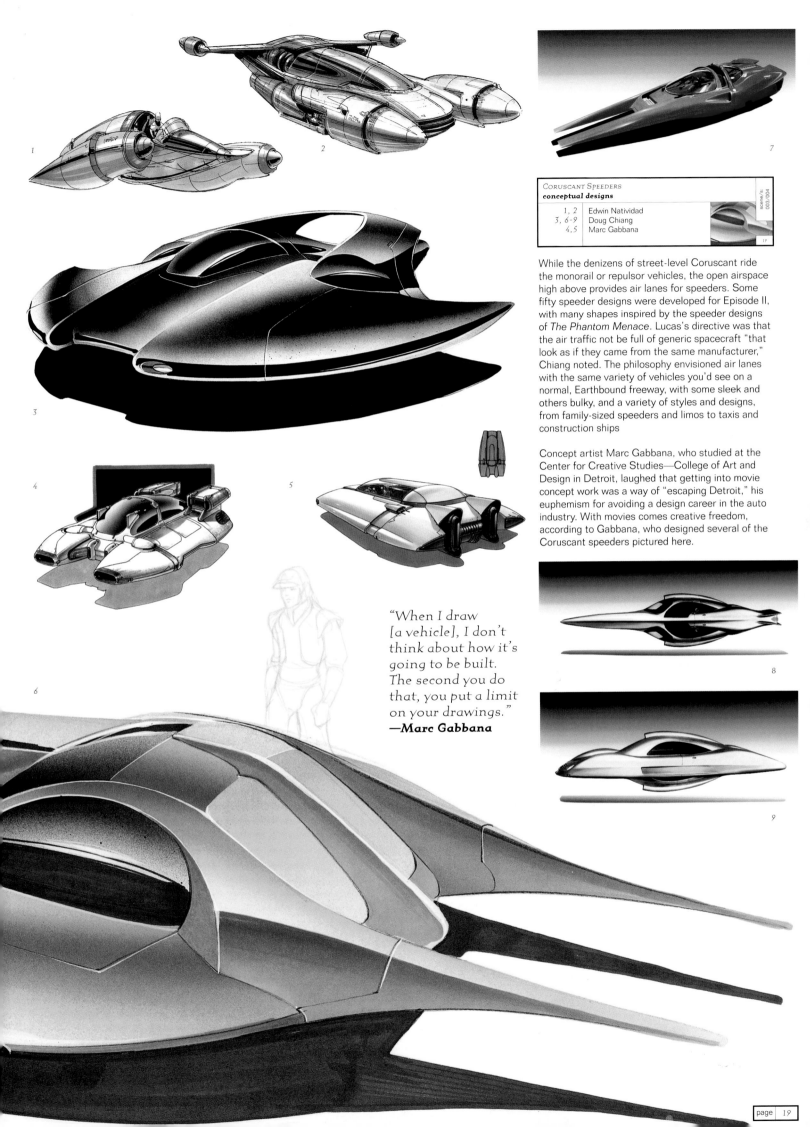

CORUSCANT SPEEDERS
conceptual designs

		scene/s: 003/004
1, 2	Edwin Natividad	
3, 6–9	Doug Chiang	
4, 5	Marc Gabbana	

While the denizens of street-level Coruscant ride the monorail or repulsor vehicles, the open airspace high above provides air lanes for speeders. Some fifty speeder designs were developed for Episode II, with many shapes inspired by the speeder designs of *The Phantom Menace*. Lucas's directive was that the air traffic not be full of generic spacecraft "that look as if they came from the same manufacturer," Chiang noted. The philosophy envisioned air lanes with the same variety of vehicles you'd see on a normal, Earthbound freeway, with some sleek and others bulky, and a variety of styles and designs, from family-sized speeders and limos to taxis and construction ships

Concept artist Marc Gabbana, who studied at the Center for Creative Studies—College of Art and Design in Detroit, laughed that getting into movie concept work was a way of "escaping Detroit," his euphemism for avoiding a design career in the auto industry. With movies comes creative freedom, according to Gabbana, who designed several of the Coruscant speeders pictured here.

"When I draw [a vehicle], I don't think about how it's going to be built. The second you do that, you put a limit on your drawings."
—**Marc Gabbana**

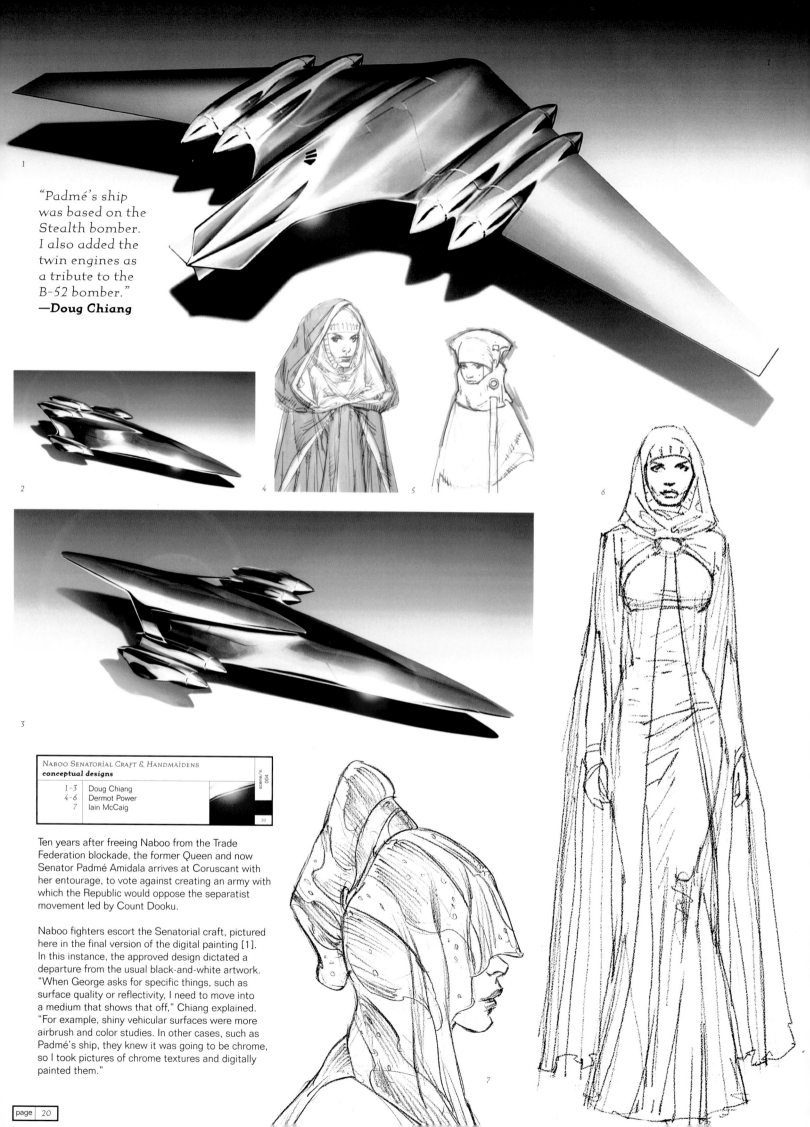

"Padmé's ship was based on the Stealth bomber. I also added the twin engines as a tribute to the B-52 bomber."
—Doug Chiang

NABOO SENATORIAL CRAFT & HANDMAIDENS	
conceptual designs	
1–3	Doug Chiang
4–6	Dermot Power
7	Iain McCaig

scene/s: 004

20

Ten years after freeing Naboo from the Trade Federation blockade, the former Queen and now Senator Padmé Amidala arrives at Coruscant with her entourage, to vote against creating an army with which the Republic would oppose the separatist movement led by Count Dooku.

Naboo fighters escort the Senatorial craft, pictured here in the final version of the digital painting [1]. In this instance, the approved design dictated a departure from the usual black-and-white artwork. "When George asks for specific things, such as surface quality or reflectivity, I need to move into a medium that shows that off," Chiang explained. "For example, shiny vehicular surfaces were more airbrush and color studies. In other cases, such as Padmé's ship, they knew it was going to be chrome, so I took pictures of chrome textures and digitally painted them."

SENATORIAL CRAFT, SENATOR PADMÉ & CAPTAIN TYPHO **conceptual designs and model**	scene/s: 004 / 21
1	John Goodson
2-4	Doug Chiang
5-7	Iain McCaig
8	Dermot Power

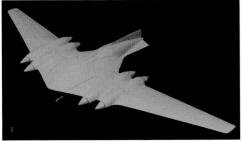

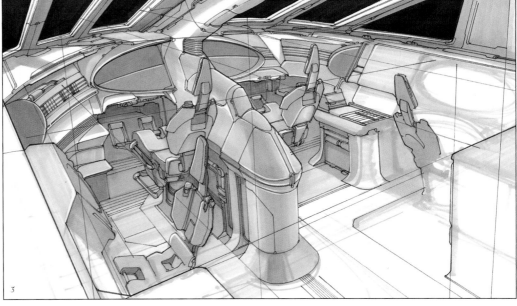

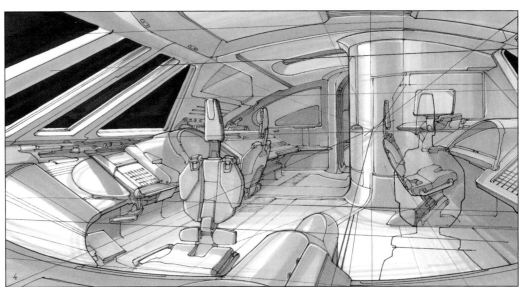

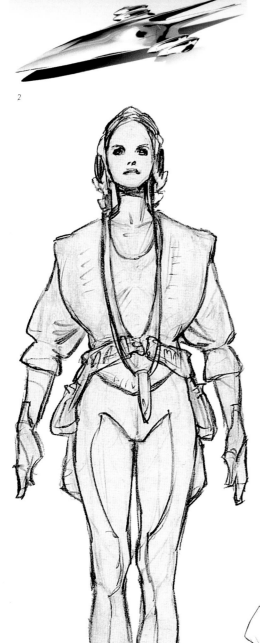

"There was some carryover in the design of Padmé's ship from the Queen's ship of Episode I. George also wanted a 'rocket' quality, so it's like a rocketship with a fin on it—the Buck Rogers look."
—John Goodson

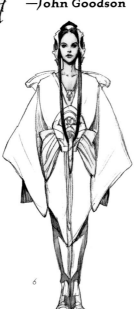

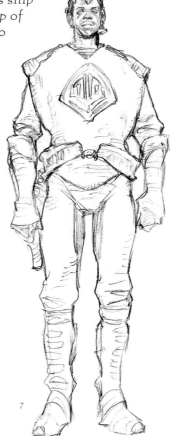

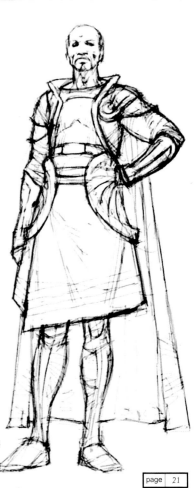

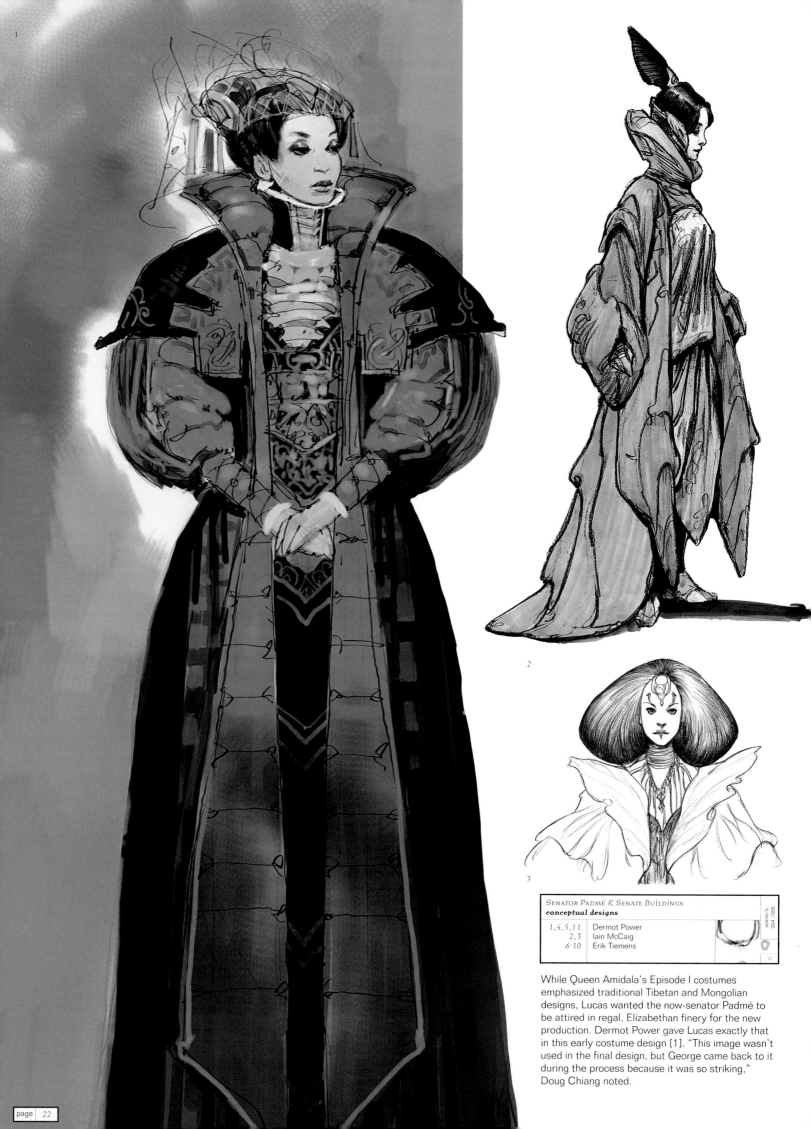

SENATOR PADMÉ & SENATE BUILDINGS
conceptual designs

1,4,5,11	Dermot Power
2,3	Iain McCaig
6-10	Erik Tiemens

scene/s:
004 /005

22

While Queen Amidala's Episode I costumes emphasized traditional Tibetan and Mongolian designs, Lucas wanted the now-senator Padmé to be attired in regal, Elizabethan finery for the new production. Dermot Power gave Lucas exactly that in this early costume design [1]. "This image wasn't used in the final design, but George came back to it during the process because it was so striking," Doug Chiang noted.

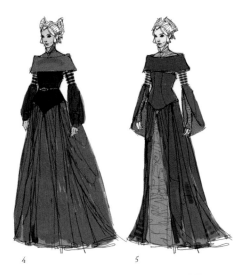

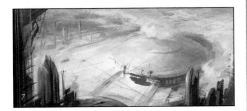

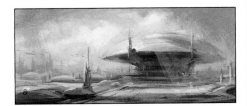

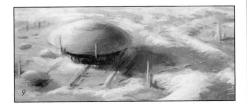

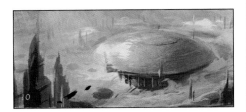

Although it was planned for Padmé to make a dramatic Senate appearance, having survived an assassination attempt upon arriving at Coruscant, that scene was dropped. Shot designer Erik Tiemens's thumbnail sketches of the Senate [7–10], one of his first assignments, followed Lucas's verbal instruction for an image of swirling fog, lighting patterns, and varied points of view.

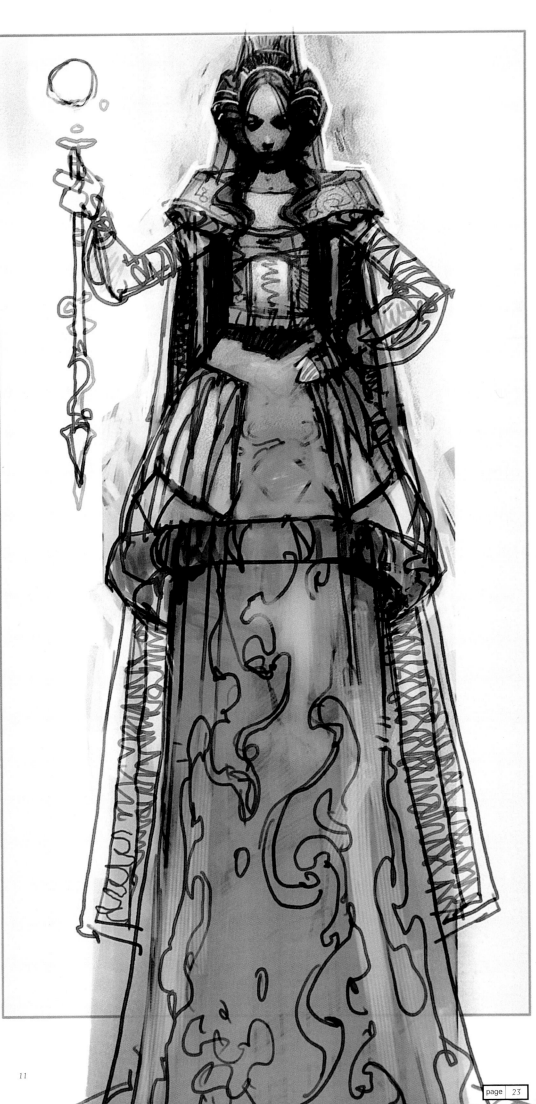

11

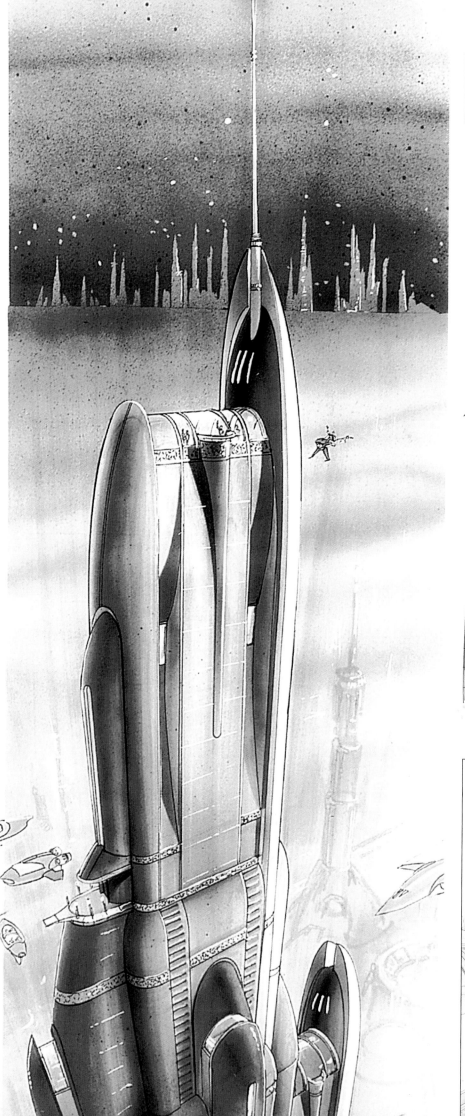

	PADMÉ'S CORUSCANT APARTMENT	scene/s: 009
	conceptual designs	
1,2,4	Gavin Bocquet (design) & Phil Shearer (drawing)	
3	Jay Shuster	24

Here is the skyscraper where Padmé maintains a penthouse apartment [page 24, 1–4]. Even at this height of power, the crusading antiwar Senator isn't safe from assassination attempts from mysterious forces. A probe droid releases the centipedelike "kouhuns" into her bedroom. These are new creatures in the *Star Wars* universe. Various designs are pictured [page 25, 2–6].

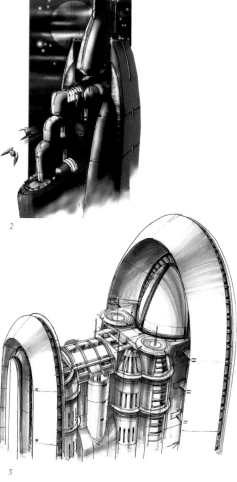

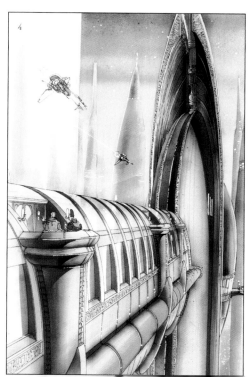

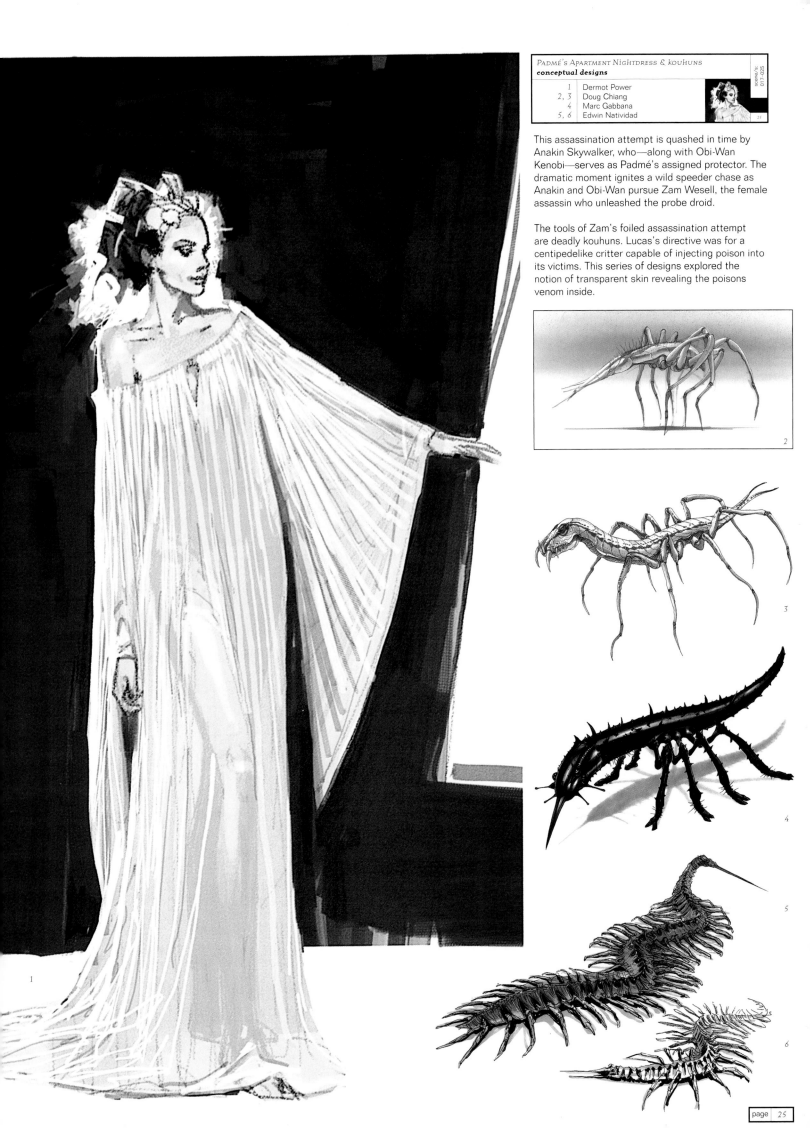

PADMÉ'S APARTMENT NIGHTDRESS & KOUHUNS
conceptual designs

		scene/s: 017–025
1	Dermot Power	
2, 3	Doug Chiang	
4	Marc Gabbana	
5, 6	Edwin Natividad	25

This assassination attempt is quashed in time by Anakin Skywalker, who—along with Obi-Wan Kenobi—serves as Padmé's assigned protector. The dramatic moment ignites a wild speeder chase as Anakin and Obi-Wan pursue Zam Wesell, the female assassin who unleashed the probe droid.

The tools of Zam's foiled assassination attempt are deadly kouhuns. Lucas's directive was for a centipedelike critter capable of injecting poison into its victims. This series of designs explored the notion of transparent skin revealing the poisons venom inside.

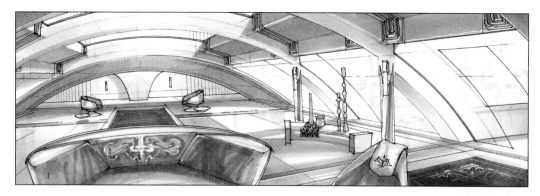

Jay Shuster, originally hired for Episode I to work on the Podrace sequence, became one of the key vehicle and hard-surface designers. The new production was a chance for Shuster to explore architectural themes. "I enjoyed designing Padmé's bachelorette pad on Coruscant," Shuster said, smiling. "It infused a bit of Frank Lloyd Wright, with an arching ceiling and an open corridor where you can see open sky and cityscape."

It's ironic that Padmé's luxurious apartment nearly becomes a deathtrap for her, as its design emphasized "freedom and openess," according to Jay Shuster. "After having ruled Theed, the apartment conveyed her newfound independence. Kind of like the farm girl who goes to the big city and ends up in a swank penthouse."

This Power costume design [5] was produced while working in the same room with fellow costume designer McCaig. "I'd finished a drawing of Padmé holding a hawk," McCaig recalled, "when, from behind his drawing board, Dermot shouted, 'Iain, I've just done this drawing of Padmé—she's holding a bird!' I held up my drawing and said, 'Do you mean like this?' Dermot and I really synched our minds together."

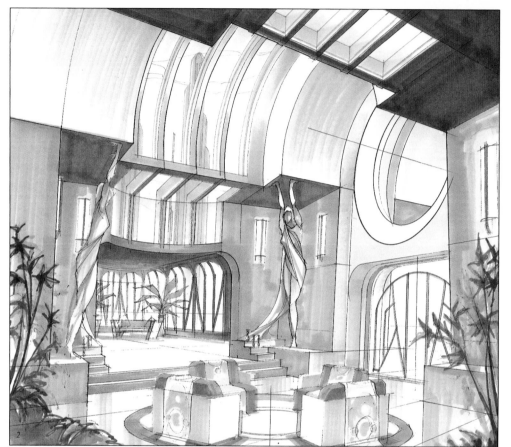

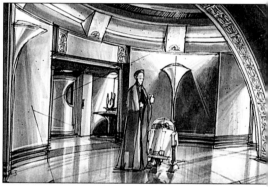

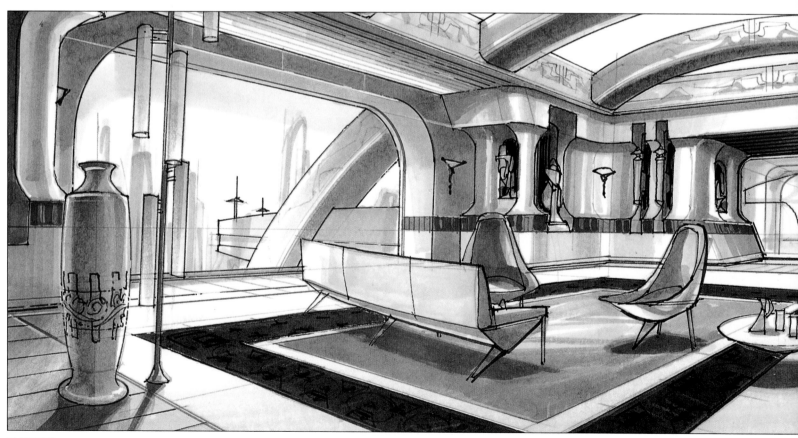

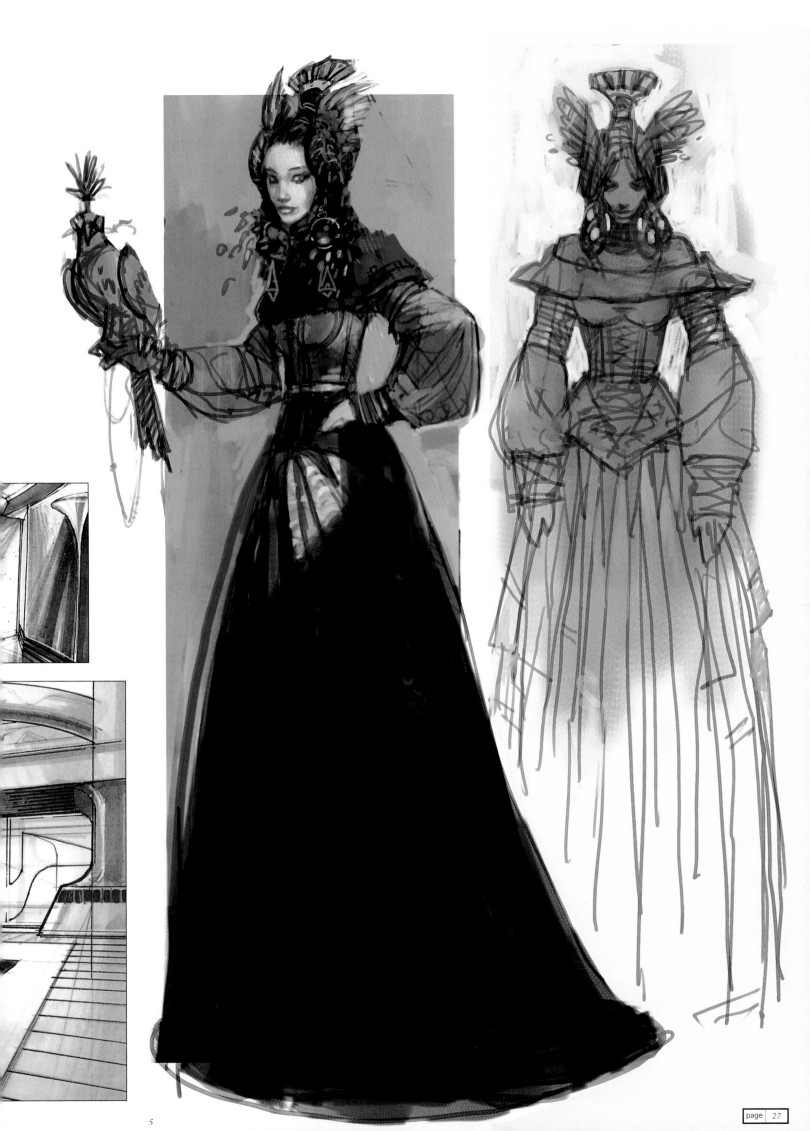

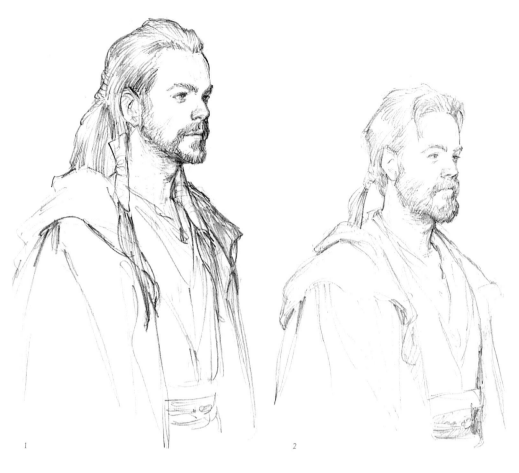

OBI-WAN COSTUMES & ANAKIN'S SPEEDER
conceptual designs & model

		scene/s:
1, 2	Iain McCaig	010/029
3, 4	Jay Shuster	
5	John Goodson	

McCaig and Power began designing the costumes for Padawan Anakin Skywalker long before actor Hayden Christensen was cast in the role, and McCaig emphasized that a design shouldn't account for the actors: "You're drawing the character, not the actor."

The concept of the Jedi Knights was grounded in the concept work of the previous production. "At one point during the Episode I design, we were thinking of the Jedi as lone samurai, then as teams of samurai," McCaig recalled. "They were going to be like a police force, dressed in black and a lot more militaristic. But they evolved into the peacekeeping force they are in the current film."

The speeder that Anakin grabs for the chase after Zam Wesell [sketches and final model, page 28, 3–5] was imagined as a souped up 1950s-style hot rod. Note the missing engine cowlings on Jay Shuster's sketches [3–4].

1

2

Jay Shuster roughed out his Anakin speeder sketches literally fifteen minutes before Lucas's review, certain that Doug Chiang's more detailed concepts would be favored. But Lucas was enthralled by Shuster's speeder. "He saw the exposed engines, the teardrop headrests— I think he saw Anakin's Podracer in it,"

Shuster recalled. "The exposed engines were also reminiscent of the street of his day, the hoods discarded to flaunt the heavy-breathing monster engines. Minutes after picking the design he assigned it a yellow paint scheme like the one for Harrison Ford's hot-rod in *American Graffiti*."

3

5

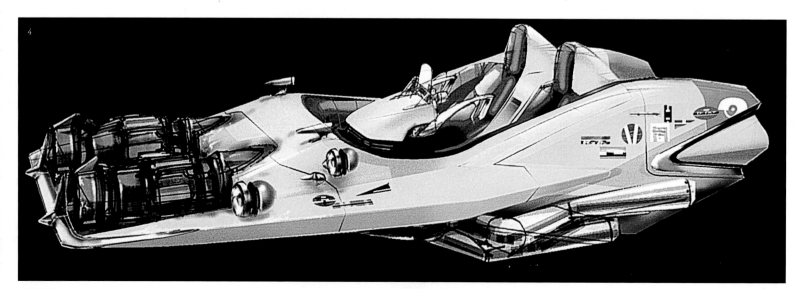

4

Power, anticipating Anakin's eventual dark side transformation into Darth Vader, produced the incarnation of evil pictured here [page 29, 4–5]. Not only did he outfit Anakin in a Vader-ish costume, but he also topped the design with a bob haircut shaped like Vader's helmet. "In this drawing, I wanted malevolence. I went for dark and evil," Power explained. "Iain took a completely different approach, with a kind of Lawrence of Arabia look [2]. Iain imagined someone so dark and evil they'd look the opposite—they're dressed in white. His take was quite interesting."

"I've really moved my performance up a notch from that day I first walked into Doug's office for Episode I. But there were huge demands made on all of us; we had to draw faster and better. It was trial by fire."
—Jay Shuster

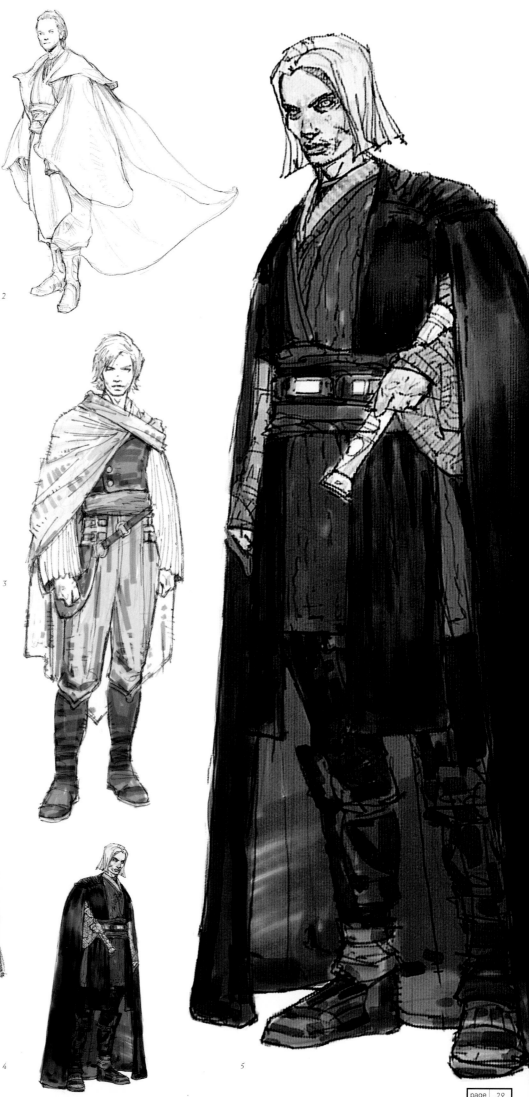

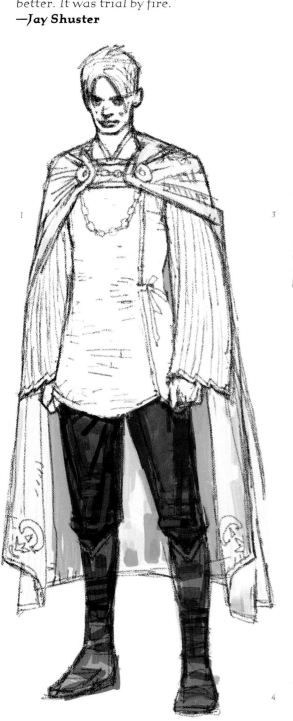

CORUSCANT SPEEDER CHASE LOCATIONS	scene/s:
conceptual designs	030
1, 3 Erik Tiemens	
2 Kurt Kaufman	30
4 Robert E. Barnes	

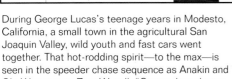

During George Lucas's teenage years in Modesto, California, a small town in the agricultural San Joaquin Valley, wild youth and fast cars went together. That hot-rodding spirit—to the max—is seen in the speeder chase sequence as Anakin and Obi-Wan pursue Zam Wesell. "George has always loved fast cars," Doug Chiang said, "and he wanted to do a classic chase scene—only it's high up in the air."

The chase was also a golden opportunity to cover Coruscant, from the superskyscrapers seen in Episode I ("classic Coruscant," as artist Ryan Church put it) through other areas of the sprawling city, including a refinery area, a massive power-generating plant, and a financial district of glittering glass buildings, ending with the crash of the assassin's speeder in the entertainment district, deep in the foundations of the city.

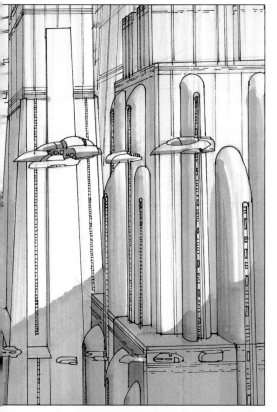

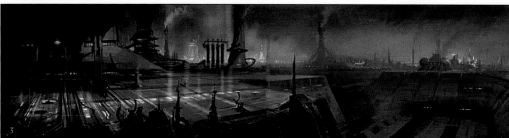

Church hailed Kurt Kaufman for establishing the look of a dense, vertical megalopolis [2]. From there, shot designers Church and Erik Tiemens began working out conceptual views of the chase route geared to the actual production. This Tiemens conceptual painting of an electrical-power-generating plant [1] was approved by Lucas and developed into a fifty-foot-long model at ILM.

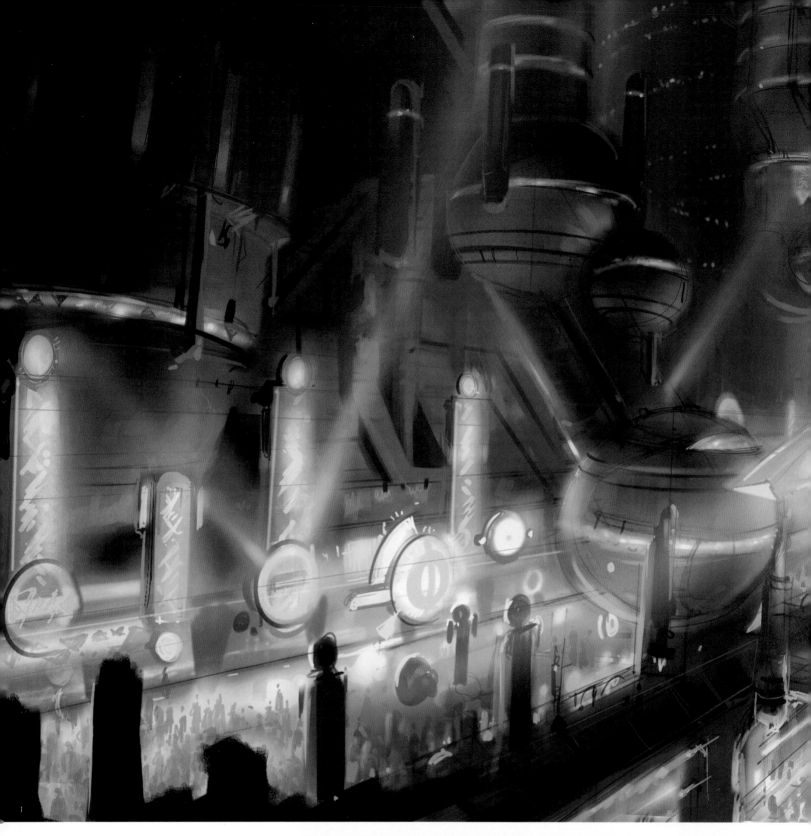

ZAM'S SPEEDER & CHASE LOCATIONS		scene/s:
conceptual designs		030
1, 2	Ryan Church	
3–5	Jay Shuster	32

Zam's speeder bursts into flame and drops in a crash descent over Coruscant's entertainment district [1]. Church began with a tight pencil sketch, then took the drawing into the computer. Here is a conceptual design from the start of the chase [2], the "old city" from Episode I. "For Erik and me, the city chase was like designing five to six mini cities," Church said, smiling. "We worked from rough animatics and the ideas Lucas had for the environments we'd see during the chase. It was very much a linear trip, [during which] you're seeing completely different areas."

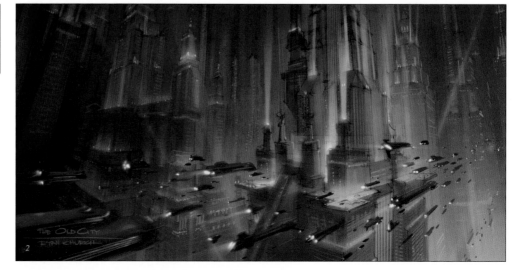

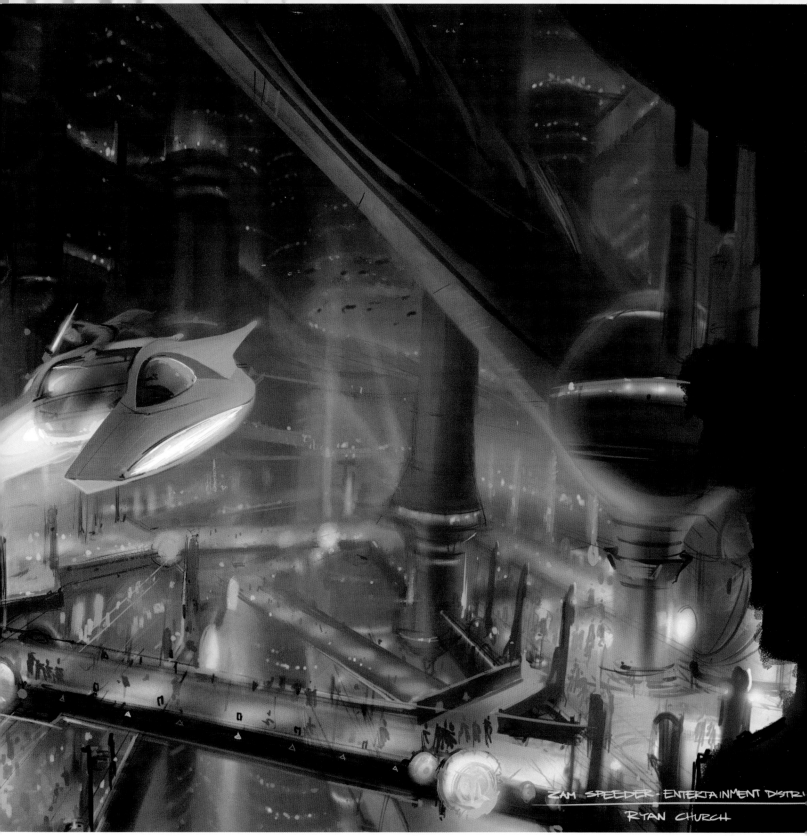

ZAM SPEEDER - ENTERTAINMENT DISTRI

RYAN CHURCH

Zam's speeder was jokingly called the "Woody Woodpecker ship" for the dramatic lines that seem to mimic the streaked-back hair and profile of the famous cartoon character [3–5]. The dramatic fins were a subtle design touch that appear throughout the production, from Padmé's ship to the final clone trooper helmets.

Zam's speeder was also characteristic of the mantra of "three to five lines," a term Jay Shuster (who contributed to its design) called "a secret handshake in car design," a guiding rule familiar to himself, Edwin Natividad, Kurt Kaufman, and others schooled in Detroit auto design. "In the pursuit of great design, simplicity is a virtue," Shuster explained. "Zam's speeder consists of two to three character lines that not only have an element of simplicity, but convey stealth and speed."

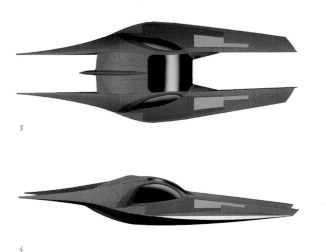

3

4

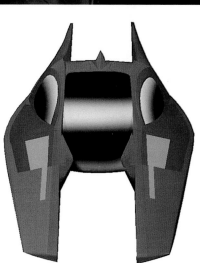

5

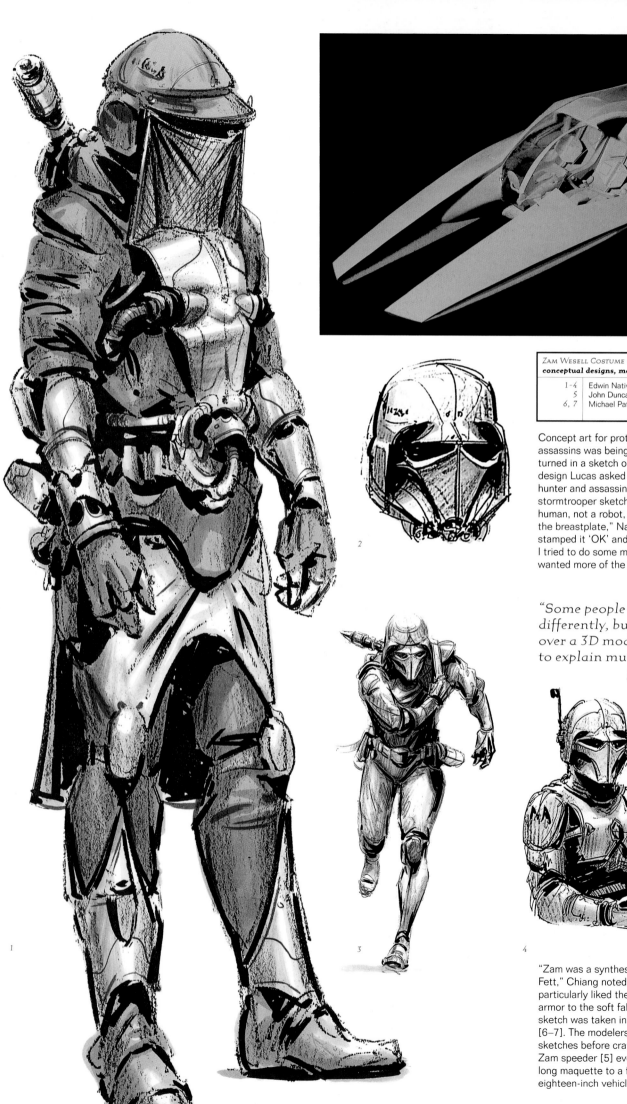

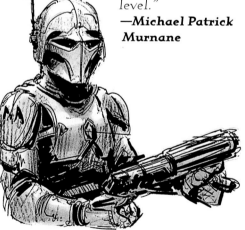

ZAM WESELL COSTUME & ZAM'S SPEEDER *conceptual designs, model and sculpts*		scene/s: 013/030
1-4	Edwin Natividad	
5	John Duncan	
6, 7	Michael Patrick Murnane	

34

Concept art for prototypal stormtroopers and assassins was being prepared when Natividad turned in a sketch of a charging trooper [3], a design Lucas asked him to develop into the bounty hunter and assassin Zam. "For my early stormtrooper sketch, I wanted to indicate it was a human, not a robot, so I had the mask attached to the breastplate," Natividad explained. "George stamped it 'OK' and chose it as the bounty hunter. I tried to do some modifications, but George always wanted more of the original sketch."

"Some people see a drawing differently, but when you hand over a 3D model, you don't have to explain much. It helps the design process to be able to talk on the same level."
—Michael Patrick Murnane

"Zam was a synthesis of stormtrooper and Boba Fett," Chiang noted of the final design [1]. Lucas particularly liked the mix of materials, from battle armor to the soft fabric of the veil. The approved sketch was taken into the final Murnane sculpts [6–7]. The modelers often produced additional sketches before crafting rough maquettes. The final Zam speeder [5] evolved from a three- to four-inch-long maquette to a final, finely detailed, fourteen-to eighteen-inch vehicle model.

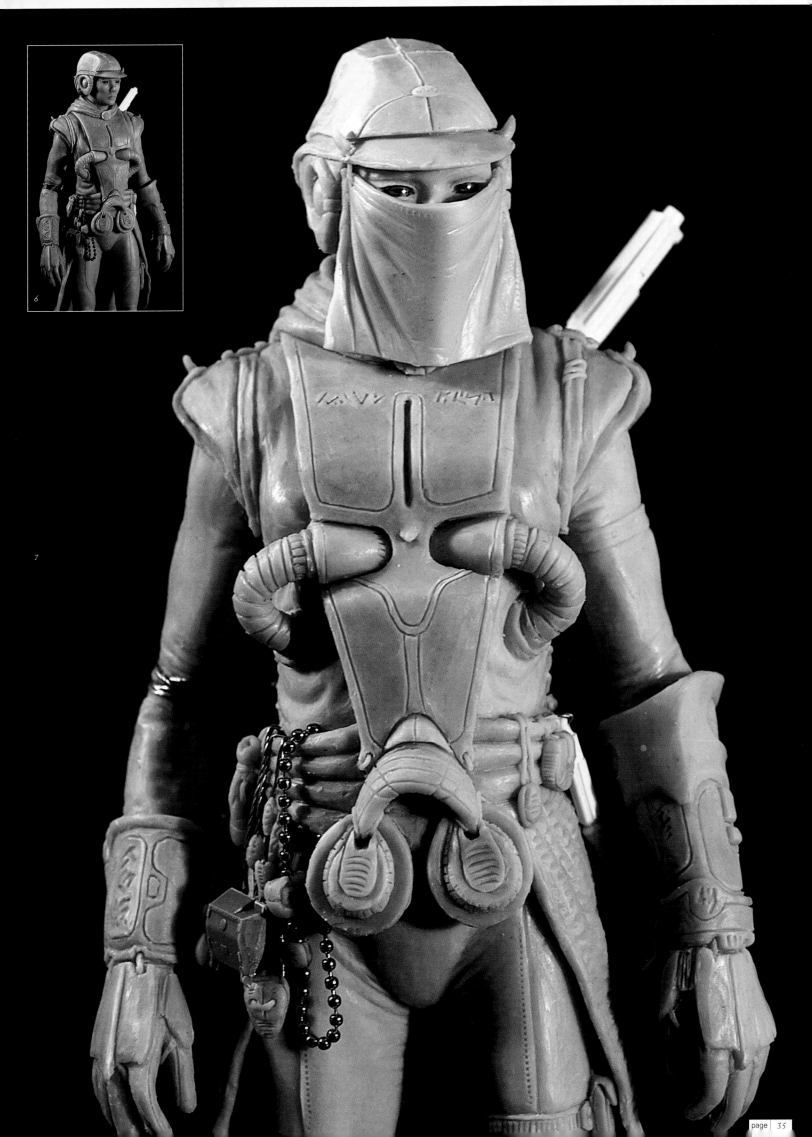

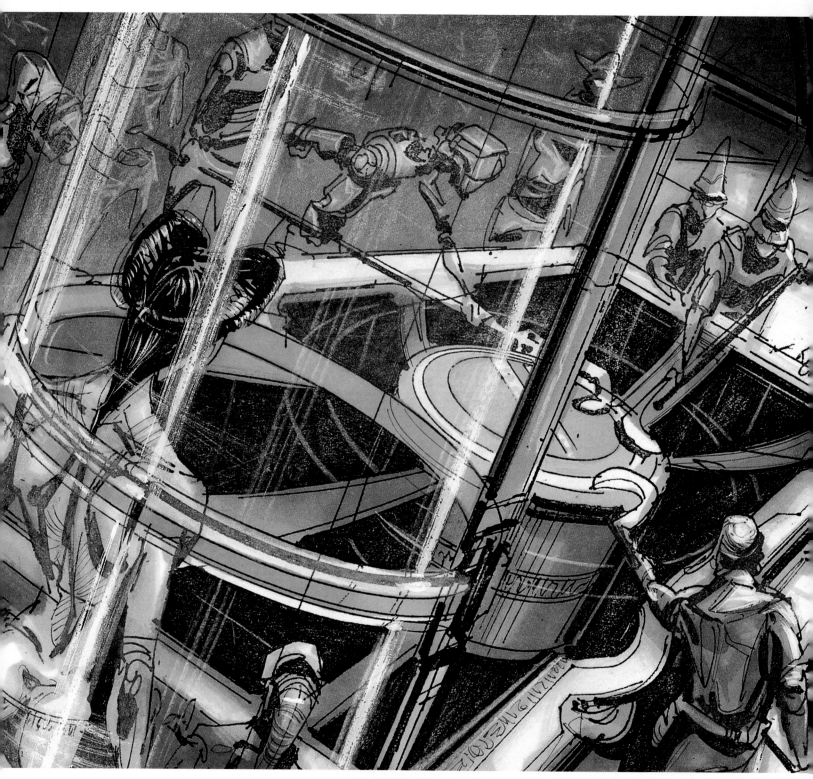

CORUSCANT NIGHTCLUB INTERIORS & COSTUMES
conceptual designs

1	Edwin Natividad
2	Marc Gabbana
3-5	Dermot Power

scene/s: 032

When the art department began working on Coruscant's nightclub interiors, the script was still in development. The artists didn't know that in this dim, high-tech space, Obi-Wan would subdue Zam with a samurai slice of his lightsaber.

The nightclub interior was "multilayered," Natividad noted; spacious, full of unconventional shapes, and displaying the motif of electronic faces flickering on omnipresent screens [far right, 1]. In one of his sketches, Jay Shuster created a mechanical, multiarmed robot bartender, a touch inspired by the Imperial probe droid of *The Empire Strikes Back*.

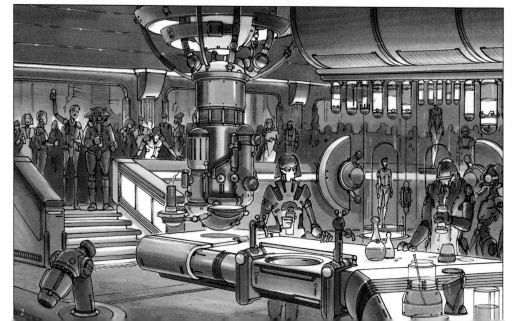

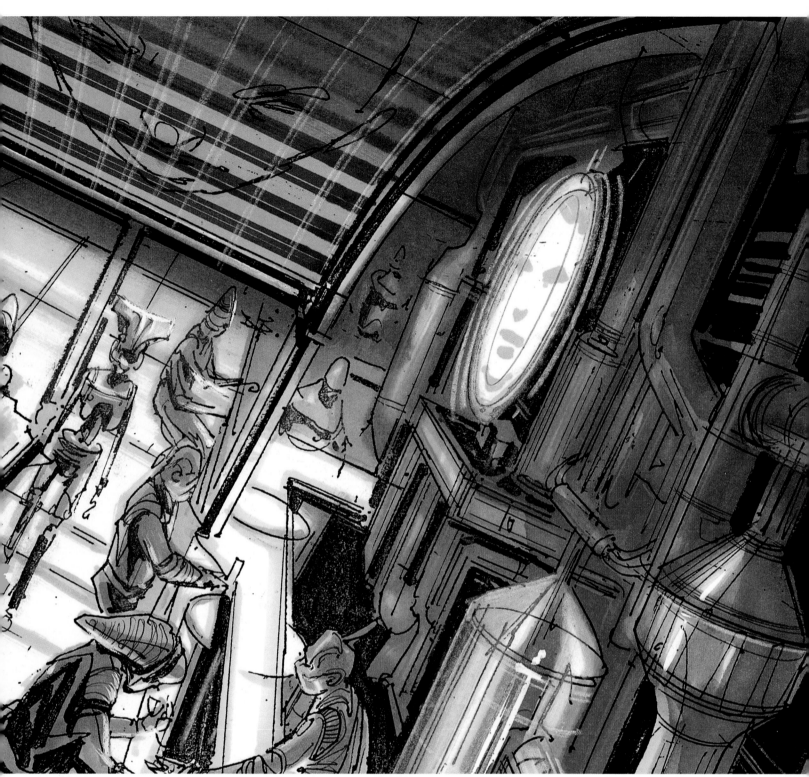

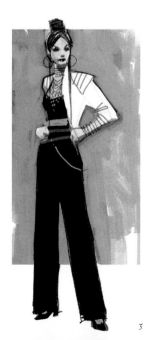

One of Lucas's ideas envisioned patrons being sucked up in tube elevators—seen in the Natividad image, far left—an homage of sorts to the retro future of TV's famous animated cartoon family. "When Doug asked for *Jetson*-type clear tubes, I rolled my eyes," Gabbana said, laughing. "Doug reassured me: 'Don't worry, it will be all right.' Which meant, 'Make it look good.' "

"*Star Wars* is reality based, but with a twist," Gabbana added. "It's not a total fantasy. We're grounded in the architecture and engineering of these worlds. The design of it is just a matter of playing with shapes."

"The Coruscant bar was less of the cantina from the first STAR WARS and more of a nightclub."
—**Jay Shuster**

3 4 5

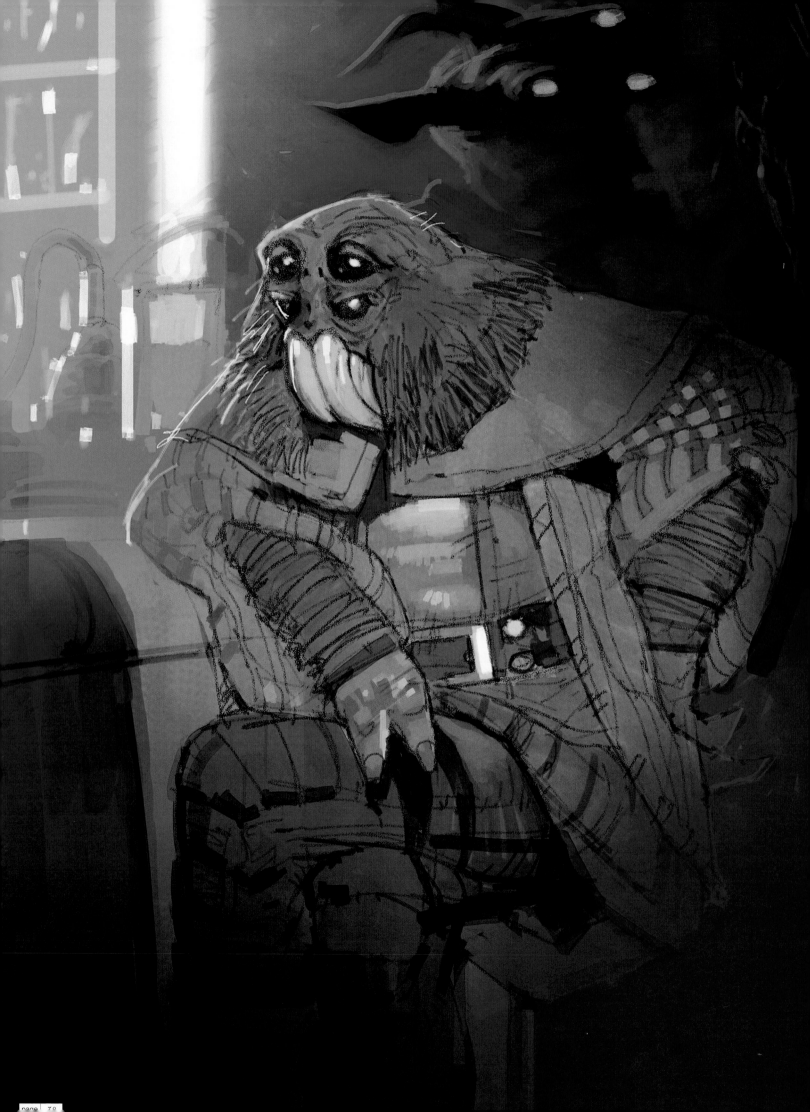

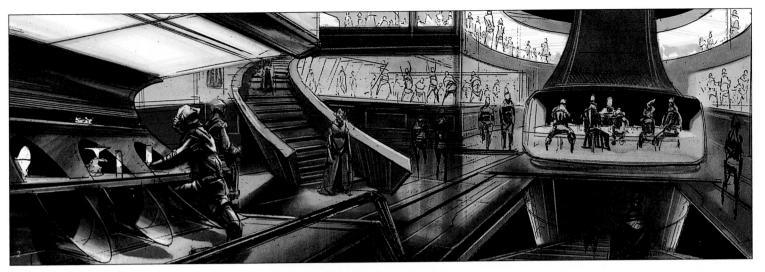

Coruscant Nightclub Interiors, Patróns & Back Ally	scene/s: 032/033
conceptual designs	

1, 3	Dermot Power
2, 5	Edwin Natividad
4, 6	Jay Shuster
7	Marc Gabbana

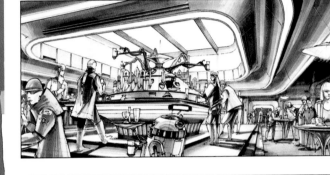

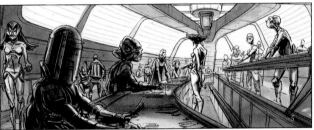

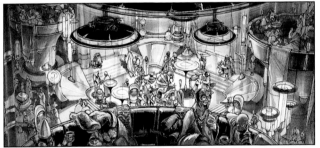

The architectural features of Coruscant, from the monorail stations to the nightclub interiors [2, 4–6], emphasized flowing lines, a design element subtly distinguishing the prequel culture. "Instead of rigid, straight lines, there are more free-flowing forms," Gabbana explained. "As we approach the timeline of the original trilogy, things will get more angular."

Meanwhile, McCaig marveled at the way Dermot Power's work, such as this nightclub patron [1], was totally digital. "I've never seen anyone work in the computer the way Dermot does. And he does it as effectively as anyone with markers and pen."

The image below [7] pictures the nightclub back alley where Zam is killed with a toxic dart just before she could reveal who hired her to assassinate Padmé. The image shows a hint of Gabbana's style, evident in the Coruscant buildings whose perspective emphasized vastness of space, with buildings going down into infinity.

"Episode II is a lot moodier than Episode I. There's more that's hidden, more things in shadows, so you're not sure what you're seeing. That whole play of illusion is much stronger."
—Doug Chiang

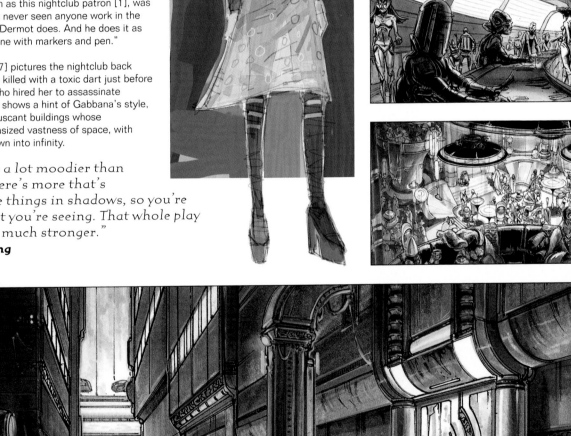

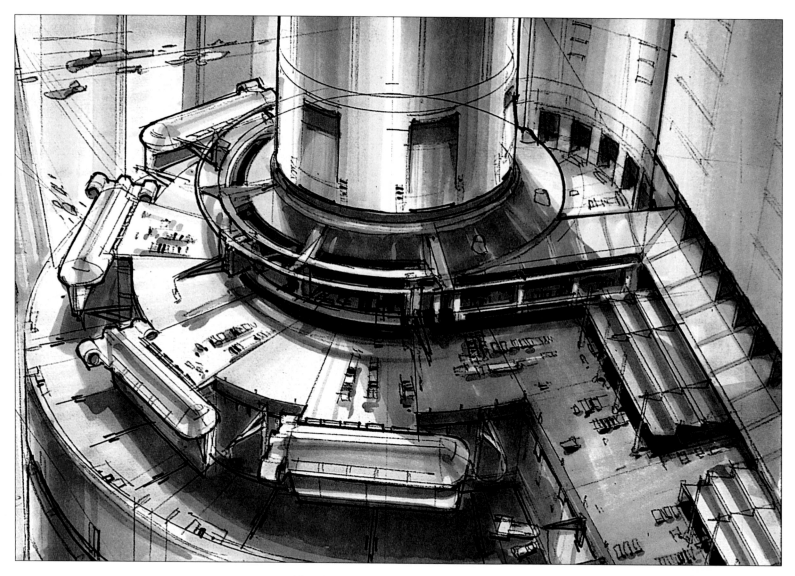

CORUSCANT SPACE PORT & FREIGHTERS
conceptual designs

| 1, 3 | Jay Shuster |
| 2 | Marc Gabbana |

scene/s: 041
40

After the assassination attempt, it's clear that Padmé's safety can't be guaranteed, so it's decided she must leave Coruscant. While Obi-Wan, with only the toxic dart as a lead, seeks to discover who is behind the plot, Padmé and Anakin board a star freighter, heading for the safety and tranquility of Naboo.

"Instead of boarding the freighters from the ground up, with a ramp rising as in a classic spaceship, Greorge had the idea of boarding the midlevel, as with an ocean liner."
—**Doug Chang**

2

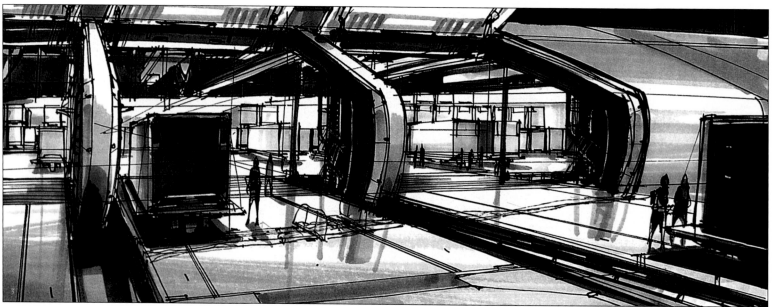

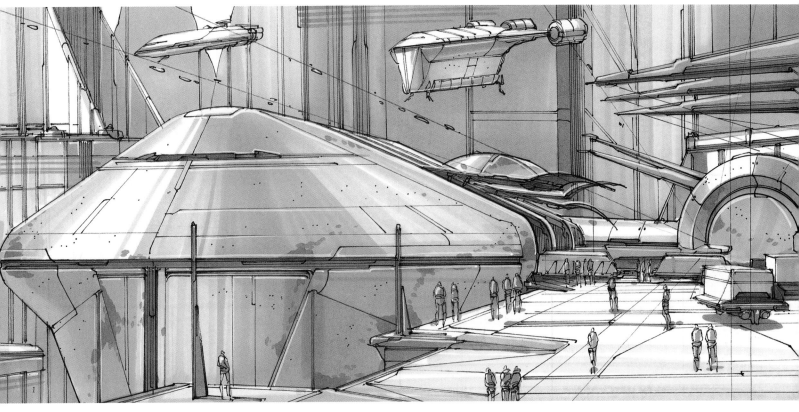

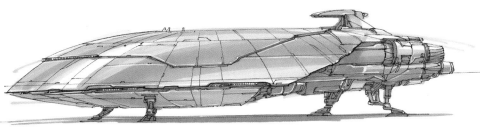

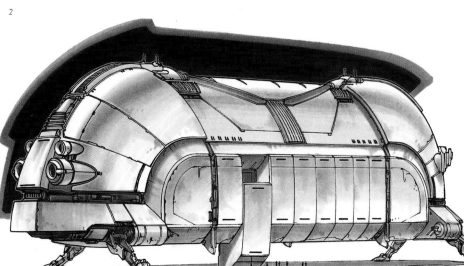

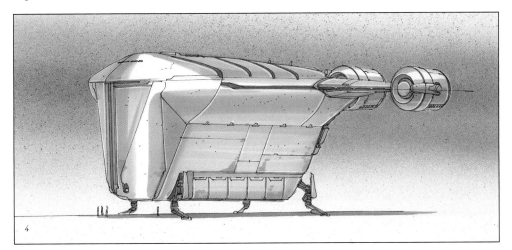

The spaceport was imagined as a vast complex in the center of Coruscant, its scale seen in Kurt Kaufman's final approved spaceport-establishing shot [page 40, 1]. Additional design sketches zoomed down into this complex, further exploring the environment. Key to the spaceport's scale was the freighter requested by Lucas [designs ranging from page 40, 2, to page 41, 2–4]. The final design [page 41, 1] depicted the freighter as huge. The two figures [5, 6] were early costume designs for Padmé's Senatorial clothing that were later used to suggest her in disguise.

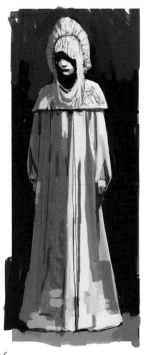

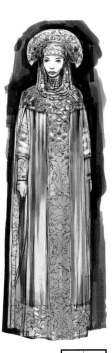

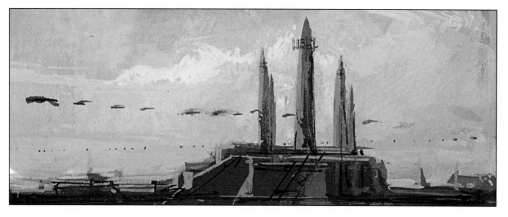

Obi-Wan's search for a clue to the plot against Padmé begins at the Jedi Temple. Here the Jedi Council convenes, young Padawans are trained, and Jedi lore and history—indeed, the history of the galaxy—are stored.

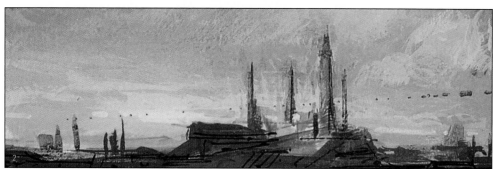

This layout of Tiemens's thumbnail paintings—truly "thumbnails," at one to three inches square—does not represent a sequential fly-in, but rather a brainstorm of potential composition and lighting, a search for a "new angle," as Tiemens explained, for the iconic Jedi Temple towers last seen in Episode I. Lucas ultimately selected a hybrid of these views. "He wanted a smoggier look to it," Tiemens added.

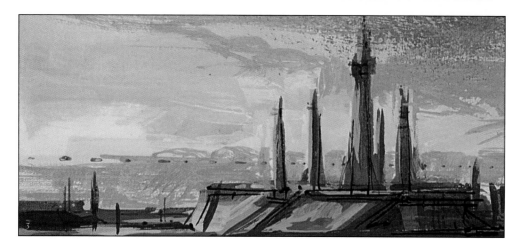

Thumbnails were a quick, efficient way of working up a variety of visual options to show George Lucas. The goal was to find lighting and composition concepts that presented even the most familiar of landmarks in startling new ways. "There have been a lot of views of the Jedi Temple, but with composition and lighting design we can get a fresh angle," explained Erik Tiemens, who with Ryan Church focused on bringing concepts to the next level of shot design. "From a clear day to one with fogs of storm clouds piling up, you can create a nuance or tone that reinforces a story point.

"Ryan and I were basically laying out the color palette and mood and lighting for a shot," Tiemens added. "We had to look at all the production footage, these simplified sets with bluescreen through which George is imagining these fantastic enviroments. We had to take that void of the bluescreen and make it come to life with sketches and concept paintings."

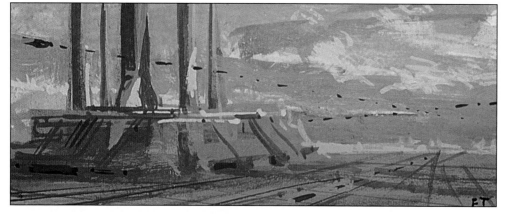

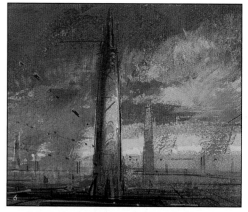

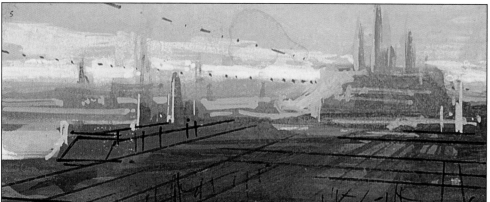

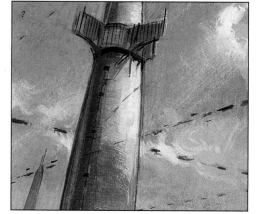

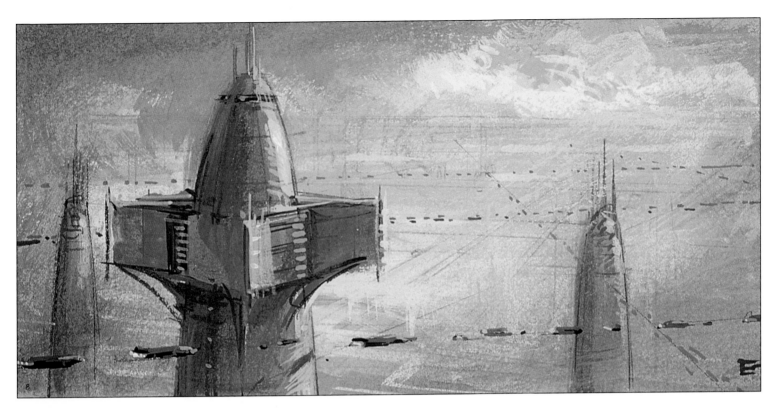

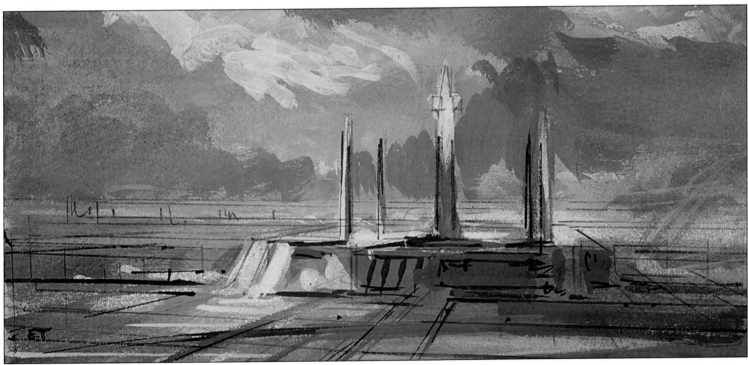

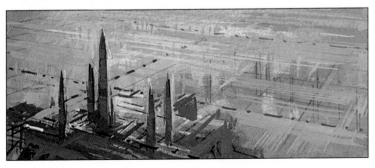

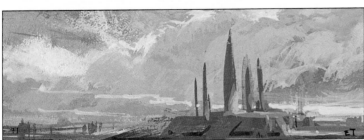

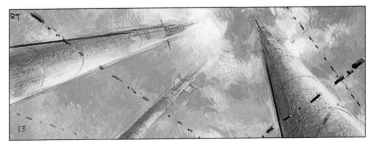

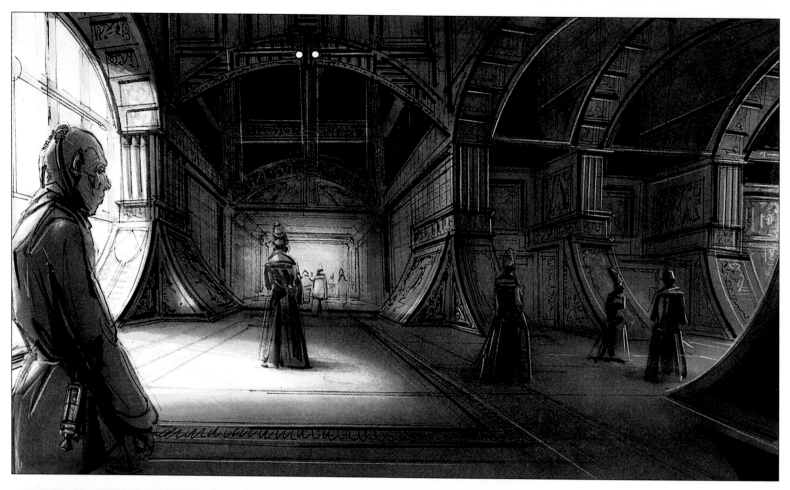

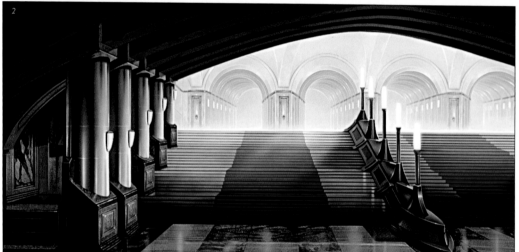

JEDI TEMPLE INTERIORS
conceptual designs

scene/s: 035

| 1, 3 | Edwin Natividad |
| 2 | Doug Chiang and Kurt Kaufman |

44

For the concept team, the door to the Jedi Temple had been opened in Episode I. With Episode II, the artists were free to wander its echoing halls and secret chambers.

The concept of a contemplative inner sanctum is evident in this image [1], complete with foreground detail of a brooding Jedi with topknot and clipped lightsaber. The Jedi Temple staircase and beckoning atrium [2] were inspired by New York's Grand Central Station. But unlike that bustling center of Earthly transport, Lucas wanted the Temple interiors "moody, like a cathedral," Natividad remembered.

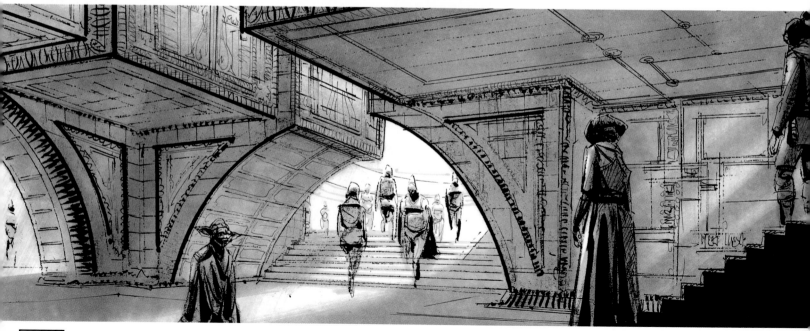

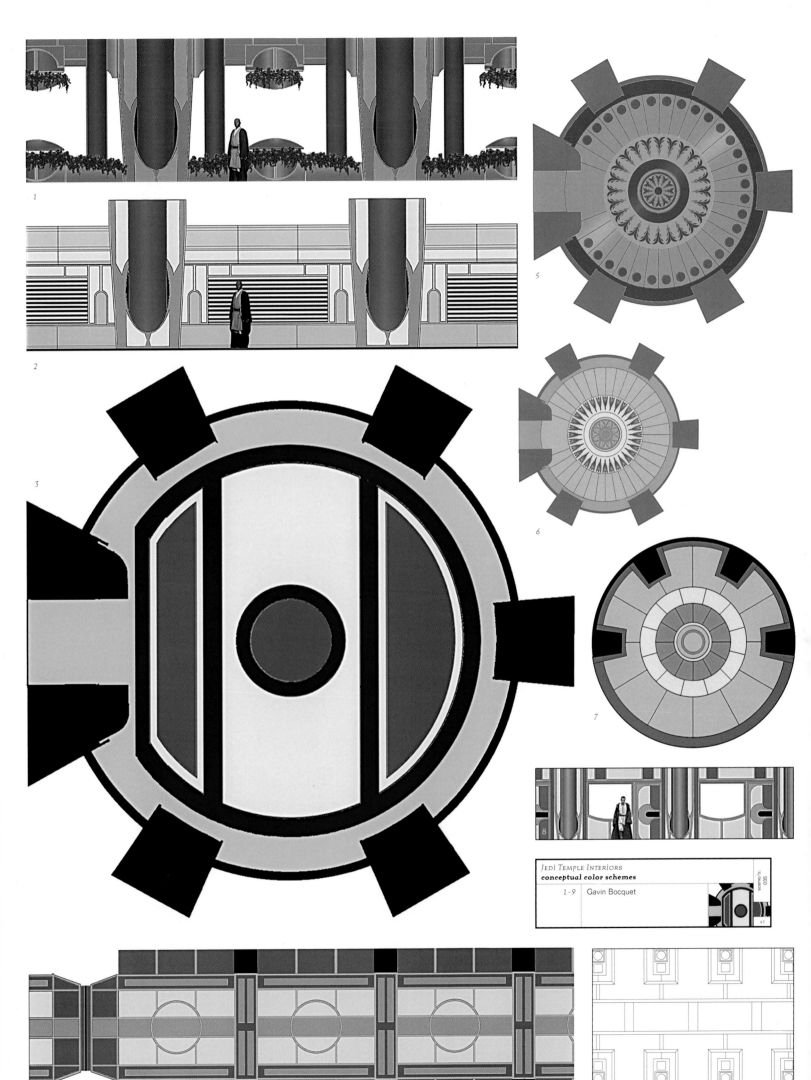

1

2

3

5

6

7

8

JEDI TEMPLE INTERIORS
conceptual color schemes

1 - 9 Gavin Bocquet

scene/s: 035

45

9

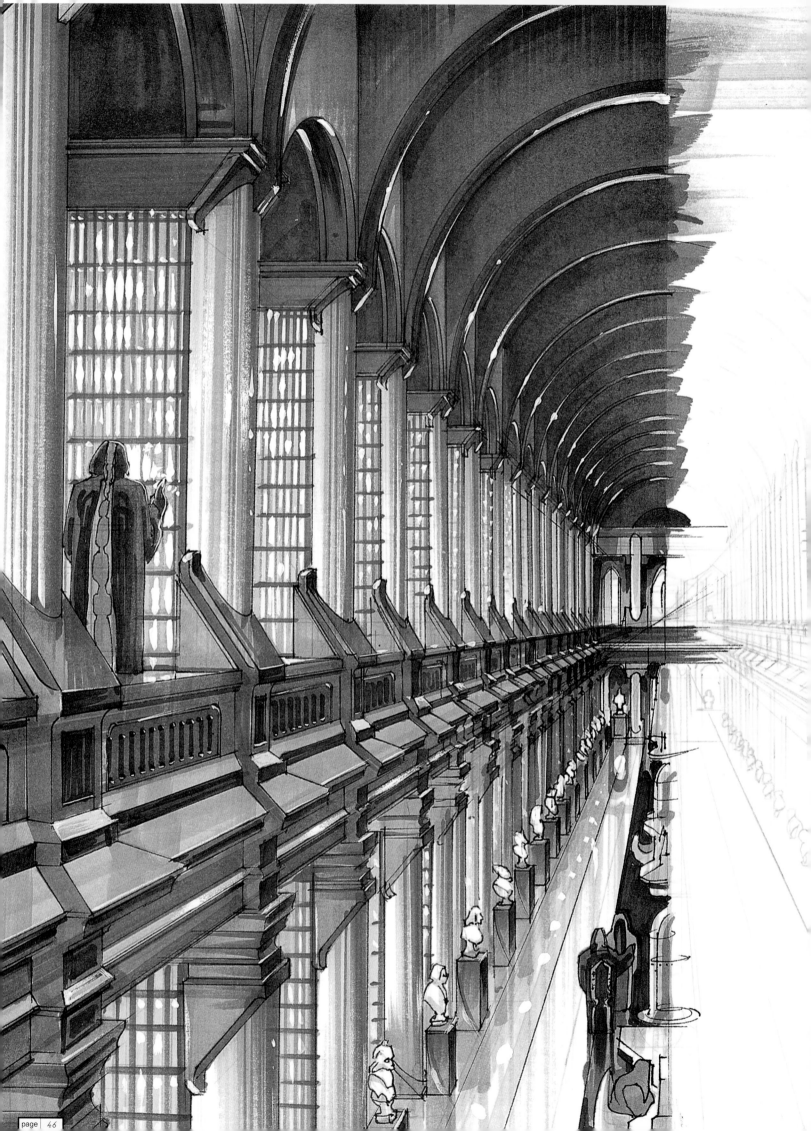

JEDI TEMPLE ARCHIVE INTERIORS		
conceptual designs		
1, 3	Jay Shuster	
2	Kurt Kaufman	

scene/s: 047

47

The Jedi Archives Room, with its vaulted ceiling and stately architecture, was inspired by a variety of libraries, from the Vatican to venerable estates and institutions in England. The busts of famous Jedi, living and dead, line the main hall. The drawing below [2] includes a bust of Master Yoda. This majestic hall still displays a bust of Count Dooku, the former Jedi now infamous as the most recent of the "Lost Twenty"—those who have left the Jedi Order.

"The Jedi Temple and its enviroment had been established in Episode I. So we had that look to go from, as well as George's directions."
—Kurt Kaufman

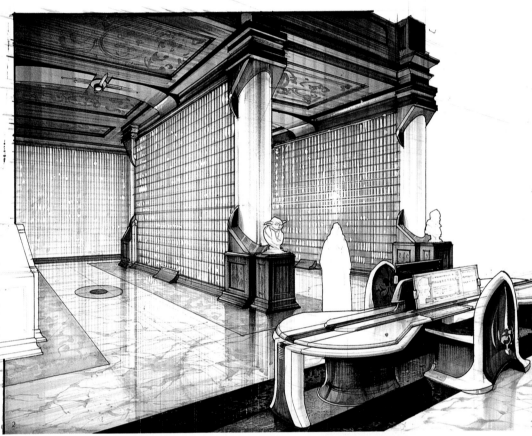

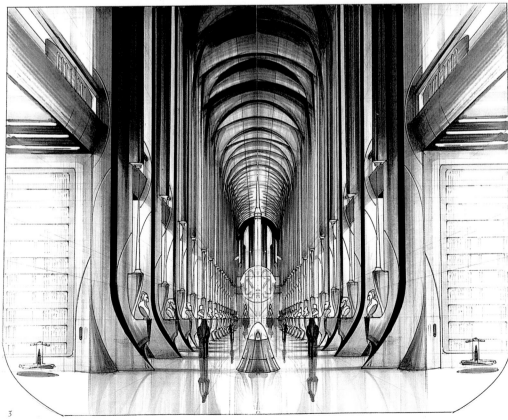

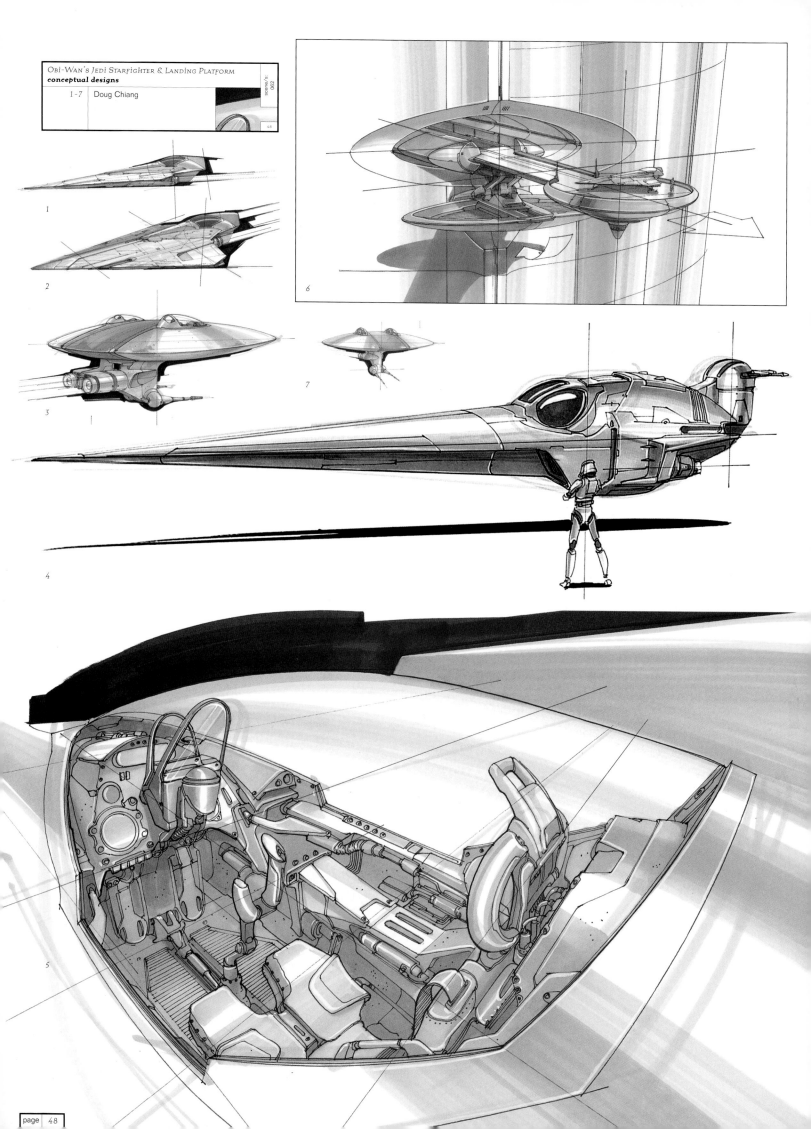

Obi-Wan's Jedi Starfighter & Landing Platform
conceptual designs

1-7 Doug Chiang

scene/s: 062

48

1

2

3

7

4

6

5

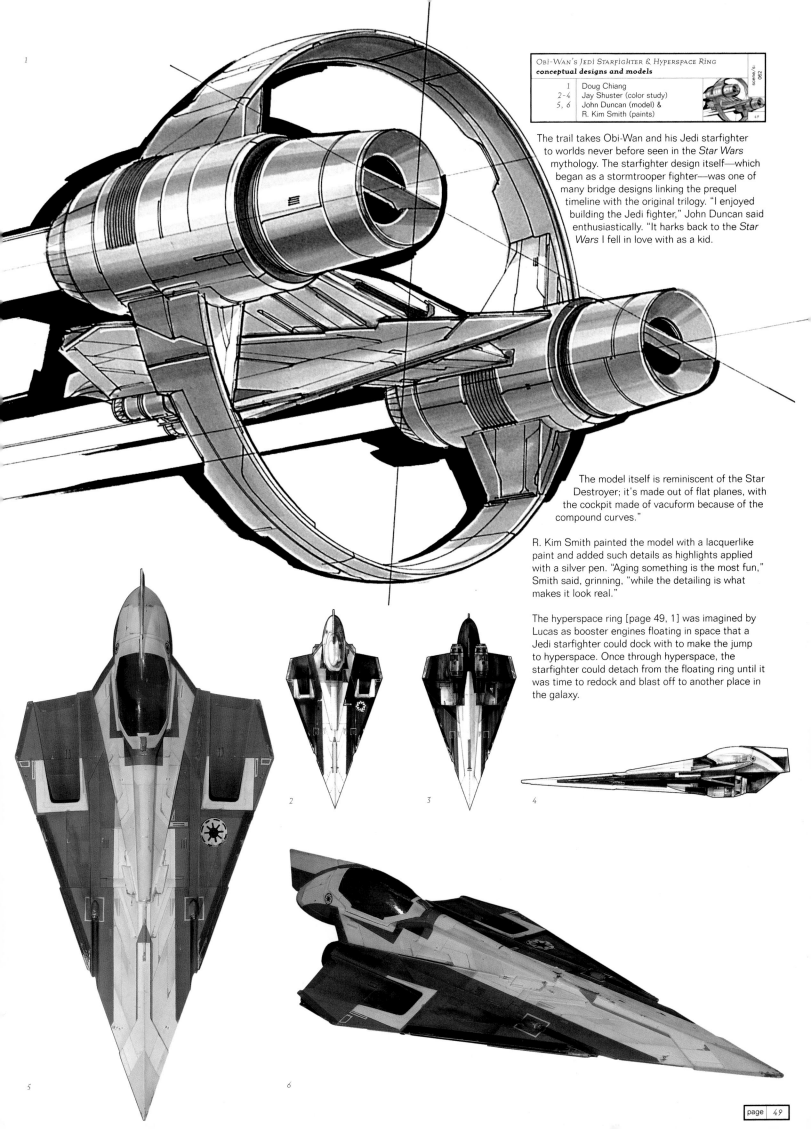

Obi-Wan's Jedi Starfighter & Hyperspace Ring
conceptual designs and models

		scene/s: 062
1	Doug Chiang	
2-4	Jay Shuster (color study)	
5, 6	John Duncan (model) &	
	R. Kim Smith (paints)	49

The trail takes Obi-Wan and his Jedi starfighter to worlds never before seen in the *Star Wars* mythology. The starfighter design itself—which began as a stormtrooper fighter—was one of many bridge designs linking the prequel timeline with the original trilogy. "I enjoyed building the Jedi fighter," John Duncan said enthusiastically. "It harks back to the *Star Wars* I fell in love with as a kid.

The model itself is reminiscent of the Star Destroyer; it's made out of flat planes, with the cockpit made of vacuform because of the compound curves."

R. Kim Smith painted the model with a lacquerlike paint and added such details as highlights applied with a silver pen. "Aging something is the most fun," Smith said, grinning, "while the detailing is what makes it look real."

The hyperspace ring [page 49, 1] was imagined by Lucas as booster engines floating in space that a Jedi starfighter could dock with to make the jump to hyperspace. Once through hyperspace, the starfighter could detach from the floating ring until it was time to redock and blast off to another place in the galaxy.

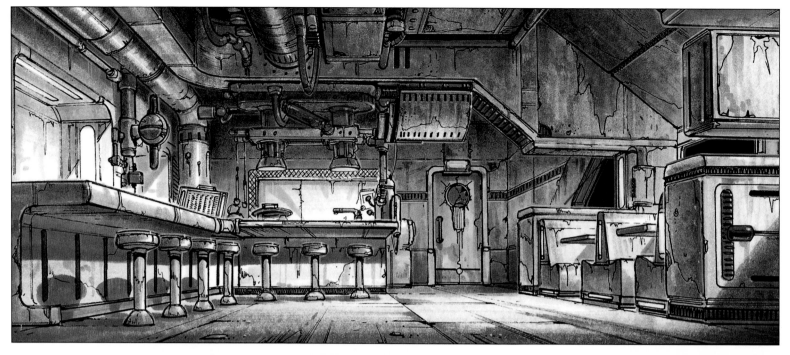

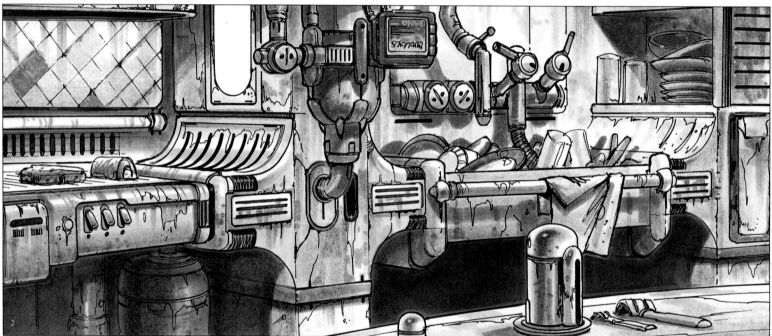

DEXTER'S DINER, COOK & WAITRESS DROID *conceptual designs*		scene/s: 045
1, 2	Marc Gabbana	
3	Dermot Power	
4	Warren Fu	50

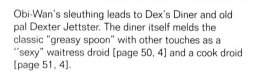

Obi-Wan's sleuthing leads to Dex's Diner and old pal Dexter Jettster. The diner itself melds the classic "greasy spoon" with other touches as a "sexy" waitress droid [page 50, 4] and a cook droid [page 51, 4].

"Because of the time compression of production, it made sense to get into 3D quicker. Dexter was a dream come true—to pour out ideas in clay."
—Robert E. Barnes

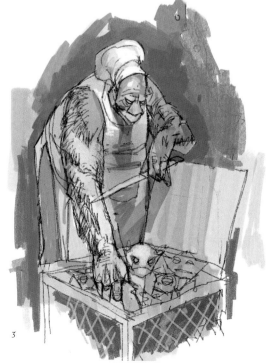

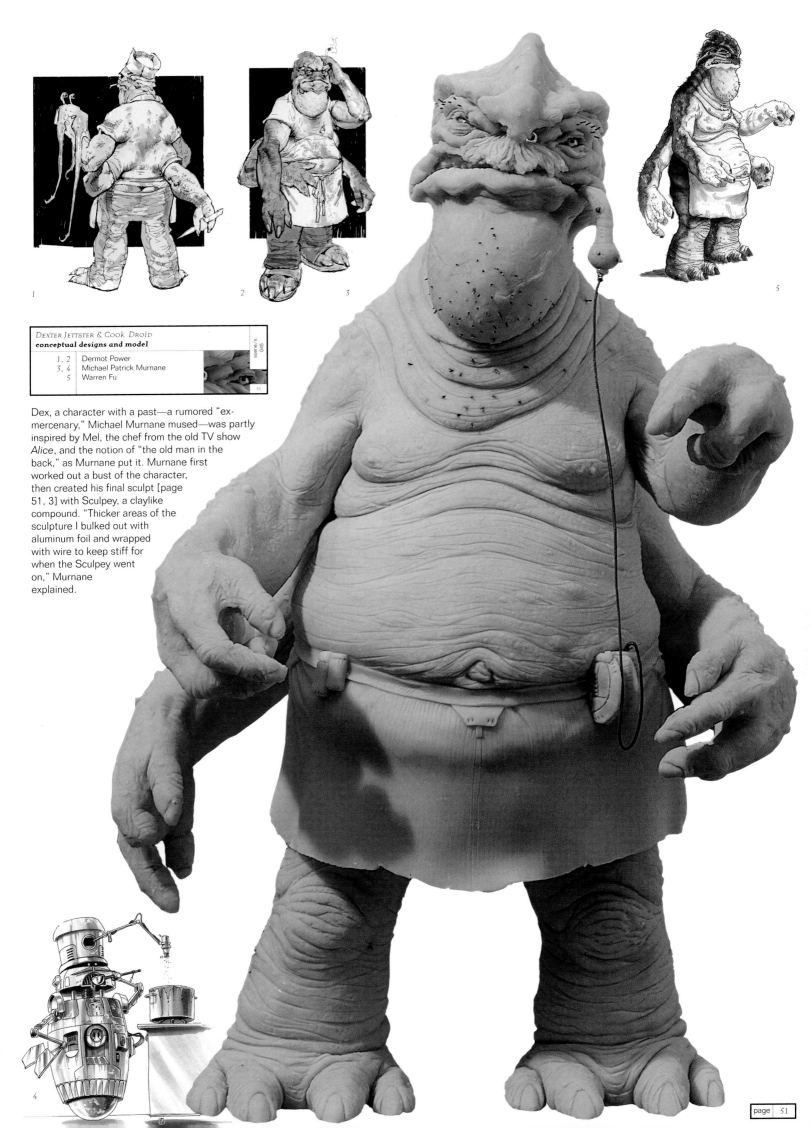

Dexter Jettster & Cook Droid
conceptual designs and model

		scene/s: 045
1, 2	Dermot Power	
3, 4	Michael Patrick Murnane	
5	Warren Fu	51

Dex, a character with a past—a rumored "ex-mercenary," Michael Murnane mused—was partly inspired by Mel, the chef from the old TV show *Alice*, and the notion of "the old man in the back," as Murnane put it. Murnane first worked out a bust of the character, then created his final sculpt [page 51, 3] with Sculpey, a claylike compound. "Thicker areas of the sculpture I bulked out with aluminum foil and wrapped with wire to keep stiff for when the Sculpey went on," Murnane explained.

NABOO SPACEPORT, AIR BUSES & COSTUMES		scene/s:
conceptual designs		052
1, 8	Marc Gabbana	
2, 5	Dermot Power	
3, 4, 6	Iain McCaig	
7, 9–11	Kurt Kaufman	52

The Naboo Spaceport, where the freighter bearing Anakin and Padmé would dock, was envisioned in the original script as a destination for immigrants from throughout the galaxy—including, as the original script detailed, the peoples of an entire world displaced because their sun was imploding. McCaig said, "This big spaceport was to be a place we'd see different races and characters. We were specifically told the people at the spaceport were poor, but not squalid and not like Coruscant, where you get the rough street life."

"We did tons of peasants. It was difficult to not make them too twee or tough," Dermot Power said. "You look at references for peasant costumes and there's a narrow line between blokes who look mad and ordinary people working the fields."

"George told us he wanted an Ellis Island in space, and it was going to be Naboo."
—Iain McCaig

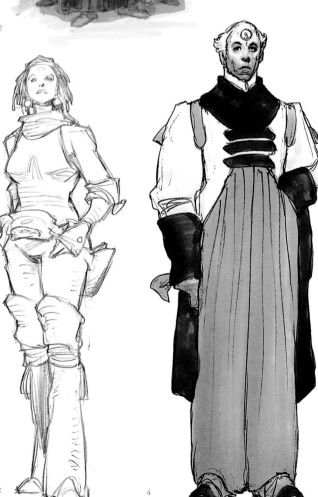

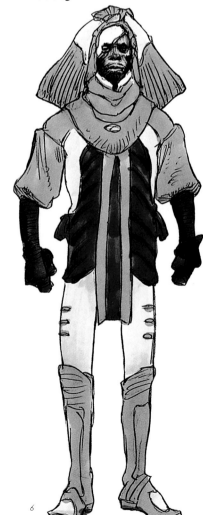

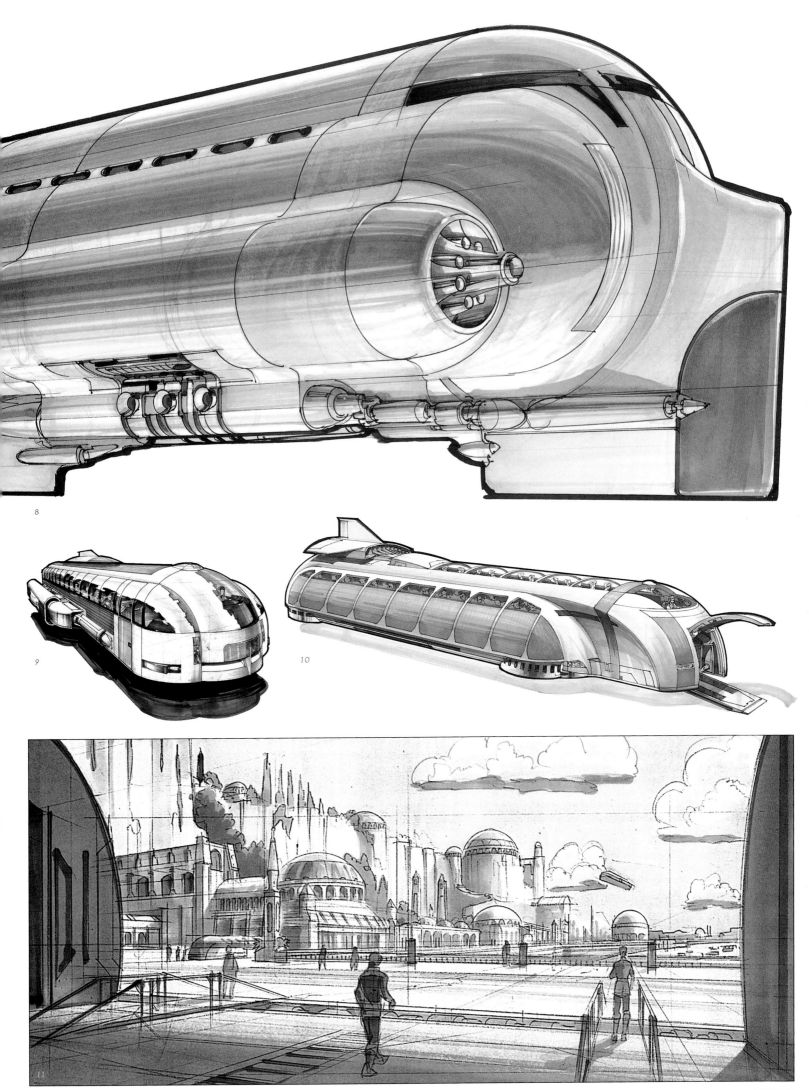

8

9

10

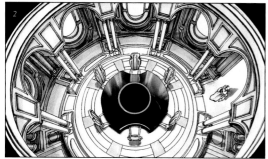

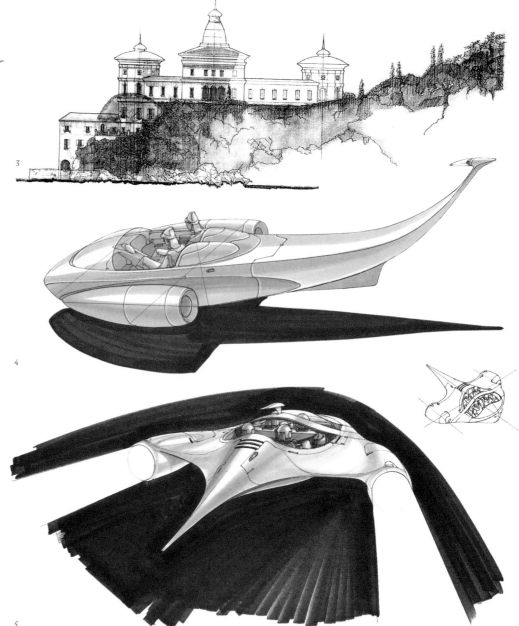

NABOO LAKE RETREAT & GONDOLA
conceptual designs

1, 2	Gavin Bocquet & Ravi Bansal	
3	Phil Harvey	
4, 5	Jay Shuster	
6	Doug Chiang	

scene/s: 065

When Padmé thinks of her homeland, she hears the hypnotic cascading of Theed's distant waterfalls. Anakin, returning to the planet he first visited as a boy ten years before, recalls shimmering sunlight and flower-scented air. Naboo is truly an idyllic place for the storybook romance between Anakin and Padmé to begin, particularly the remote lake country to which the budding lovers retreat. Anakin knows the Jedi oath forbids attachment; Padmé knows her Senatorial demands leave no time for romance—but here, despite all, they share a first kiss.

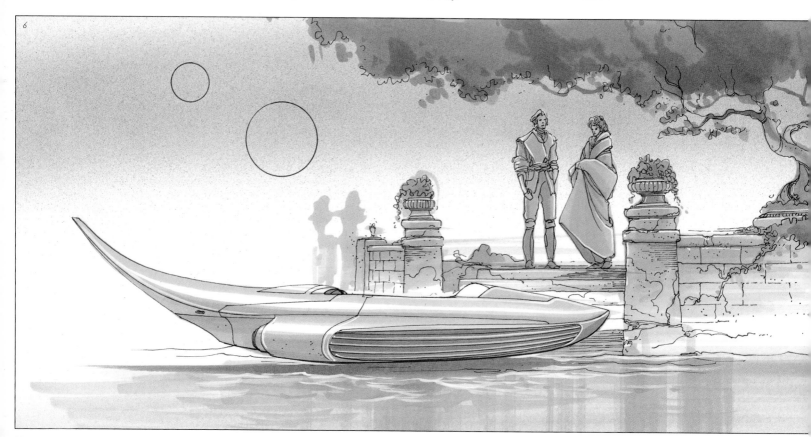

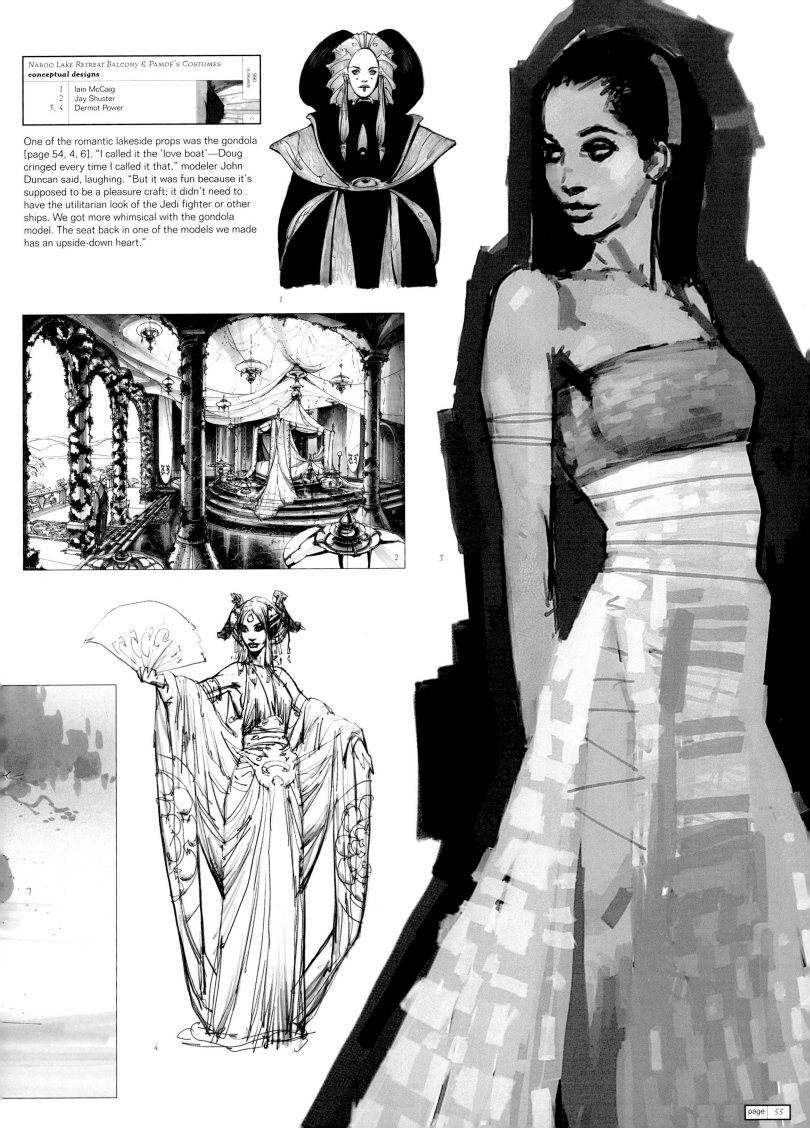

NABOO LAKE RETREAT BALCONY & PAMDÉ'S COSTUMES
conceptual designs

1	Iain McCaig
2	Jay Shuster
3, 4	Dermot Power

scene/s: 066

One of the romantic lakeside props was the gondola [page 54, 4, 6]. "I called it the 'love boat'—Doug cringed every time I called it that," modeler John Duncan said, laughing. "But it was fun because it's supposed to be a pleasure craft; it didn't need to have the utilitarian look of the Jedi fighter or other ships. We got more whimsical with the gondola model. The seat back in one of the models we made has an upside-down heart."

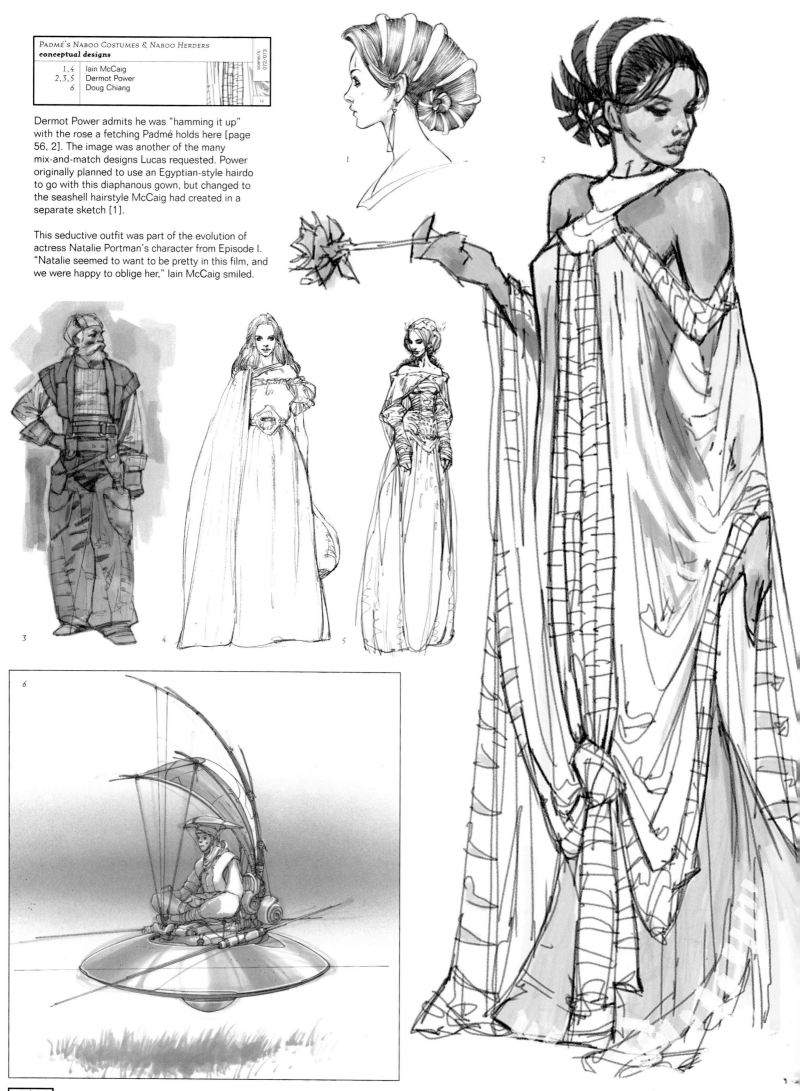

PADMÉ'S NABOO COSTUMES & NABOO HERDERS
conceptual designs

		scene/s:
1,4	Iain McCaig	072/073
2,3,5	Dermot Power	
6	Doug Chiang	

Dermot Power admits he was "hamming it up" with the rose a fetching Padmé holds here [page 56, 2]. The image was another of the many mix-and-match designs Lucas requested. Power originally planned to use an Egyptian-style hairdo to go with this diaphanous gown, but changed to the seashell hairstyle McCaig had created in a separate sketch [1].

This seductive outfit was part of the evolution of actress Natalie Portman's character from Episode I. "Natalie seemed to want to be pretty in this film, and we were happy to oblige her," Iain McCaig smiled.

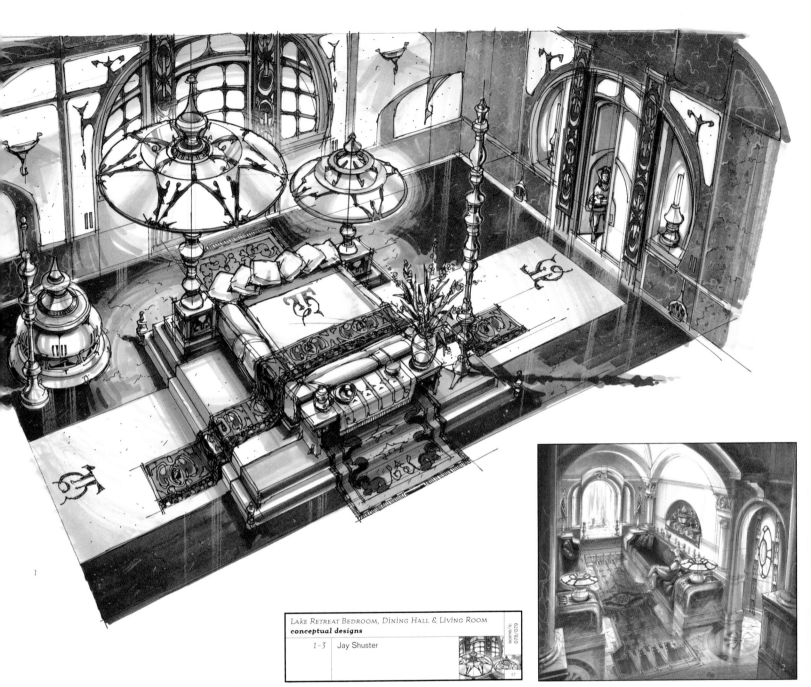

1

LAKE RETREAT BEDROOM, DINING HALL & LIVING ROOM		scene/s:
conceptual designs		078/079
1–3	Jay Shuster	
		57

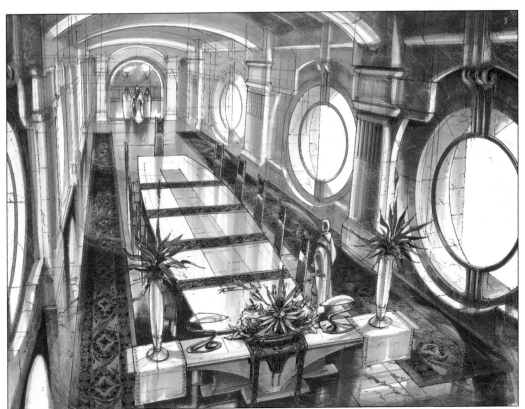

Padmé's bedroom at the lake retreat is one of what Jay Shuster called the "personal spaces" on Naboo, used to reinforce the romantic turn of the storyline. Rounding out the lakefront's pastoral atmosphere are nerf and shaak herders [page 56, 3, 6], who tend their flocks in the surrounding mountain meadows.

The Reggia Palace in Caserta, Italy, which served as a location for Theed Palace in Episode I, inspired Shuster's bedroom design [page 57, 1]. The elegant lighting fixtures also "infused a bit of richness," Shuster noted, "and captured the look of Naboo." That Nabooian style is seen throughout the house in the way simple spaces are layered with baroque, but elegant, details.

> *"Iain could draw Padmé like someone who didn't realize she was beautiful. I tried, but she doesn't look innocent in my drawings!"*
> —**Dermot Power**

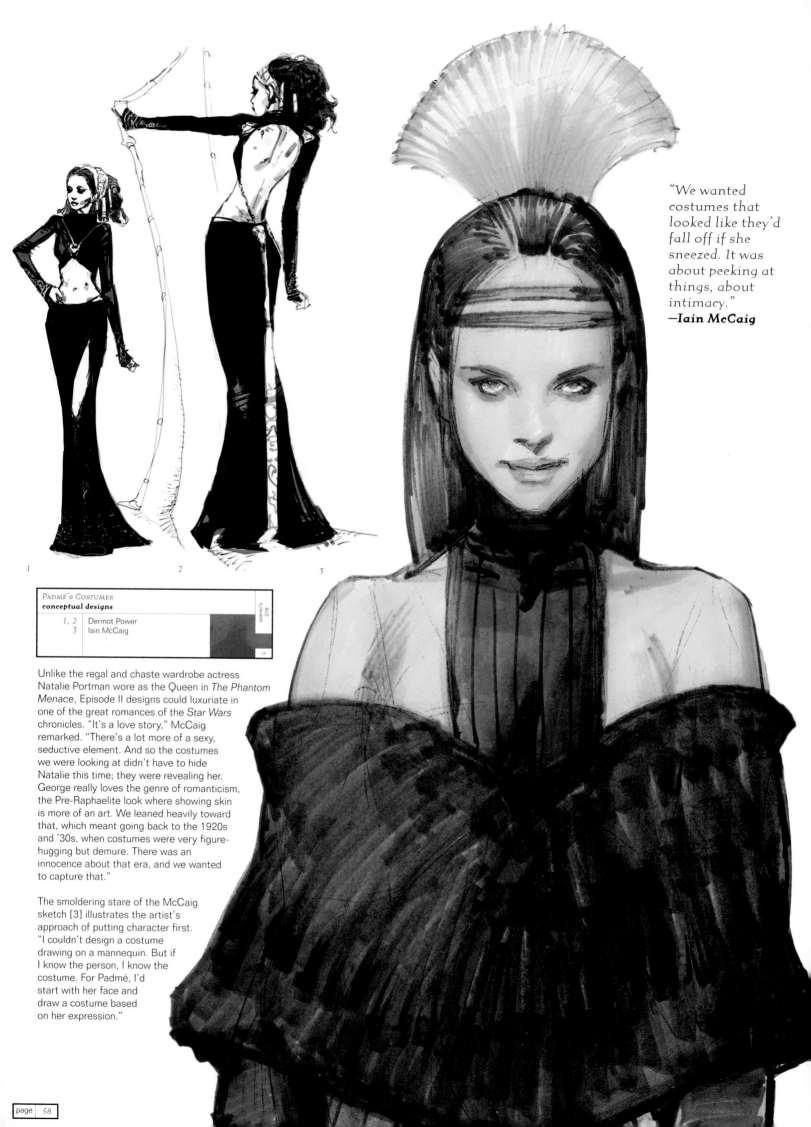

Padmé's Costumes				
conceptual designs				scene/s:
1, 2	Dermot Power			070
3	Iain McCaig			
				58

Unlike the regal and chaste wardrobe actress
Natalie Portman wore as the Queen in *The Phantom
Menace*, Episode II designs could luxuriate in
one of the great romances of the *Star Wars*
chronicles. "It's a love story," McCaig
remarked. "There's a lot more of a sexy,
seductive element. And so the costumes
we were looking at didn't have to hide
Natalie this time; they were revealing her.
George really loves the genre of romanticism,
the Pre-Raphaelite look where showing skin
is more of an art. We leaned heavily toward
that, which meant going back to the 1920s
and '30s, when costumes were very figure-
hugging but demure. There was an
innocence about that era, and we wanted
to capture that."

The smoldering stare of the McCaig
sketch [3] illustrates the artist's
approach of putting character first.
"I couldn't design a costume
drawing on a mannequin. But if
I know the person, I know the
costume. For Padmé, I'd
start with her face and
draw a costume based
on her expression."

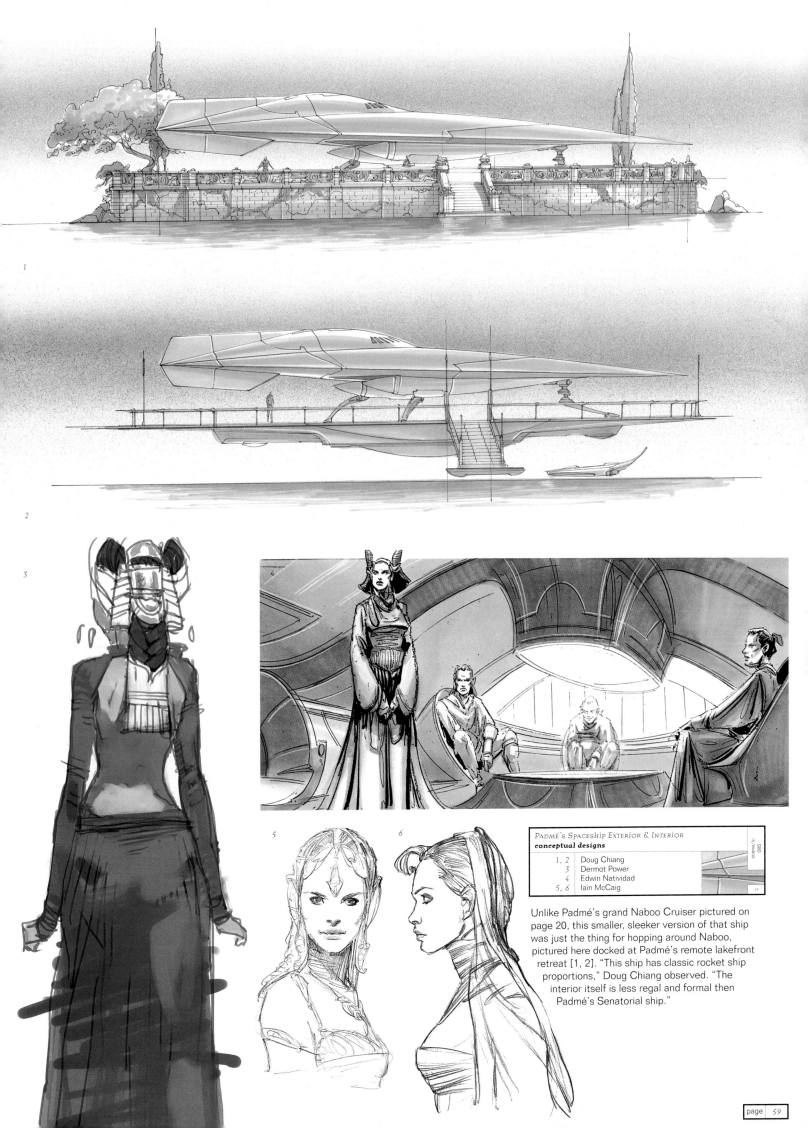

	PADMÉ'S SPACESHIP EXTERIOR & INTERIOR
	conceptual designs
1, 2	Doug Chiang
3	Dermot Power
4	Edwin Natividad
5, 6	Iain McCaig

scene/s: 085

Unlike Padmé's grand Naboo Cruiser pictured on page 20, this smaller, sleeker version of that ship was just the thing for hopping around Naboo, pictured here docked at Padmé's remote lakefront retreat [1, 2]. "This ship has classic rocket ship proportions," Doug Chiang observed. "The interior itself is less regal and formal then Padmé's Senatorial ship."

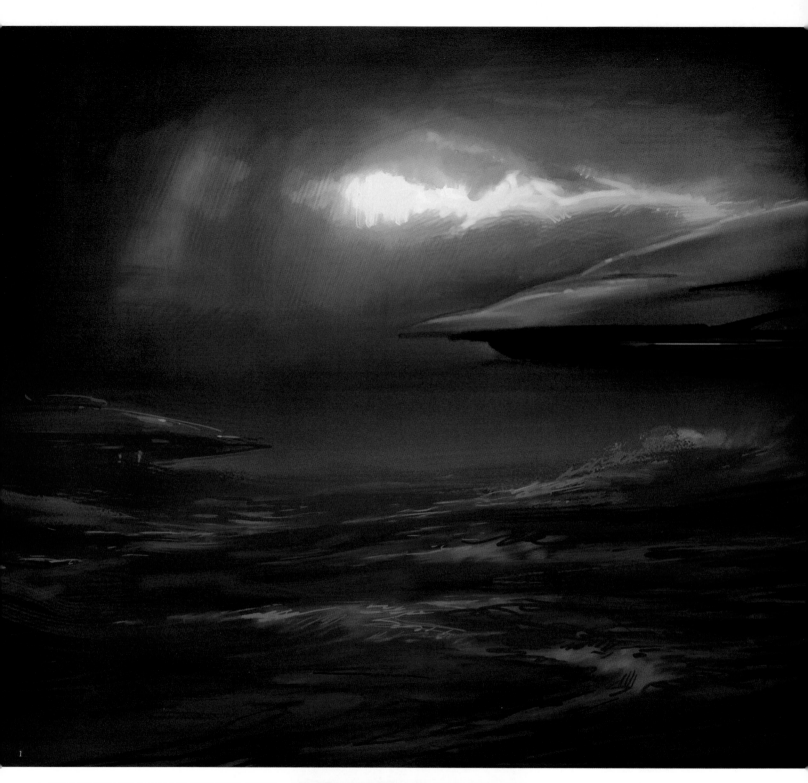

1

When Obi-Wan brought the toxic dart to Dexter Jettster, who once prospected beyond the Outer Rim, he was quick to recognize the markings on the weapon as those of a saberdart belonging "to them cloners" from the Outer Rim world of Kamino. In this moody Erik Tiemens design [1], we see Kamino's Tipoca City as Obi-Wan, arriving in his starfighter, might have glimpsed it through the windblown mists—a monolithic structure standing defiantly above the battering waves of a watery planet.

2

3

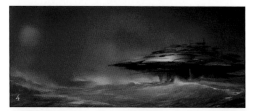

4

"This was one of those critical images," Tiemens recalled of the establishing shot, a computer painting done in Painter. "We wanted an image that within a beat or two summed up a sense of scale and the image of a water planet, a stormy place where it's always raining." This was one of six digital concept paintings Tiemens produced, variations on Doug Chiang's original Tipoca City concept painting.

Both Tiemens's and Church's shot design concepts emphasized the stormy atmosphere surrounding Tipoca City. The roiling sea and thick mist dominated the images, making even more dramatic the occasional break in the clouds and the sunshine playing on the waves. But the elemental ferocity also underscored the indomitable will of the Kaminoans. "The seas around them are stormy and they live in stilted city structures, but they're in control," Tiemens concluded. "Their ability to survive shows their incredible intelligence."

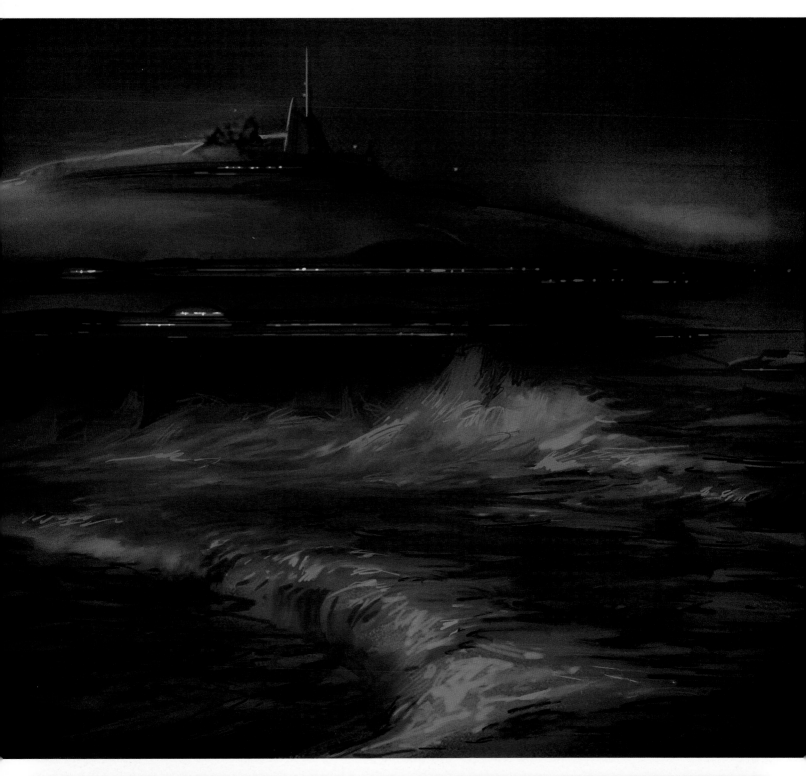

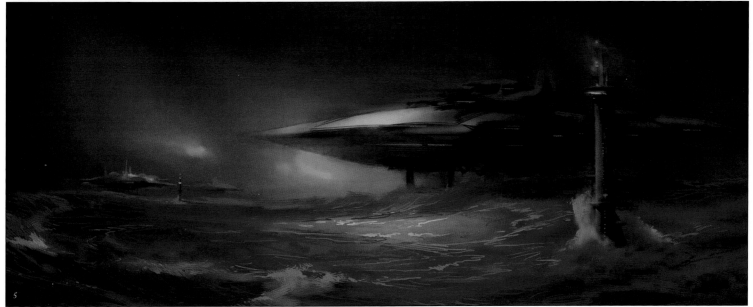

5

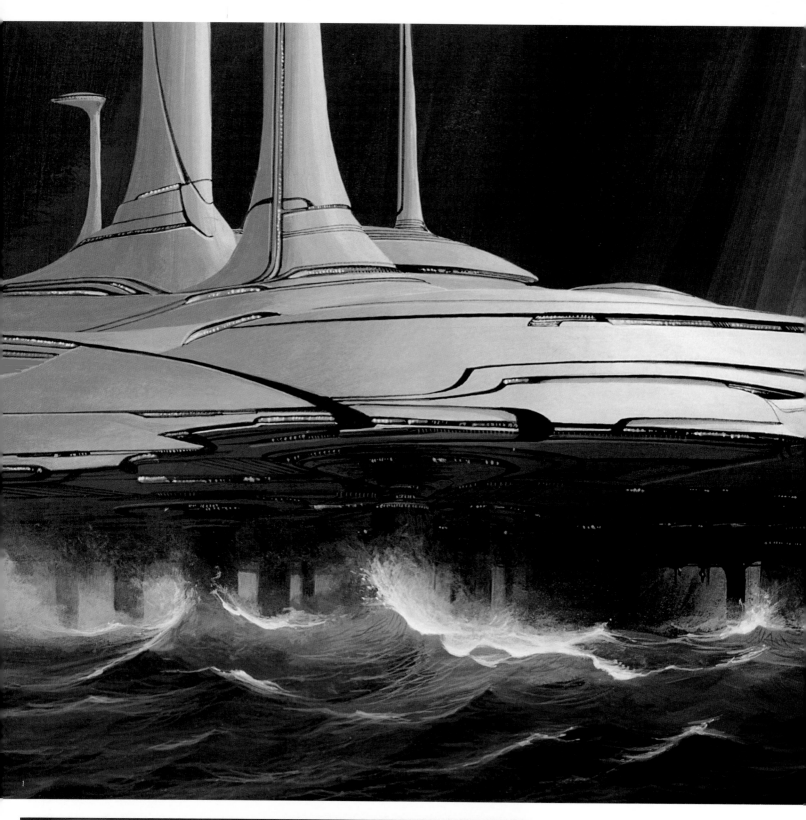

The earliest concepts for what Lucas had called the "cloning world" imagined a city perched above a stormy sea. Doug Chiang's first production painting was this dramatic approach to Tipoca City [1]. "George described this as a planet consumed by storms but with very high-tech, sophisticated cities built on stilts," Chiang recalled. "That image was very appealing, since I've always liked the striking image of oil derricks in the North Atlantic. When I was painting, I was trying to capture that mood where there's a break in the weather and a shaft of sunlight is highlighting the city, but the rain and winds are still powerful."

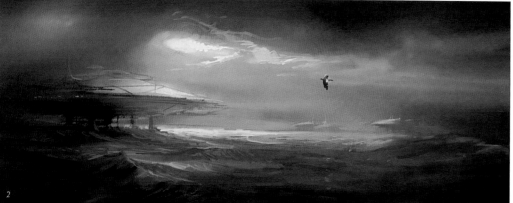

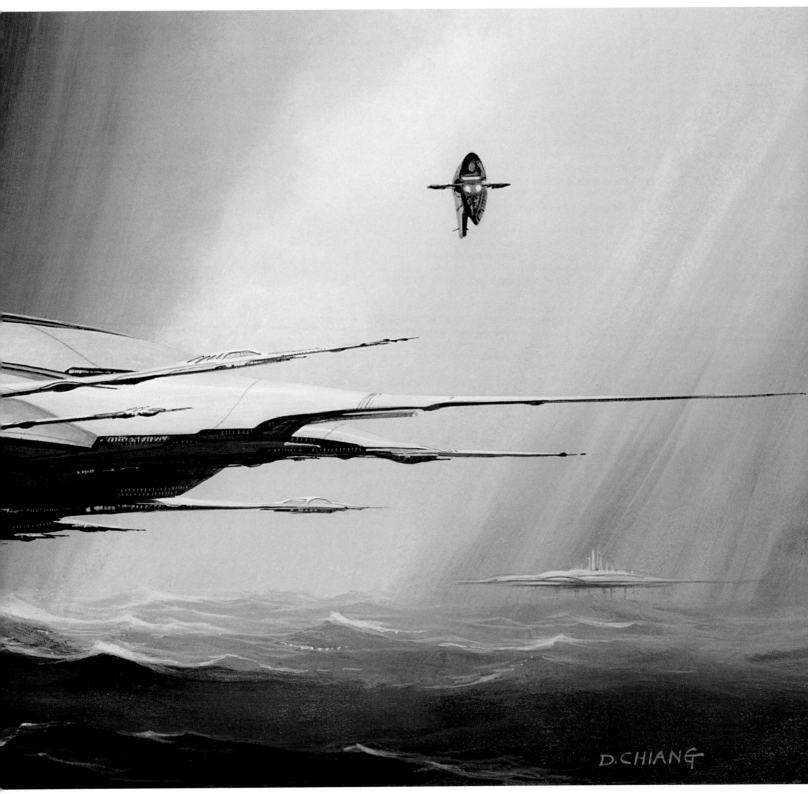

Kamino: Tipoca City
conceptual designs

| 1, 3 | Doug Chiang |
| 2 | Erik Tiemens |

scene/s:
062/074

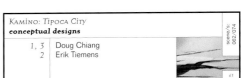

To this painting Chiang added the *Slave I* starship familiar to fans of bounty hunter Boba Fett. It's more than an evocative touch—in storm-wracked Tipoca City, Obi-Wan meets a ten-year-old Boba and his mysterious bounty hunter father. The Jedi Knight also learns that the city is a massive cloning center producing soldiers for the Republic.

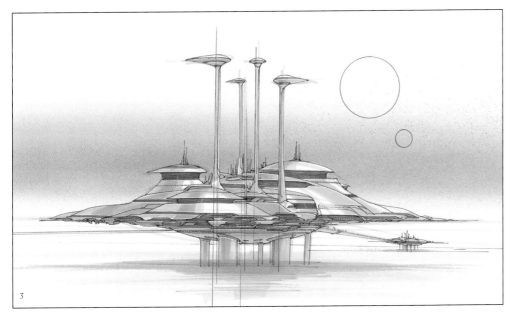

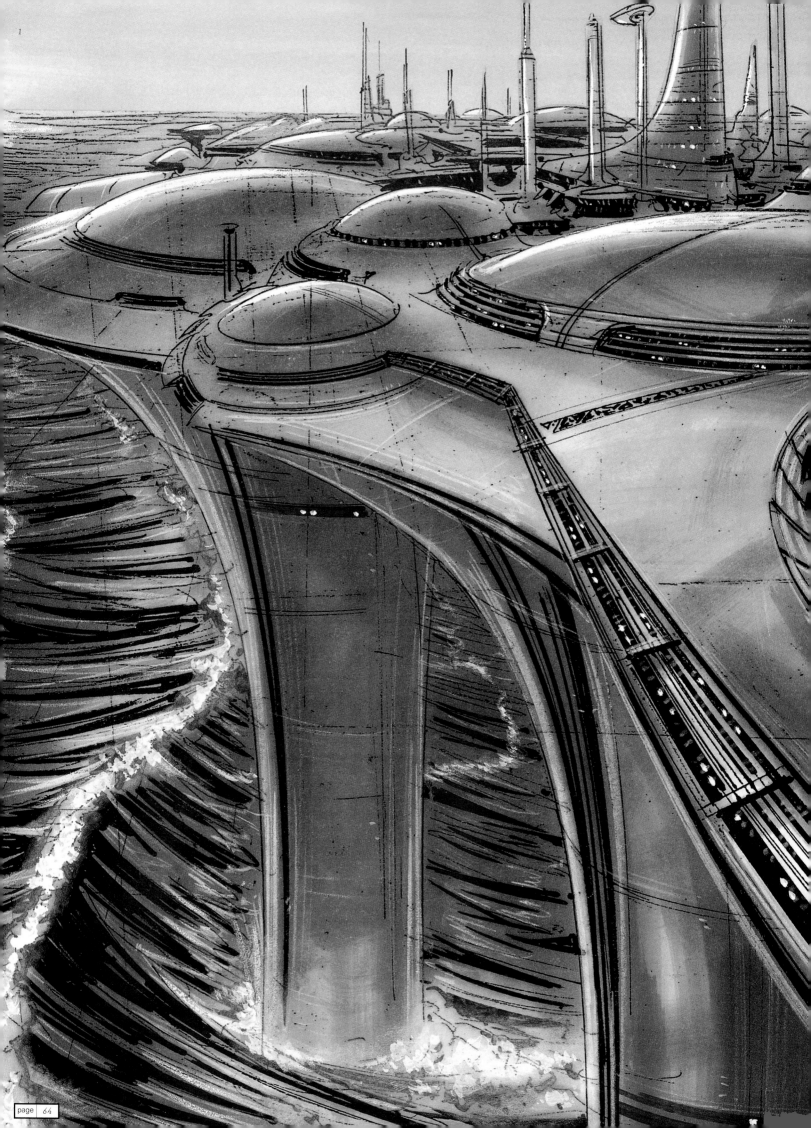

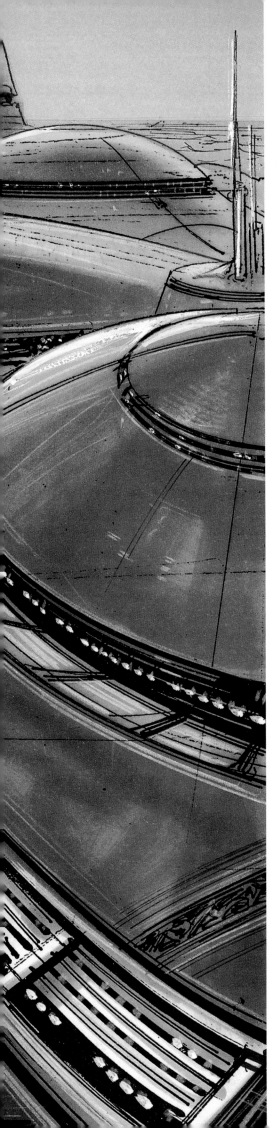

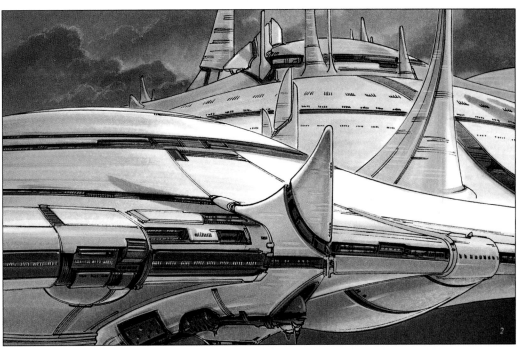

Tipoca City Exterior
conceptual designs

1	Edwin Natividad	
2-4	Marc Gabbana	
5	Doug Chiang	

scene/s: 062/063

65

When Natividad worked on this exterior image [1], Tipoca was labeled the water city. To capture the planet's elemental force, Natividad recalled the waves of Hawaii, where he has a home, as well as production paintings of sea storms such as those he'd seen created for *The Perfect Storm*. The city structures themselves were slick, flying saucer shapes—"the retro thing again," he noted.

Marc Gabbana's sketches [2–3] emulated Chiang's idea of oil rigs, but imagined them as the size of New York City. "I emphasized the space, to give a sense of danger," Gabbana said. "Like Doug told me: 'There are no handrails in the *Star Wars* universe.' " When visitors arrive, a Kaminoan emissary [5] bids them come in out of the rain and enter the city.

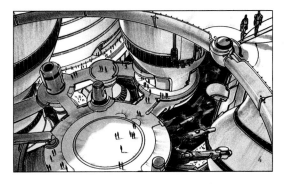

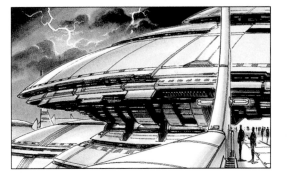

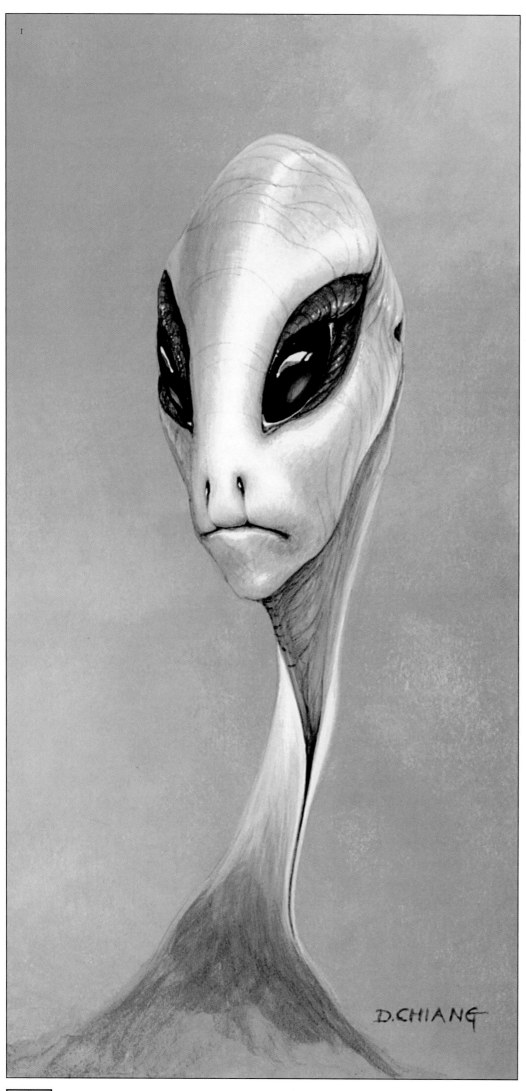

Lucas's direction for the watery world, and the Kaminoans themselves, "took us by surprise," McCaig admitted. "It was much more the *2001* look, the early days of space where everything is white and sterile."

Lucas envisioned Kamino as a stormy environment outside but with bright and ethereal inner-city spaces, everything seemingly made of pure light. "The interior spaces of the water planet definitely emulate the science-fiction look of the 1960s," Chiang agreed. "It's a clean, plastic look that's alien and exotic, and contrasts with the film's other environments."

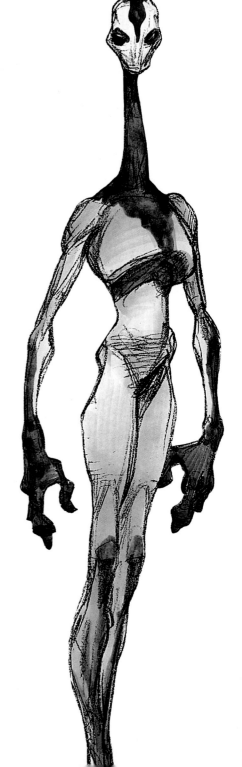

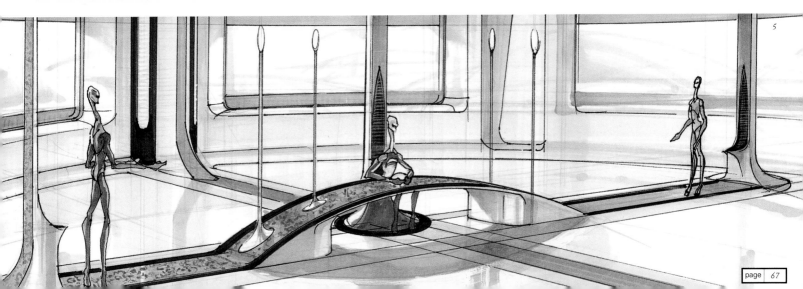

5

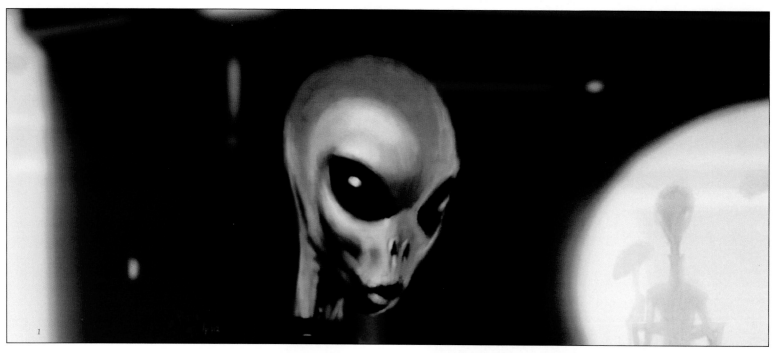

KAMINOANS *conceptual designs*		scene/s: 063/064
1, 3, 4, 6-10	Dermot Power	
2	Doug Chiang	
5	Iain McCaig	68

What McCaig called the "clone makers" were initially inspired as a hybrid of the *Close Encounters* alien and innocent, round-eyed seals. That design took a turn, Natividad noted, leaving behind the *Close Encounters* alien for an "aquatic theme," with fins to mimic fish, a detail Murnane added to his final sculpt of Prime Minister Lama Su [page 69, 11]. For the Kaminoans, "A major imagery was the hybrid of a brightly lit, sterile environment, and these scientific people doing this 'underground' work," observed Robert Barnes, who sculpted a generic Kaminoan [page 69, 12]. "My image was of a cerebral race, with these elongated forms George wanted. I was picturing graceful movements and gestures."

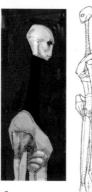

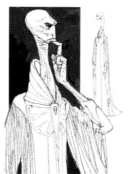

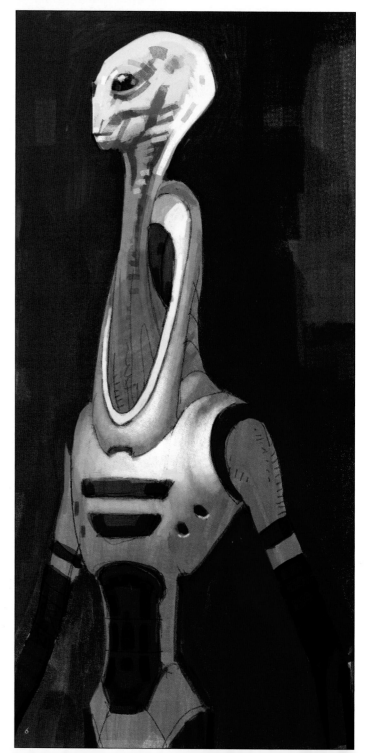

KAMINOANS *conceptual sculpts*		scene/s: 063/064
11	Michael Patrick Murnane	
12	Robert E. Barnes	68

The prime minister of Kamino was initially conceived as a tall female with Mohawk hair. But then there was a "gender shift," Barnes noted, and Lama Su was finaled as a Kaminoan male.

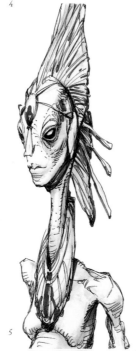

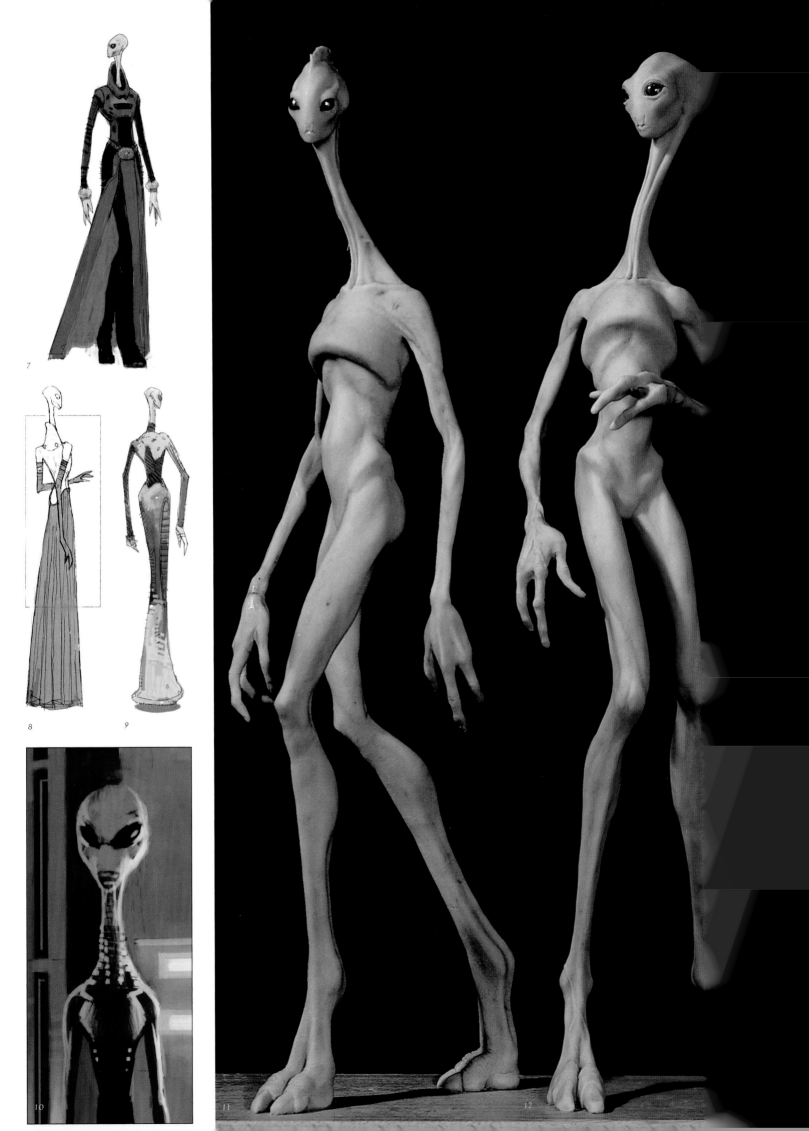

7

8 9

10

11 12

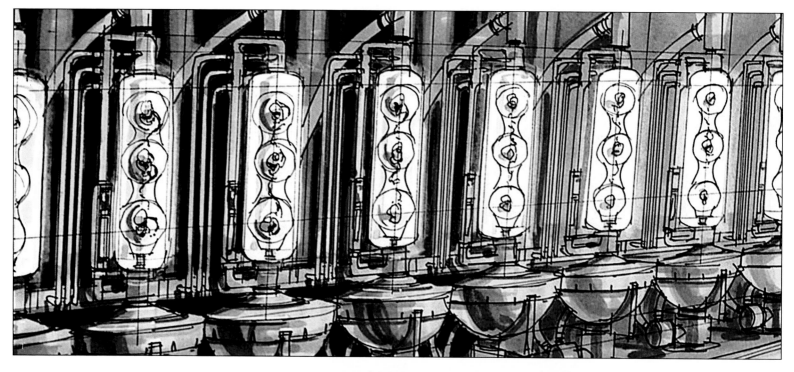

Kamino Cloning Facility
conceptual designs

1, 8	Jay Shuster
2–7	Edwin Natividad

scene/s 068/070

70

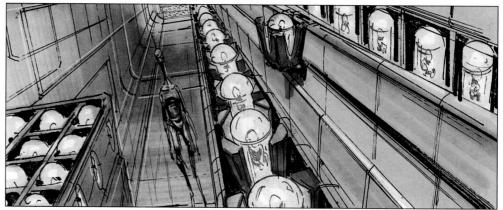

The cloning area itself was imagined as a spotless incubation facility illuminated by fluorescent lights. The secret to this design, according to Natividad, was simple shapes that instantly conveyed the complex enviroment. Natividad's research for the cloning facility included studying concepts of the symmetry naturally occuring in physics and nature. The precise geometric forms of the incubation chambers reveal the mathematical minds of the Kaminoans, a species that may be pure science incarnate."

"In time, the cloning facility designs adopted their strongest and most apparent theme—vast amounts of white space with strong graphic elements. It instantly conveyed the sterile conditions and eerie calm of the facility."
—Jay Shuster

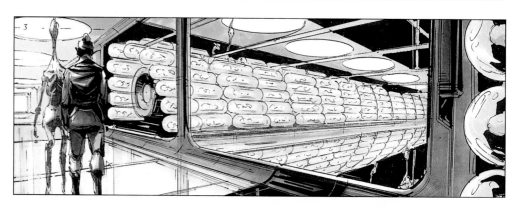

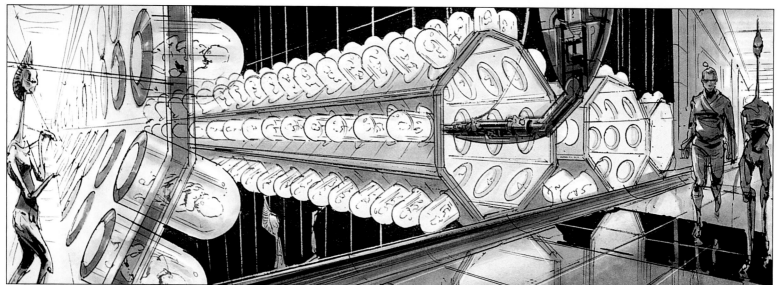

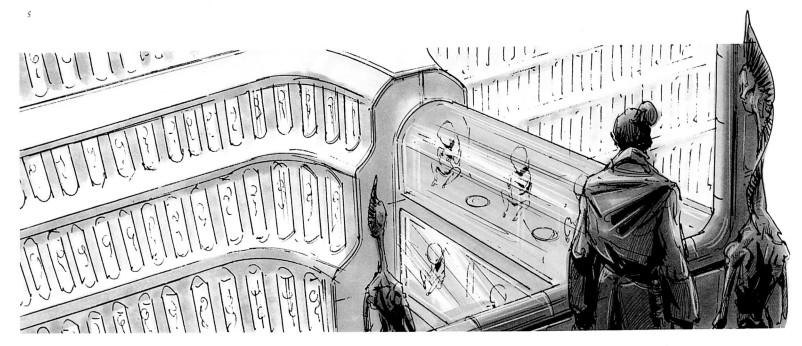

In this sketch sequence, the prime minister, mistaking Obi-Wan for an ally, escorts the Jedi through the cloning facility. The disturbing tour reveals stations where embryos incubate and grow into fetuses and eventually the living soldiers designed to serve the Republic in an army the cloners have been secretly building for ten years.

"This tour is about the prime minister selling Obi-Wan on the idea of these organic warriors," Natividad revealed. "My series of drawings were almost like storyboards, to visualize what it'd be like to lead Obi-Wan through this complex." Jay Shuster noted that an "erie calm and huge spaces designed to hold legions of clones" were the mood and enviromental cues for the cloning facility. "We had to struggle with the bad design mojo of monotony and repetition," Shuster sighed. "The battle for a solution had many forms: making the space *ultra*-huge, populating it with thousands of clones, and creating elements to break up the vastness and repetition without screwing up the overall scale."

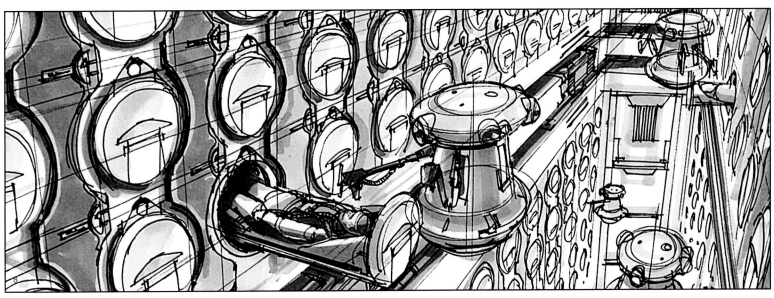

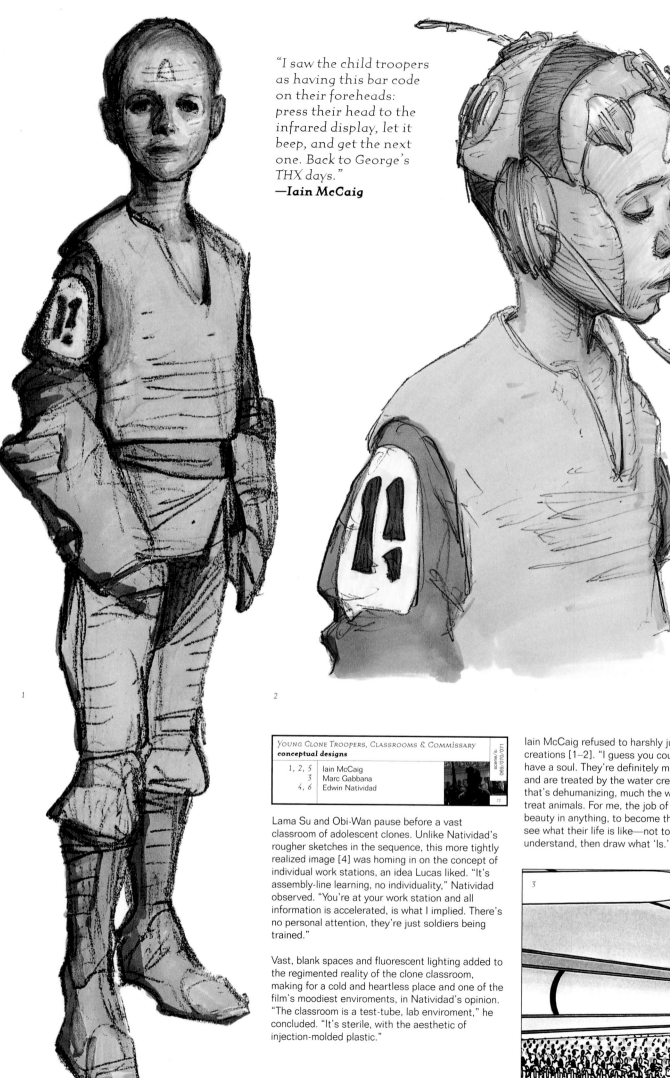

"I saw the child troopers as having this bar code on their foreheads: press their head to the infrared display, let it beep, and get the next one. Back to George's THX days."
—Iain McCaig

1

2

YOUNG CLONE TROOPERS, CLASSROOMS & COMMISSARY
conceptual designs

1, 2, 5	Iain McCaig
3	Marc Gabbana
4, 6	Edwin Natividad

scene/s:
069/070/071

72

Lama Su and Obi-Wan pause before a vast classroom of adolescent clones. Unlike Natividad's rougher sketches in the sequence, this more tightly realized image [4] was homing in on the concept of individual work stations, an idea Lucas liked. "It's assembly-line learning, no individuality," Natividad observed. "You're at your work station and all information is accelerated, is what I implied. There's no personal attention, they're just soldiers being trained."

Vast, blank spaces and fluorescent lighting added to the regimented reality of the clone classroom, making for a cold and heartless place and one of the film's moodiest enviroments, in Natividad's opinion. "The classroom is a test-tube, lab enviroment," he concluded. "It's sterile, with the aesthetic of injection-molded plastic."

Iain McCaig refused to harshly judge his own clone creations [1–2]. "I guess you could say they don't have a soul. They're definitely missing something and are treated by the water creatures in a way that's dehumanizing, much the way we sometimes treat animals. For me, the job of an artist is to find beauty in anything, to become that character and see what their life is like—not to judge it. I try to understand, then draw what 'Is.'"

3

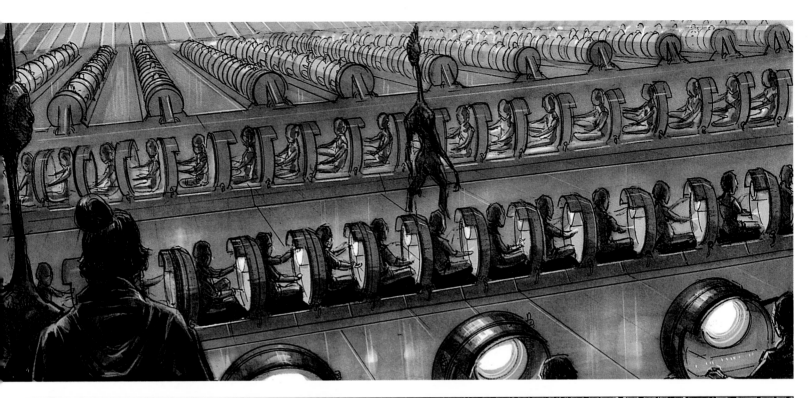

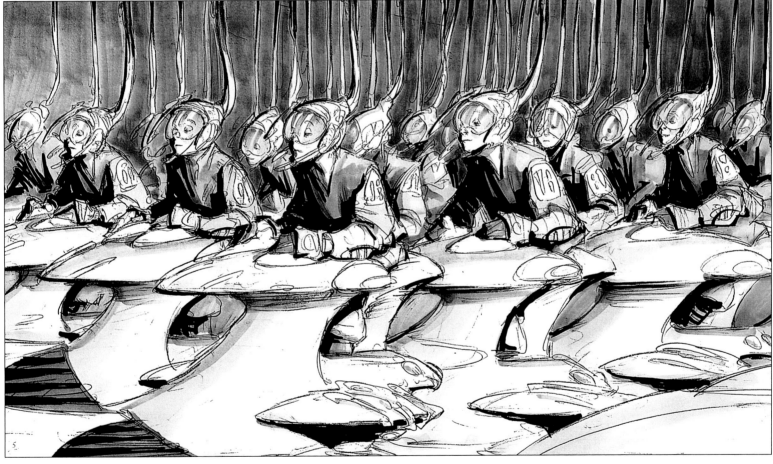

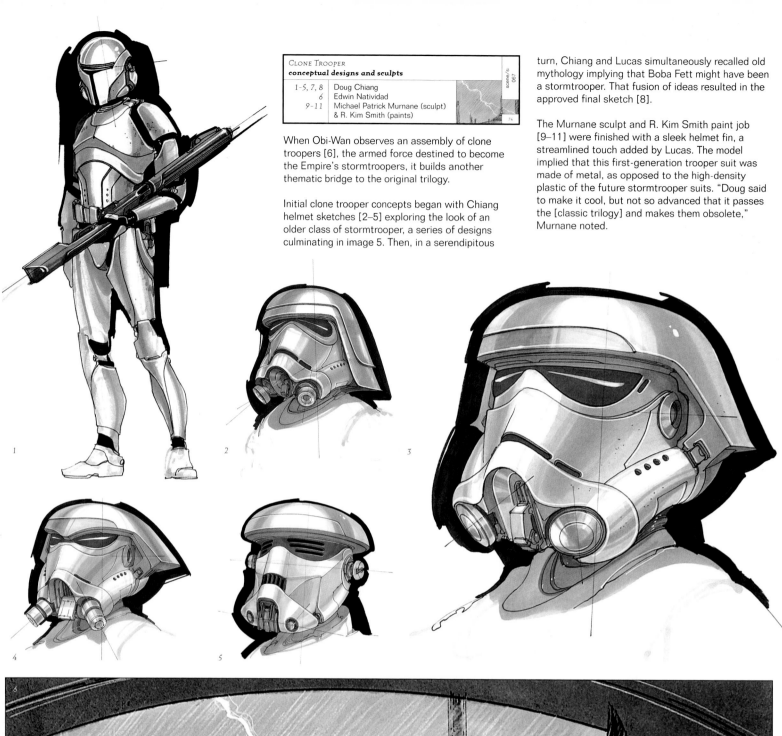

CLONE TROOPER
conceptual designs and sculpts

1–5, 7, 8	Doug Chiang
6	Edwin Natividad
9–11	Michael Patrick Murnane (sculpt)
	& R. Kim Smith (paints)

scene/s: 067
74

When Obi-Wan observes an assembly of clone troopers [6], the armed force destined to become the Empire's stormtroopers, it builds another thematic bridge to the original trilogy.

Initial clone trooper concepts began with Chiang helmet sketches [2–5] exploring the look of an older class of stormtrooper, a series of designs culminating in image 5. Then, in a serendipitous

turn, Chiang and Lucas simultaneously recalled old mythology implying that Boba Fett might have been a stormtrooper. That fusion of ideas resulted in the approved final sketch [8].

The Murnane sculpt and R. Kim Smith paint job [9–11] were finished with a sleek helmet fin, a streamlined touch added by Lucas. The model implied that this first-generation trooper suit was made of metal, as opposed to the high-density plastic of the future stormtrooper suits. "Doug said to make it cool, but not so advanced that it passes the [classic trilogy] and makes them obsolete," Murnane noted.

1

2

3

4

5

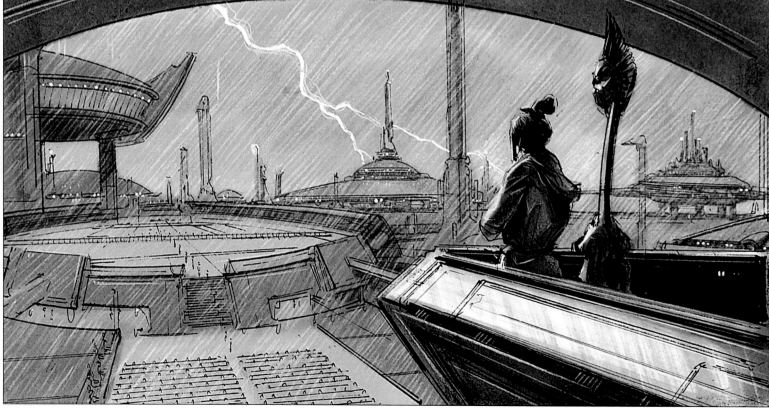

6

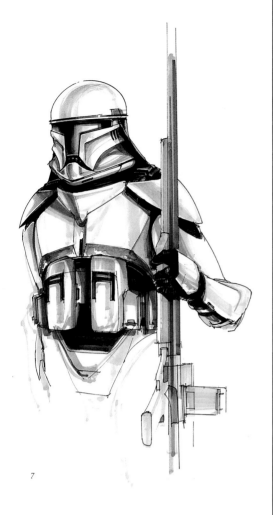

7

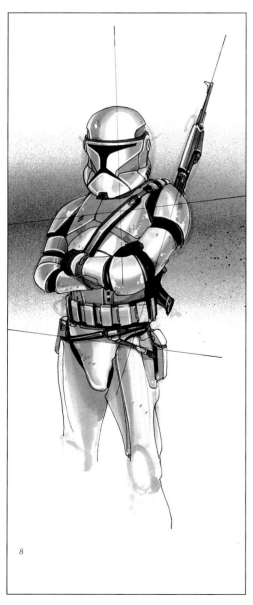

8

9

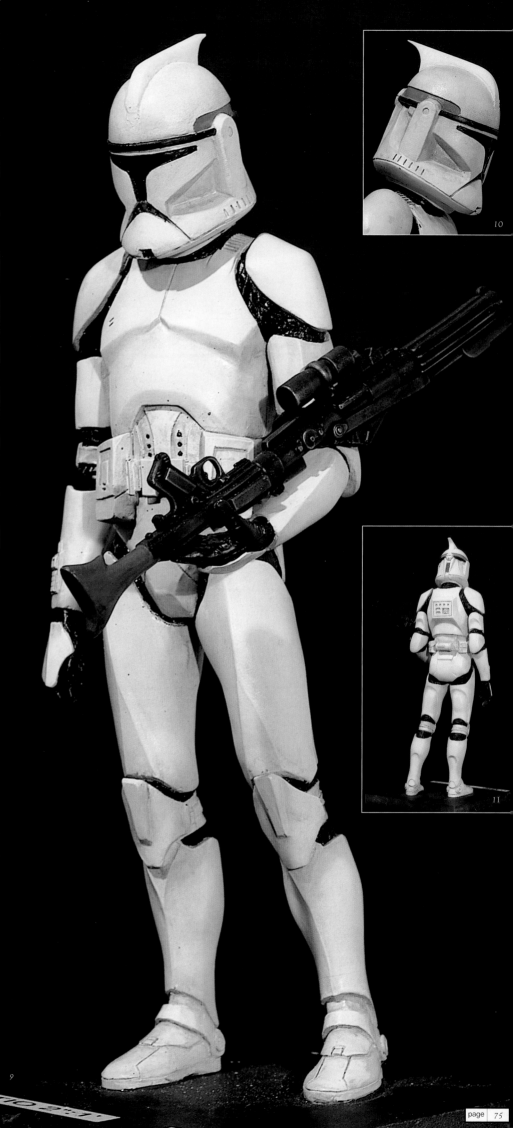

10

11

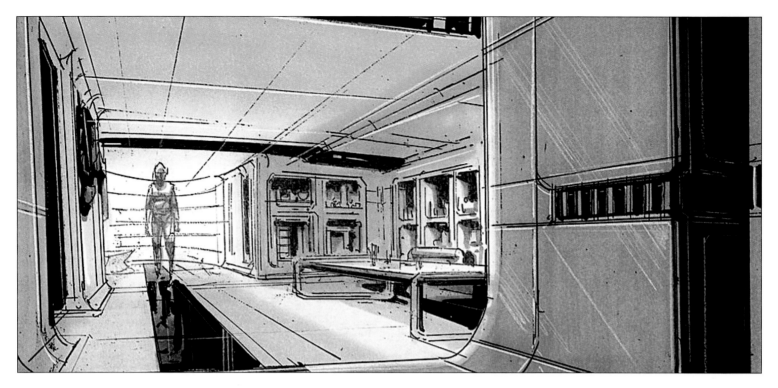

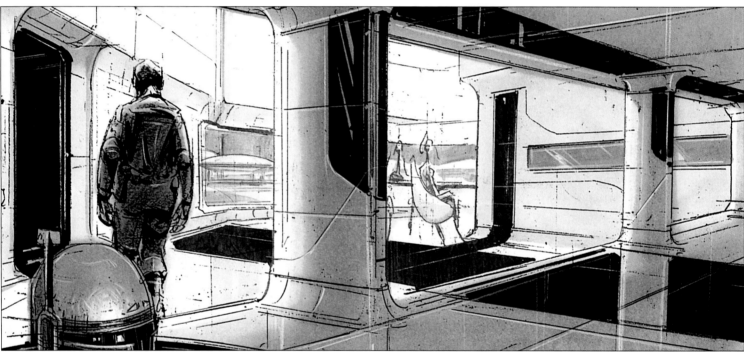

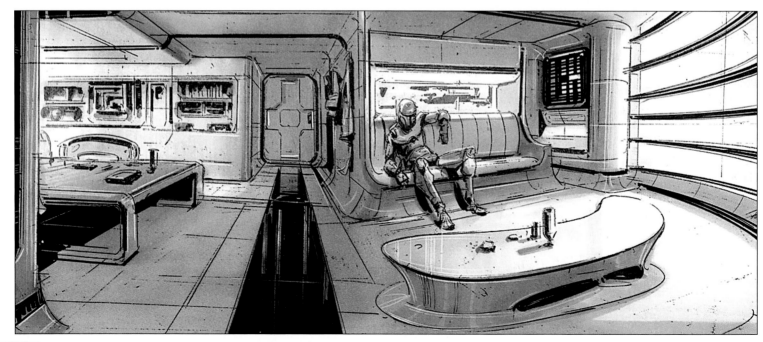

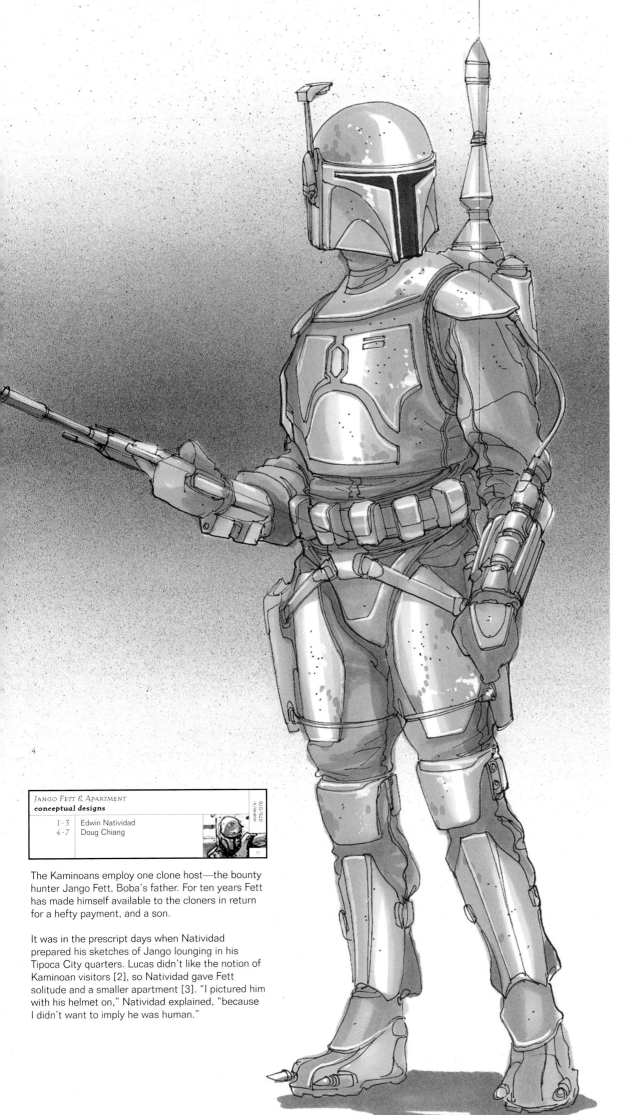

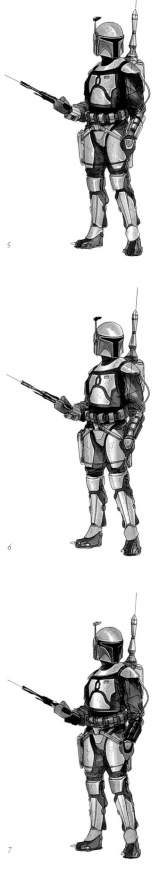

Jango Fett & Apartment
conceptual designs

1-3	Edwin Natividad
4-7	Doug Chiang

scene/s: 075/076

The Kaminoans employ one clone host—the bounty hunter Jango Fett, Boba's father. For ten years Fett has made himself available to the cloners in return for a hefty payment, and a son.

It was in the prescript days when Natividad prepared his sketches of Jango lounging in his Tipoca City quarters. Lucas didn't like the notion of Kaminoan visitors [2], so Natividad gave Fett solitude and a smaller apartment [3]. "I pictured him with his helmet on," Natividad explained, "because I didn't want to imply he was human."

"We all assumed it was Boba Fett, but something was weird, he'd have been too old. But as a placeholder we always called Jango 'Boba Fett.'"
—Edwin Natividad

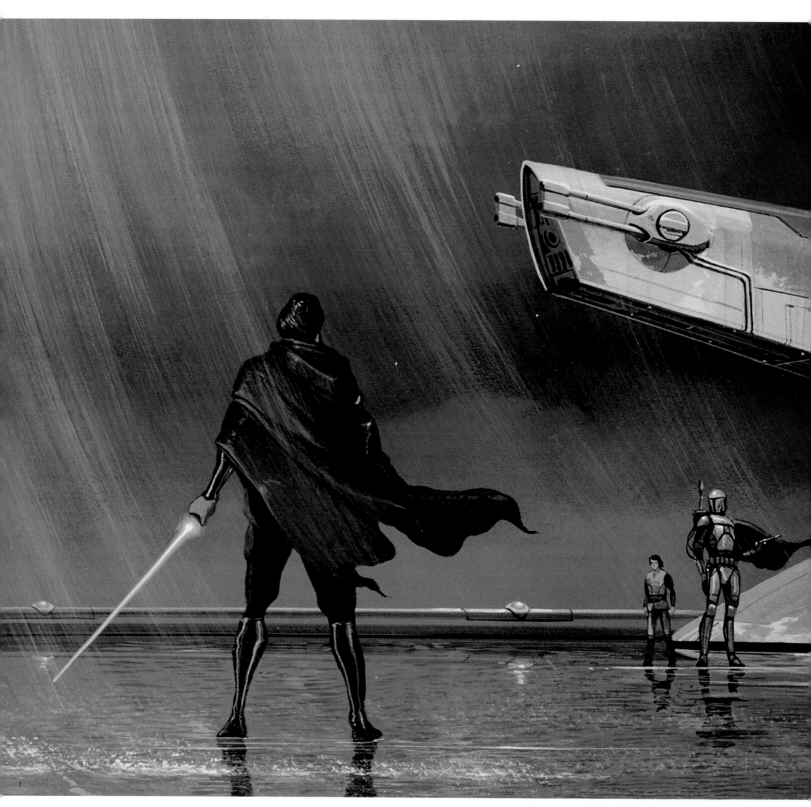

SLAVE I, LANDING PAD & COCKPIT INTERIOR DETAILS
conceptual designs

1	Doug Chiang
2	Marc Gabbana
3-6	Kurt Kaufman

scene/s: 089

78

Jango Fett's *Slave I* was developed down to its cockpit details. "Doug suggested that in dressing that space we look at the *Millennium Falcon*," Kurt Kaufman explained, "and take some of those details to make it look as if Jango's ship might have been built at the same time, maybe by the same manufacturer."

The evocative Chiang painting of a stormy Tipoca landing pad sets the stage for a battle between Obi-Wan and Jango, with Boba looking on. "The fight was a highlight for me—lightsabers in the rain," Chiang said, smiling.

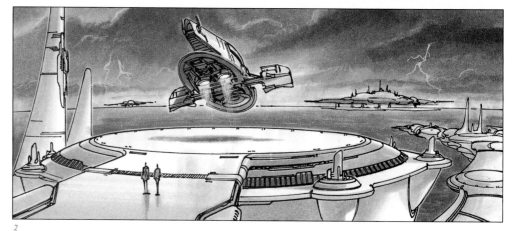

2

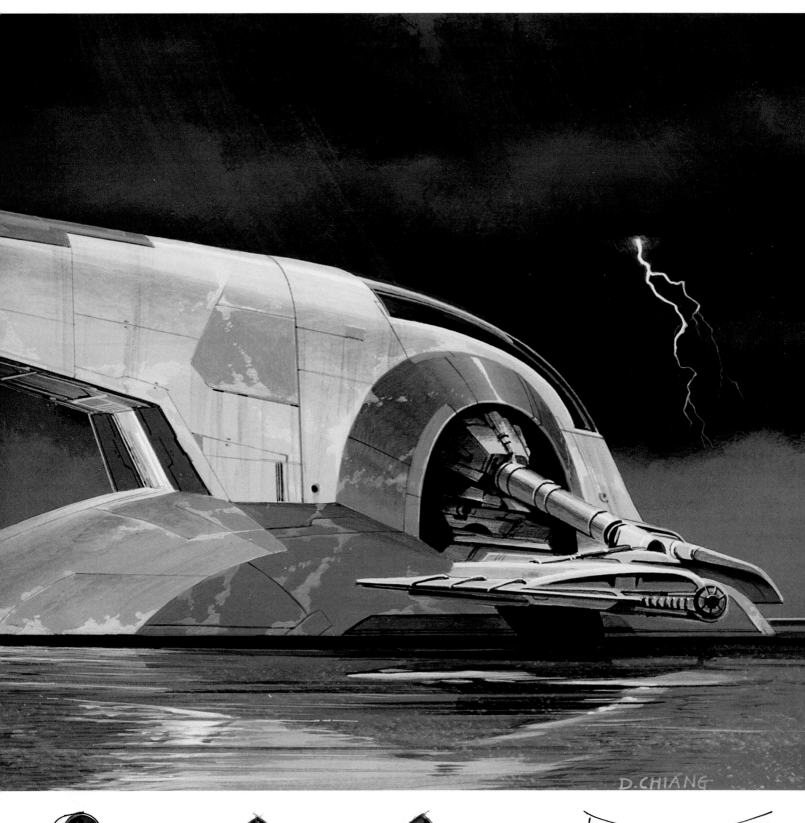

3 4 5 6

Shmi, Owen & Beru Lars & Rickshaw with Droid	
conceptual designs and model	
1-3	Dermot Power
4	Jay Shuster
5-7	Marc Gabbana
8	R. Kim Smith

scene/s:
091 /100/101 /102

80

"Drawing Owen and the original Mos Eisley homestead was great! I got to dig out my old Star Wars books and be completely influenced by that history"
-Dermot Power

Tatooine is revisited when headstrong Anakin, plagued by nightmares of his suffering mother, violates his orders and journeys with Padmé to the desert planet. He hasn't seen his mother in ten years, and things have changed: Watto, the Toydarian junk dealer who owned Shmi Skywalker, has sold her to a moisture farmer named Cliegg Lars; she now lives in a desert homestead with other settlers.

What should be happy news—that Shmi has a new life since Lars freed and married her—is quickly obliterated when Anakin learns his mother has been kidnapped.

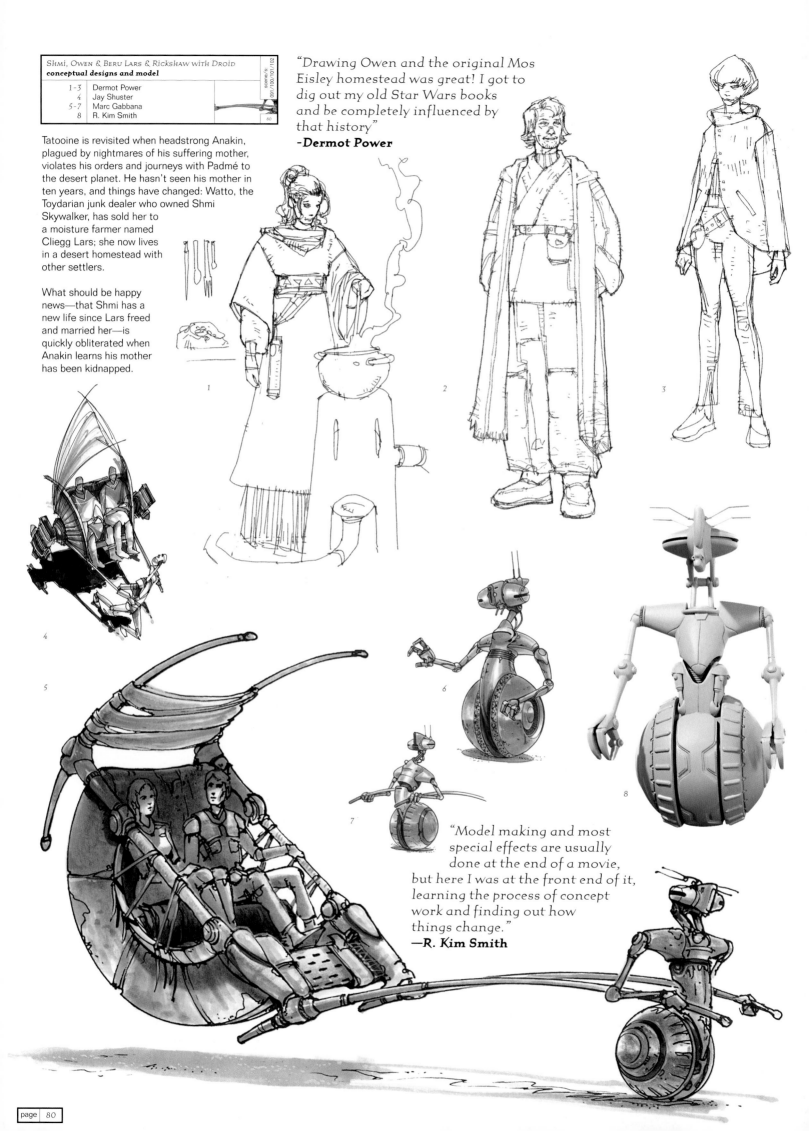

1

2

3

4

5

6

7

8

"Model making and most special effects are usually done at the end of a movie, but here I was at the front end of it, learning the process of concept work and finding out how things change."
—R. Kim Smith

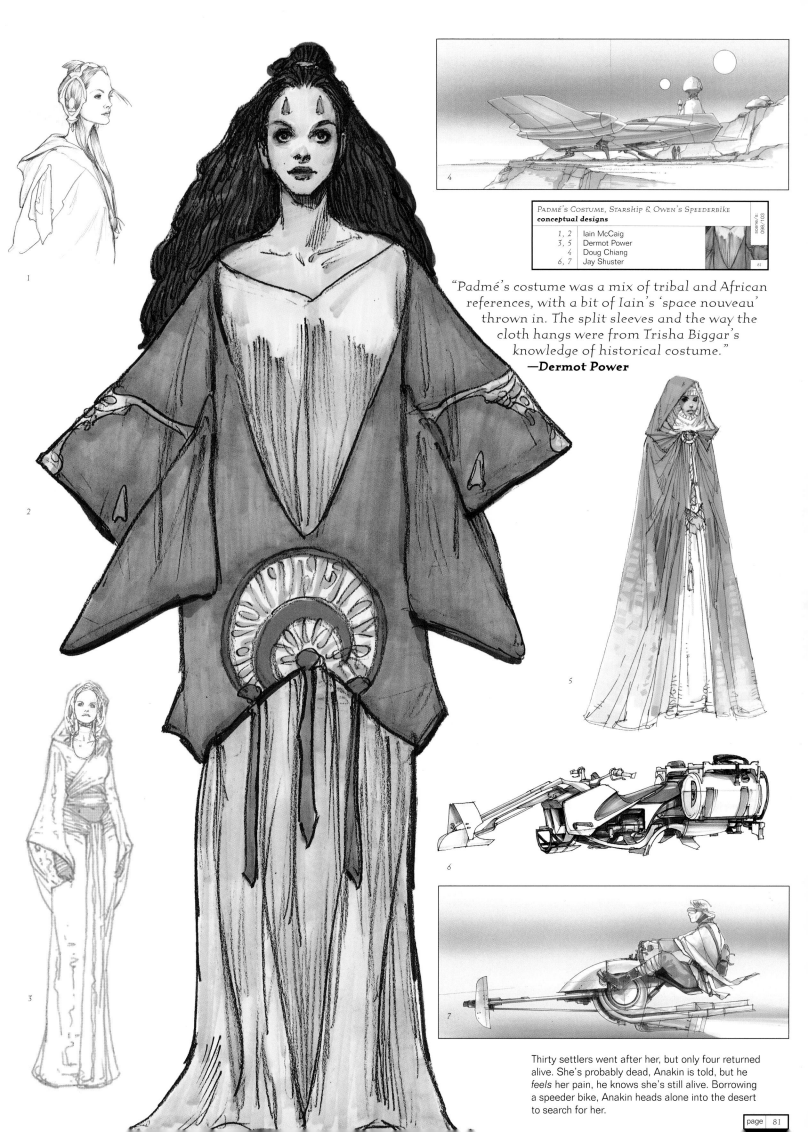

PADMÉ'S COSTUME, STARSHIP & OWEN'S SPEEDERBIKE
conceptual designs

		scene/s:
1, 2	Iain McCaig	098/103
3, 5	Dermot Power	
4	Doug Chiang	
6, 7	Jay Shuster	81

"Padmé's costume was a mix of tribal and African references, with a bit of Iain's 'space nouveau' thrown in. The split sleeves and the way the cloth hangs were from Trisha Biggar's knowledge of historical costume."
—Dermot Power

Thirty settlers went after her, but only four returned alive. She's probably dead, Anakin is told, but he *feels* her pain, he knows she's still alive. Borrowing a speeder bike, Anakin heads alone into the desert to search for her.

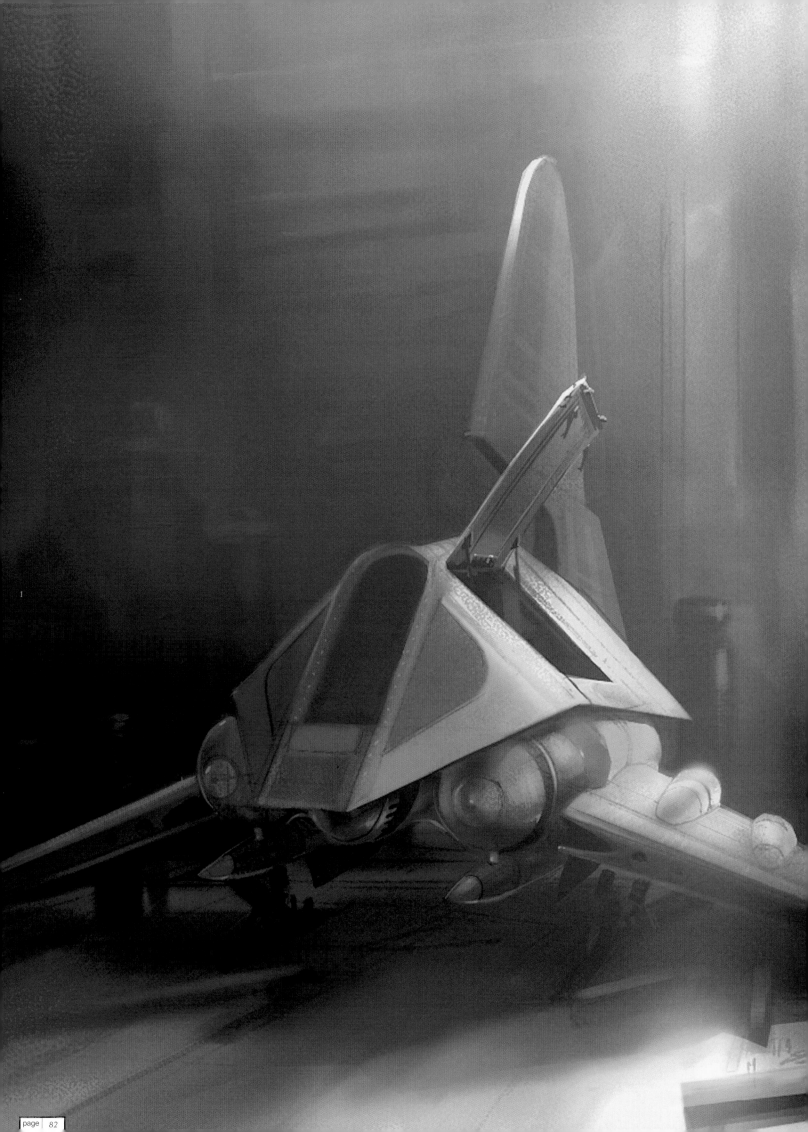

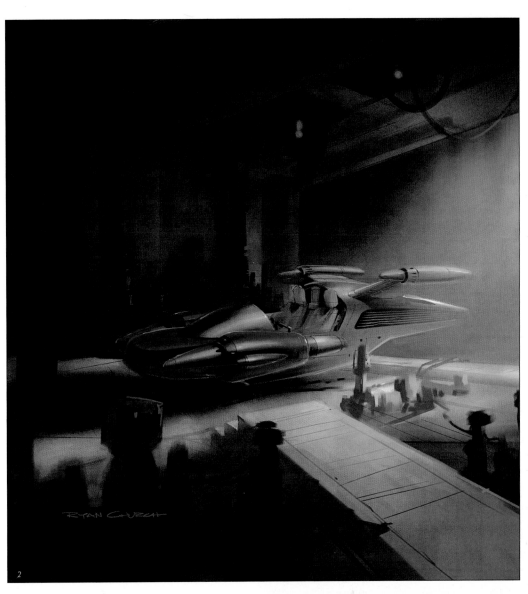

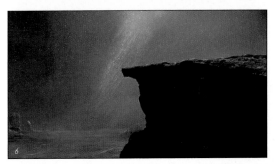

LARS'S HOMESTEAD GARAGE & TATOOINE VISTAS
conceptual designs

| 1, 2 | Ryan Church |
| 3-6 | Paul Topolos |

scene/s:
104/109

The trip to Tatooine afforded the opportunity to assemble classic characters—Luke's future guardians Owen and Beru Lars, and the droids C-3PO and R2-D2—in an old, familiar setting, the moisture farm where Luke Skywalker would one day grow up.

In this more utilitarian environment, scarce equipment is jiggered and retrofitted as needed, such as Owen's speeder bike designs [page 81, 6–7], which adapt the classic speederbike form for use as a farm vehicle. Another motif for the rural encampment, imagined as being miles from the nearest town, was the floating rickshaw droid that evolved from sketches to final model [page 80, 4–8].

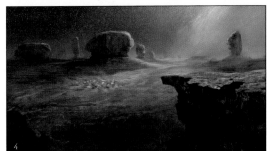

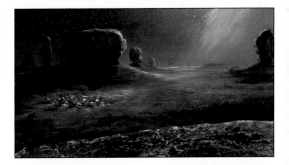

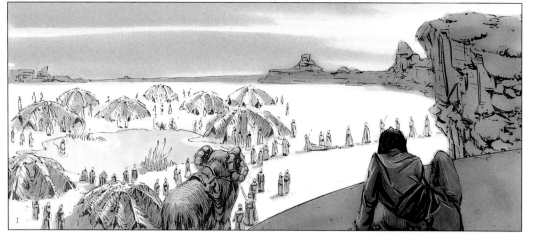

The art department's directive for the Tusken Raider camp was for a nomadic settlement of a hundred people, with a pond and animals [faybos, 4 below] drinking. The notion of a pond providing both water and mud to build temporary huts was developed by McCaig, who created the tusk-hut pictured here [page 85, 8], and Natividad incorporated the concept into his own drawings [page 84, 3].

For the Tusken Raider garb, Power referenced nomadic tribes of northern Iraq. "The tendency should be not to just draw what comes out of your mind, but to look at the real world and see what's there, to ground a concept in reality," Power explained. "The nomadic women of Iraq wear these heavily jeweled outfits and cover their faces with veils. I replaced the veils with simple metal parts, as if they'd been scavenged."

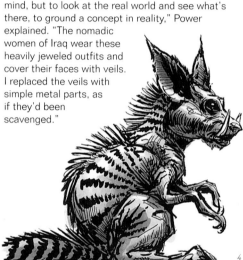

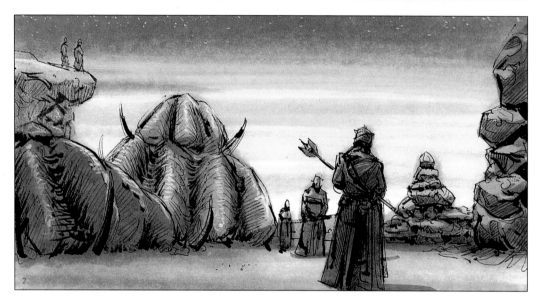

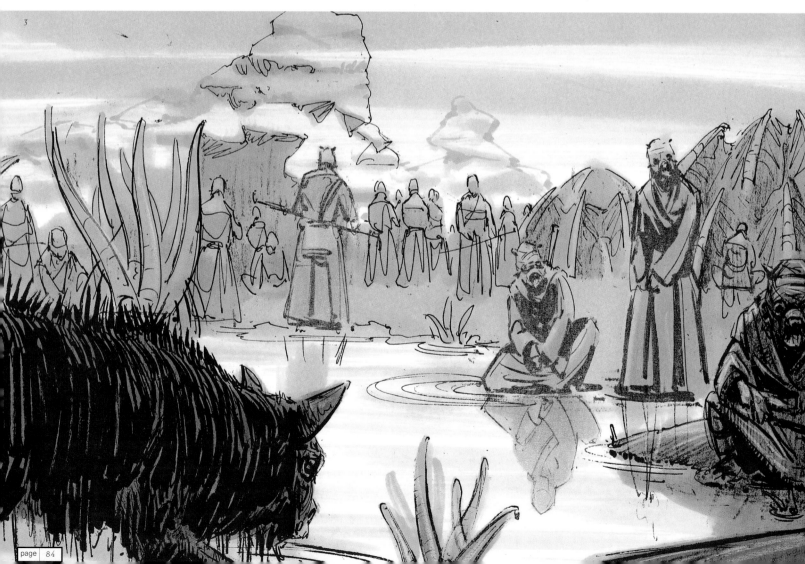

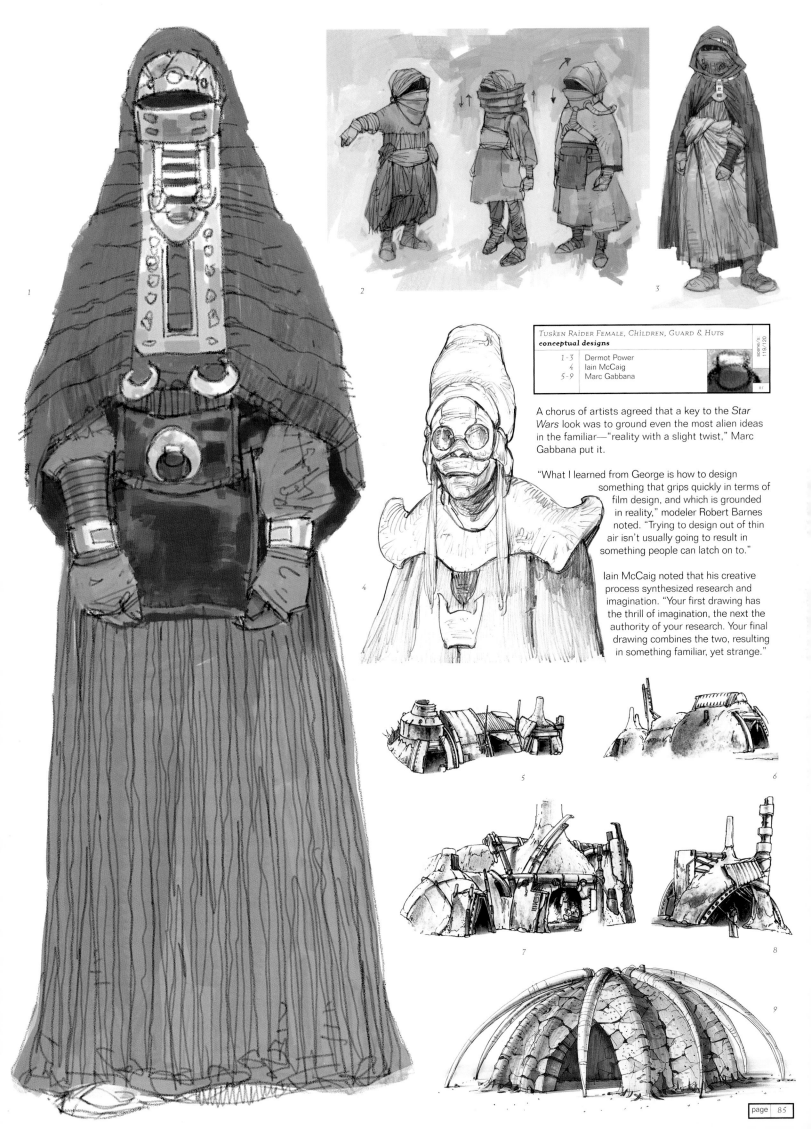

TUSKEN RAIDER FEMALE, CHILDREN, GUARD & HUTS
conceptual designs

		scene/s: 119/120
1-3	Dermot Power	
4	Iain McCaig	
5-9	Marc Gabbana	

A chorus of artists agreed that a key to the *Star Wars* look was to ground even the most alien ideas in the familiar—"reality with a slight twist," Marc Gabbana put it.

"What I learned from George is how to design something that grips quickly in terms of film design, and which is grounded in reality," modeler Robert Barnes noted. "Trying to design out of thin air isn't usually going to result in something people can latch on to."

Iain McCaig noted that his creative process synthesized research and imagination. "Your first drawing has the thrill of imagination, the next the authority of your research. Your final drawing combines the two, resulting in something familiar, yet strange."

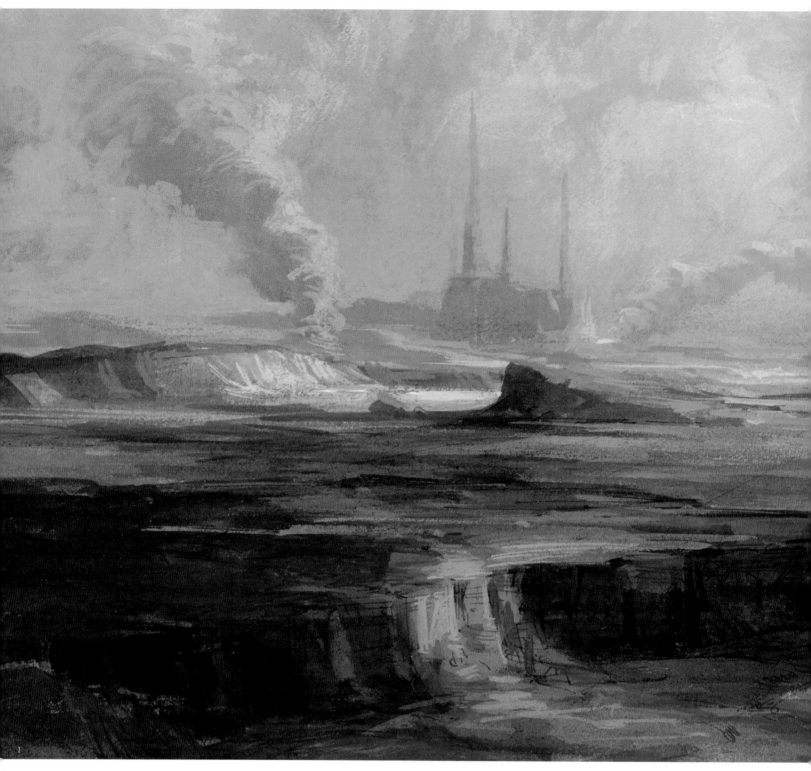

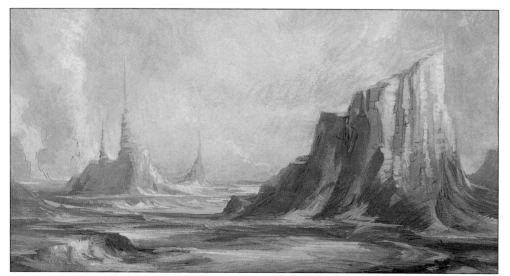

GEONOSIS *conceptual designs*		scene/s: 097
1-3	Erik Tiemens	
		86

Obi-Wan, pursuing Jango Fett, follows the trail to Geonosis, the production's other great new world and the thematic opposite of Kamino's stormy water planet.

Geonosis was conceived as being surrounded by an asteroid field, the redrock planet itself a rugged, arid surface of rocky buttes and stalagmitic structures. It's in the foundries of Geonosis that an army of Battle Droids is being secretly produced for the coalition of trade, manufacturing, and banking clans being organized by Count Dooku.

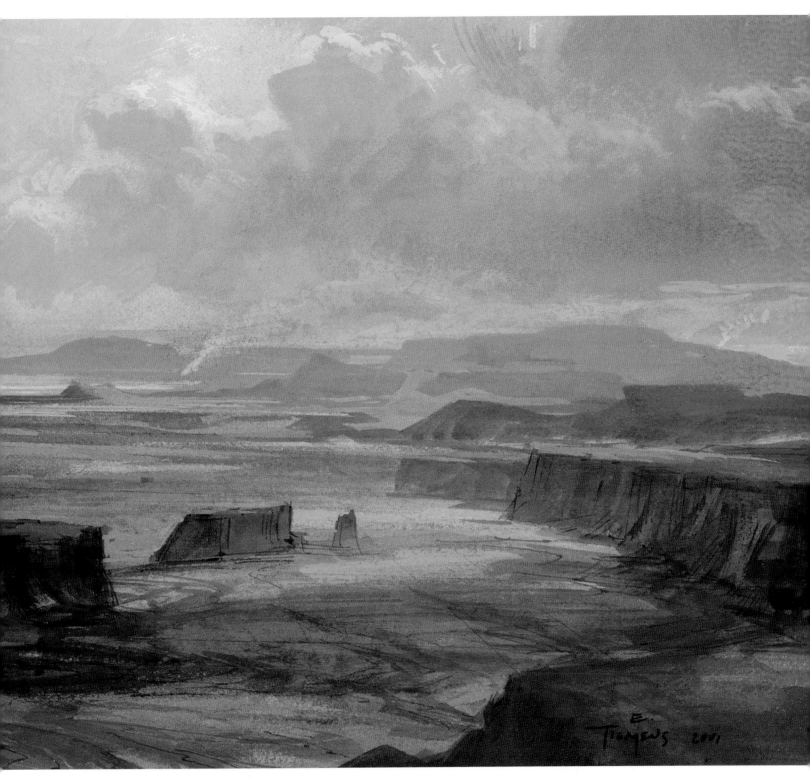

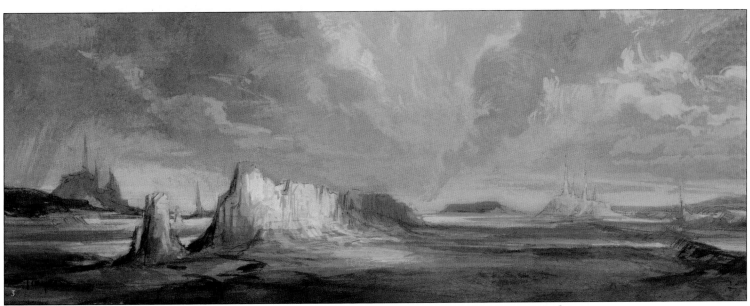

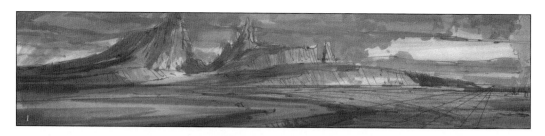

"Dramatic use of lighting, atmosphere, and color choices define the mood of a STAR WARS film."
—Erik Tiemens

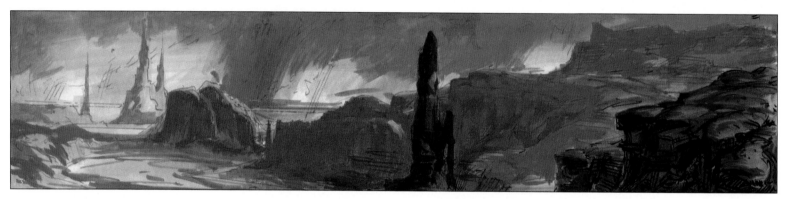

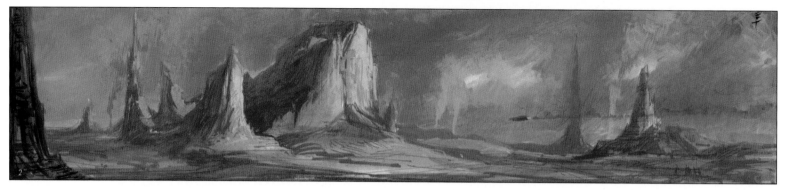

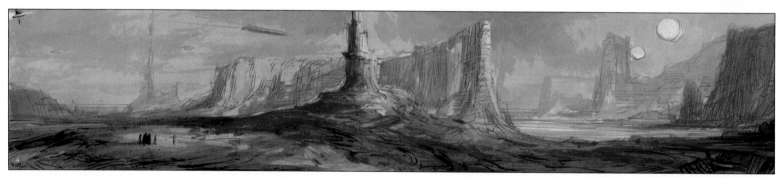

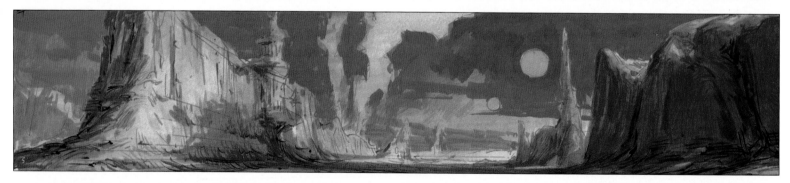

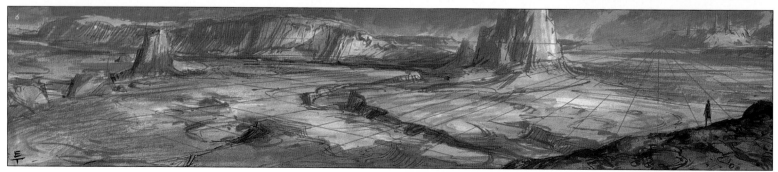

GEONOSIS CITY TOWERS, RAY GUNS & LANDSCAPE
conceptual designs and thumbnail sketches

1-6	Erik Tiemens
7,8,10	Doug Chiang
9	Edwin Natividad

scene/s:
110

89

"A big part of it is also thinking about painters I respect and wondering, 'How would they do this?' There's also a feeling in the landscapes that George was always pushing, he was always talking about making the skies 'poetic and interesting.' "

The Geonosian landscapes created by Erik Tiemens [6–11] incorporate a little bit of Monument Valley, as well as something of the redrock surface of Mars. But Tiemens, an avid landscape painter, noted that creating a concept environment involves more than the sum of your reference material. "You'll never find the perfect reference. Whenever I have an assignment like this, all my past landscape painting and sketching comes back to me; it's a formation of past experiences. So I'll get ideas while I'm drawing. I might remember being in Arizona and seeing a whirling dervish dust cloud or a distant rain burst.

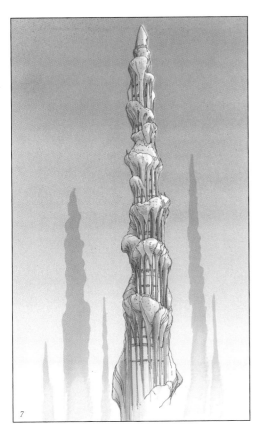

7

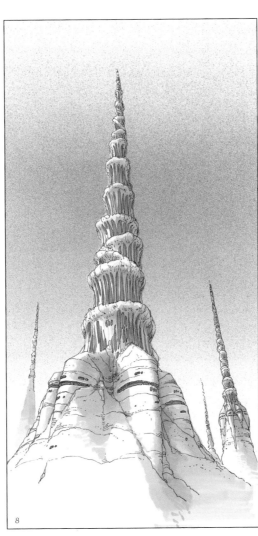

8

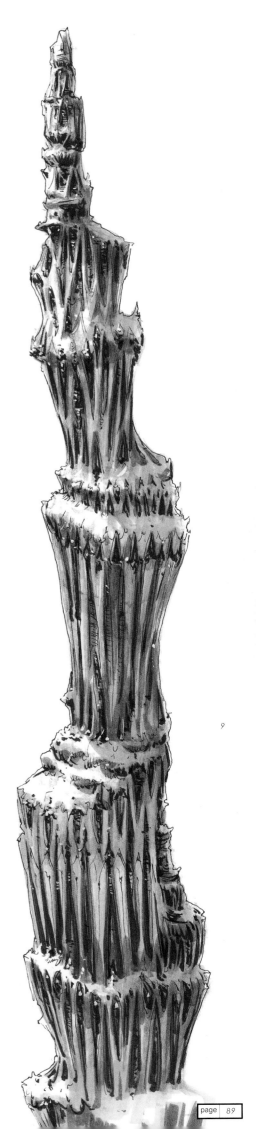

9

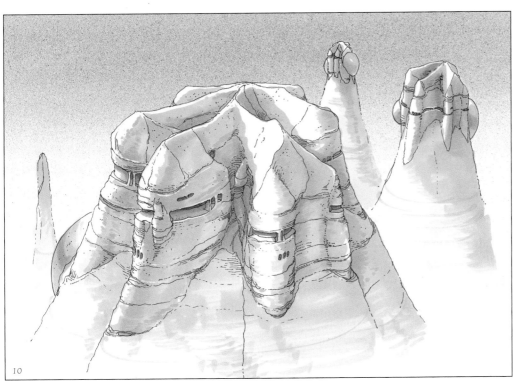

10

GEONOSIS LANDSCAPE & MASSIFF **conceptual designs and model**		scene/s: 097/110
1	Michael Patrick Murnane (sculpt) & Robert E. Barnes (sculpt & paints)	
2	Edwin Natividad	
3	Doug Chiang	90

The massiff, a lizard creature that attacks Obi-Wan, was originally developed as the orray, a Geonosian creature that picadors ride into a gladiatorial arena. "Since the orray originally had a fierce dimension, George decided it could instead work as the massiff, just scaled down," modeler Robert Barnes said. "We made the eyes bigger and put spines on it—which, of course, wouldn't work for a mounted animal." While painting models was often a luxury, Barnes developed a color scheme in Photoshop for this thirteen-inch-long model [3], because ILM needed a color reference for the production filming that had already begun.

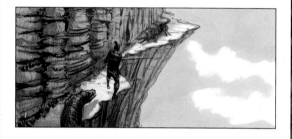

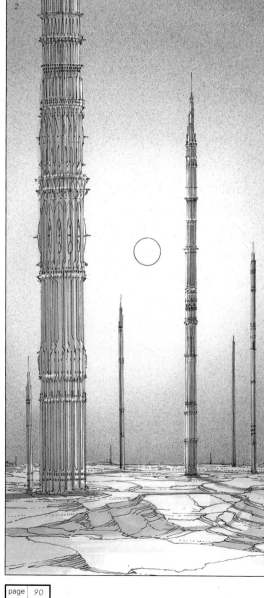

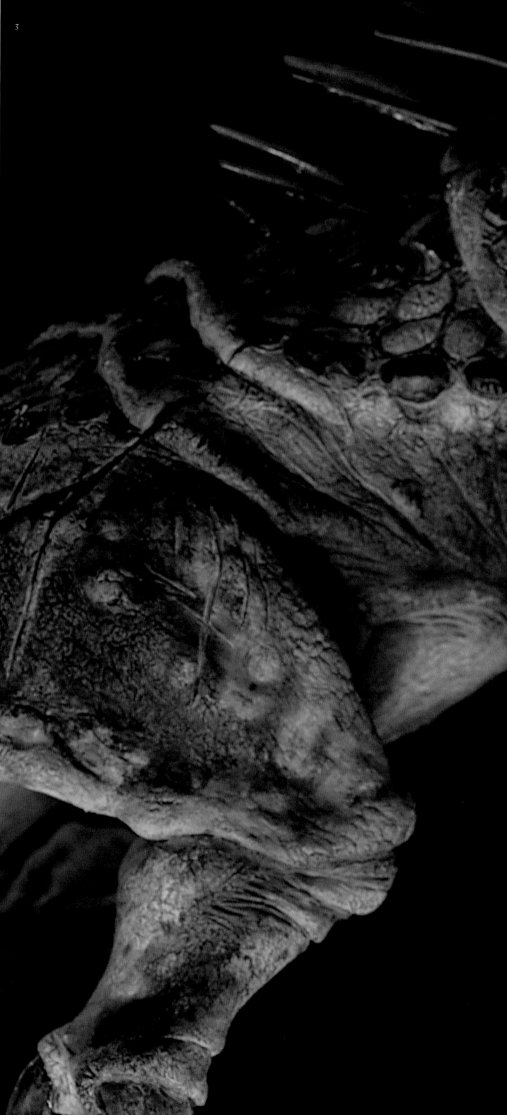

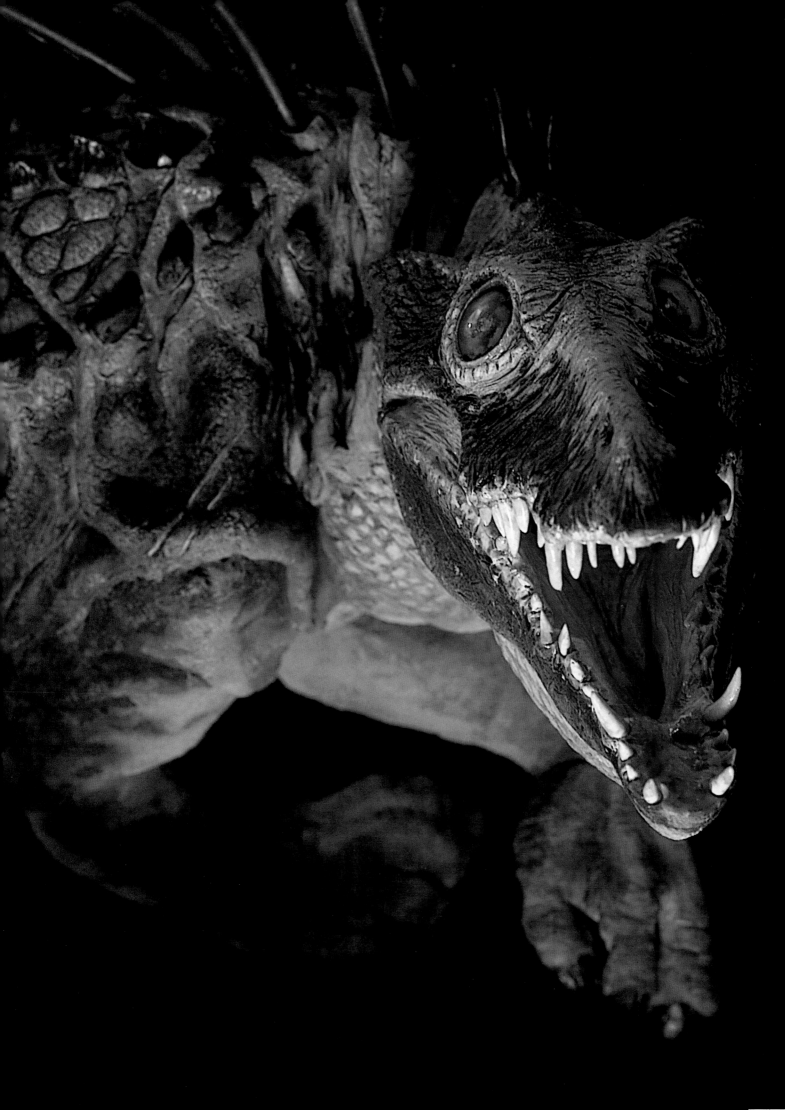

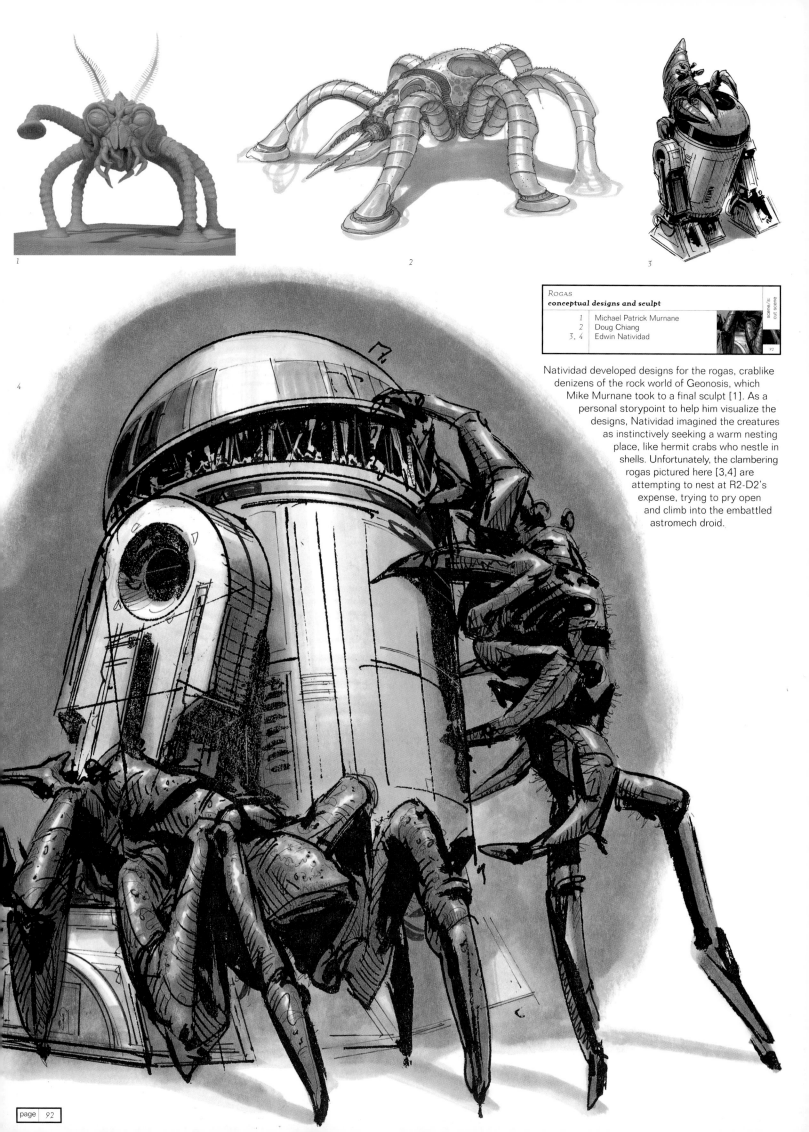

ROGAS
conceptual designs and sculpt

		scene/s: cut scene
1	Michael Patrick Murnane	
2	Doug Chiang	
3, 4	Edwin Natividad	92

Natividad developed designs for the rogas, crablike denizens of the rock world of Geonosis, which Mike Murnane took to a final sculpt [1]. As a personal storypoint to help him visualize the designs, Natividad imagined the creatures as instinctively seeking a warm nesting place, like hermit crabs who nestle in shells. Unfortunately, the clambering rogas pictured here [3,4] are attempting to nest at R2-D2's expense, trying to pry open and climb into the embattled astromech droid.

1

2

3

4

GEONOSIAN TOWER EXTERIOR		scene/s:
conceptual designs		112
1-3	Edwin Natividad	

Geonosian culture was conceived as a mix of high tech—evidenced by the droid-making facility—and an alien primitivism, with living spaces carved out of a planet's natural stone and rock formations. Natividad's sketches [page 93, 1–3] follow Obi-Wan as he scales a Geonosian tower and prepares to truly enter the "rock world," as the art department dubbed Geonosis. "Ed brings a textural, gritty look to his work [that's] perfect for the rock world," Chiang explained. "He's wonderful at exotic, alien environments. His mind is wired to be different; he'll take me into new places I wasn't thinking of before, which is great because I can then guide him in that world."

"These designs of Obi-Wan scaling a Geonosian tower not only established scale and a jeopardy situation, but were designed to convey an extreme sports activity audiences might relate to."
—Edwin Natividad

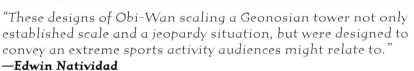

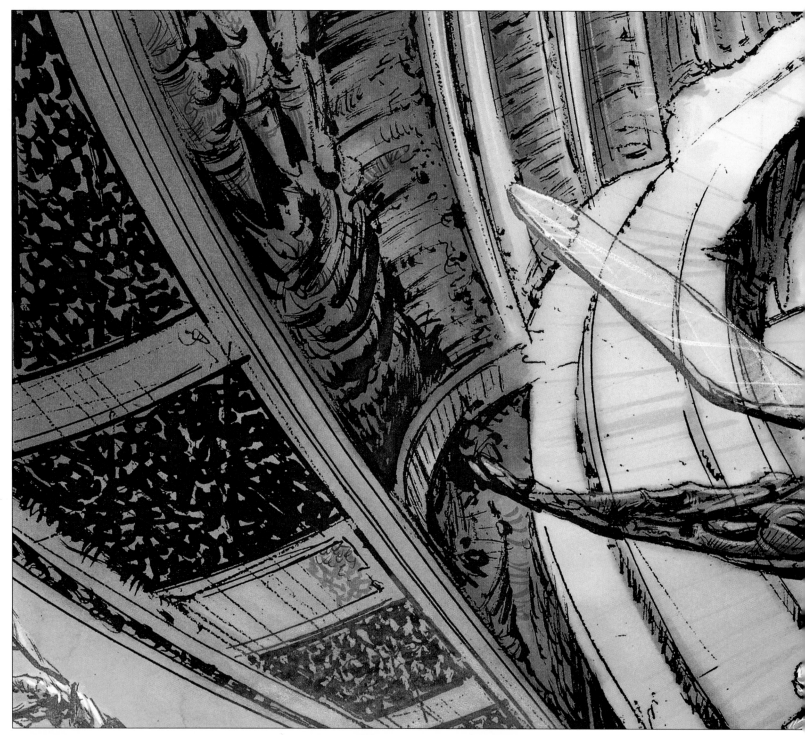

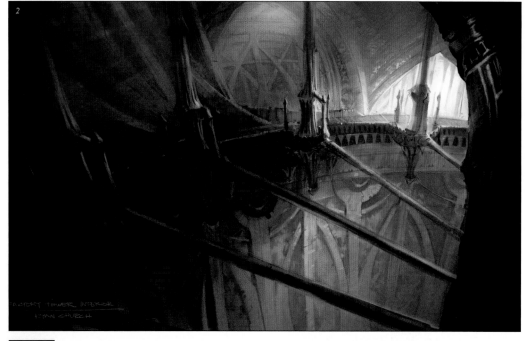

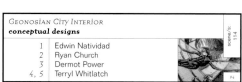

GEONOSIAN CITY INTERIOR		scene/s:
conceptual designs		114
1	Edwin Natividad	
2	Ryan Church	
3	Dermot Power	
4, 5	Terryl Whitlatch	
		94

The world carved inside the stalagmitic structures was "like an insect hive," as Chiang described it. In a circuitous creative path, the Geonosians were inspired by the original designs for the Trade Federation Neimoidians of Episode I, that concept based on the notion that Neimoidians built Battle Droids in their own image. "They didn't do the Neimoidians digital; they went for rubber masks on performers," Natividad recalled, "but for Episode II they wanted to bring back that idea of the droids mimicking the look of the race that built them."

"Each planet has its radically different motif," Natividad noted, "and on Geonosis it's rock formations and the kinds of species you'd find in caves. There are walkways and tunnels carved out of the interior of the rock. We find out that this is where droids are manufactured."

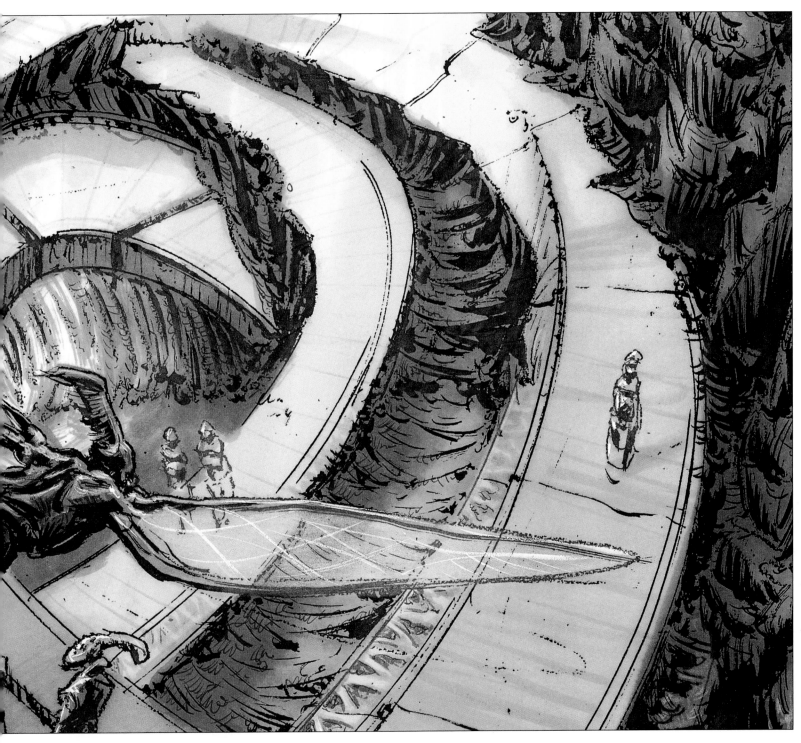

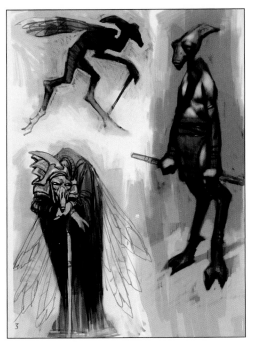

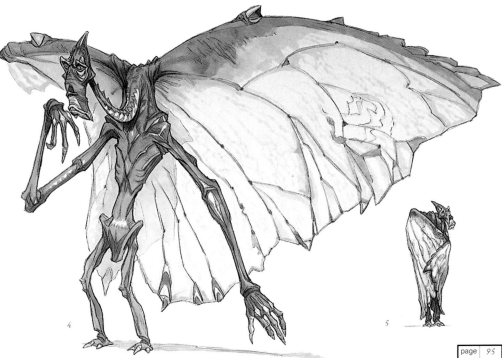

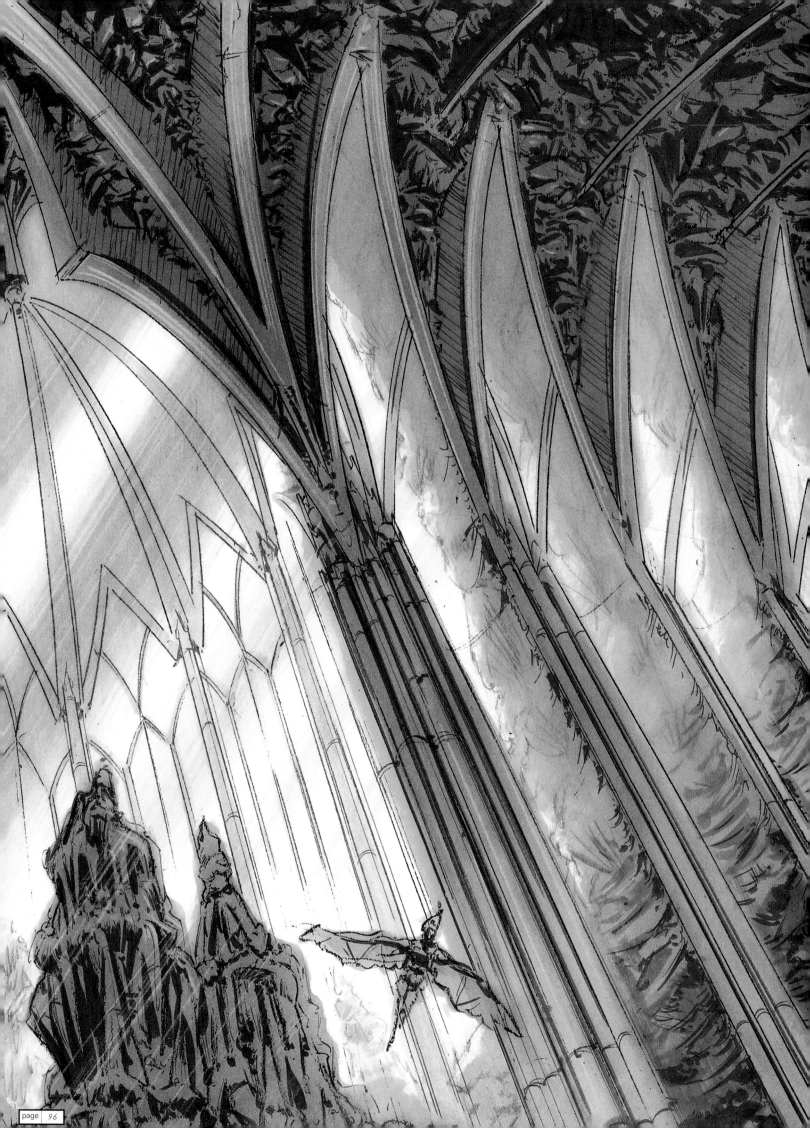

GEONOSIAN CITY INTERIOR & GEONOSIANS		scene/s:
conceptual designs		114
1	Edwin Natividad	
2-8	Dermot Power	
9	Glen McIntosh	
10	Terryl Whitlatch	
		97

The interior world of Geonosis was filled with Gothic influences, an aesthetic that reached its height in this vaulting, cathedral-like ceiling sketch [1]. "George wanted it to be Gothic, but not quite Gothic," Chiang noted. "It became a cross between Gothic and art nouveau—a new style."

"I think this cathedral design was too literal," Natividad reflected. "They saved the cathedral thing for the Jedi Temple. Ultimately the interior world became more like a bat cave, a geological dwelling carved out of the rock."

Inspiration for the Geonosians themselves included termites, particularly in these larvalike images [2, 3]. As sentient beings of the *Star Wars* universe, culture and clothes were key to the species design, with costume concepts ranging from tribal gowns and diaphanous dress to armor and heavy fabrics. The final design emphasized their organic connection to the enviroment, with a less functional, more ornamental look to Geonosian dress.

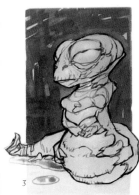

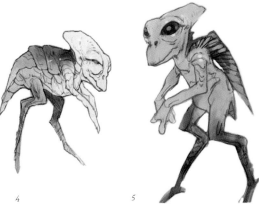

"Doug e-mailed me a picture Iain had done of the Geonosians with the original Neimoidian face from Episode I, and I went from there. That design was too good not to use."
—Dermot Power

"Originally, George wanted the Geonosians to blend into their enviroment, so we explored the notion that they could change colors like chameleons. That idea is still there in the final design, although using light and shadow."
—Doug Chiang

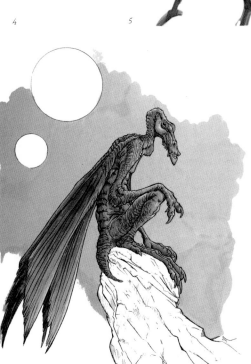

GEONOSIANS
conceptual designs and sculpt

1, 2	Doug Chiang
3	Tony McVeigh (sculpt) &
	Robert E. Barnes (paints)

scene/s: 115

98

The final, approved sculpt captured the look of the typical Geonosian. Their social structure was imagined as including a winged lower class that makes up the labor pool and military force, and which served a Geonosian elite that, while sometimes retaining their wings, had outgrown their need for flight.

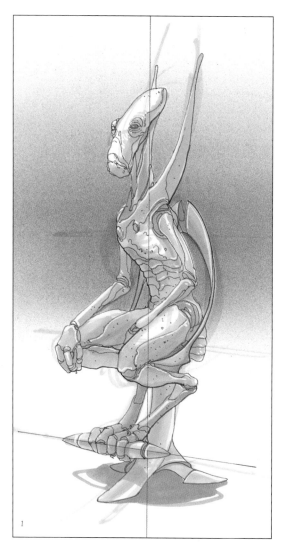

1

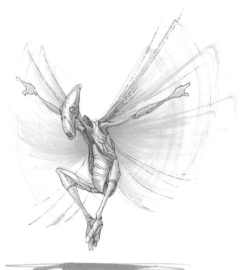

2

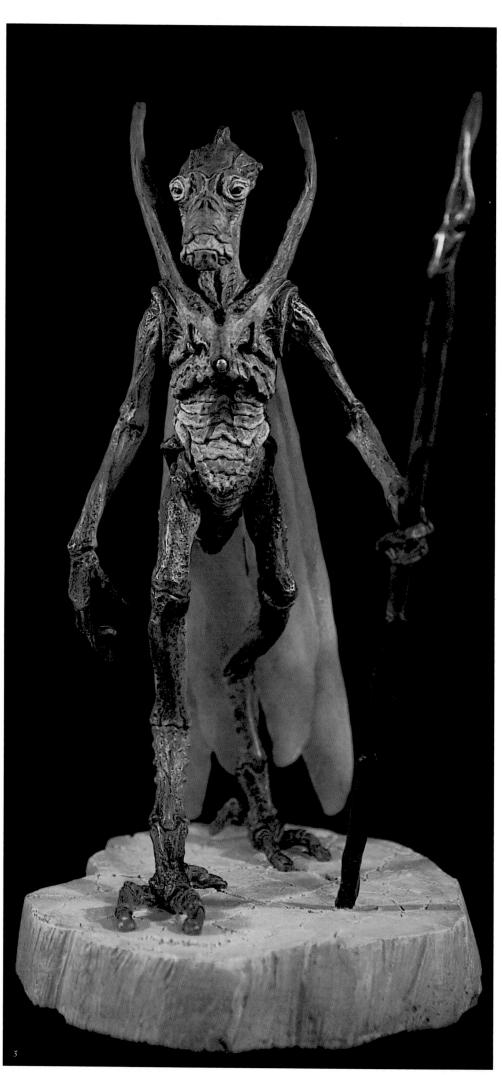

3

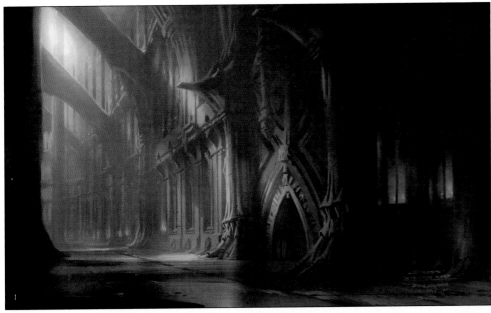

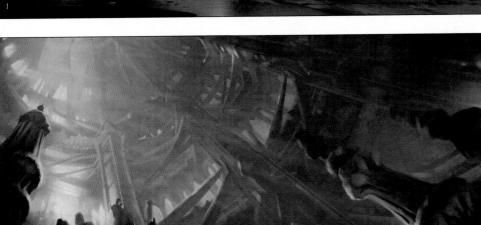

GEONOSIAN DUNGEON & CITY INTERIOR
conceptual designs

		scene/sc: 138
1, 3	Ryan Church	
2	Doug Chiang	
4	Edwin Natividad	99

Ryan Church's shot design of the city interior didn't utilize any production plate footage, but was a total creative concept. "We kept getting shots looking down, so Erik and I thought it'd be interesting to have an up-shot of the Geonosian towers," Church explained. "We basically took Ed Natividad's sketches and fleshed them out a bit."

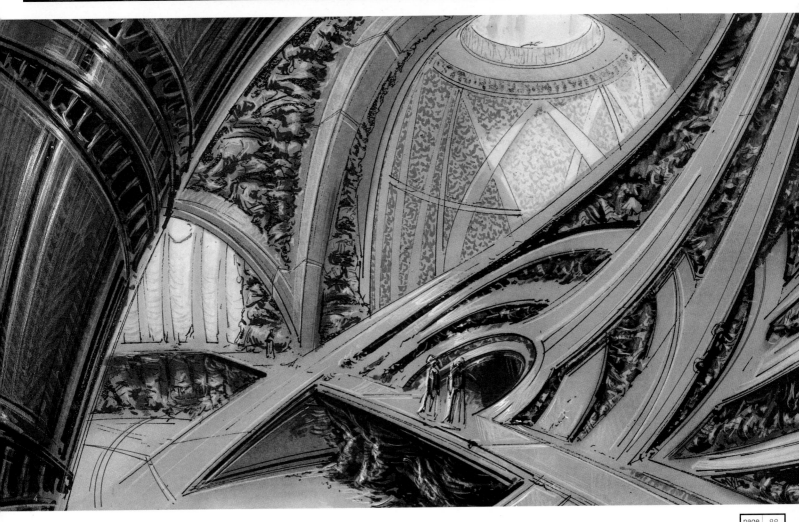

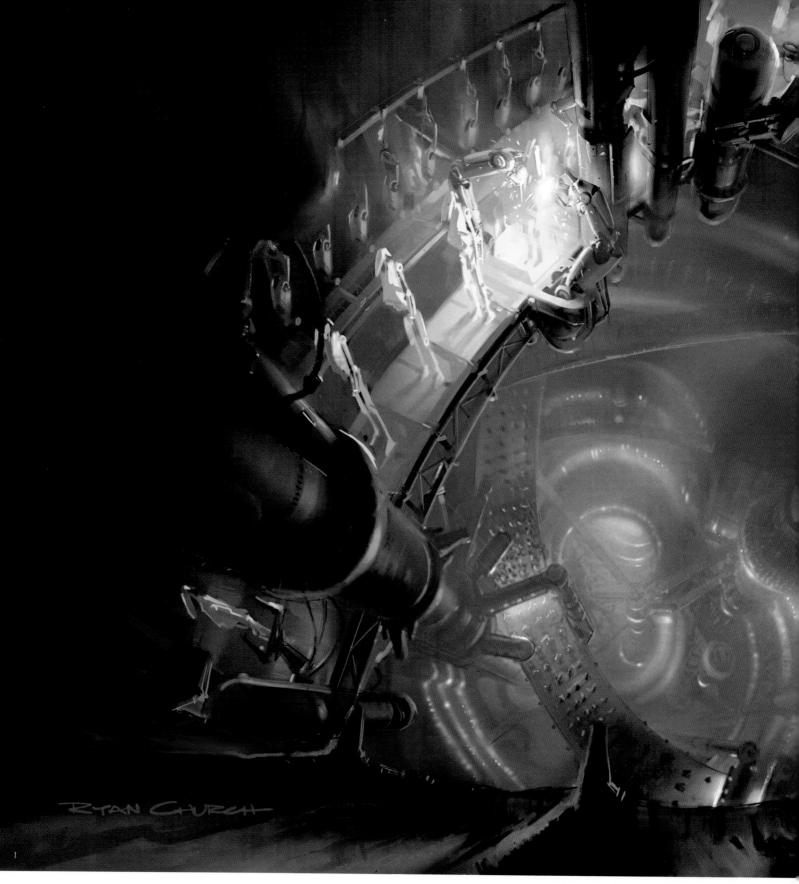

RYAN CHURCH

DROID FACTORY		scene/s: 113
conceptual designs		
1	Ryan Church	
2	Marc Gabbana	
		100

The Marc Gabbana design sketch of the Geonosian droid factory [2] inspired Church's shot design for the film [1], a down-shot that would be Obi-Wan's—and the audience's—first view of the place. As such, it had to be an "Ohh-ahh!" shot, Church noted, instantly conveying an atmosphere the artist summed up as "a hellish place where they build evil robots."

The Church painting was further modified before being developed for the movie. "George suggested that the robots on the right side of this image weren't visible enough," Church explained. "He said we should really sell this idea of a robot assembly line."

Lucas also felt this shot design image was so powerful it would be a shame to confine it to only one or two ILM matte paintings. Thus, the concept inspired reshoots of the actors for a later, elaborate visual-effects sequence of Anakin and Padmé being chased through the dangerous droid factory. Church noted that the whole production was organized in a way that would allow Lucas to request the creation of entire environments at will, even after principal photography had been

completed. Not only could ILM create completely computer-generated sequences, but the live-action work itself usually was played out against minimal sets, with surrounding bluescreens that would accommodate the later conjuring of any final environment.

"Some of the things that are normally figured out in preproduction were actually being done *during* production," Church noted. "It allowed George, while he was cutting and editing, to bounce off our artwork and ask for new stuff. It's kind of backward, but a lot more fluid, too. This is more typical of a digital feature than a typical live-action show."

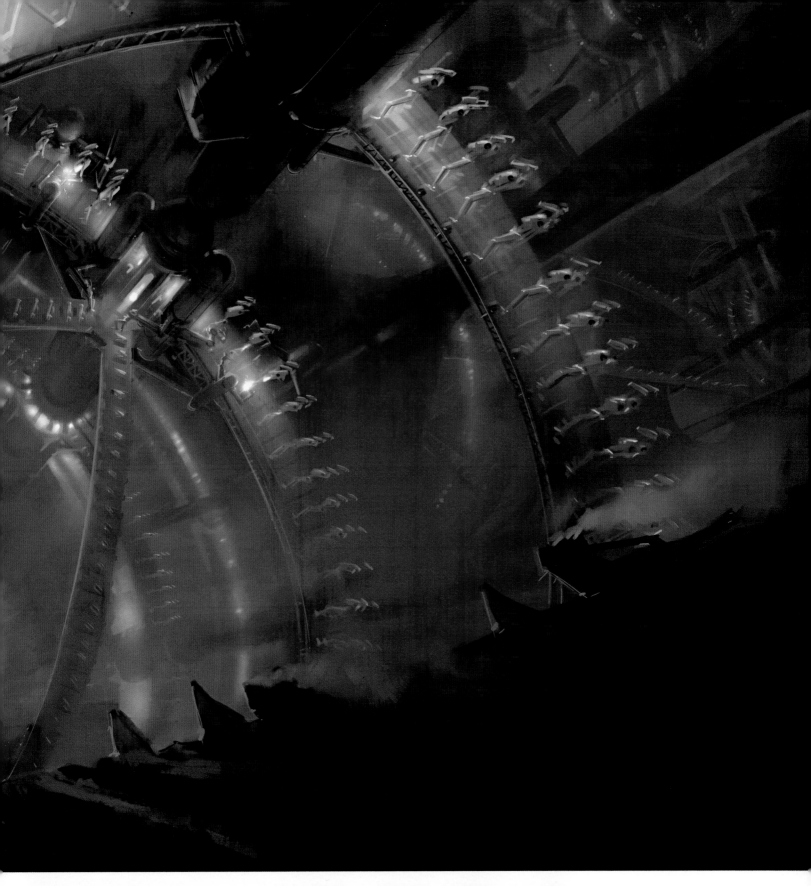

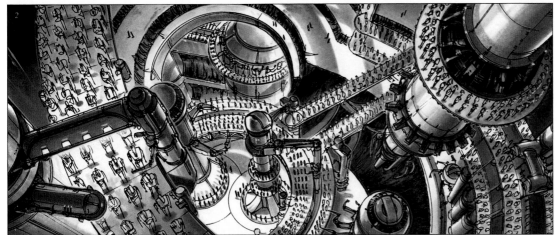

"The droid factory is a superthreatening environment, a place by robots for robots. Soft, living flesh doesn't belong here."
—**Ryan Church**

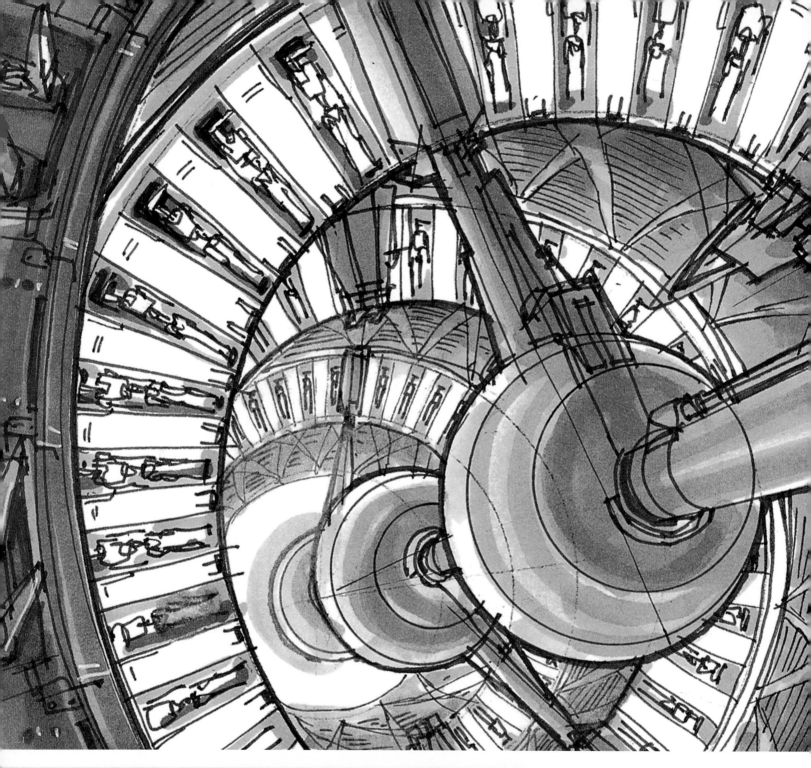

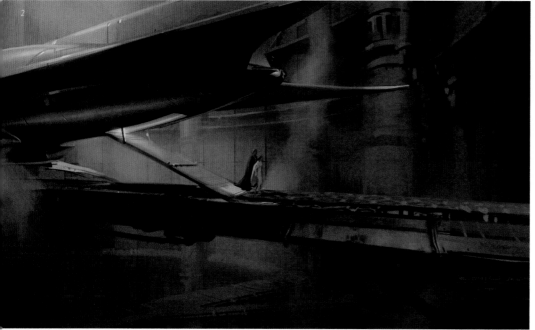

DROID FACTORY & ENTRANCE
conceptual designs

		scene/s:
1	Jay Shuster	142/144
2, 4	Ryan Church	
3	Doug Chiang	

Emblematic of the conceptual evolution from design sketch—such as the dramatic Shuster art above— to shot design is this image of Anakin and Padmé in the droid factory [4]. To plot the sequence, Church took live-action plates of the actors, and digitally painted the surrounding environment, using Painter to create a sophisticated form of "previsualizing."

"It's like a matte painting," Church concluded. "In a few hours we can have a quick pre-viz of the scene to prove out the aesthetic."

The ideal scenario, according to Chiang, was that the editorial department provided plates that Church and Tiemens used as templates for their digital paintings. "The artists could then give back [their digital paintings] to the animatic guys," Chiang explained, "and they'd composite the painting with the original plate to check the lighting and other aesthetic concerns."

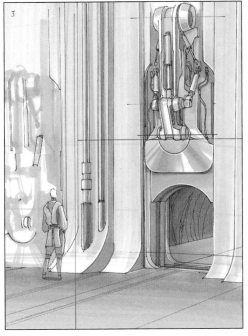

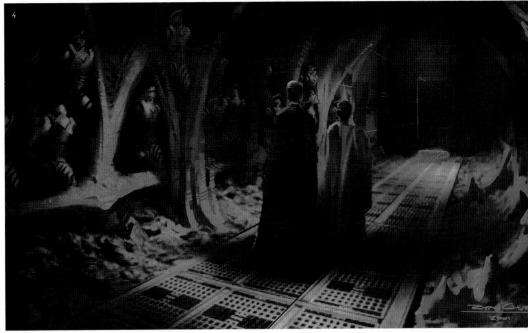

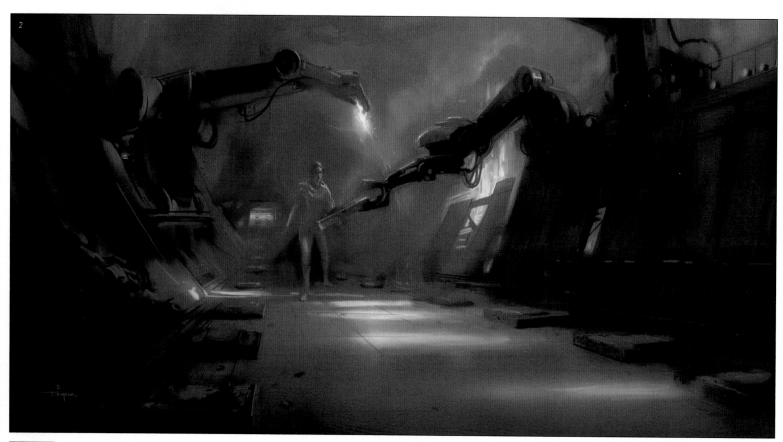

DROID FACTORY INTERIOR		
conceptual designs		
1, 3, 6	Ryan Church	scene/s: 144/145
2, 4, 5	Erik Tiemens	
7, 8	Doug Chiang	104

Anakin and Padmé run the gauntlet of the droid factory in these designs [1–6]. The image above is an homage to the famous *A New Hope* shot of Luke and Leia similarly, and precariously, perched on a narrow Death Star platform. For the shot, the artists received a digital production plate showing the actors on a bluescreen set ready to jump, and his final digital art provided the illusion of a classic jeopardy situation. "This is how a lot of our work is done," Church said. "We could take live action of actors and do a production illustration *around* them."

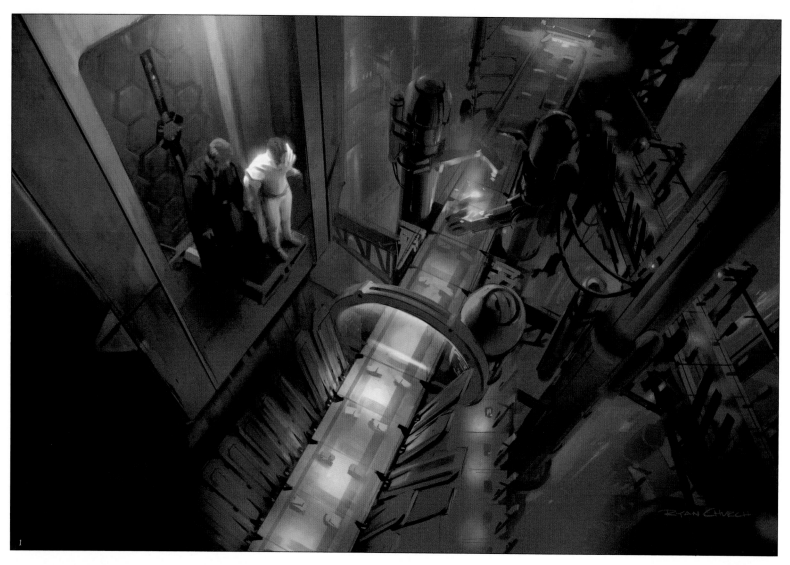

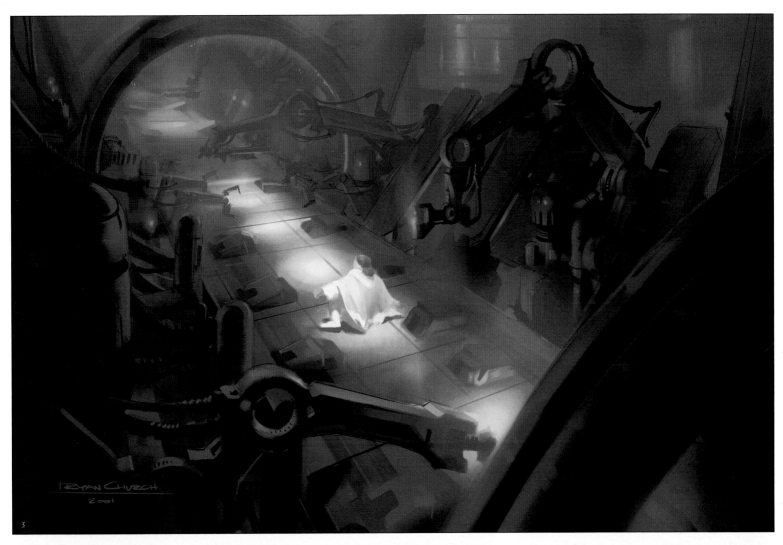

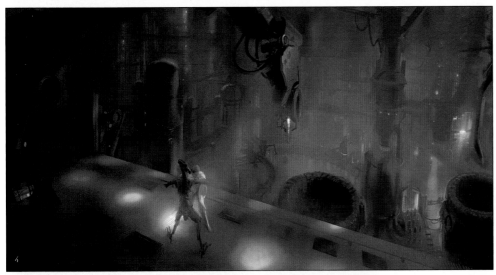

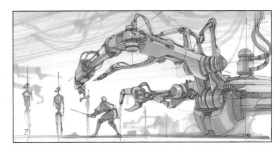

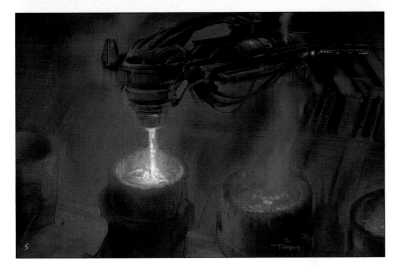

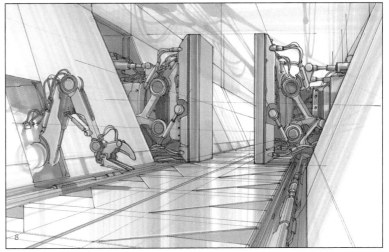

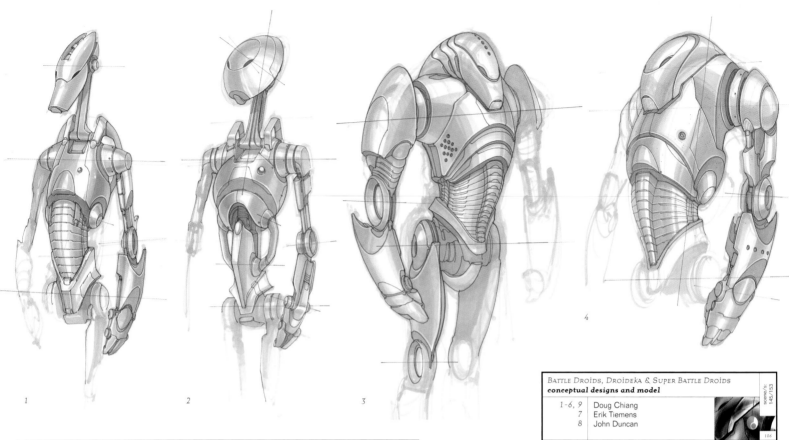

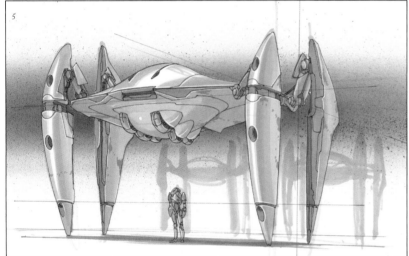

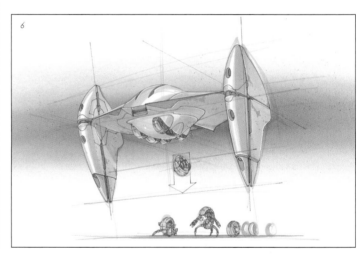

1 2 3

4

Battle Droids, Droideka & Super Battle Droids
conceptual designs and model

scene/s:
145/153

1-6, 9	Doug Chiang
7	Erik Tiemens
8	John Duncan

106

5

6

7

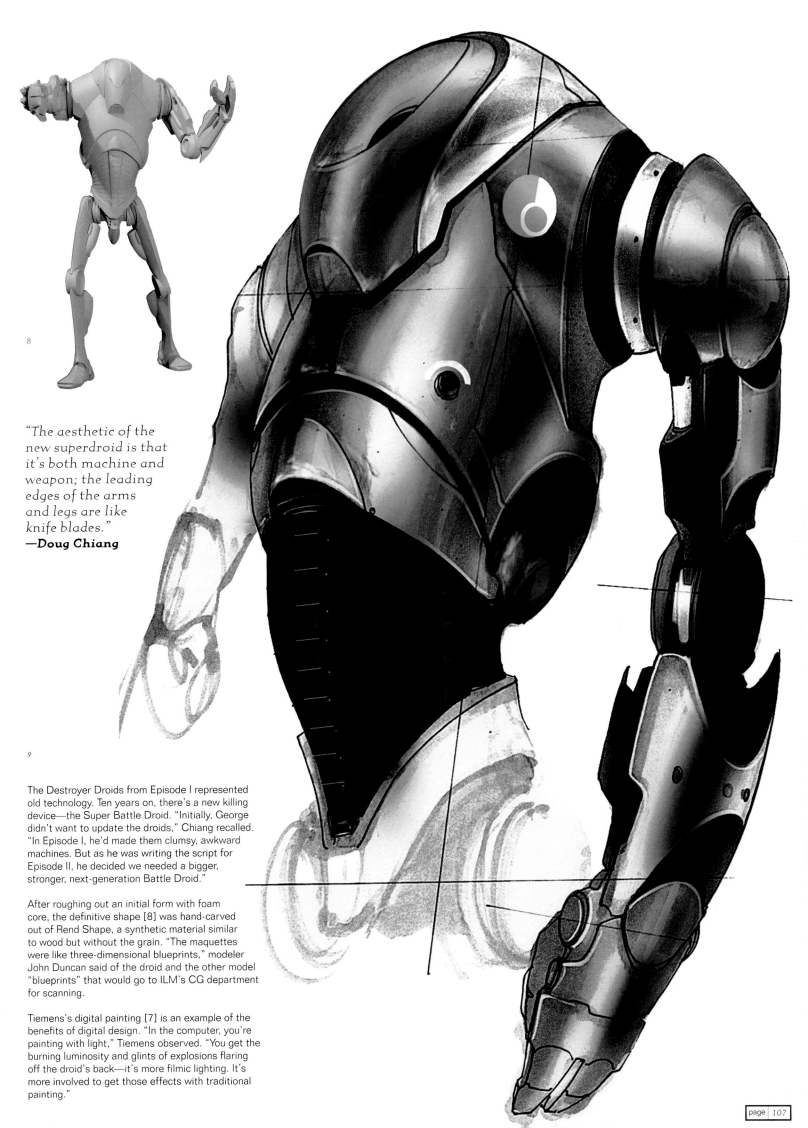

8

*"The aesthetic of the
new superdroid is that
it's both machine and
weapon; the leading
edges of the arms
and legs are like
knife blades."*
—**Doug Chiang**

9

The Destroyer Droids from Episode I represented
old technology. Ten years on, there's a new killing
device—the Super Battle Droid. "Initially, George
didn't want to update the droids," Chiang recalled.
"In Episode I, he'd made them clumsy, awkward
machines. But as he was writing the script for
Episode II, he decided we needed a bigger,
stronger, next-generation Battle Droid."

After roughing out an initial form with foam
core, the definitive shape [8] was hand-carved
out of Rend Shape, a synthetic material similar
to wood but without the grain. "The maquettes
were like three-dimensional blueprints," modeler
John Duncan said of the droid and the other model
"blueprints" that would go to ILM's CG department
for scanning.

Tiemens's digital painting [7] is an example of the
benefits of digital design. "In the computer, you're
painting with light," Tiemens observed. "You get the
burning luminosity and glints of explosions flaring
off the droid's back—it's more filmic lighting. It's
more involved to get those effects with traditional
painting."

Concept design is a process during which interesting ideas surface, are developed, and are often discarded. Back on *The Empire Strikes Back*, two Ralph McQuarrie concepts—a deserted city on Hoth and manta-ray-like sky creatures flying among floating ghost cities above Bespin—were never realized. And some Episode II ideas, such as costume designs for Padmé's planned Senate appearance, were sometimes taken to approved finals, only to be scrapped.

One of the lost concepts for Episode II was the deadly, spiderlike Annihilator Droid. "Before the annihilator droid was written out, it was going to be one of the powerful, next-generation droids," Chiang observed. "What was curious was, George felt there were too many droids so he dropped this, but then a bunch of new robots were created for the end battle. But the Annihilator Droid never came back."

It was when Lucas was cutting material in the animatics phase that he realized the annihilator droid concept could inspire development of fighting droids needed for the Banking and Commerce clans and the other forces clashing at the end battle. In the Annihilator Droid concept drawings below [2], Chiang was inspired by the Episode I Destroyer Droid.

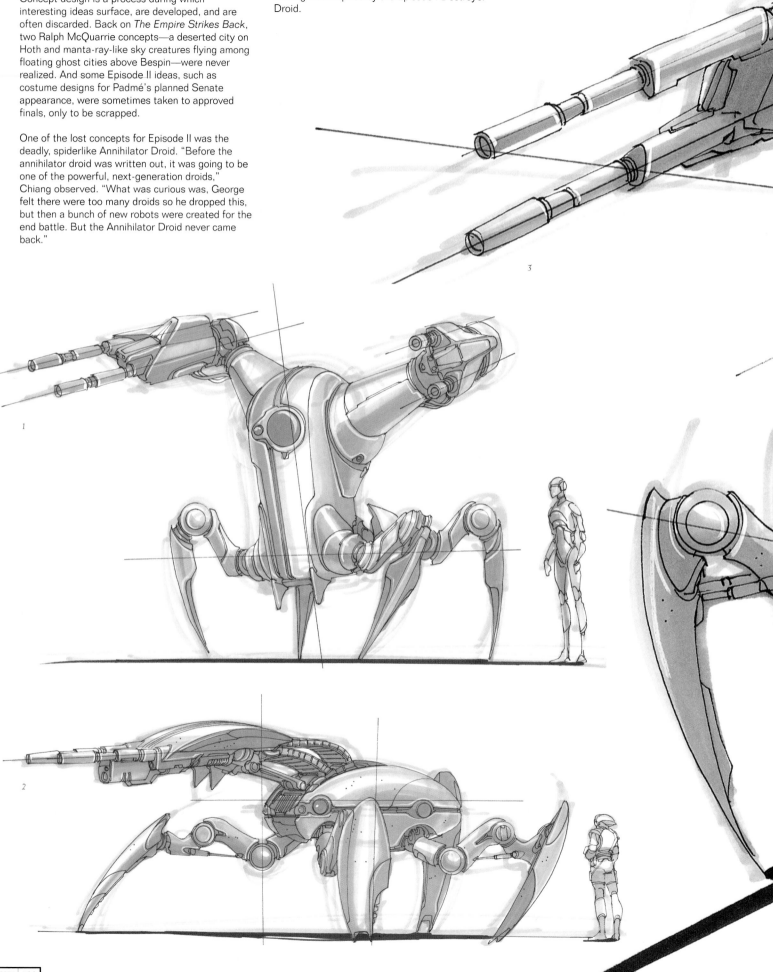

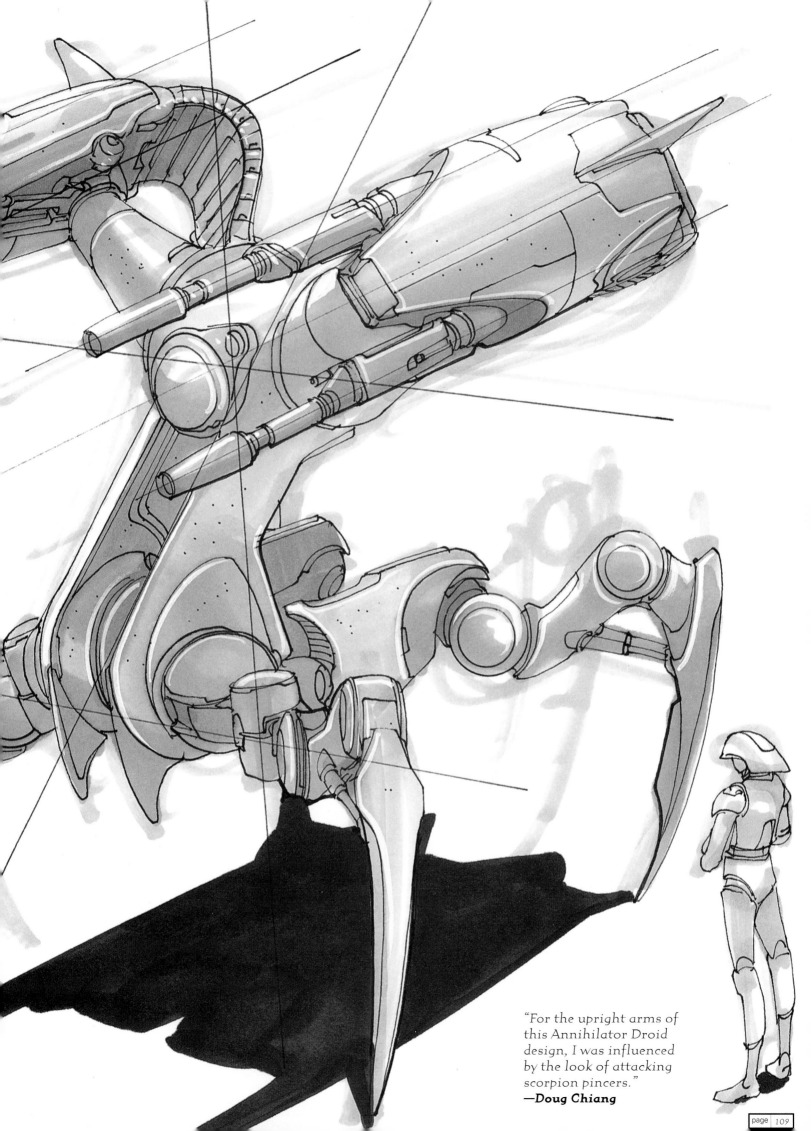

"For the upright arms of this Annihilator Droid design, I was influenced by the look of attacking scorpion pincers."
—**Doug Chiang**

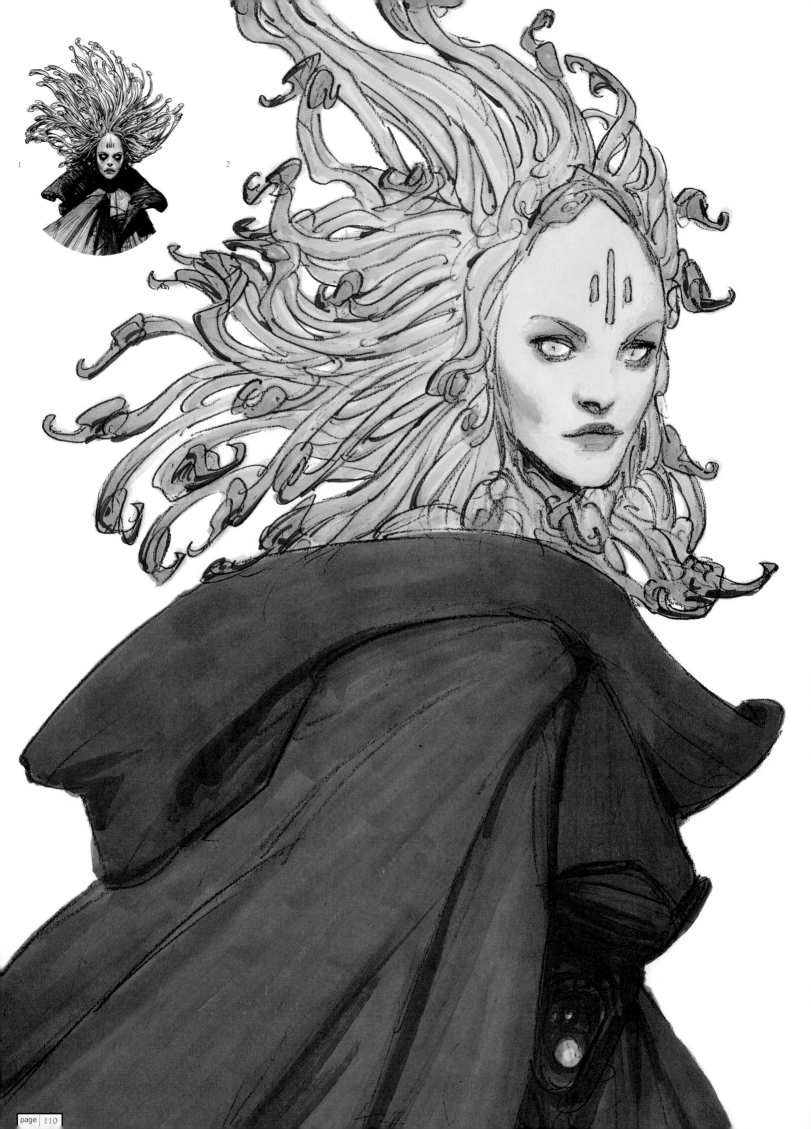

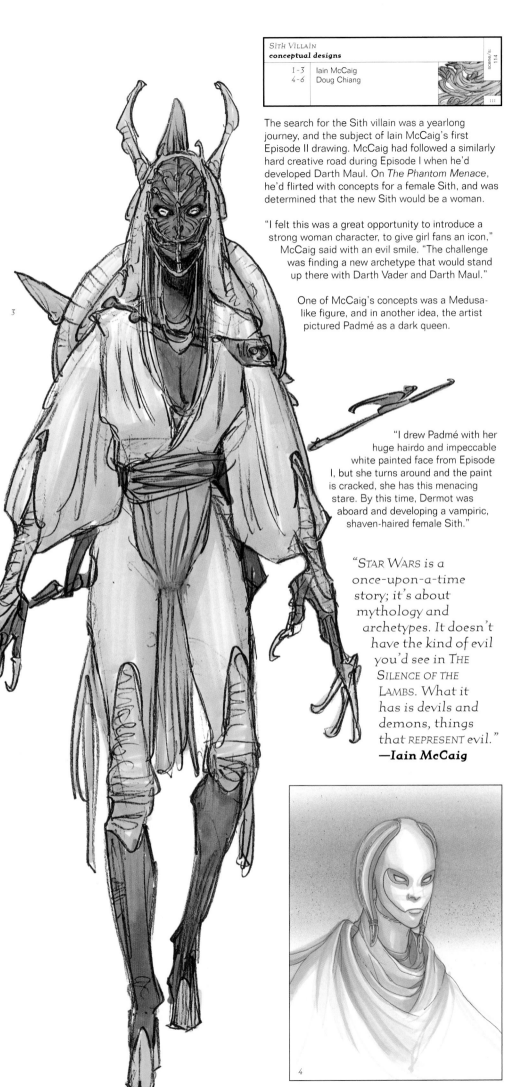

SITH VILLAIN		
conceptual designs		
1-3	Iain McCaig	
4-6	Doug Chiang	

SCENE/S: 114

111

The search for the Sith villain was a yearlong journey, and the subject of Iain McCaig's first Episode II drawing. McCaig had followed a similarly hard creative road during Episode I when he'd developed Darth Maul. On *The Phantom Menace*, he'd flirted with concepts for a female Sith, and was determined that the new Sith would be a woman.

"I felt this was a great opportunity to introduce a strong woman character, to give girl fans an icon," McCaig said with an evil smile. "The challenge was finding a new archetype that would stand up there with Darth Vader and Darth Maul."

One of McCaig's concepts was a Medusa-like figure, and in another idea, the artist pictured Padmé as a dark queen.

"I drew Padmé with her huge hairdo and impeccable white painted face from Episode I, but she turns around and the paint is cracked, she has this menacing stare. By this time, Dermot was aboard and developing a vampiric, shaven-haired female Sith."

"STAR WARS is a once-upon-a-time story; it's about mythology and archetypes. It doesn't have the kind of evil you'd see in THE SILENCE OF THE LAMBS. What it has is devils and demons, things that REPRESENT evil."
—Iain McCaig

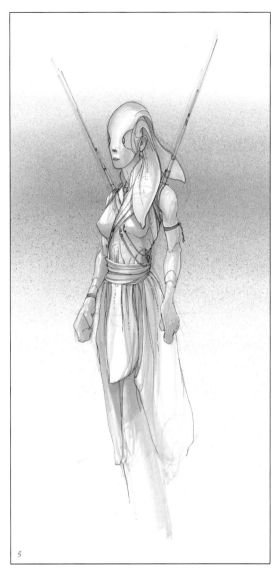

5

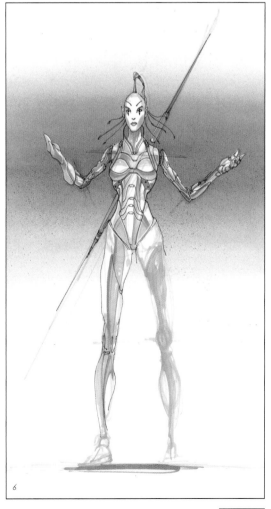

6

4

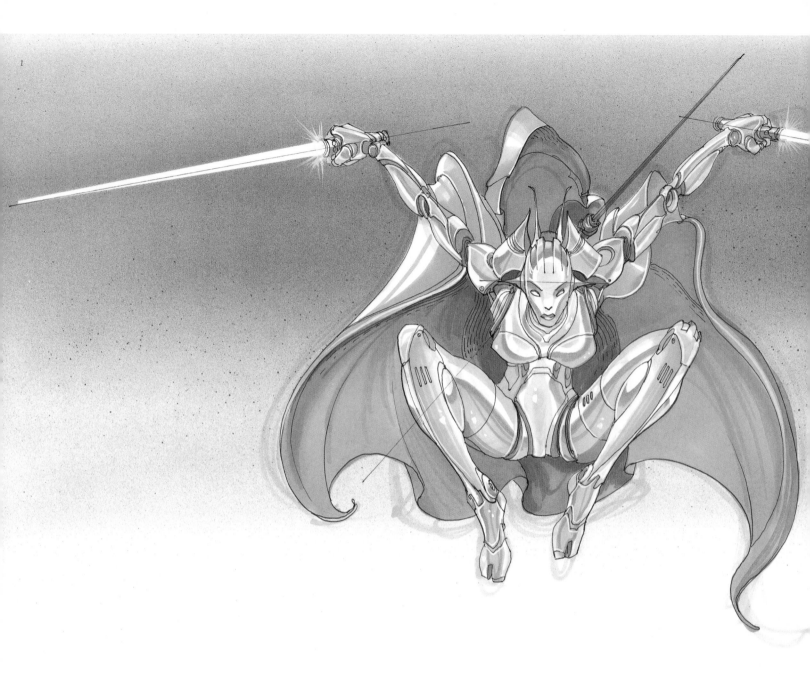

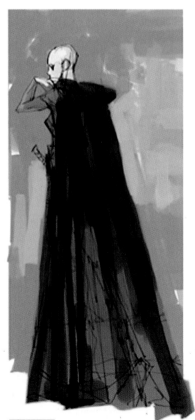

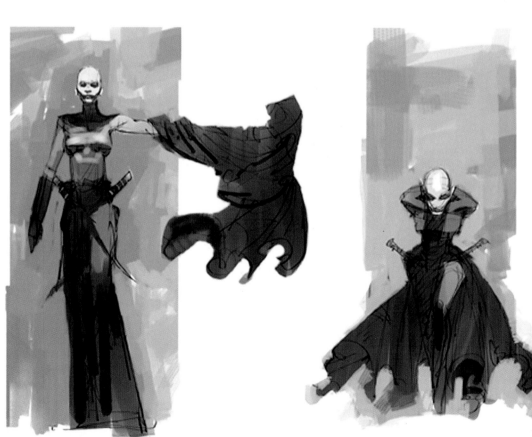

1

2

3

4

SITH VILLAIN		scene/st.
conceptual designs		114
1	Doug Chiang	
2-6	Dermot Power	
		113

Dermot Power's Sith drew on his own youthful fascination with martial arts, imagining a female figure embodying athletic grace and samurai sword-handling skills. "The stance I drew for the Sith is about solidity and grounding, with the lower body as an anchor to a slender upper body. I was also trying to think how she'd move with two lightsabers." Other concepts for the female Sith ranged from a chrome-plated fembot [1] to a witch [next page].

"I deliberately curved the Sith's lightsaber. I wanted something exotic, almost Arabic."
—Dermot Power

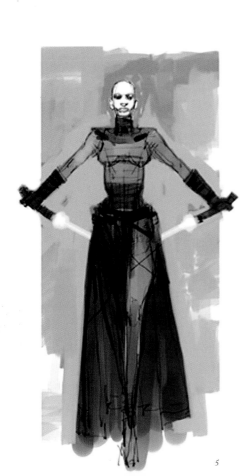

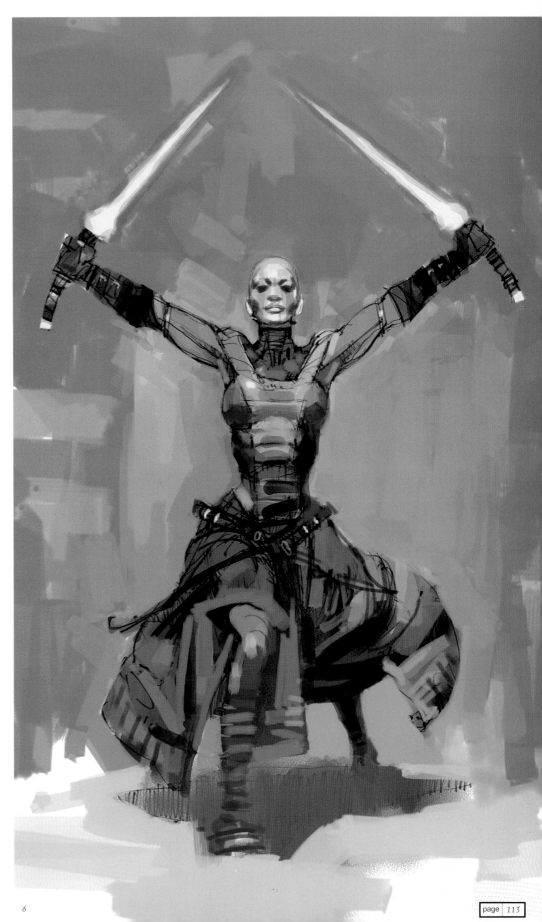

5 6

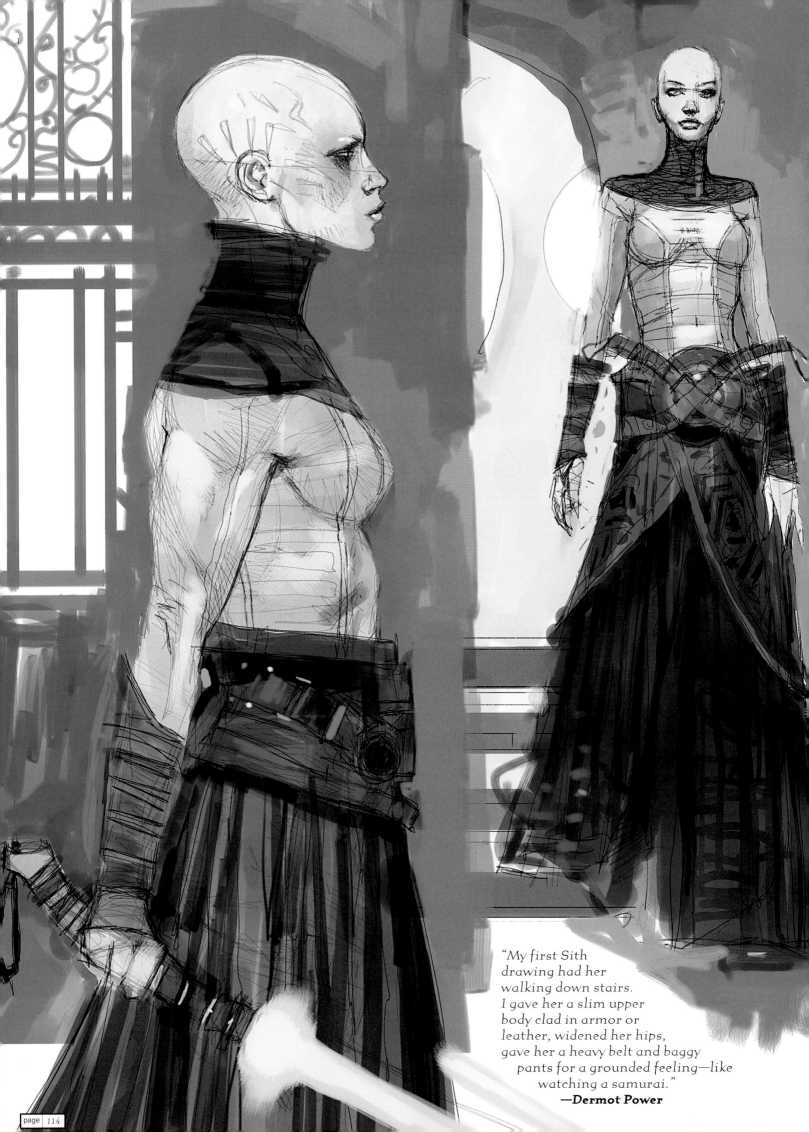

"My first Sith
drawing had her
walking down stairs.
I gave her a slim upper
body clad in armor or
leather, widened her hips,
gave her a heavy belt and baggy
pants for a grounded feeling—like
watching a samurai."
—**Dermot Power**

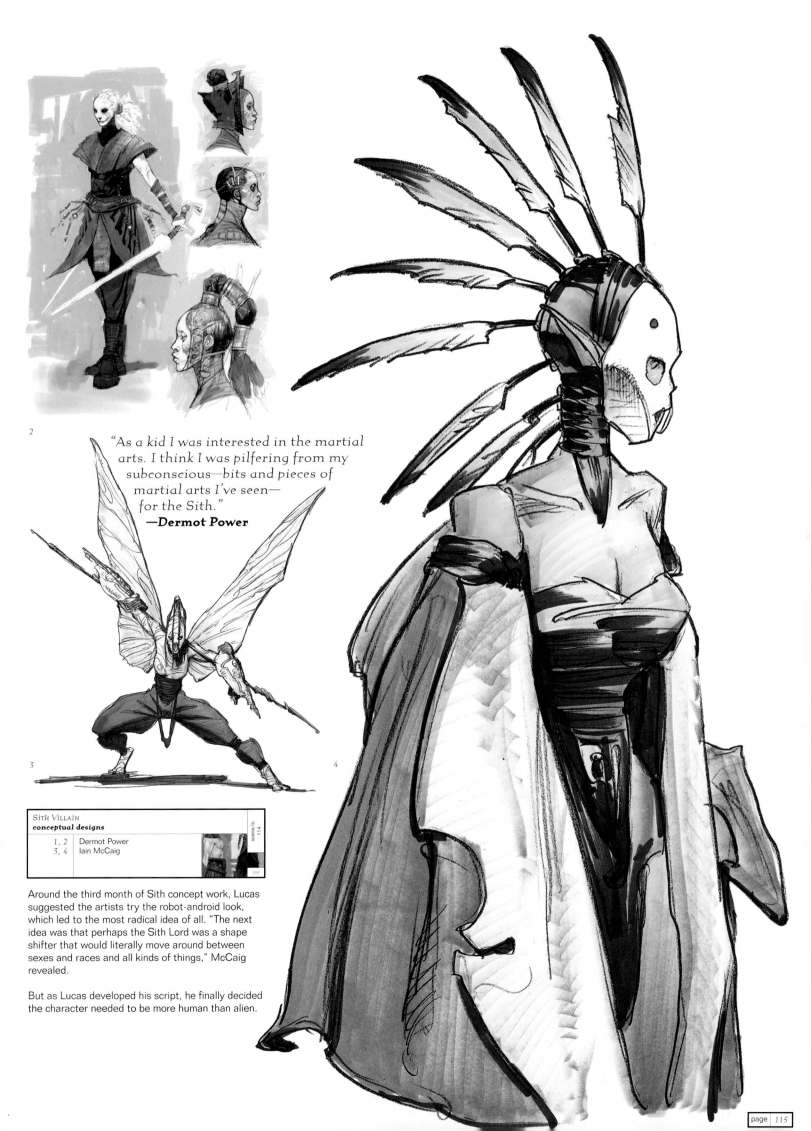

"As a kid I was interested in the martial arts. I think I was pilfering from my subconscious—bits and pieces of martial arts I've seen— for the Sith."
—**Dermot Power**

3

4

SITH VILLAIN		scene/s:
conceptual designs		114
1, 2	Dermot Power	
3, 4	Iain McCaig	

Around the third month of Sith concept work, Lucas suggested the artists try the robot-android look, which led to the most radical idea of all. "The next idea was that perhaps the Sith Lord was a shape shifter that would literally move around between sexes and races and all kinds of things," McCaig revealed.

But as Lucas developed his script, he finally decided the character needed to be more human than alien.

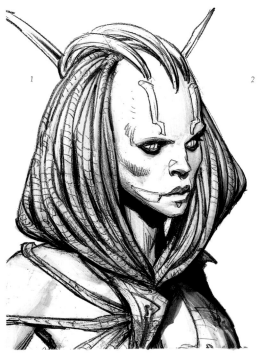

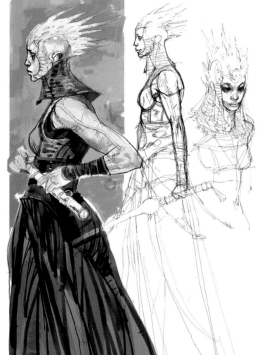

Most of Power's Sith art featured lightsabers with a curved, arabesque design to the handles. Power also reworked his original Sith look, trying out an alien head [5]. The drawing of a character seemingly cloaked in an executioner's mask [3] was actually an attempt to throw the face into shadow and highlight the detailed, leathery costume, which emphasized "strong, horizontal lines, like the belly of an alligator," he explained. "I wanted to make her look tough."

He also drew up some male figures. "We tried everything possible for the Sith. We ranged across the board from androids to Hannibal Lecter," McCaig recalled. "I thought of Lecter's expression, and the dawning realization you'd have that you were around a deadly thing if you were in the room with him. It was a subtle shift, but I then began drawing elderly humans that were strong, not feeble."

McCaig was personally disappointed that the search for the Sith veered away from a female character. "The first drawing I did for Episode II was a female Sith," McCaig recalled. "I remember George coming up and looking at it and asking what it was. 'It's your Sith, George,' I said. 'It's got to be a woman!' In Darth Vader and Darth Maul we had two male Sith Lords and I thought this was a great opportunity to put a strong woman character out there."

"Creating the Sith was a challenge, but it was great," Dermot Power concluded. "The difficult part was refining and making subtle changes. It's difficult to get what George wants."

"To me, it's not just drawing the figure that's important—it's all about who's in there, the spirit that a character manifests."
—Iain McCaig

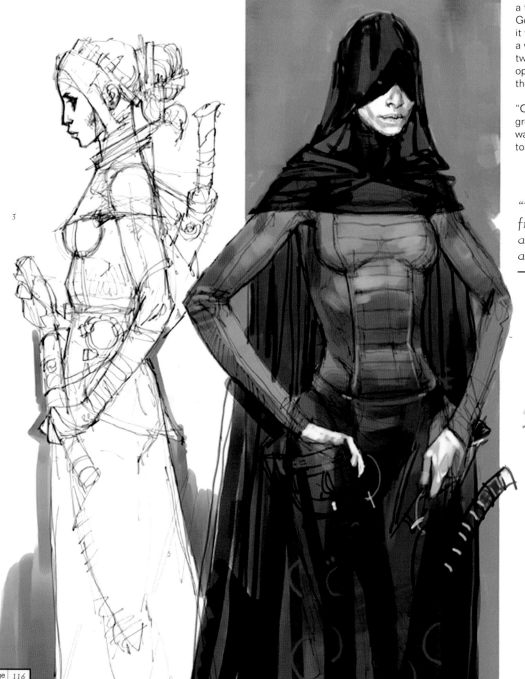

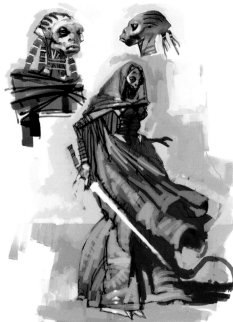

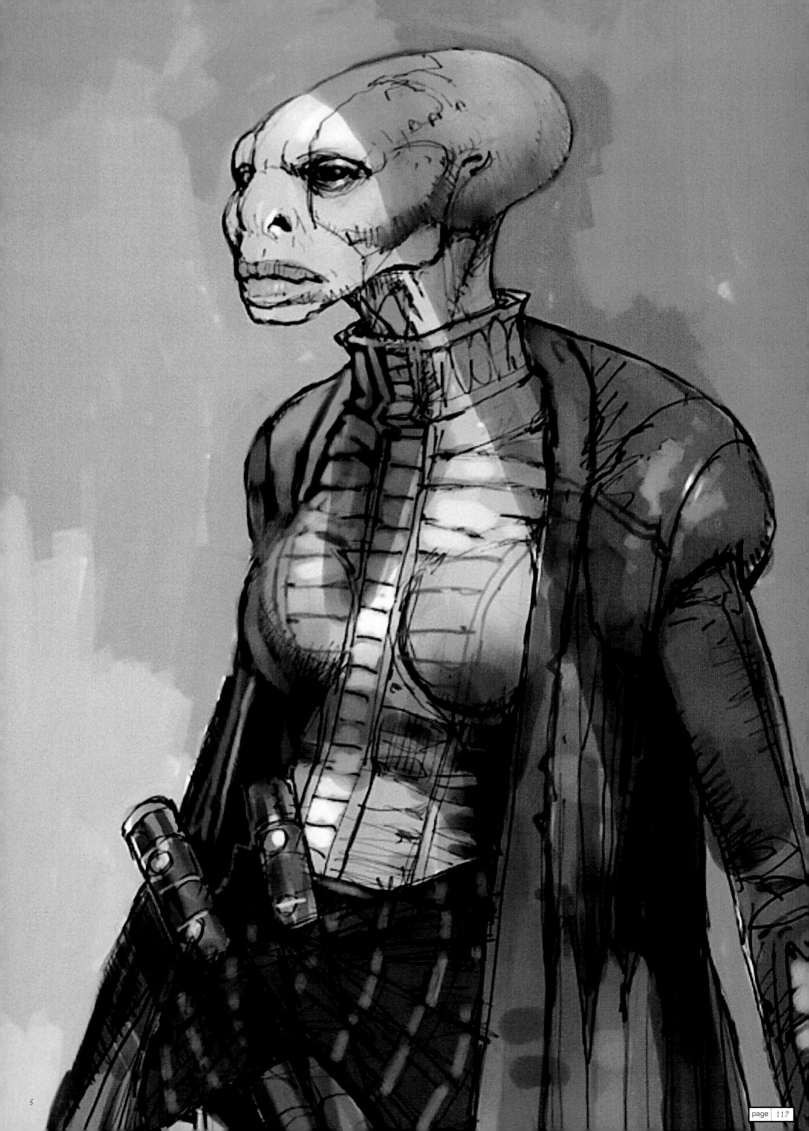

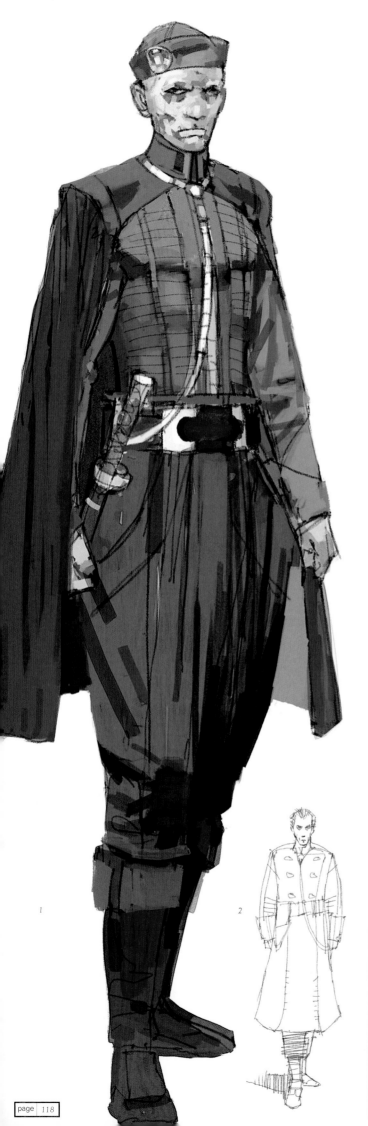

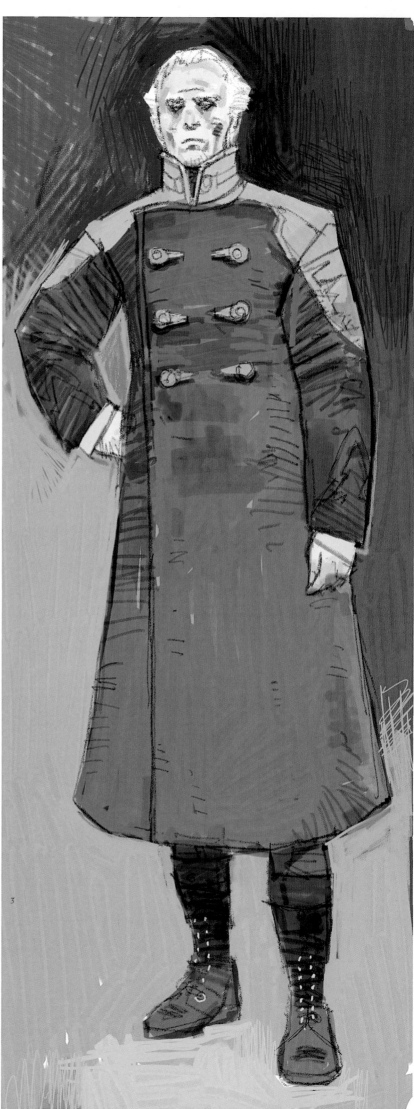

1

2

3

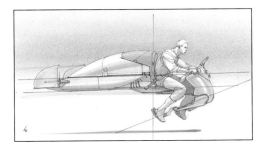

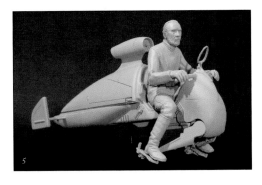

COUNT DOOKU & SPEEDER conceptual designs and model		scene/s: 114/166
1-3	Dermot Power	
4	Doug Chiang	
5	John Goodson	
6, 7	Iain McCaig	

This profile [7] was originally imagined by Iain McCaig as a Coruscant policeman, but also was in the running for the Sith villain. McCaig's final Sith drawings purposely moved far from the notion of a young, lithe, sexy female to images of an older woman [6] who appeared frail but was vicious and nimble.

This image was McCaig's last drawing for the Sith. Lucas accepted it, telling McCaig the final incarnation of the Sith would be either based on this drawing—or a completely different character played by Christopher Lee.

That was the first anyone had heard of Lee's potential involvement. The veteran actor was hired to play Count Dooku, a character ultimately revealed as a Sith. Lee joined in the pantheon of *Star Wars* villains his late friend and colleague Peter Cushing, a fellow Hammer horror film star who played Grand Moff Tarkin in *A New Hope*. The Dermot Power designs at left [1–3] imagine the imperious count.

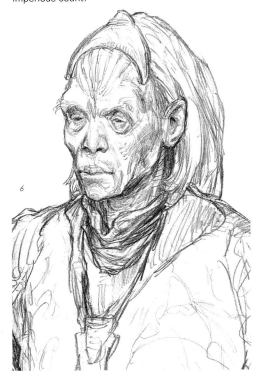

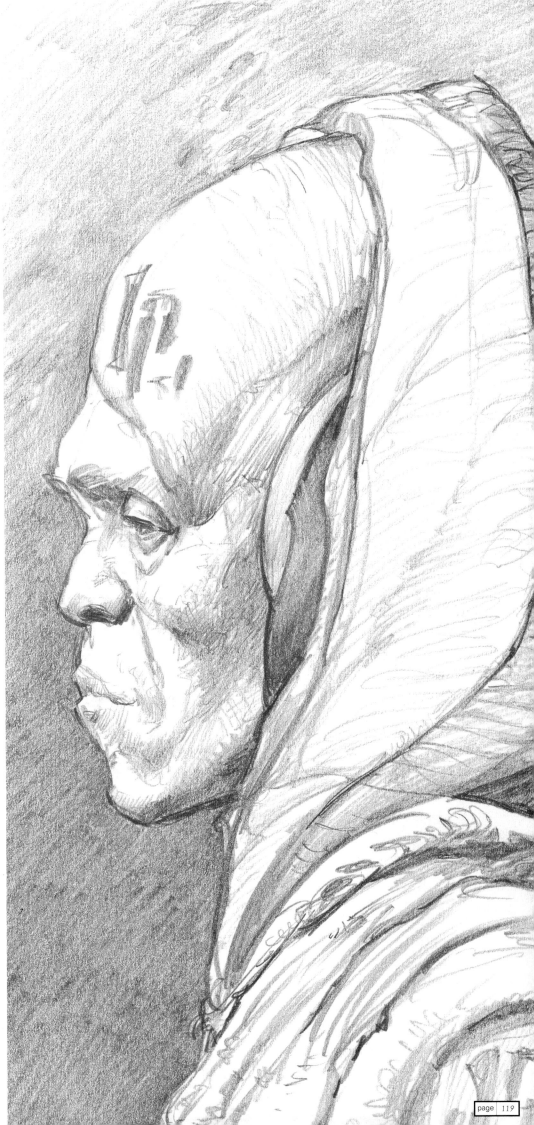

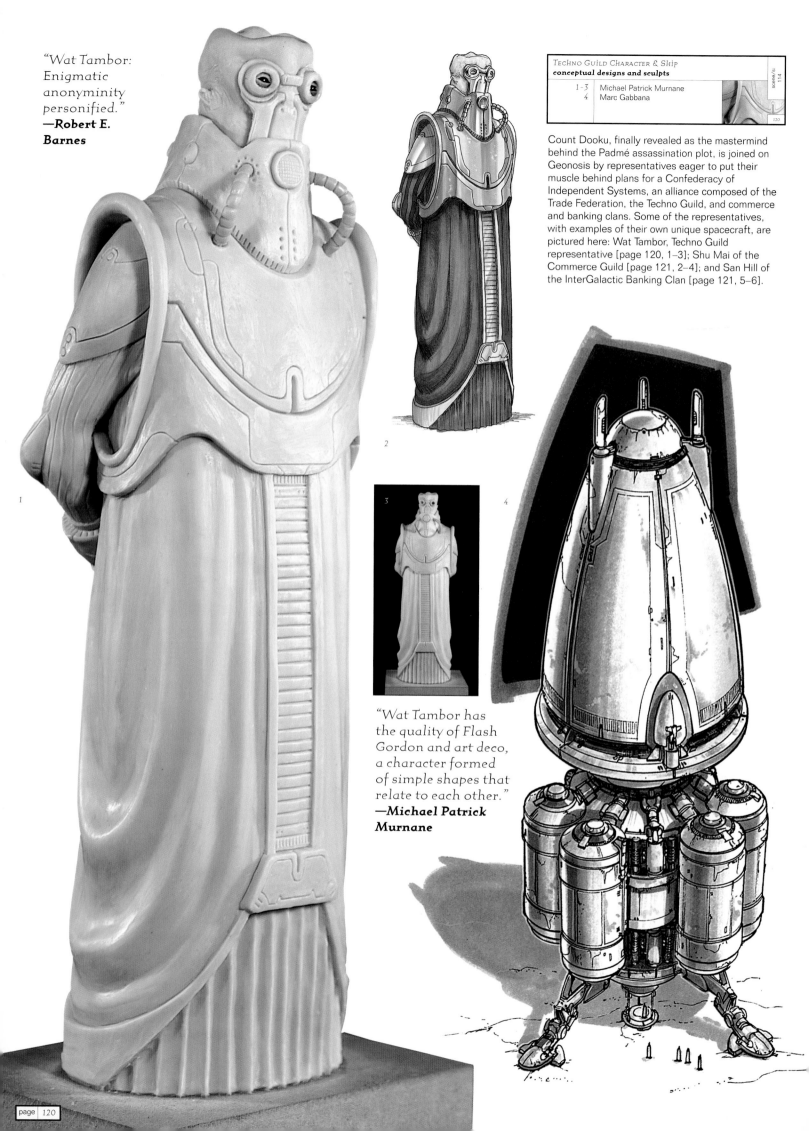

"Wat Tambor: Enigmatic anonyminity personified."
—**Robert E. Barnes**

TECHNO GUILD CHARACTER & SHIP
conceptual designs and sculpts

| 1–3 | Michael Patrick Murnane |
| 4 | Marc Gabbana |

scene/s: 114

120

Count Dooku, finally revealed as the mastermind behind the Padmé assassination plot, is joined on Geonosis by representatives eager to put their muscle behind plans for a Confederacy of Independent Systems, an alliance composed of the Trade Federation, the Techno Guild, and commerce and banking clans. Some of the representatives, with examples of their own unique spacecraft, are pictured here: Wat Tambor, Techno Guild representative [page 120, 1–3]; Shu Mai of the Commerce Guild [page 121, 2–4]; and San Hill of the InterGalactic Banking Clan [page 121, 5–6].

"Wat Tambor has the quality of Flash Gordon and art deco, a character formed of simple shapes that relate to each other."
—**Michael Patrick Murnane**

COMMERCE & BANKING CLANS CHARACTERS & SHIPS		Jacsono/s:
conceptual designs		114/115
1	Doug Chiang	
2, 5, 6	Dermot Power	
3, 4	Iain McCaig	
7	Marc Gabbana	121

Marc Gabbana summed up the Commerce and Banking Clan ships as capable of vertical take-offs and landings, much in the manner of the rocket ships of classic science-fiction novels and movies.

"I didn't want to make the Clan ships look too clean and sleek, so I bulked them up to fit into the *Star Wars* universe," Gabbana added. "In this design [7] I added a dark opening near the top to break up the tall, cylindrical form."

"For the Commerce and Banking Clan ships, George wanted designs that harkened back to 1950s-style rocket ships."
—**Marc Gabbana**

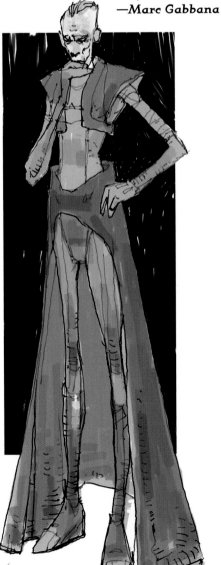

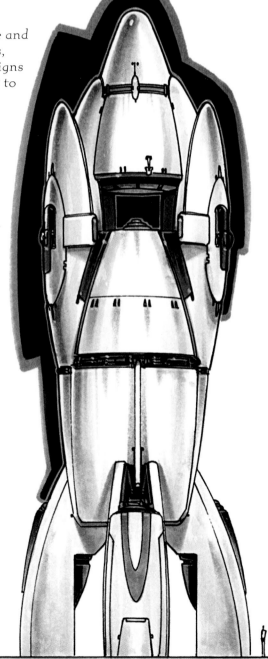

1

2

3

4

5

6

7

		scene/s:
1	Erik Tiemens	111
2	Doug Chiang	
3	Marc Gabbana	122

In Episode I, the Trade Federation battleship that blockaded Naboo was designed with an open doughnut shape, adding a "bridge ball" to the battleship's center section. In Episode II, that Trade Federation bridge ball—now called the "control sphere"—is revealed as detachable from the mother ship, on its own a massive spacecraft that can be piloted and is equipped with its own landing gear. Here it sits on the rugged surface of Geonosis, waiting to be loaded up with its order of Battle Droids.

The detachable control spheres—nicknamed "core ships" by the artists—were imagined at an epic 3,000 feet tall. The reality of the spheres as integral parts of Trade Federation battleships would not be readily revealed in Episode II. The first sight of the spheres would be as mysterious, already detached fly-by vehicles. The "reveal" would come in planned shots showing the spheres evacuating from Geonosis and docking in the rings of the orbiting Trade Federation ships.

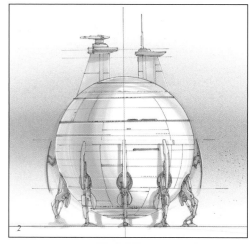

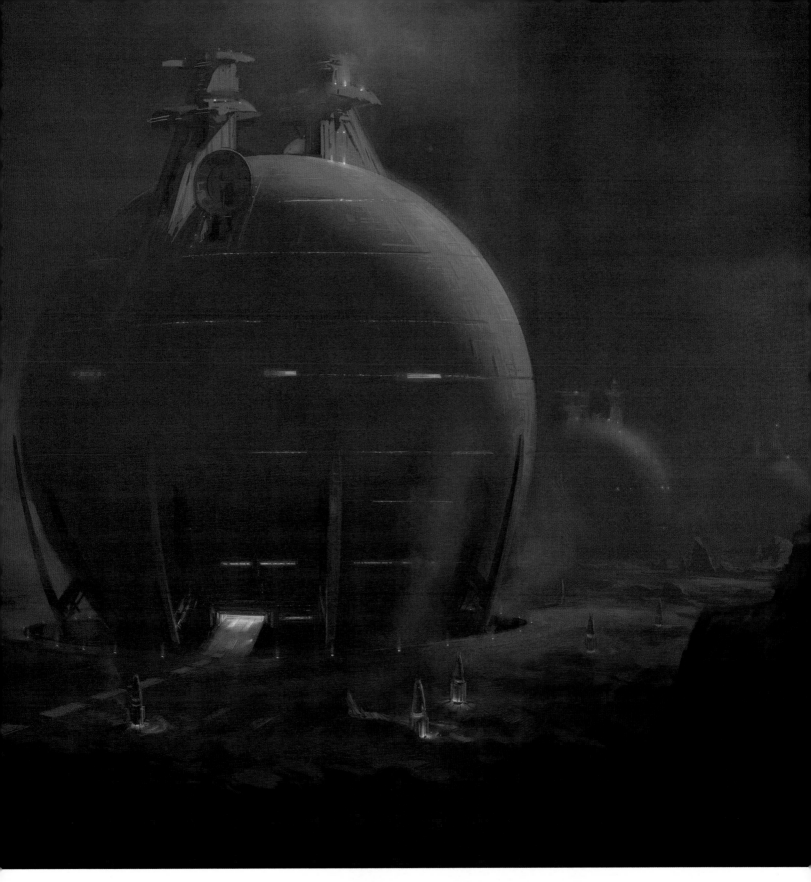

The Erik Tiemens shot design both illustrates the scale of the control sphere and provides a graphic contrast with the spiky rock formations and barren surface of Geonosis. The sphere also stands as an homage to the *Aries* spacecraft of *2001*.

Despite their gigantic scale, special surface docking bays on Geonosis could open and allow the spheres to be lowered underground, as in this sketch [3].

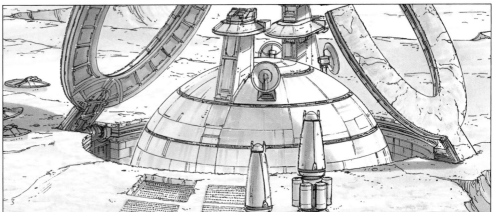

TRADE FEDERATION CORE RAMP
conceptual designs

1	Ryan Church
2	Marc Gabbana

scene/s: 111

124

This Trade Federation core ramp, created in Painter, took early design inspiration from such images as this tight, detailed Marc Gabbana drawing [2], and established a visual template for the shot that would be created for the movie. "We were going for sheer scale here," Church explained. "It wasn't that we'd do that all the time, but we took advantage when

the situation presented the opportunity for a grand design. This whole movie was about how far we could push things, scalewise."

The gargantuan scale of the Trade Federation control spheres is illustrated in this detail for an end battle scene of Jedi boarding in hopes of knocking out the controls for the droid army. While the land-

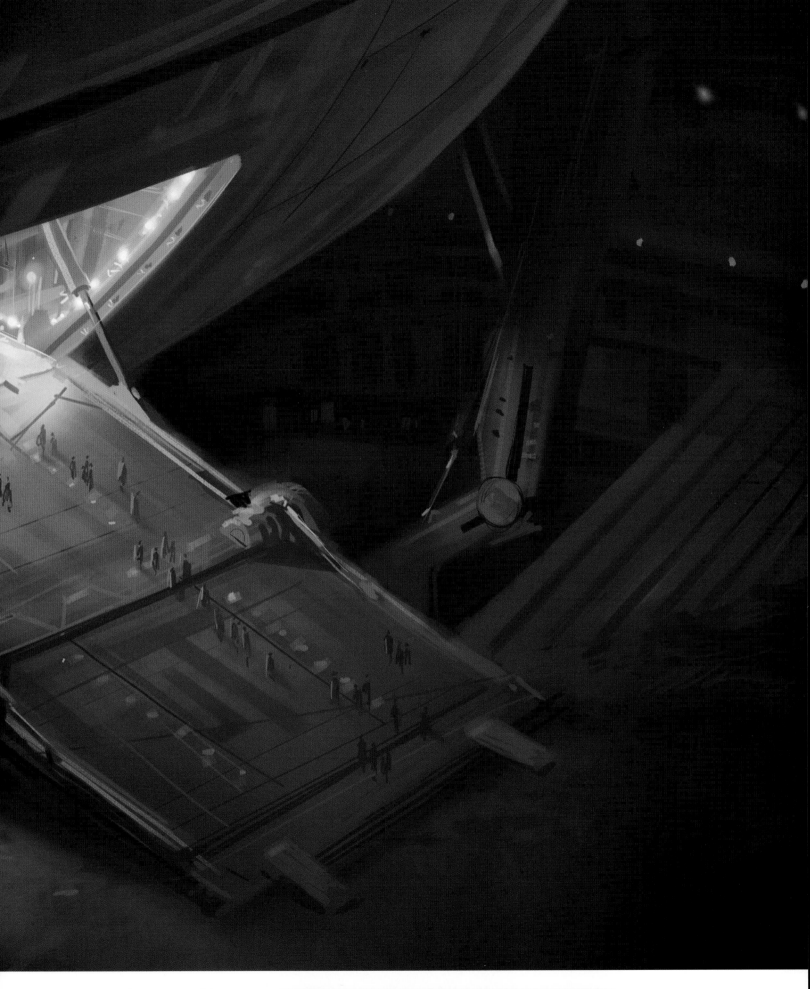

ing ramp in this Marc Gabbana image [2] is accurate to angle and scale, the above concept painting is a visual cheat designed to work for the film (in reality the ramp's angle should be more parallel to the ground). "It's not about how the machinery itself works, but the storypoint of how the Jedi get into the sphere," Chiang noted.

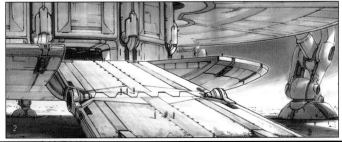

	SUPREME CHANCELOR PALPATINE & AIDE	
	conceptual designs	800/900
		is/vands
1	Dermot Power	
2	Edwin Natividad	
		126

As the separatist crisis builds, Palpatine—who has been elected Supreme Chancellor by the Senate—broods in this early Natividad drawing.

Like Anakin Skywalker, who is destined by the established *Star Wars* storyline to become Darth Vader, Palpatine is fated to become the Emperor whose tyranny leads to the Galactic Civil War. As such, the concept artists began foreshadowing the character's dark side turn in many of their sketches.

For Edwin Natividad, the growing darkness was foreshadowed in the gloomy atmosphere surrounding Palpatine. "In Episode II we see Palapatine becoming evil," Natividad explained. "It's in the lighting, seeing the future Emperor in the distance—it's more of a negative feeling that's being conveyed."

"In Episode II the images of Palpatine were moving towards moody and dark. He's got an edge—but he's not yet the dark Emperor."
—Dermot Power

1

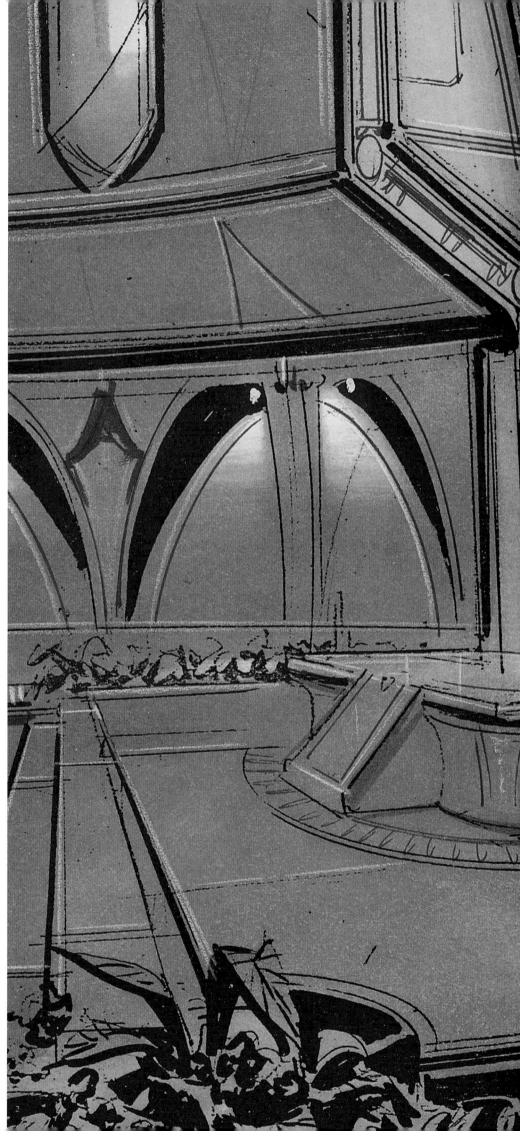

2

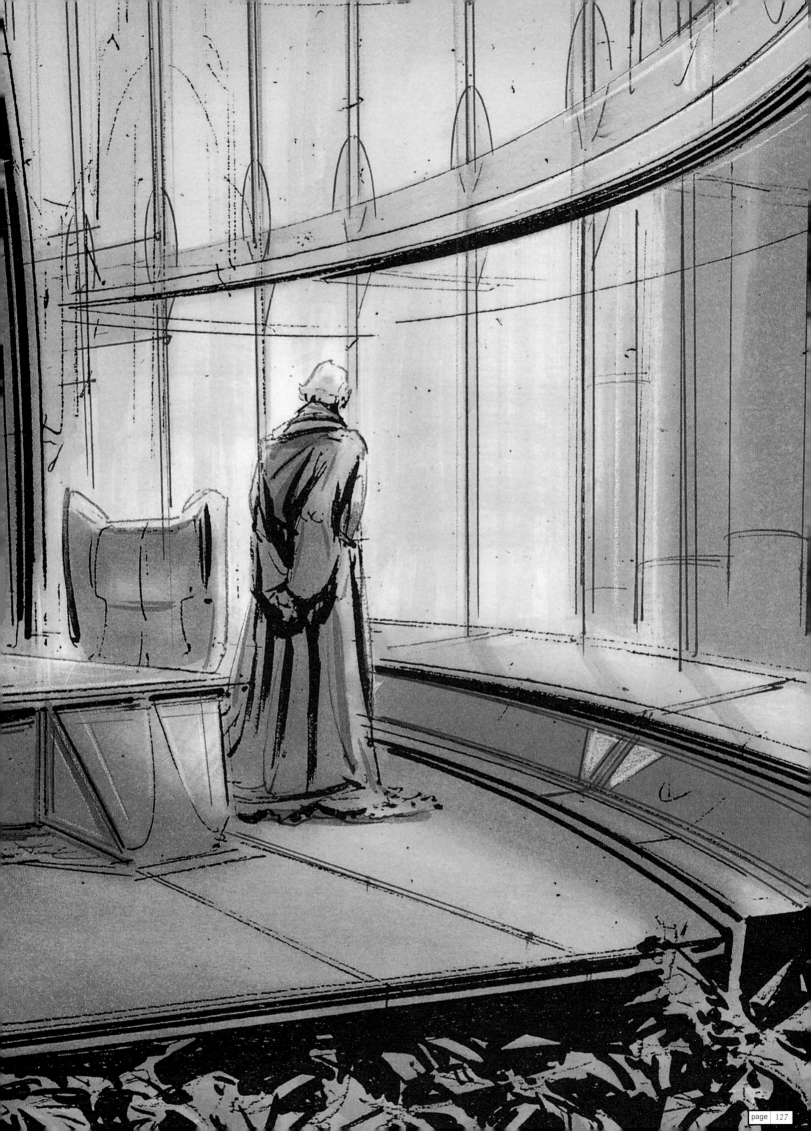

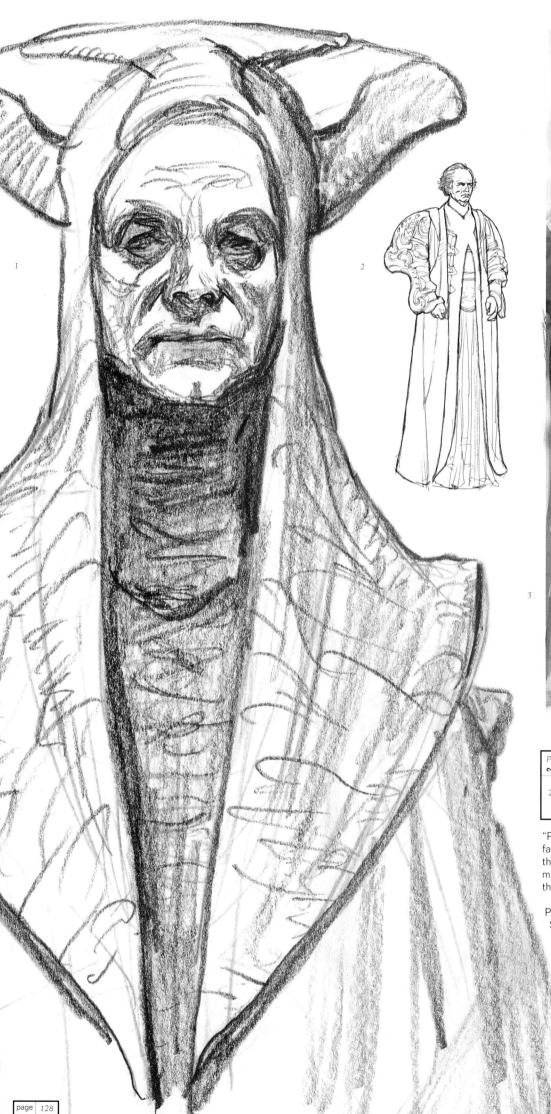

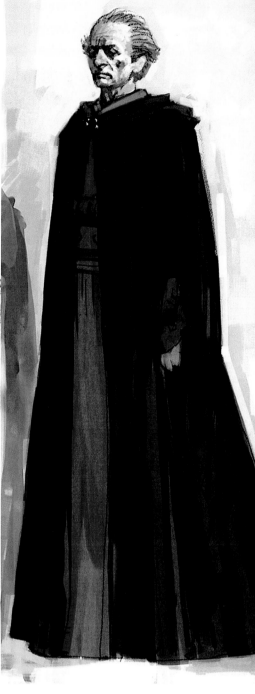

Palpatine, Aides, Desk & Chair _conceptual designs_		scene/s: 008
1	Iain McCaig	
2, 3, 8-10	Dermot Power	
4-7	Ravi Bansal	
11	Jay Shuster	
		128

"Palpatine's face is showing signs of the Emperor's facial markings," McCaig revealed. "The idea is that the evil inside him is corrupting his flesh. This is the missing link between [the prequel character] and the Emperor from the original films."

Palpatine's homeland of Naboo is reflected in Jay Shuster's baroque design of the desk at which the Chancellor confers with shrouded confidants. "In this drawing, I wasn't thinking of Palpatine as evil, but I suppose it's a subconscious thing," Shuster observed. "This image of him surrounded by his peons, hooded like Druids, does give a weird, ominous feeling of him being in control."

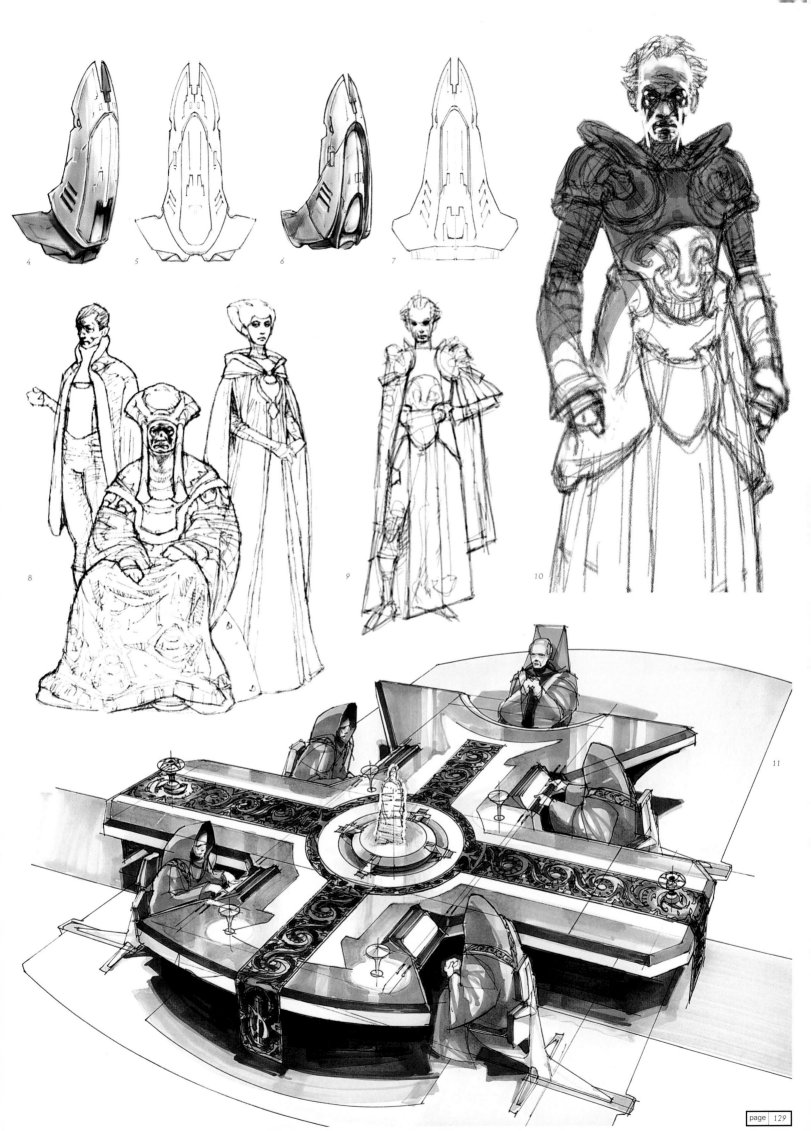

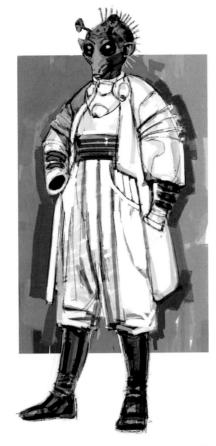

In his drawings of Palpatine in conference, Natividad lit the scene to enhance the sinister atmosphere. Lucas had specifically requested that color be added to the drawing. "George said, 'Let's make the conference room red, like the Imperial Guards.' So I just added an Imperial Guard to the image," said Natividad, noting that the artwork sets up the future appearance of the Emperor's loyal, red-robed warrior elite in *Return of the Jedi*. "We're seeing Palpatine become more evil, but the people around him are shady, as well."

The designs of Palpatine's offices and quarters went through many iterations, with Lucas having his concept artists keep to uncluttered, "cleared space" designs, as Natividad put it. The spaces would be shadowy and hint at the consolidation of evil intentions through such effects as this lit conference table set in a darkened room [2]. "The table becomes the main light source," Natividad explained. "By underlighting, the faces of the people seated around the table look more sinister."

3

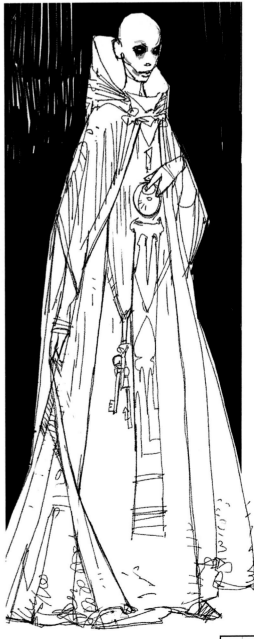

4

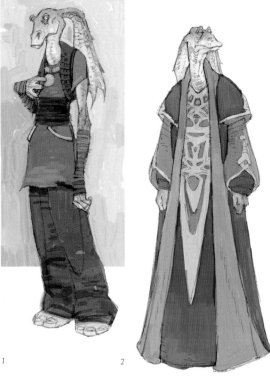

Jar Jar Binks and Palpatine's Offices
conceptual designs

		scene/s: 008/012
1, 2	Dermot Power	
3, 4	Kurt Kaufman	
5, 6	Gavin Bocquet (design) &	
	Caine Dickinson (3-D render)	132

The Gungan Jar Jar Binks becomes an unwitting dupe of larger political forces, proposing to the Senate that Palpatine be granted "emergency powers." Palpatine accepts, solemnly assuring that he will honor the democratic process. In the original script, it was decided that Jar Jar, notable in Episode I for his garbled Gungan-speak, would speak in an articulate "diplodialect" befitting his new stature as a member of the Galactic Representative Commission. That idea was dropped, with Binks giving his Senate speech in his normal Gungan dialect.

1

2

3

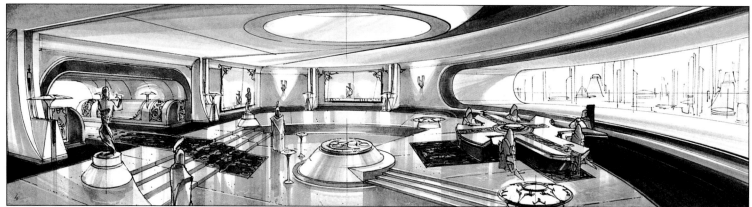

4

5

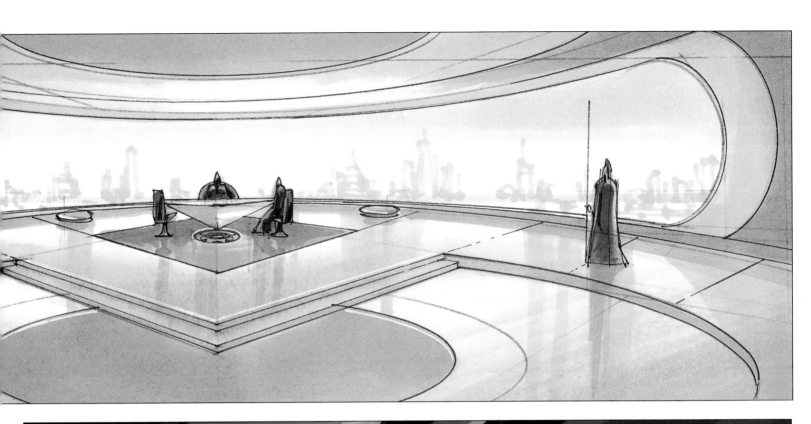

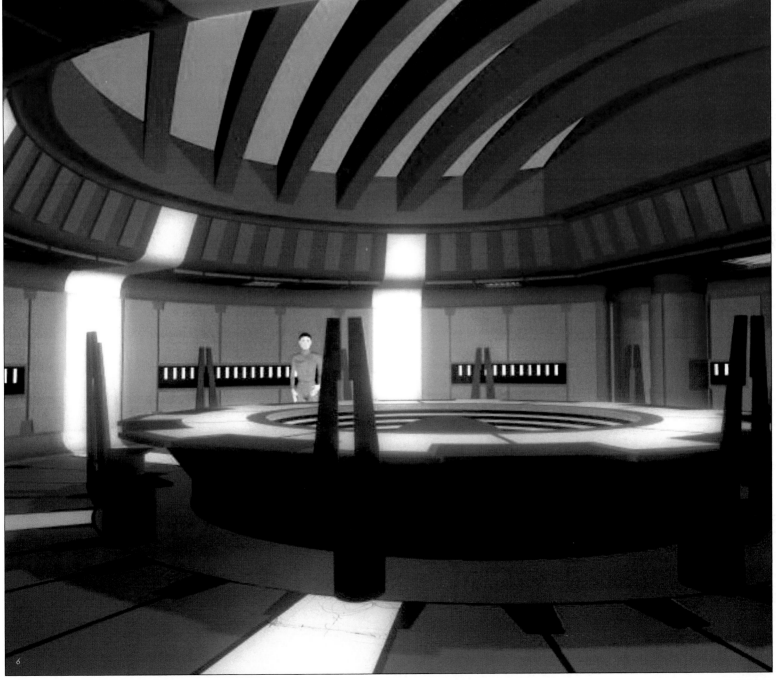

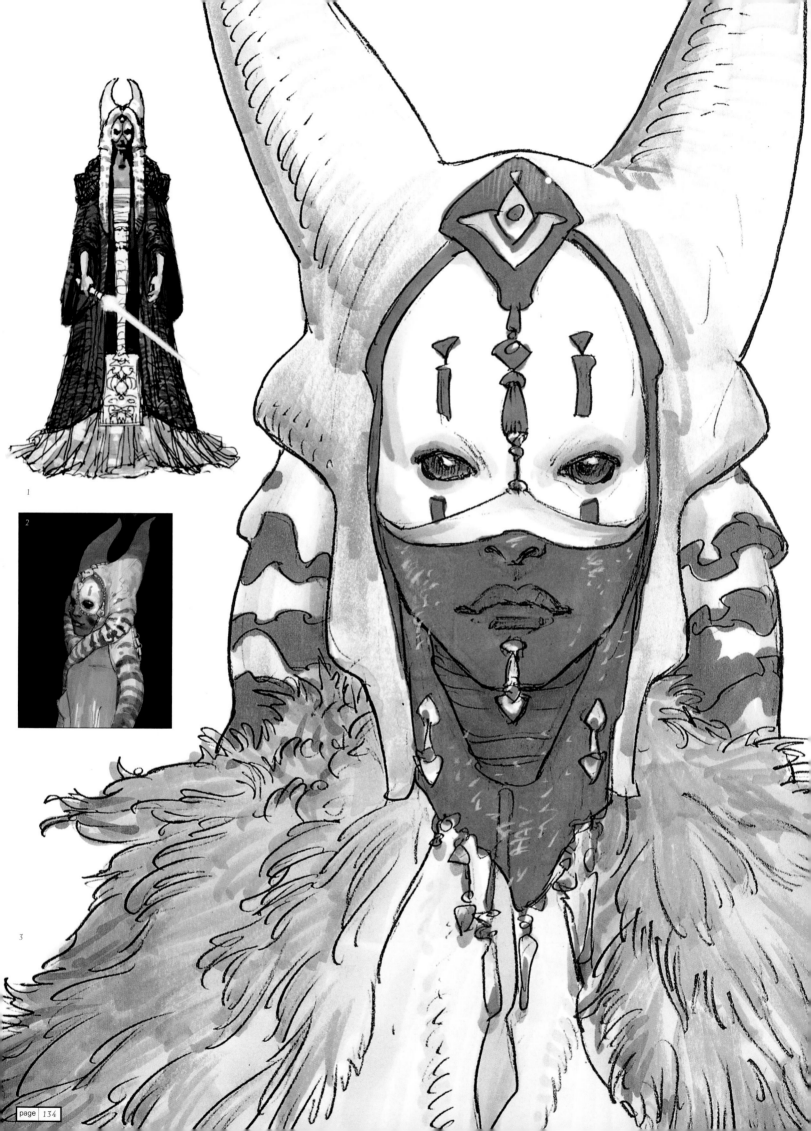

1

2

3

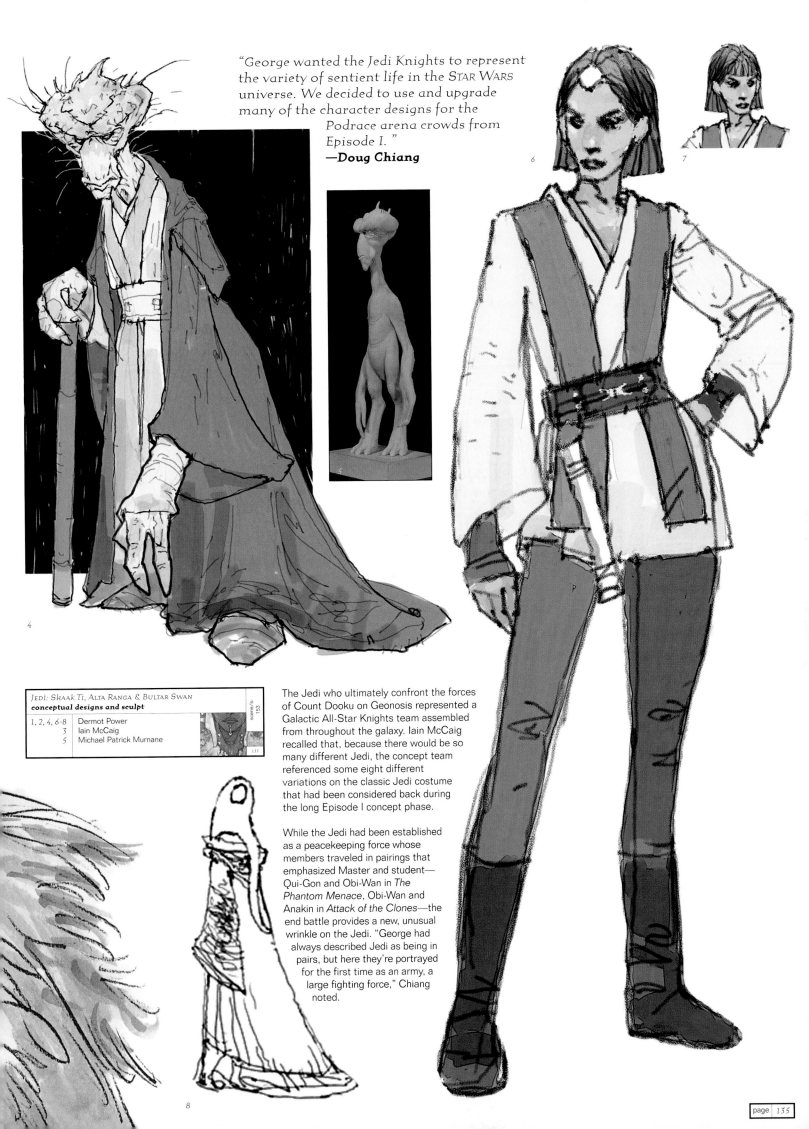

"George wanted the Jedi Knights to represent the variety of sentient life in the STAR WARS universe. We decided to use and upgrade many of the character designs for the Podrace arena crowds from Episode I."
—Doug Chiang

The Jedi who ultimately confront the forces of Count Dooku on Geonosis represented a Galactic All-Star Knights team assembled from throughout the galaxy. Iain McCaig recalled that, because there would be so many different Jedi, the concept team referenced some eight different variations on the classic Jedi costume that had been considered back during the long Episode I concept phase.

While the Jedi had been established as a peacekeeping force whose members traveled in pairings that emphasized Master and student—Qui-Gon and Obi-Wan in *The Phantom Menace*, Obi-Wan and Anakin in *Attack of the Clones*—the end battle provides a new, unusual wrinkle on the Jedi. "George had always described Jedi as being in pairs, but here they're portrayed for the first time as an army, a large fighting force," Chiang noted.

JEDI: SHAAK TI, ALTA RANGA & BULTAR SWAN conceptual designs and sculpt	
1, 2, 4, 6-8	Dermot Power
3	Iain McCaig
5	Michael Patrick Murnane

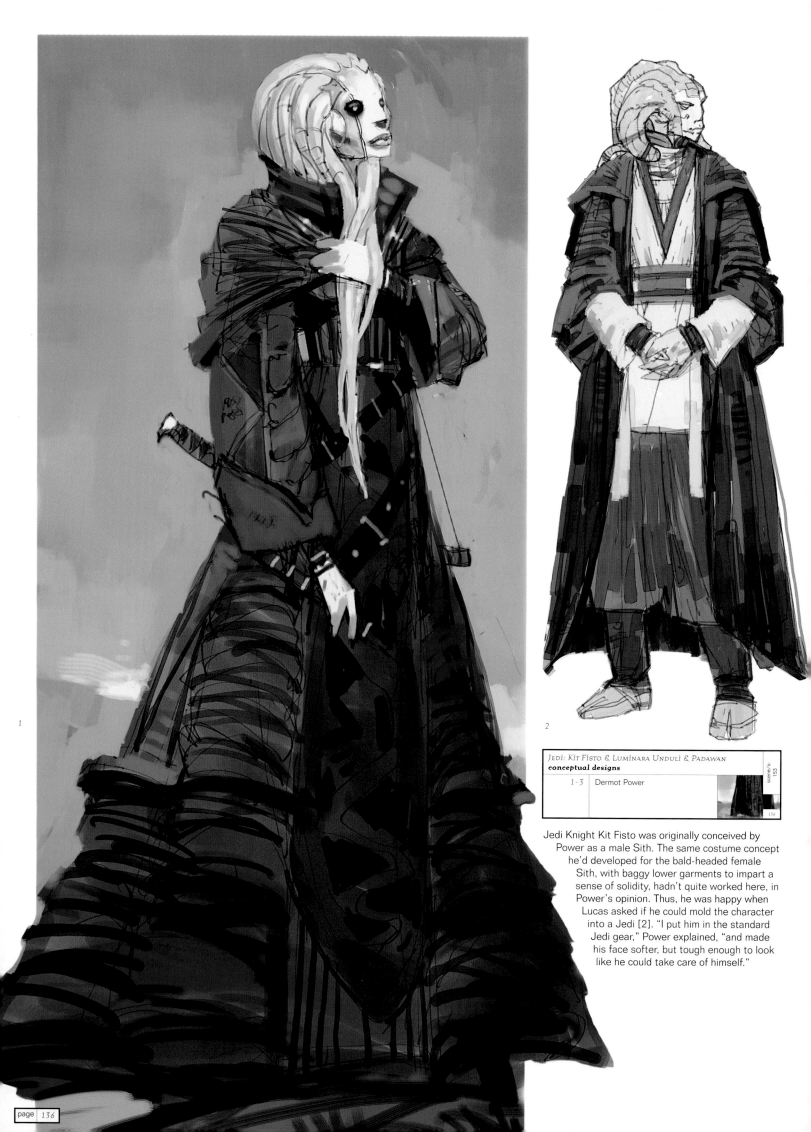

Jedi: Kit Fisto & Luminara Unduli & Padawan		scene/s: 153
conceptual designs		
1-3	Dermot Power	
		136

Jedi Knight Kit Fisto was originally conceived by Power as a male Sith. The same costume concept he'd developed for the bald-headed female Sith, with baggy lower garments to impart a sense of solidity, hadn't quite worked here, in Power's opinion. Thus, he was happy when Lucas asked if he could mold the character into a Jedi [2]. "I put him in the standard Jedi gear," Power explained, "and made his face softer, but tough enough to look like he could take care of himself."

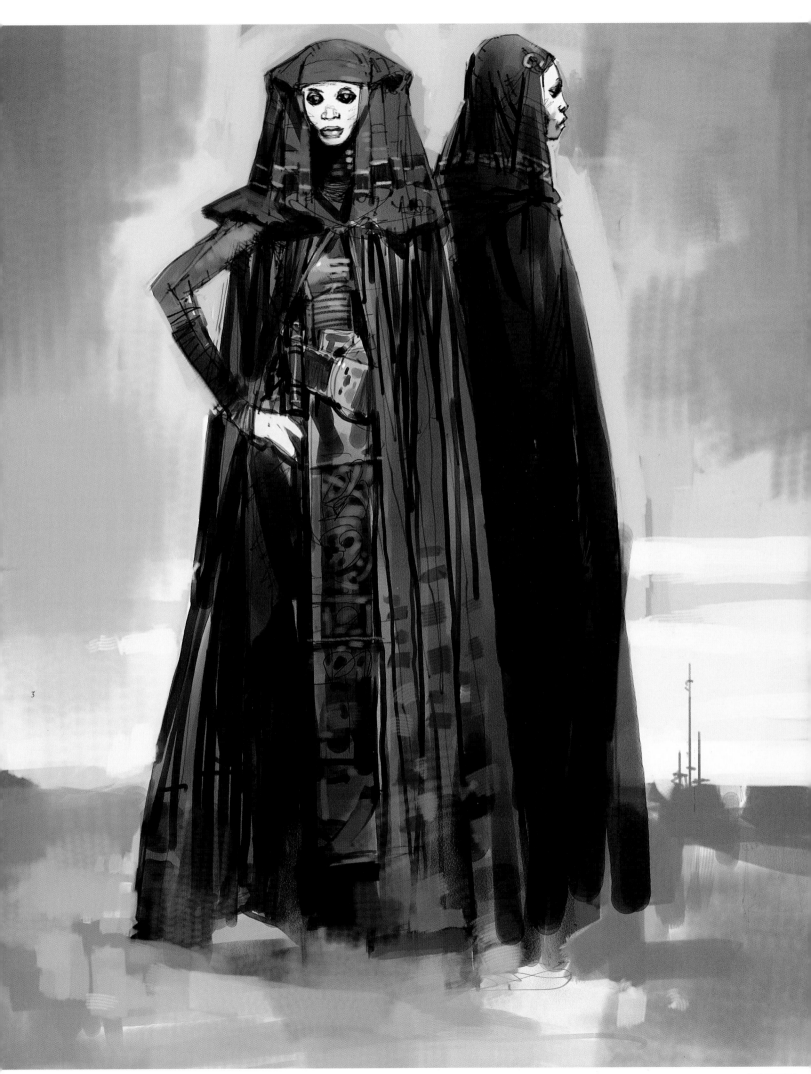

3

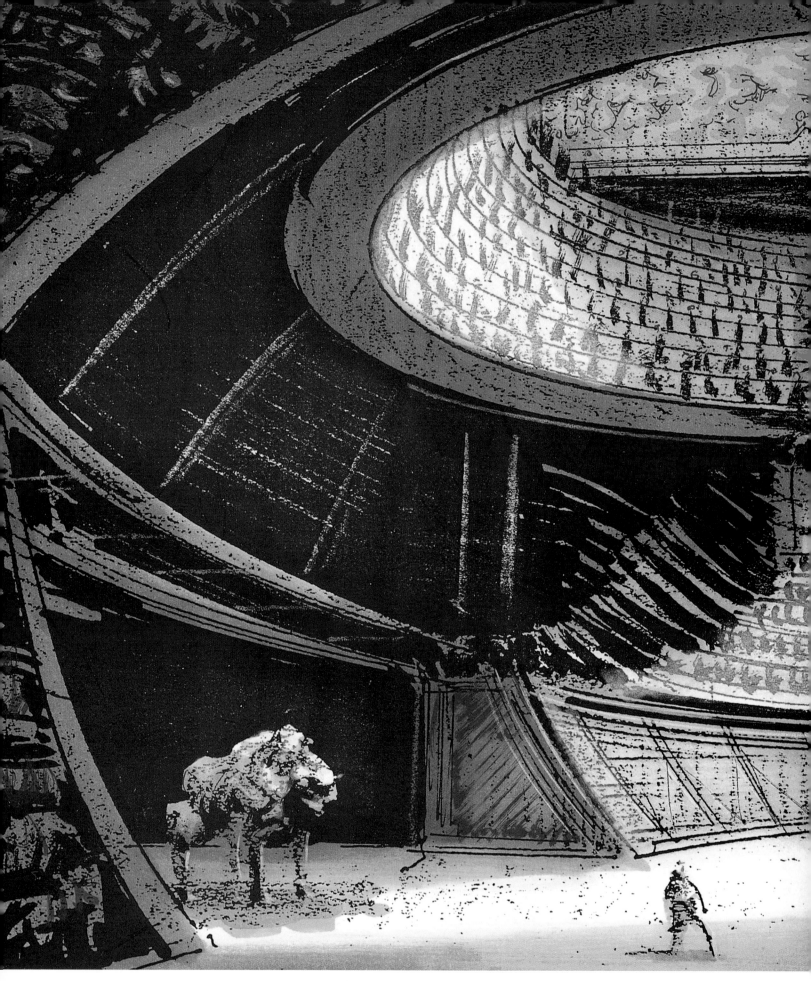

In ancient Rome, the use of ferocious, exotic beasts as an integral part of triumphal games reportedly began in 167 B.C., when Aemilus Paullus, after defeating Perseus, ordered army deserters crushed by elephants. That notion—victims thrown to wild animals in the sporting arena—is a haunting image that still resonates with primal ferocity. *Attack of the Clones* returns to the theme in the Geonosian arena where Obi-Wan, Anakin, and Padmé have been condemned by Count Dooku to face the monsters of the arena.

The arena concept—like no gladiatorial stage ever seen on Earth—was a seminal work that Lucas kept referencing during the its development from sketches to sculpture. The initial goal, Natividad

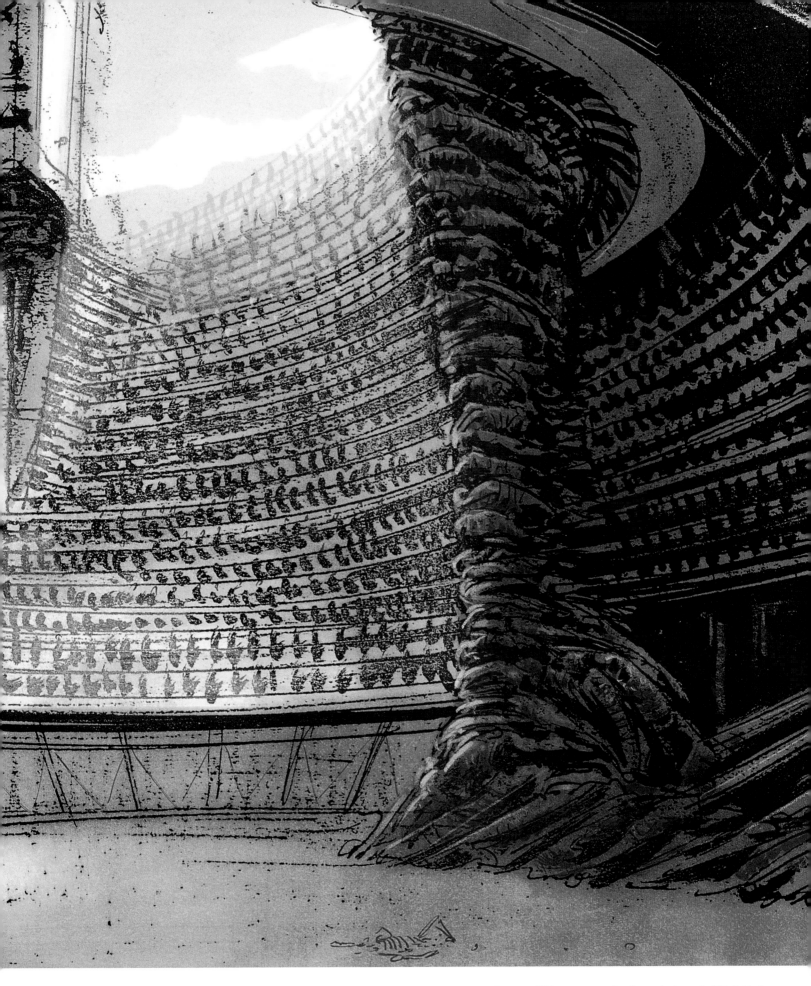

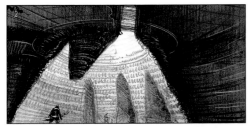

recalled, was to be expansive, avoiding the confines of the pit in which Luke Skywalker fought the rancor monster in *Return of the Jedi*. Natividad followed the architectural precedent of a planet where dwellings and structures were carved out of natural rock formations.

"This was more of a shape study, really," Natividad explained, "an ellipse cutting into the sky instead of just creating an oval arena shape. The look was part of the mood, too, of this natural arena. Light enters in certain places and leaves other areas in darkness, such as this victim caught in a spotlight of light, with the arena creature waiting more in darkness."

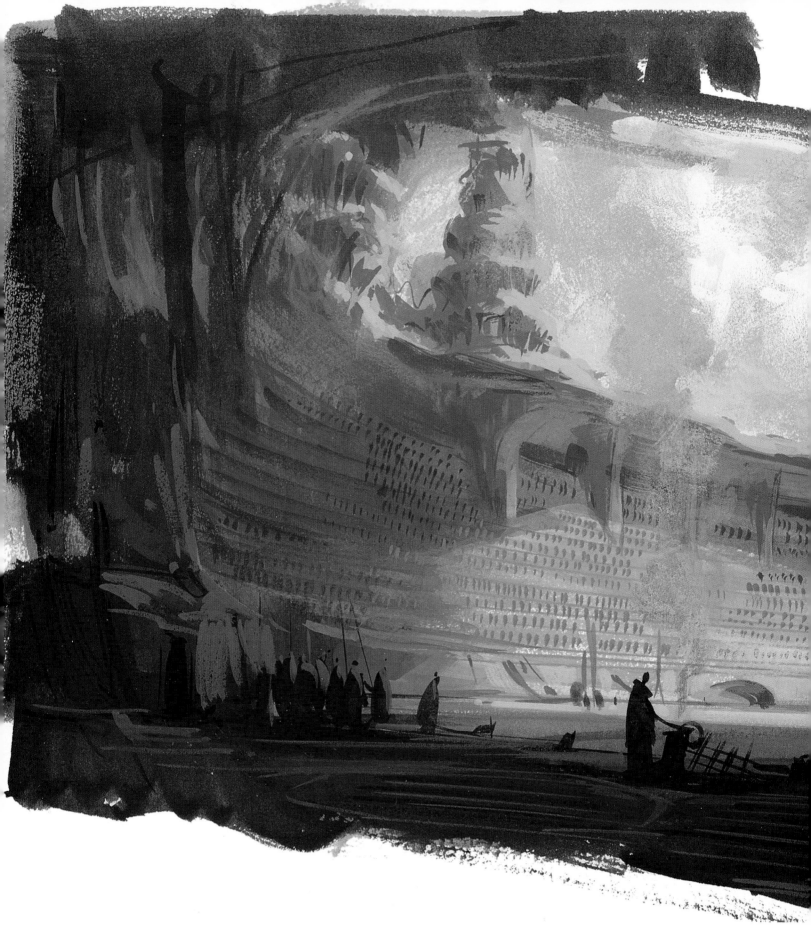

GEONOSIAN ARENA
conceptual designs and model

1	Erik Tiemens	
2, 3	R. Kim Smith & Carol Bauman	

scene/s 152

140

This Erik Tiemens painting was one of the first interiors used to explore the contrasts between sunlight and shadows at a certain time of day in the arena. As such, the dark figures glimpsed far left

and right are there to study scale, not to represent Geonosian gladiators. "This was just exploring the form, the feeling of a place carved out of rock," Tiemens explained.

While Tiemens's study was inspired by the early Natividad sketches, he based most of his reference on the elaborate model developed by Carol Bauman and R. Kim Smith. The final sculpted foam model was so detailed it could have been shot for the film, and was an impressive reference at four feet wide

and almost six feet tall. "So much was logistical about the arena," modeler Bauman said. "We first made a small version for George to approve, then the larger one, made of three pieces. It was like doing the limbo to get that model into the Friday meetings."

Bauman and Smith noted that another of their models, comprised of the arena's sky opening [2], reminded them of spun-sugar Easter egg windows—

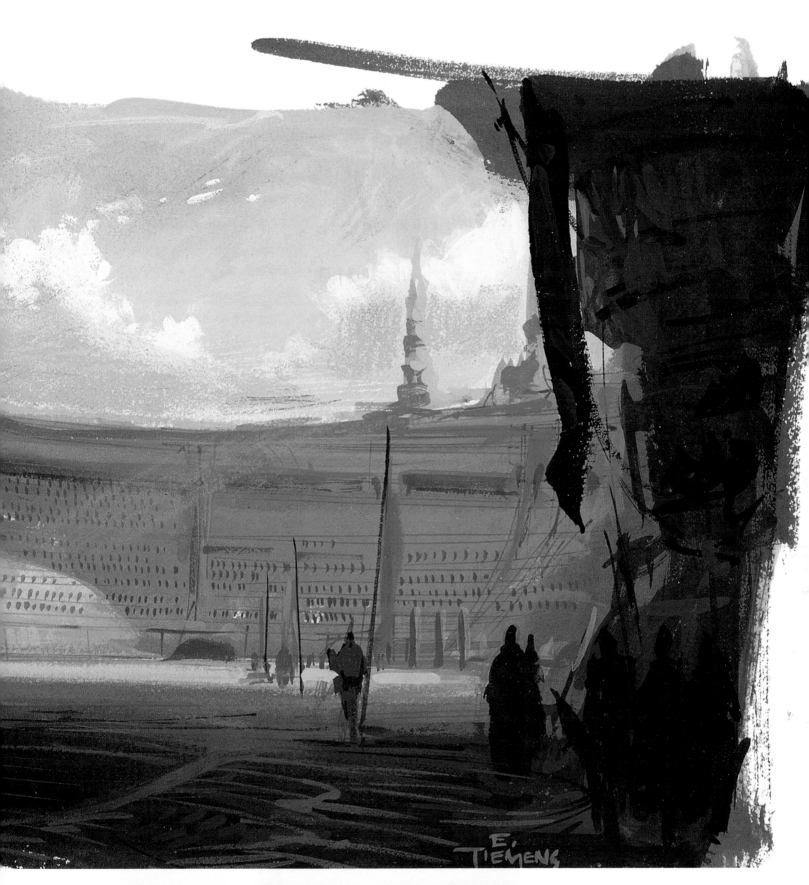

so much so that they dressed out the interior with grass and chicks and brought it to a Friday meeting, much to the surprise and delight of Lucas and the assembled artists. (The arena model also reminded Smith of Yankee Stadium, she said, but she didn't get around to her plan to transform it into a baseball field.)

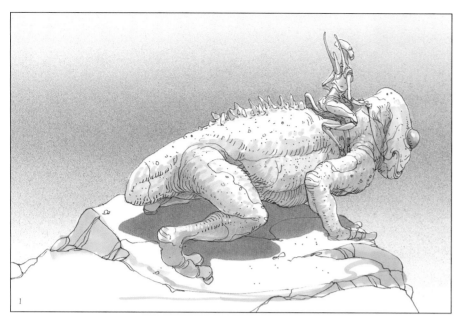

1

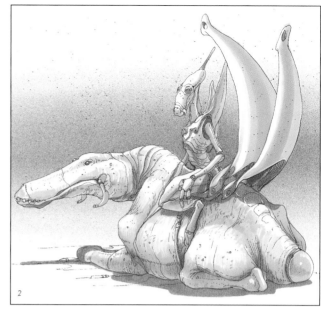

2

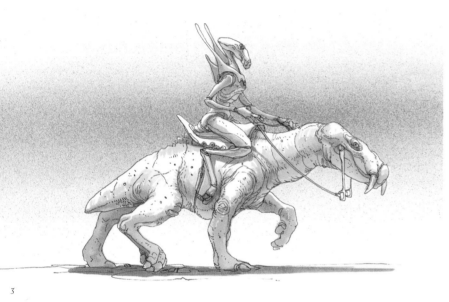

3

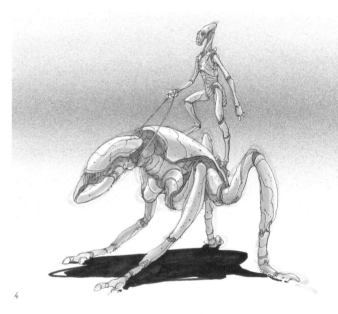

4

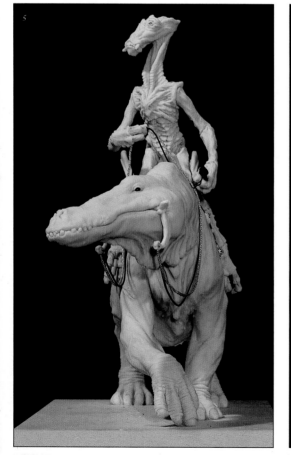

5

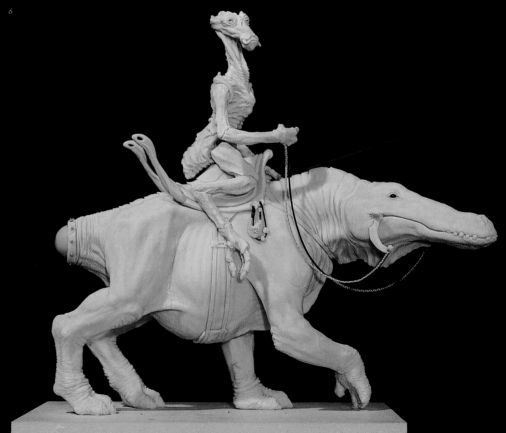

6

ORRAY, EXECUTION CART & ARENA BOX
conceptual designs and sculpts

1-4	Doug Chiang
5, 6, 8, 9	Michael Patrick Murnane
7, 10	Edwin Natividad

scene/s: 151/152

143

While the initial designs of the fierce orray were adapted to the lizardlike massiff, the idea of an orray creature remained, but its nature changed. Although still ridden by picadors into the arena, the ferocious creature was replaced by the hulking beast of burden pictured in conceptual designs and sculpts [1–6, 8–9].

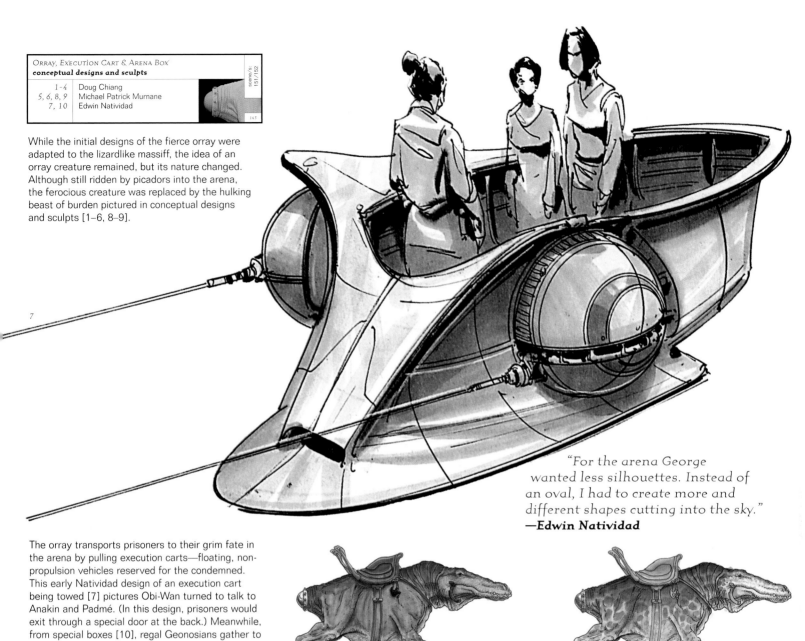

7

"For the arena George wanted less silhouettes. Instead of an oval, I had to create more and different shapes cutting into the sky."
—**Edwin Natividad**

The orray transports prisoners to their grim fate in the arena by pulling execution carts—floating, non-propulsion vehicles reserved for the condemned. This early Natividad design of an execution cart being towed [7] pictures Obi-Wan turned to talk to Anakin and Padmé. (In this design, prisoners would exit through a special door at the back.) Meanwhile, from special boxes [10], regal Geonosians gather to enjoy a better view of the blood sport in store.

8

9

10

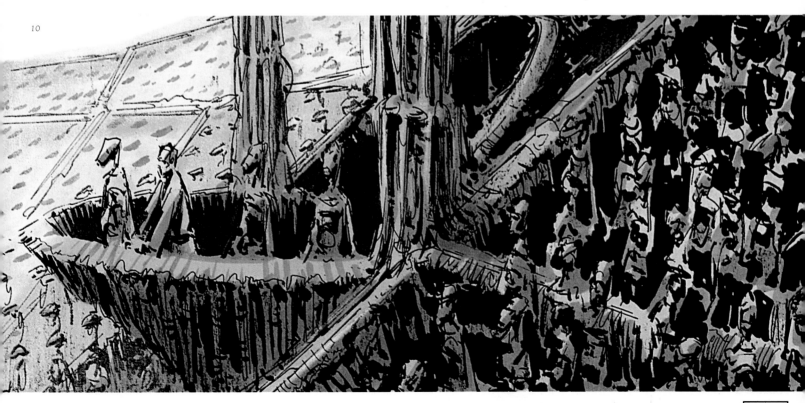

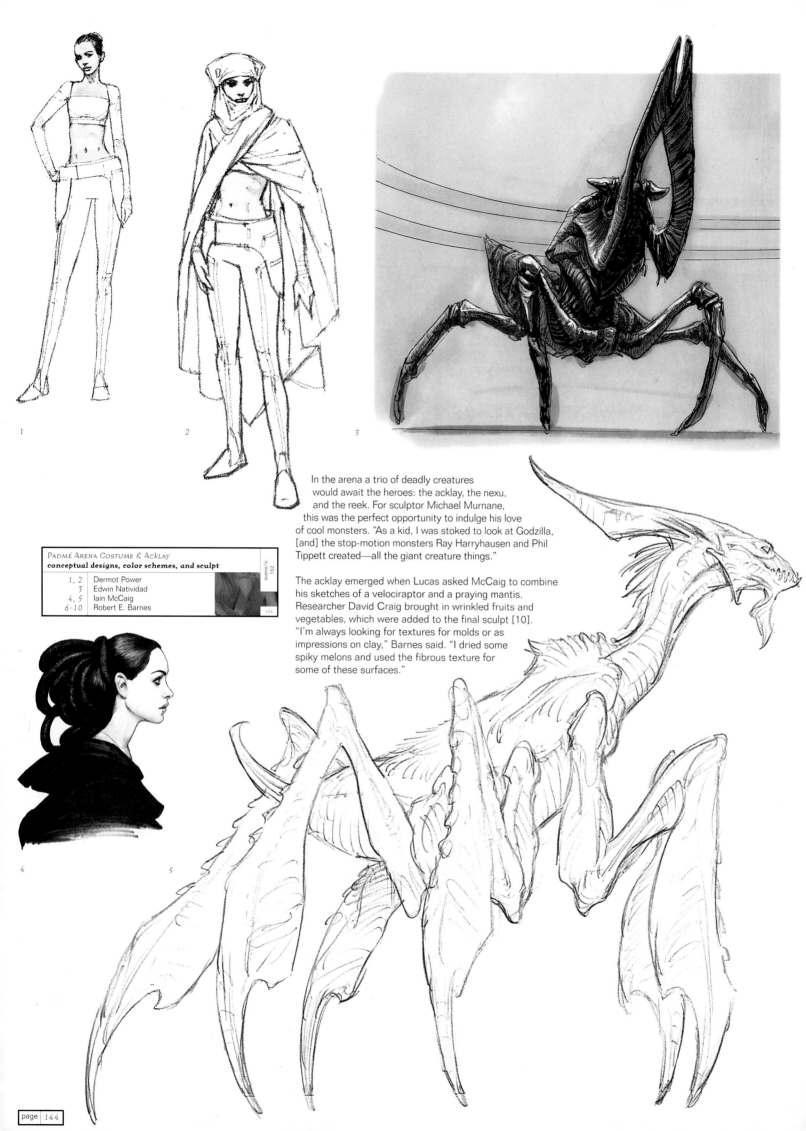

1 2 3

In the arena a trio of deadly creatures
would await the heroes: the acklay, the nexu,
and the reek. For sculptor Michael Murnane,
this was the perfect opportunity to indulge his love
of cool monsters. "As a kid, I was stoked to look at Godzilla,
[and] the stop-motion monsters Ray Harryhausen and Phil
Tippett created—all the giant creature things."

The acklay emerged when Lucas asked McCaig to combine
his sketches of a velociraptor and a praying mantis.
Researcher David Craig brought in wrinkled fruits and
vegetables, which were added to the final sculpt [10].
"I'm always looking for textures for molds or as
impressions on clay," Barnes said. "I dried some
spiky melons and used the fibrous texture for
some of these surfaces."

PADMÉ ARENA COSTUME & ACKLAY
conceptual designs, color schemes, and sculpt

1, 2	Dermot Power
3	Edwin Natividad
4, 5	Iain McCaig
6-10	Robert E. Barnes

scene/s:
152
144

4 5

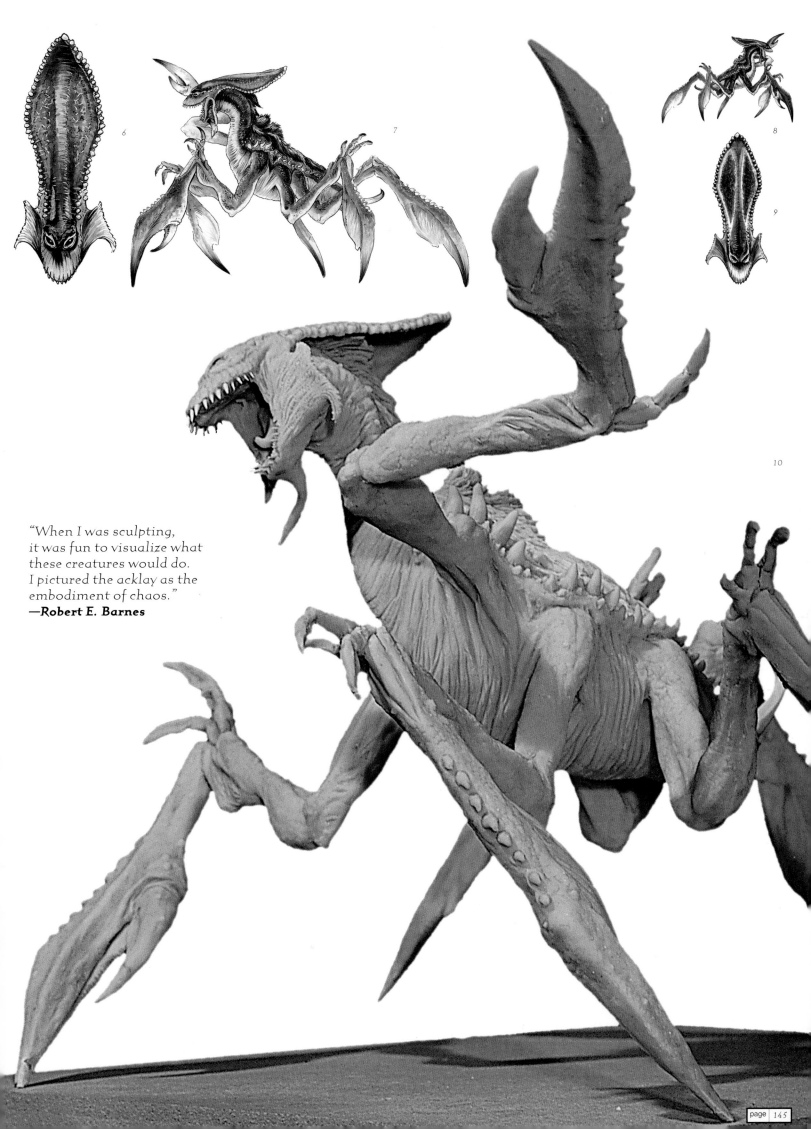

6

7

8

9

10

"When I was sculpting,
it was fun to visualize what
these creatures would do.
I pictured the acklay as the
embodiment of chaos."
—**Robert E. Barnes**

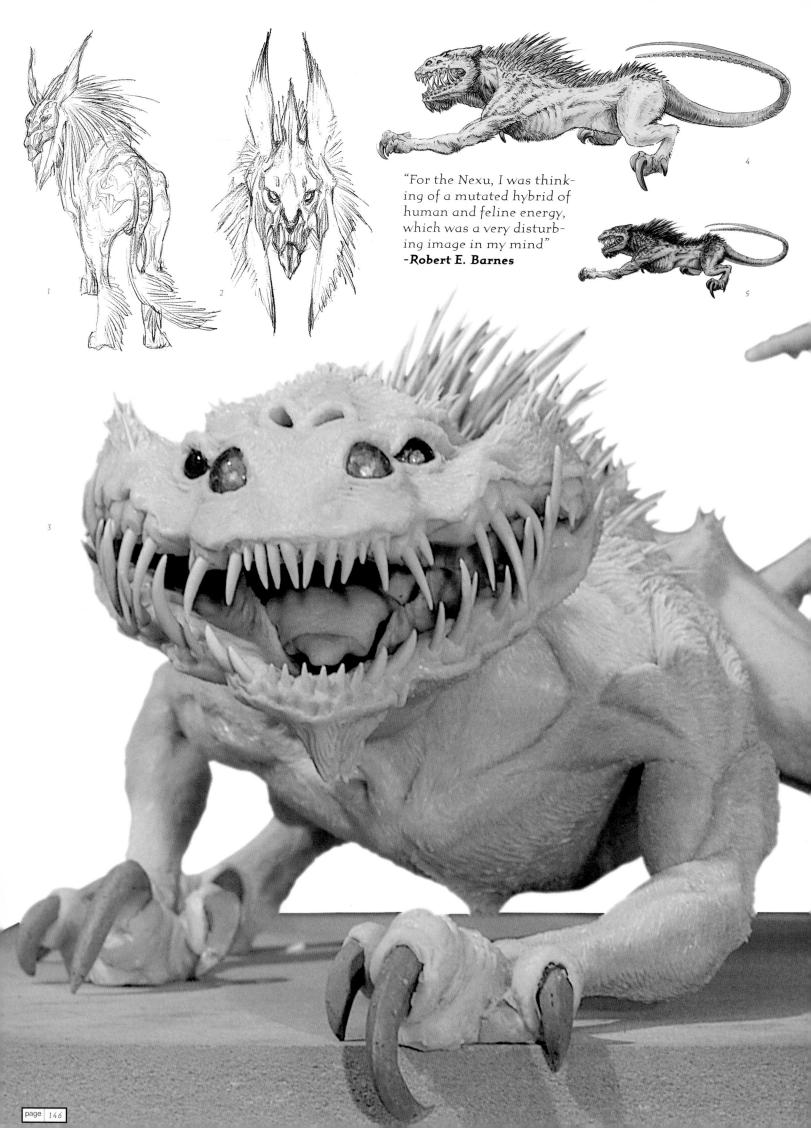

"For the Nexu, I was thinking of a mutated hybrid of human and feline energy, which was a very disturbing image in my mind"
-Robert E. Barnes

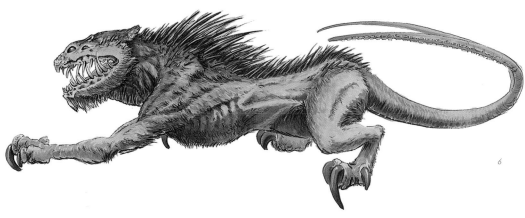

Nexu
conceptual designs, color schemes and sculpt

		scene/s:
1, 2	Iain McCaig	152
3–9	Robert E. Barnes	
8, 9	Dermot Power	
		147

Barnes was developing a lionlike creature when he realized that Lucas wanted a *feeling*, not a literal translation. Once a head design was approved, Barnes began developing the nexu body. Since it would be a climbing creature, Barnes added splayed, primate arms and gigantic claws to the final model.

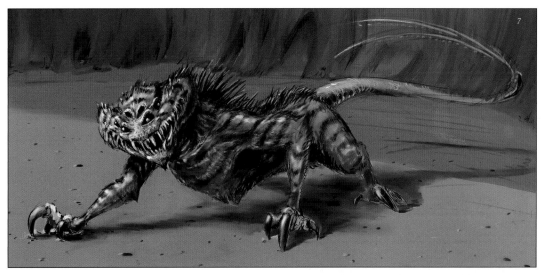

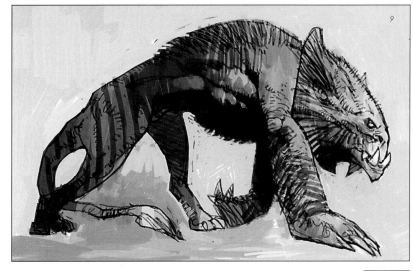

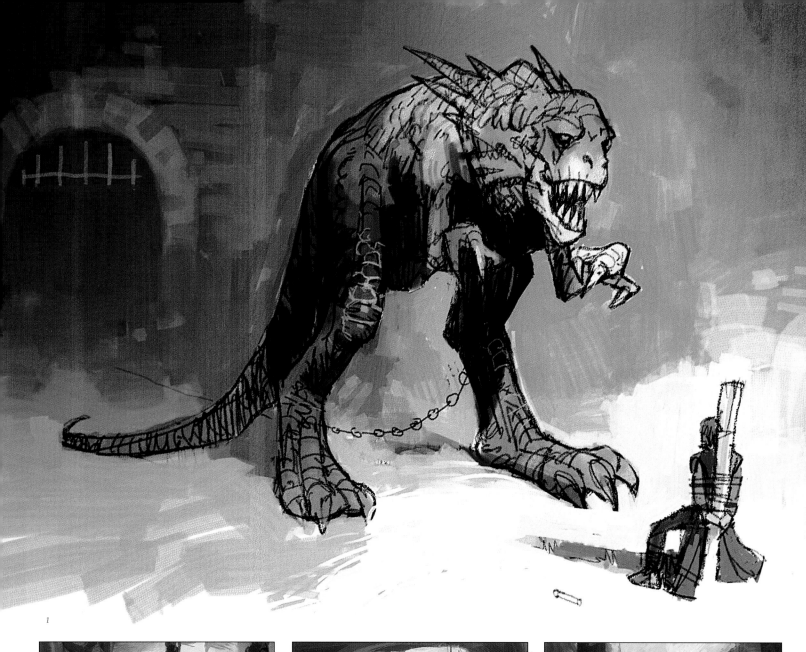

1

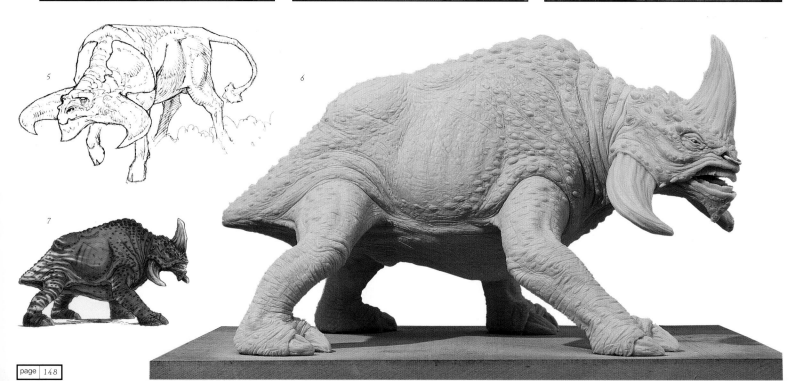

2 3 4

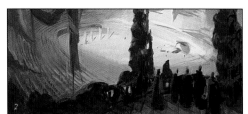

5

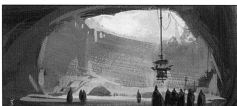

6

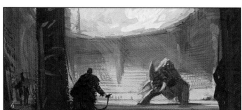

7

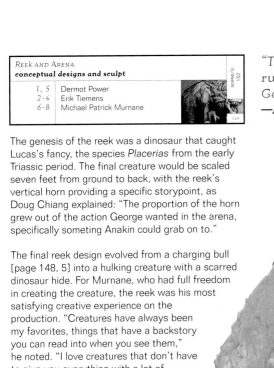

REEK AND ARENA
conceptual designs and sculpt

1, 5	Dermot Power
2–4	Erik Tiemens
6–8	Michael Patrick Murnane

scene/s: 152

149

"The reek's been beaten up pretty good, he's run into walls, one of his horns has damage. George said, 'I like this guy, he's different.'"
—**Michael Patrick Murnane**

The genesis of the reek was a dinosaur that caught Lucas's fancy, the species *Placerias* from the early Triassic period. The final creature would be scaled seven feet from ground to back, with the reek's vertical horn providing a specific storypoint, as Doug Chiang explained: "The proportion of the horn grew out of the action George wanted in the arena, specifically someting Anakin could grab on to."

The final reek design evolved from a charging bull [page 148, 5] into a hulking creature with a scarred dinosaur hide. For Murnane, who had full freedom in creating the creature, the reek was his most satisfying creative experience on the production. "Creatures have always been my favorites, things that have a backstory you can read into when you see them," he noted. "I love creatures that don't have to give you everything with a lot of movements—they can just stand there."

8

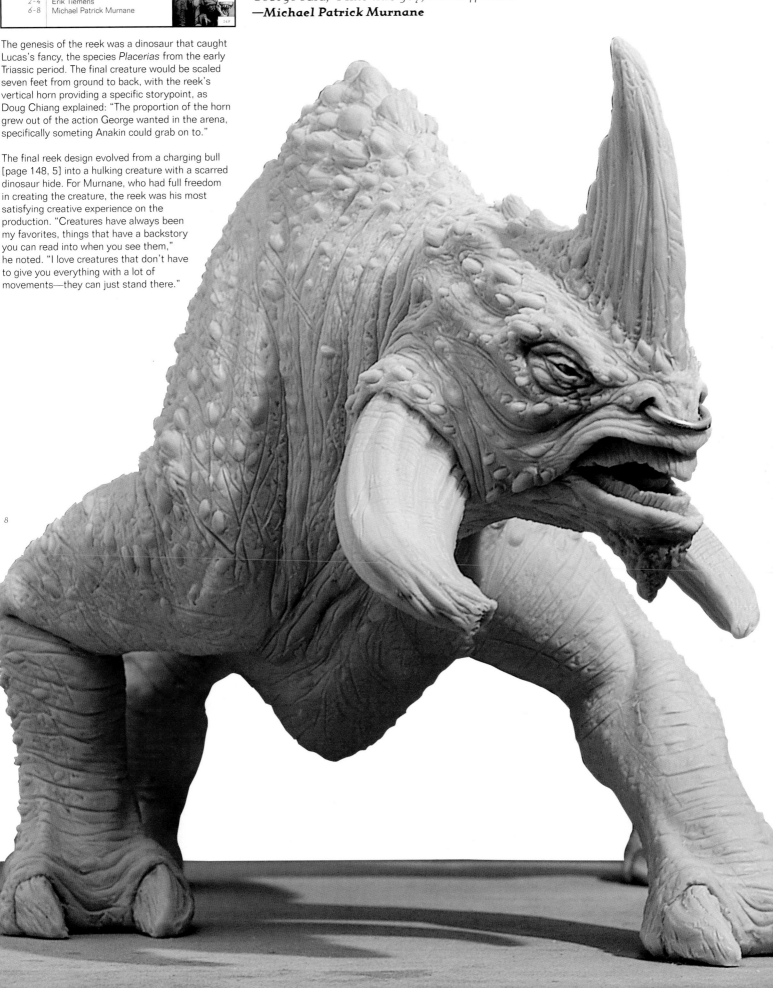

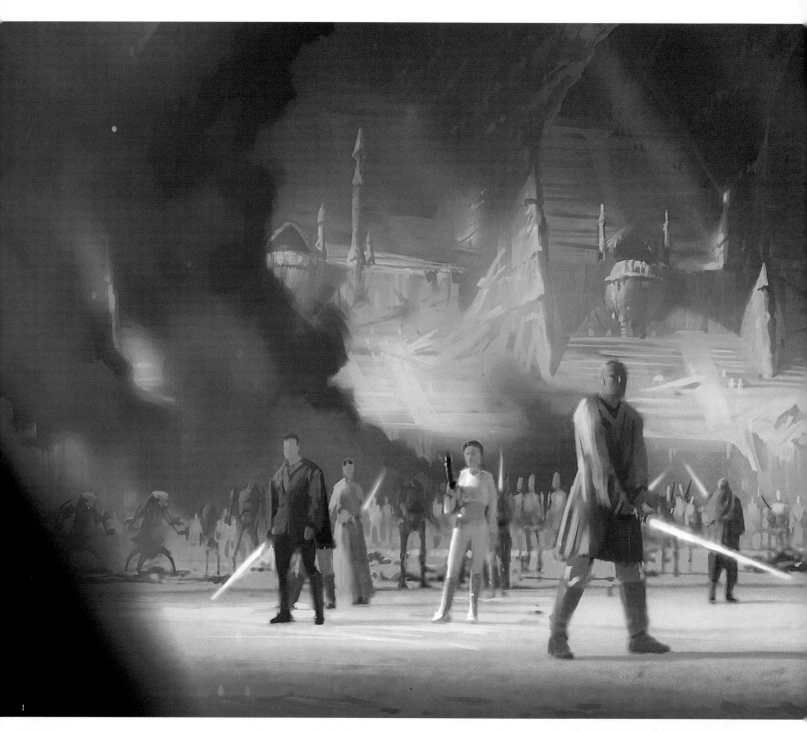

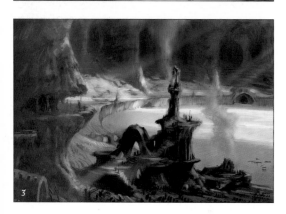

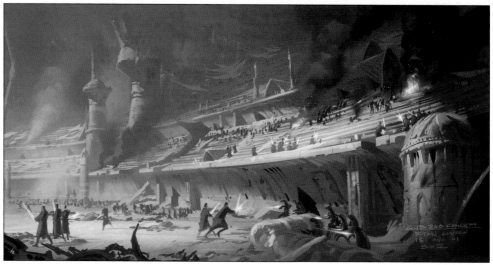

In this Ryan Church design, seen from inside a troop transport [5], clone troopers arrive to rescue Anakin, Padmé, and Obi-Wan from the arena. Note the lightsabers flashing in the battle. The Gunship with Yoda [5] arrives to save the day.

GEONOSIAN ARENA BATTLE		
conceptual designs		
1, 2, 4, 5	Ryan Church	
3	Erik Tiemens	

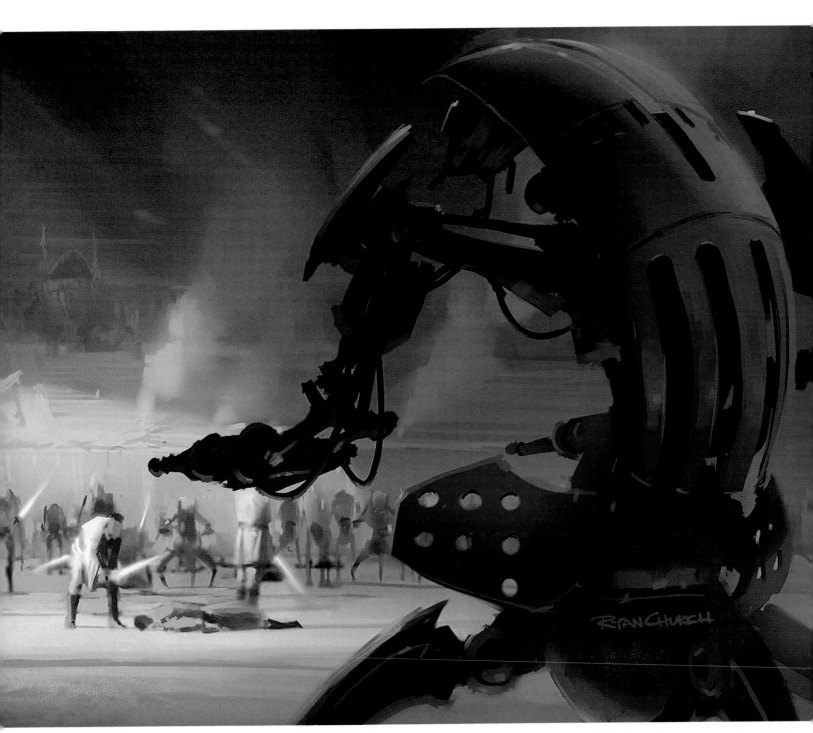

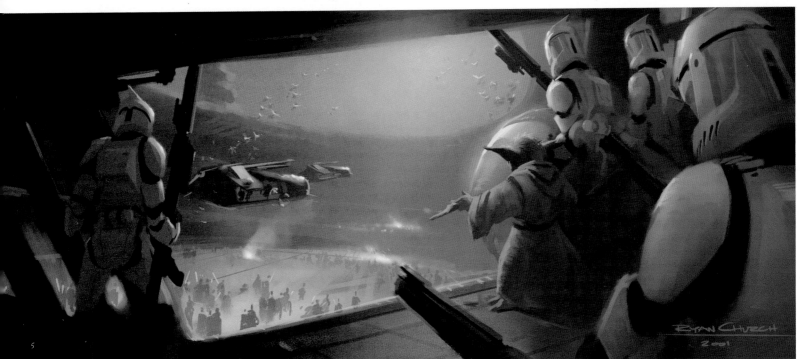

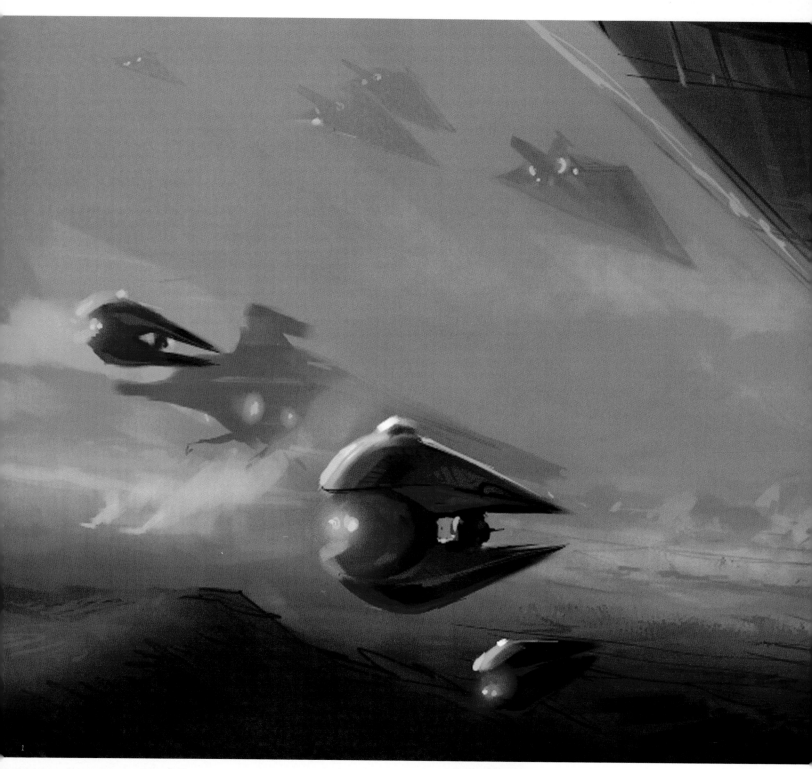

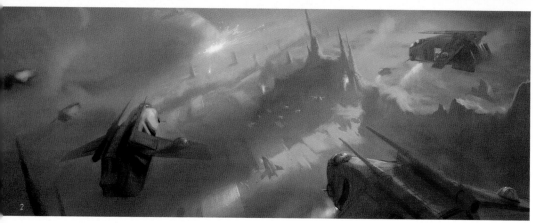

GEONOSIAN GROUND BATTLE
conceptual designs

1	Ryan Church	scene/s: 156
2, 3	Erik Tiemens	

Church and Tiemens created a total of fourteen concept paintings for the end battle—all of which Lucas approved. "These images were more improvised on our part; conceptually we kind of went crazy," Church recalled. "That they got approved by George meant we were all on the same page. At the time, the look of the end battle was still nebulous. Although the designs of these troop gunships and other things were final, this was a neat chance to compose them. Erik and I had to conceptualize what actually happens at the ground battle."

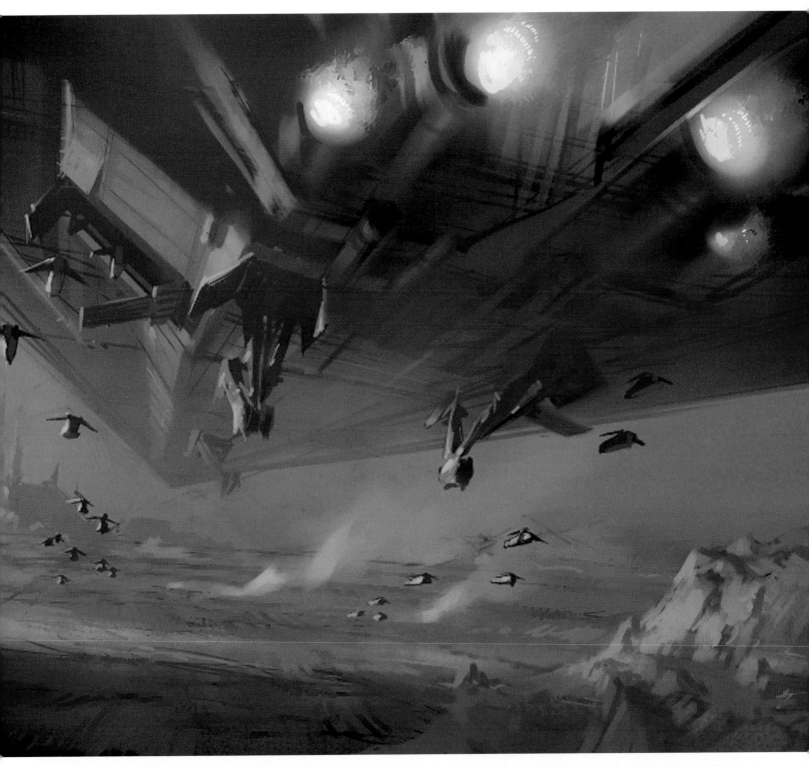

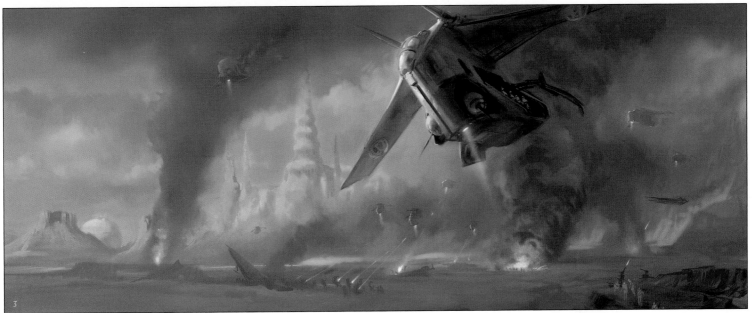

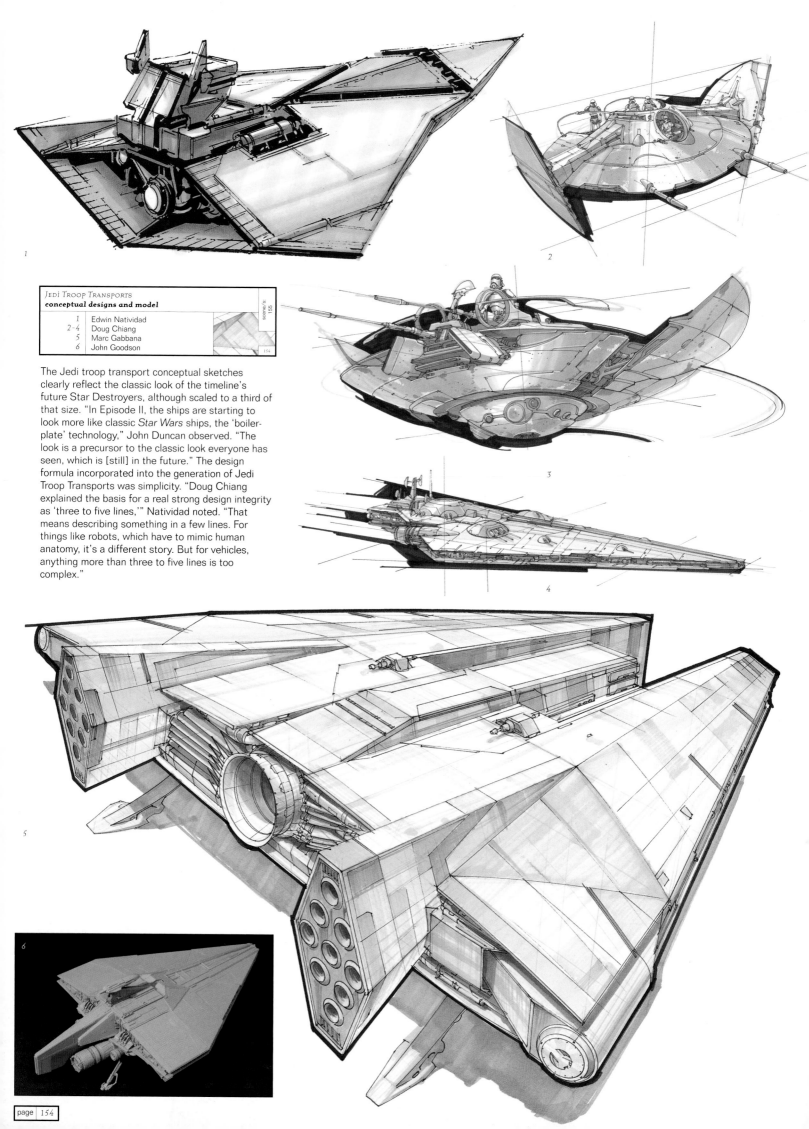

JEDI TROOP TRANSPORTS	
conceptual designs and model	
1	Edwin Natividad
2-4	Doug Chiang
5	Marc Gabbana
6	John Goodson

scene/s: 155

The Jedi troop transport conceptual sketches clearly reflect the classic look of the timeline's future Star Destroyers, although scaled to a third of that size. "In Episode II, the ships are starting to look more like classic *Star Wars* ships, the 'boiler-plate' technology," John Duncan observed. "The look is a precursor to the classic look everyone has seen, which is [still] in the future." The design formula incorporated into the generation of Jedi Troop Transports was simplicity. "Doug Chiang explained the basis for a real strong design integrity as 'three to five lines,'" Natividad noted. "That means describing something in a few lines. For things like robots, which have to mimic human anatomy, it's a different story. But for vehicles, anything more than three to five lines is too complex."

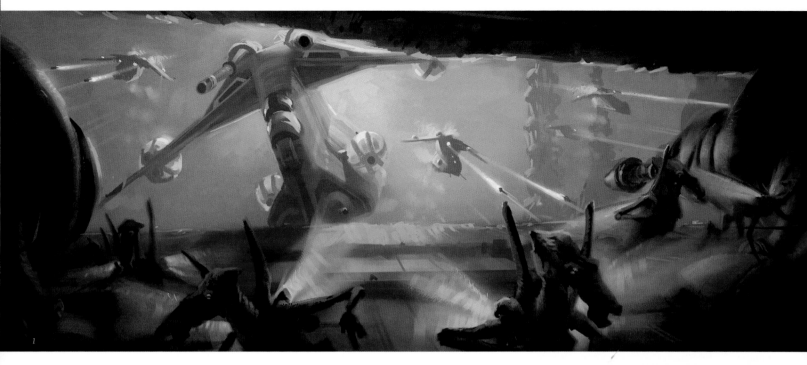

GEONOSIAN RAY GUN & ARENA EXTERIOR BATTLE SCENES		scene/s:
conceptual designs		156
1	Ryan Church	
2-5	Doug Chiang	
6	Erik Tiemans	155

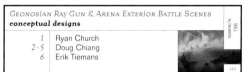

Bunkerlike openings in the stalagmitic rock towers allow for the placement of ray guns, the Geonosian version of heavy artillery and another Lucas homage to the Flash and Buck school of swashbuckling science fiction.

Indeed, a direct Flash Gordon tribute was built into the Geonosian artillery guns, based on 1950s ray-gun toys [3-5]. The guns could be positioned to fire through the slits in special Geonosian towers [2]. "I was once in George's office, and in a case he had a Flash Gordon or Buck Rogers ray gun," John Goodson recalled. "It was rusty and beat-up, but obviously dear to him."

"The first time I saw the designs for the attack helicopters, I thought they were great," Ryan Church recalled. "I think these copters are going to be as iconic as the X-wing or the Naboo starfighter. It is what it is—a *very* aggresive vehicle."

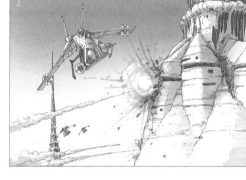

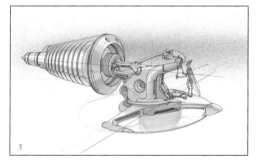

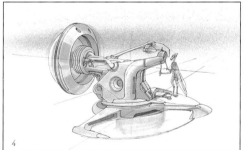

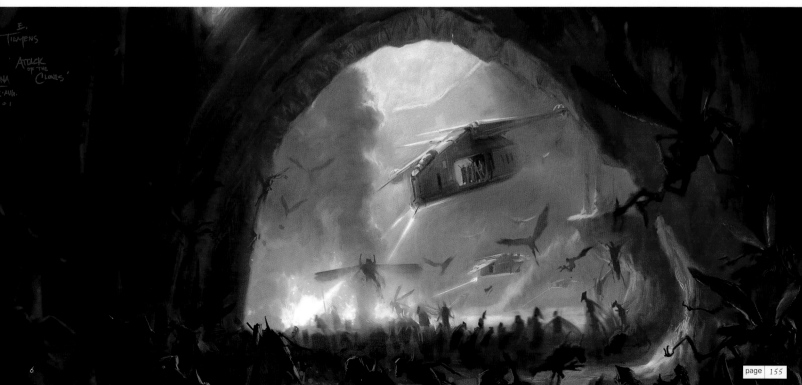

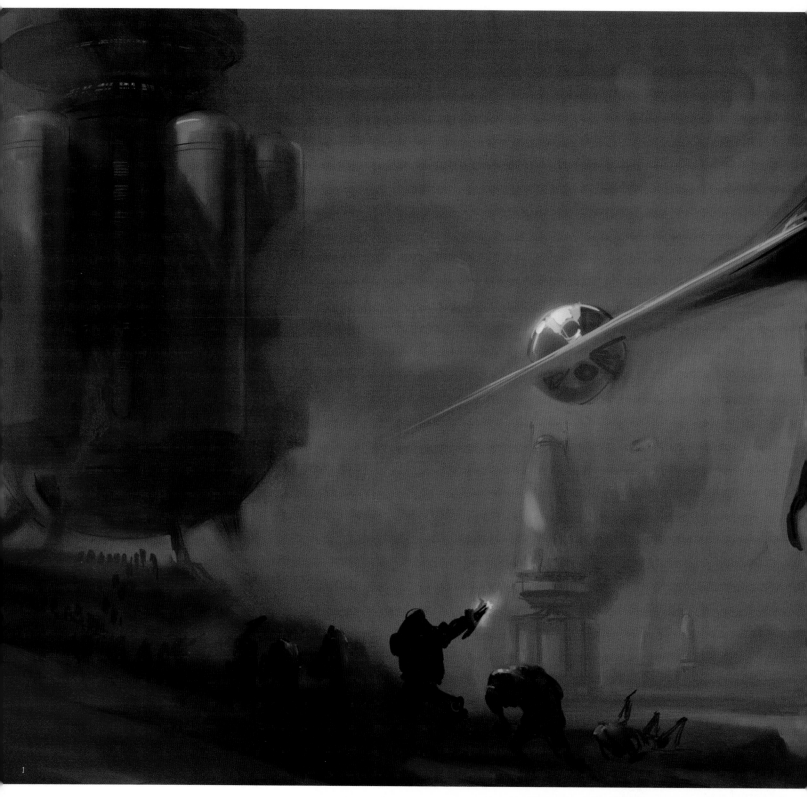

ARENA EXTERIOR BATTLE SCENES
conceptual designs

1	Erik Tiemens
2, 3	Doug Chiang

Concept illustrations ranged from clone troopers "having a quiet moment before all the chaos," Chiang observed [3], to images of chaos unleashed. Tiemens envisioned a gunship blasting through, with Battle Droids on the ground firing back (note the Techno Guild ship at left and the shadow of the arena in the background). This Tiemens painting was used in the rough cut of the film, a template for the eventual image that would be realized by ILM.

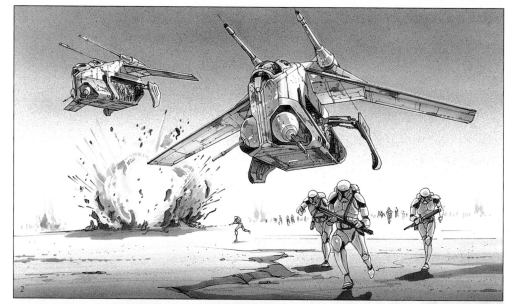

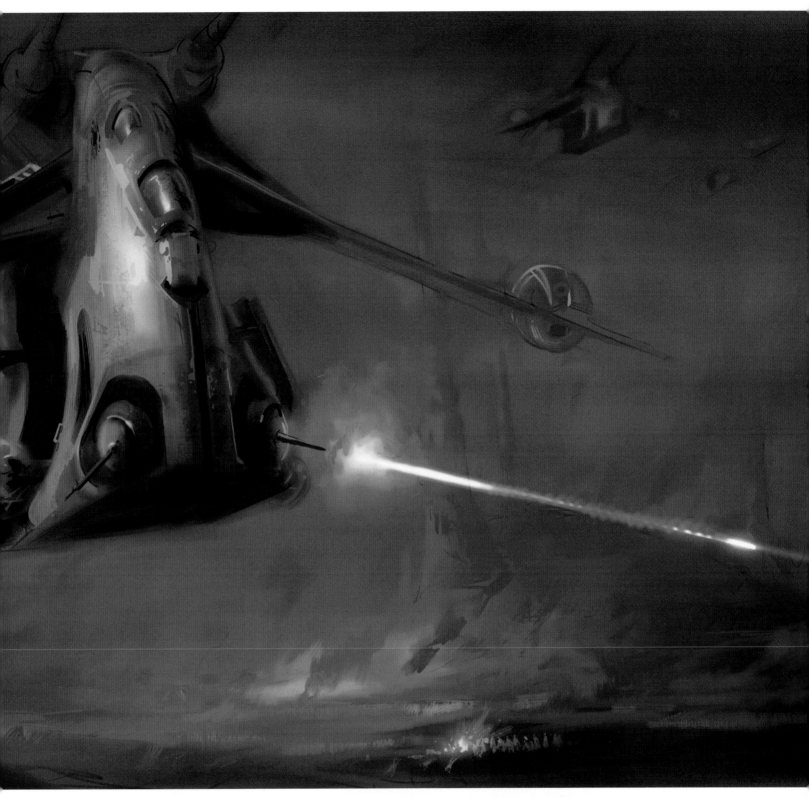

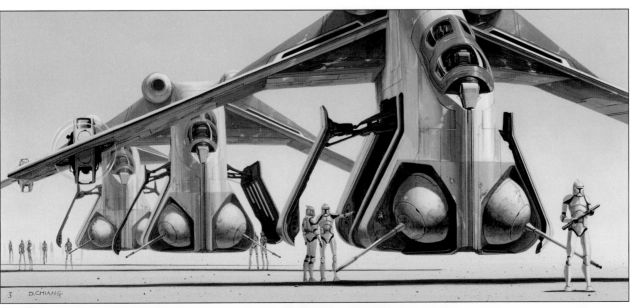

3 D.CHIANG

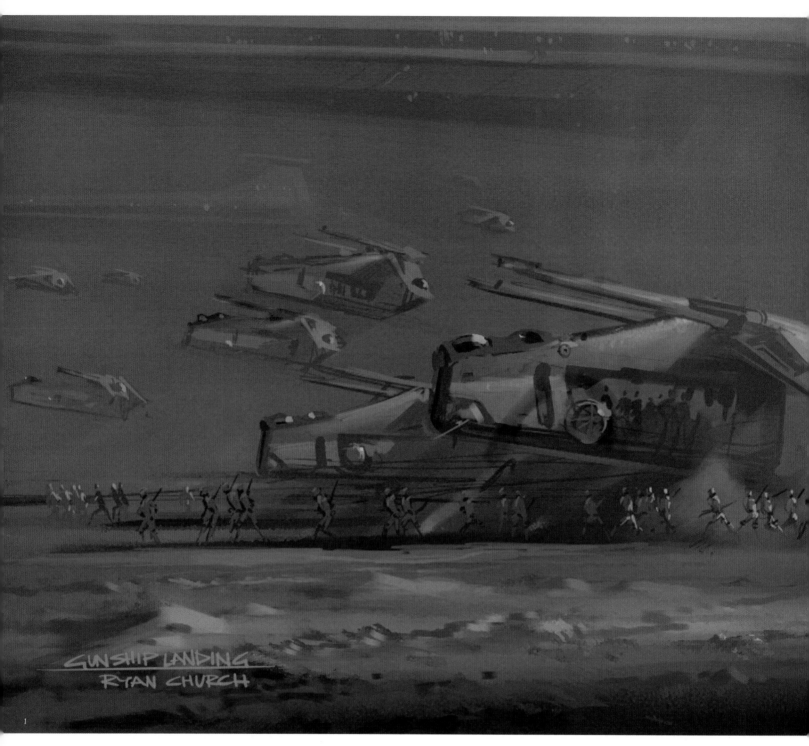

GUNSHIP LANDING
RYAN CHURCH

1

FINAL BATTLE
conceptual designs

1, 3	Ryan Church	
2	Doug Chiang	

scene/s:
160/167

158

The final battle of Episode II, which foreshadows the conflagration of the Clone Wars, pits clone troopers hatched for service to the Republic against the Battle Droids manufactured for the coalition led by Count Dooku.

This Ryan Church concept illustration of clone troopers off-loading [1] was inspired by a rough animatic that cut together clips of war footage showing artillery and landing combat helicopters. This is much the same approach Lucas took in designing the Rebel attack on the Death Star in *A New Hope*, inspired by classic aerial combat footage.

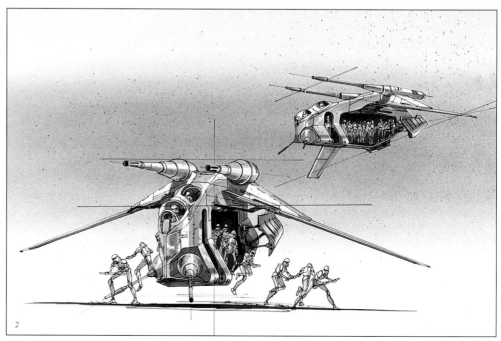

2

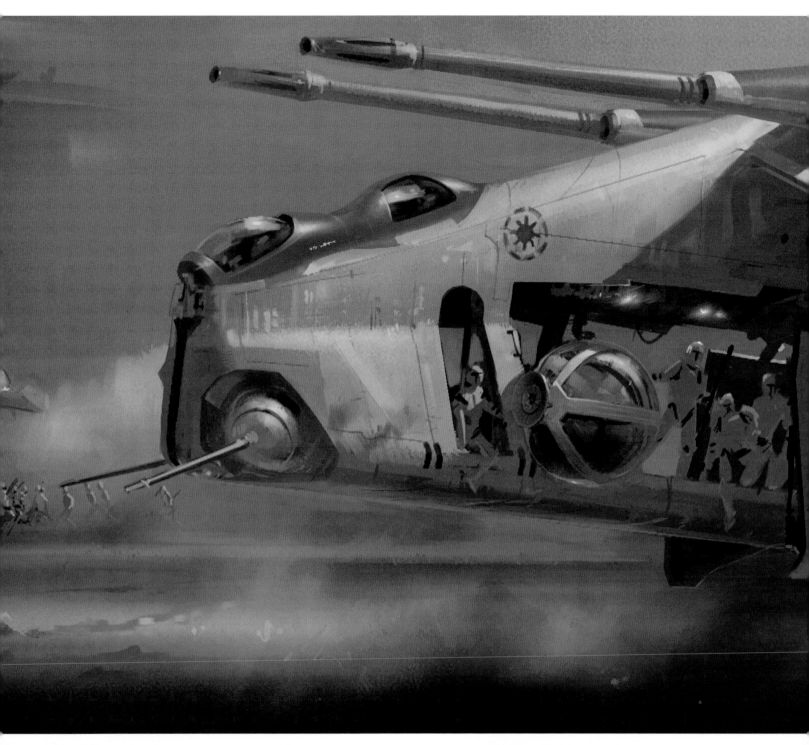

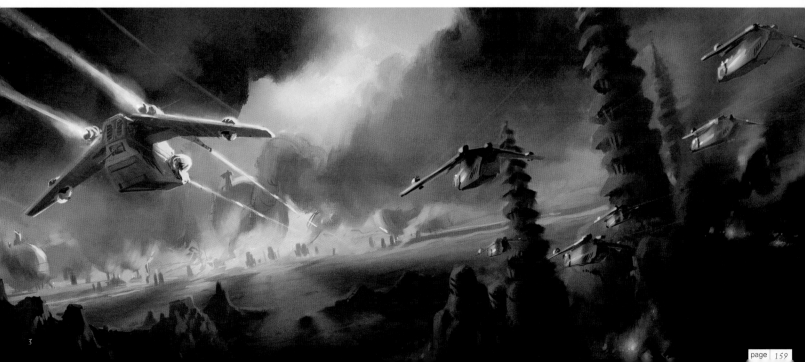

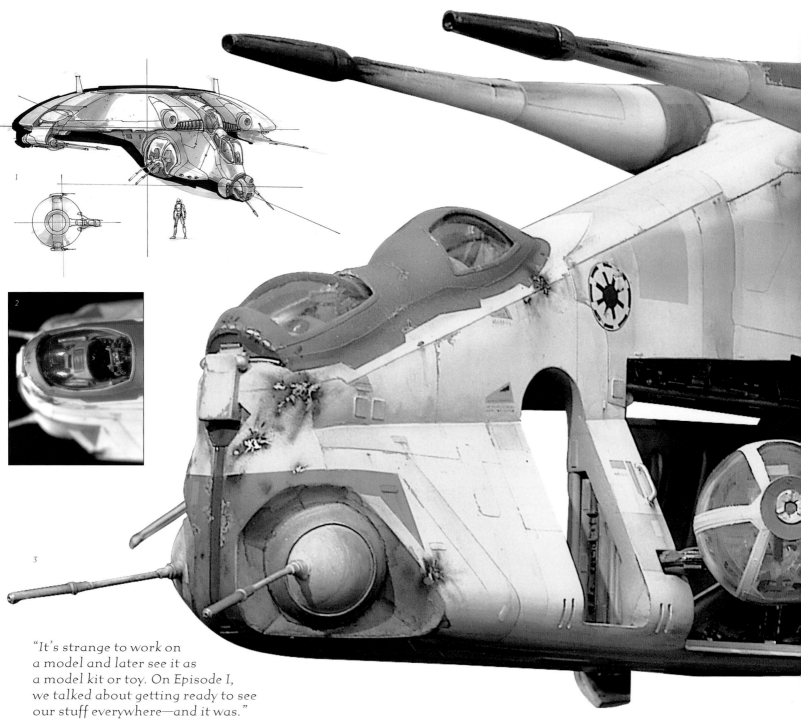

"It's strange to work on a model and later see it as a model kit or toy. On Episode I, we talked about getting ready to see our stuff everywhere—and it was."
—**John Goodson**

Jedi Gunship		scene/s:
conceptual designs and model		155/169
1, 4, 5 7, 8	Doug Chiang	
2, 3, 6	John Goodson (model) & R. Kim Smith (paints)	160

The Jedi gunships show the battered look of the classic "used universe" design aesthetic. "George wanted these to be helicopterlike flying vehicles," Chiang said. "Nothing clicked until we went with a TIE fighter–ish look."

"You can take any shape and put the right visual cues on it, and it becomes one of these [Star Wars] vehicles," Goodson noted. "There are stories about how on the first films, Joe Johnston went around with a chisel he called the Editor, and if he didn't like your detailing on a model he'd knock it off the ship."

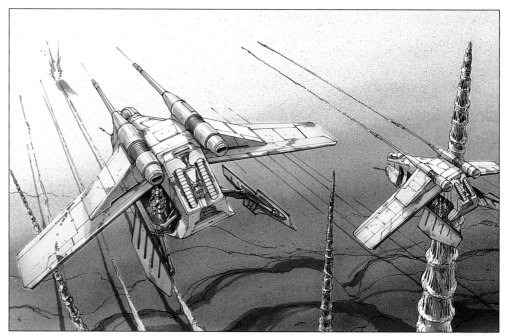

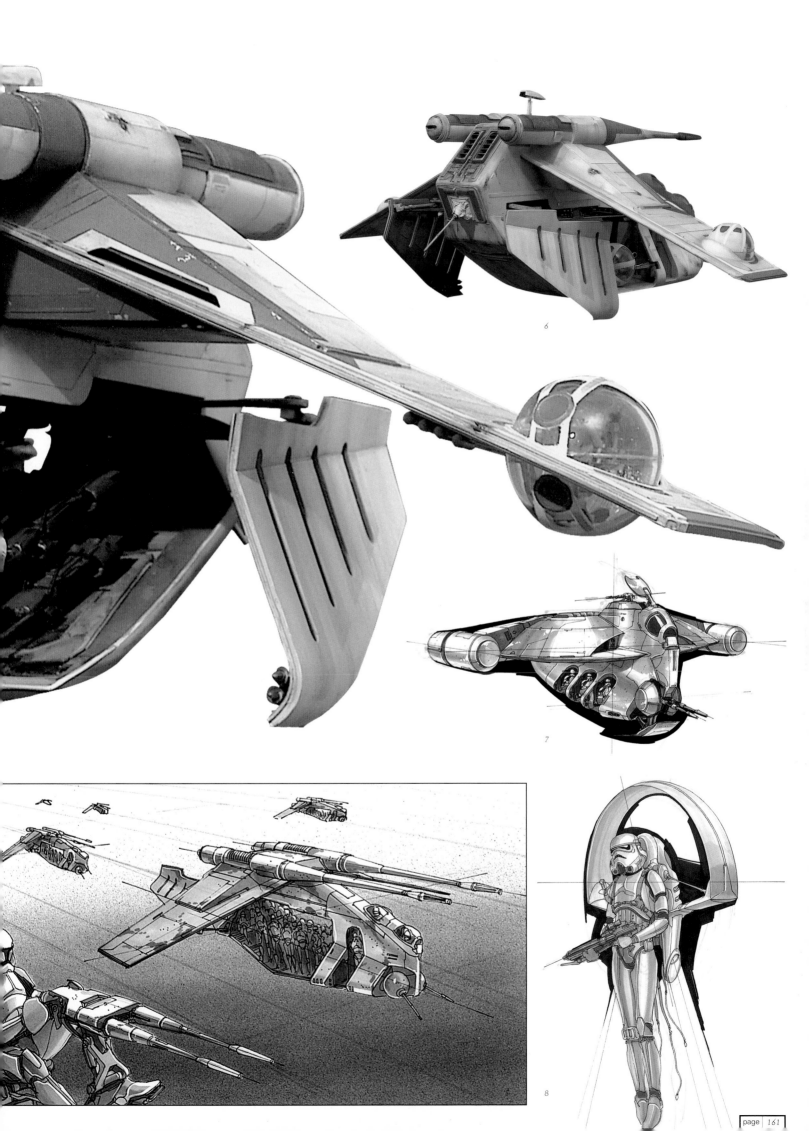

6

7

8

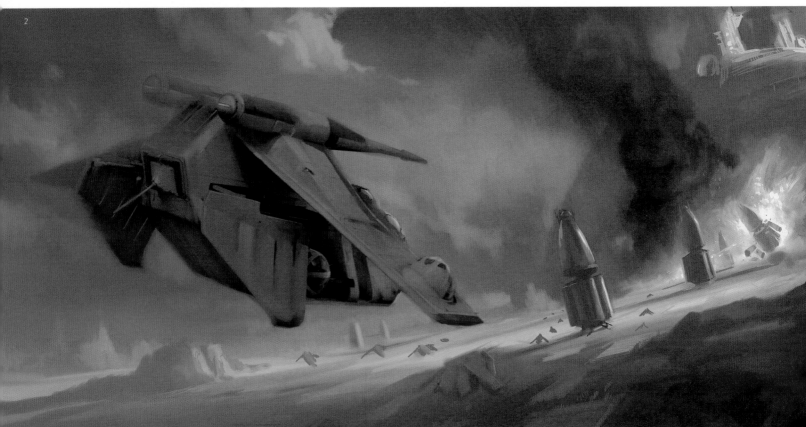

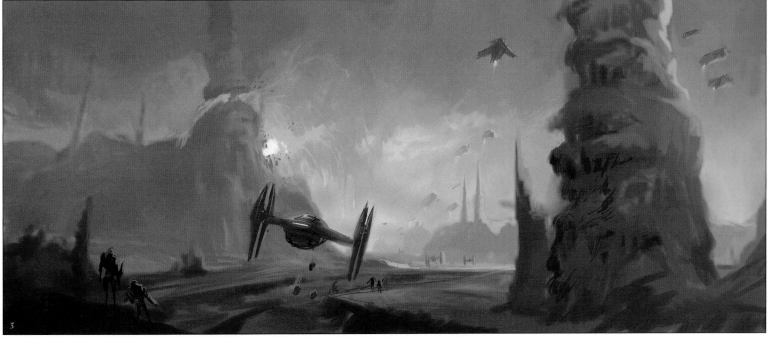

GEONOSIS ARENA EXTERIOR BATTLE SCENES
conceptual designs

| 1–3 | Erik Tiemens | |

Just as old aerial combat footage inspired George Lucas's design of the Rebel and Imperial fighters battling in *A New Hope*, Erik Tiemens and Ryan Church studied World War II and Vietnam War films for a sense of everything from artillery firing to combat copters landing. Even footage of the burning oil fields of Kuwait from the Persian Gulf War provided inspiration for their shot design paintings of the rugged battlefield of Geonosis.

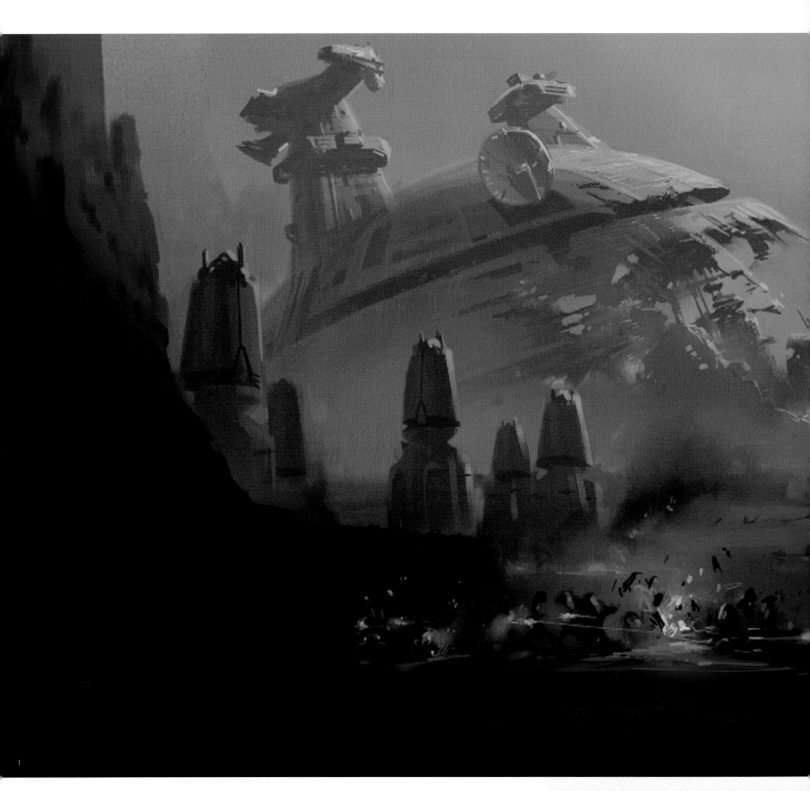

GEONOSIS ARENA EXTERIOR BATTLE SCENES		
conceptual designs		
1, 3	Ryan Church	
2	Erik Tiemens	

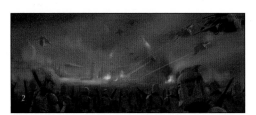

When Tiemens and Church were creating shot designs for the end battle, their design approach was to go for dramatic source material that would be used by ILM. In his painting [2], Church imagined what Lucas called the "vulture droids" of Episode I, but pictured them at hundreds of feet tall, not their normal scale of thirty feet.

The battlefield shot designs also featured distinctive, organic-looking Geonosian architecture —what Eirk Tiemens called "a valley of spires" —dwarfed by the burning Federation sphere in this panoramic Church image [1]. Tiemens noted that termites inspired his view of the Geonosians as builders. "Termite mounds can be hard as cement and get ten feet high and drop another ten feet

below ground, complete with cooling veins and air vents," Tiemens explained.

For the dramatic image of clone troopers firing away, as a blasted Trade Federation sphere burns in the background, Church went for maximum visual impact, inspired by classic movie moments, such as the attack by the hulking Imperial walkers of *The Empire Strikes Back*. "Images like the walkers are so deliberately composed, they convey everything about what they mean," Church noted. "In *Empire*, you see a walker advancing, crushing its foot down, and you know you're going to be dead in five minutes—it sums itself up. This image is a symbolic representation for the end battle."

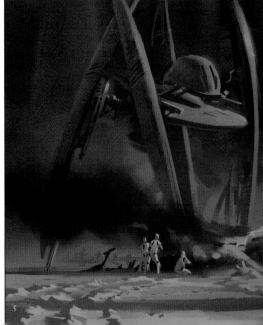

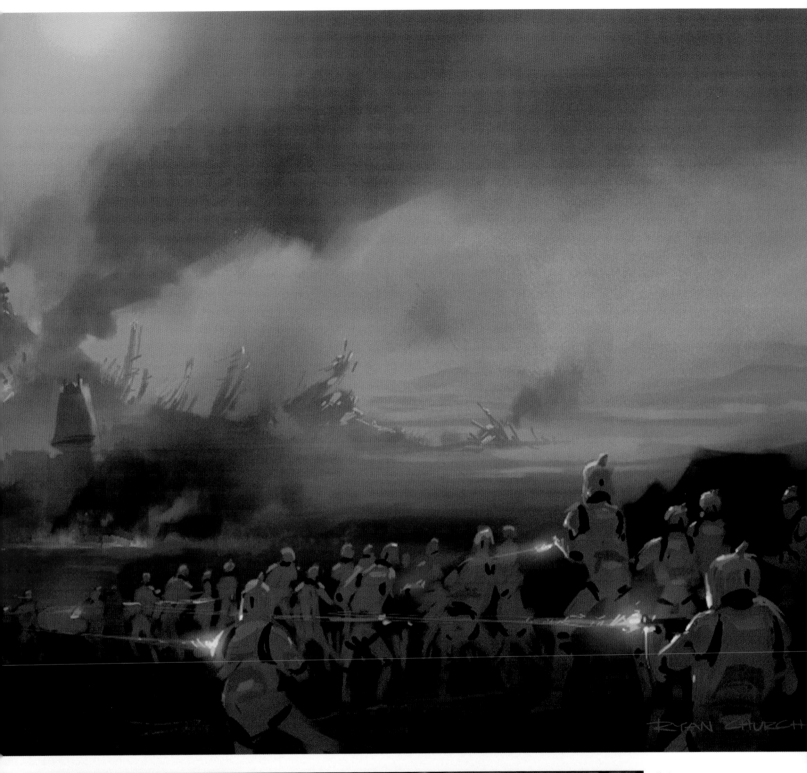

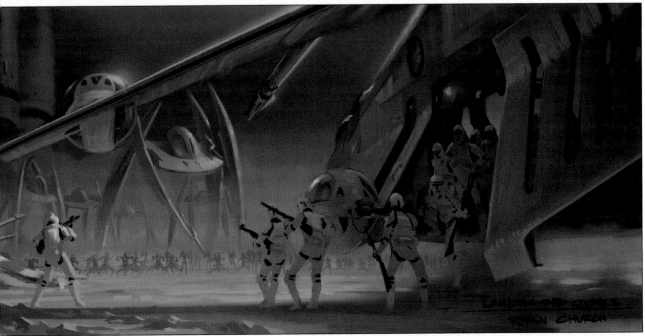

"To sum up the action, to encapsulate the moment—THAT'S what a production illustration should do."
—Ryan Church

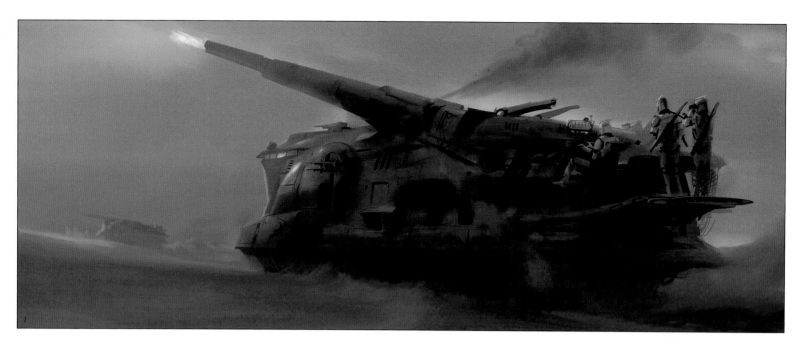

CLONE TANK & WALKER

conceptual designs

scene/s: 156/165

| 1 | Erik Tiemens |
| 2-5 | Ryan Church |

166

Concepts for the battle zone around the arena included such deployment devices as clone tanks, rendered by Ryan Church in Painter. The six-legged "walking tank" [4] was conceptualized by Church as an early prototype of the All Terrain Armored Transport (AT-AT), the hulking walker of *The Empire Strikes Back*.

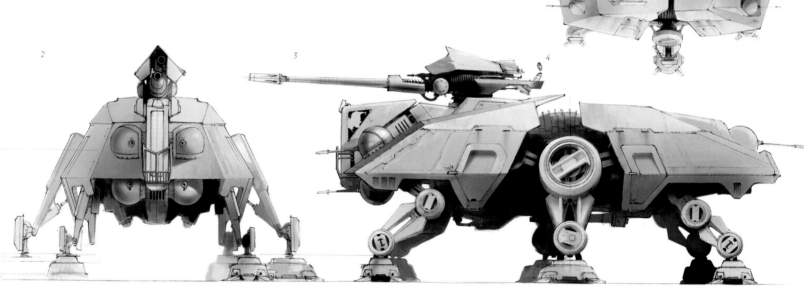

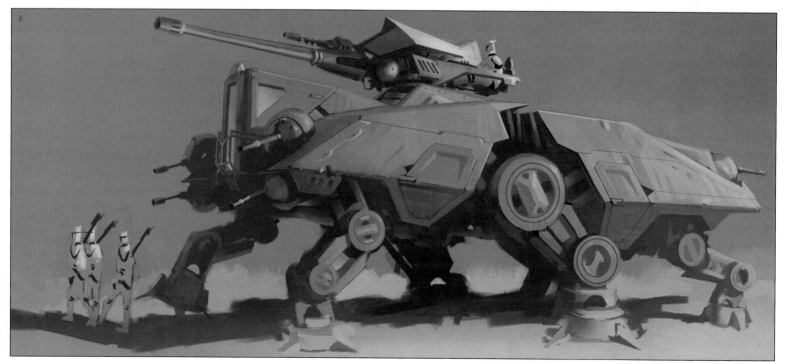

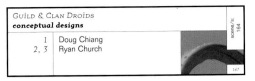

GUILD & CLAN DROIDS
conceptual designs

		scene/s: 164
1	Doug Chiang	
2, 3	Ryan Church	

167

Lucas requested "point defenders" for the Trade Federation and Commerce Guild ships, which made for another opportunity to populate the ground battle with more robots and vehicles. Point defenders ranged from a spider-legged droid [1] to track and wheeled tanks [2–3].

For the track tank [2], Church reached back to his college training in transportation design. "In *Star Wars*, it's all about iconic, instantly recognizable shapes," Church explained. "I didn't want a traditional tank shape; I wanted a triangular shape and a sense of forward thrust."

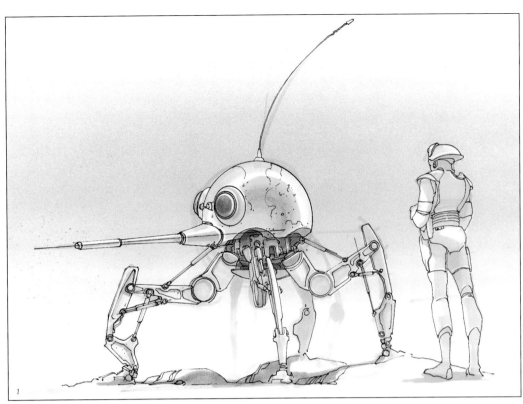

1

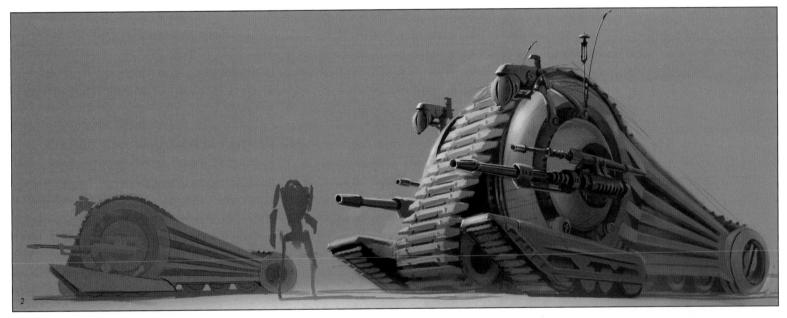

2

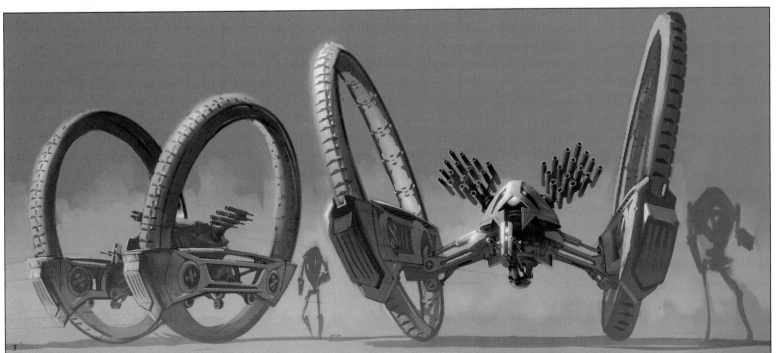

3

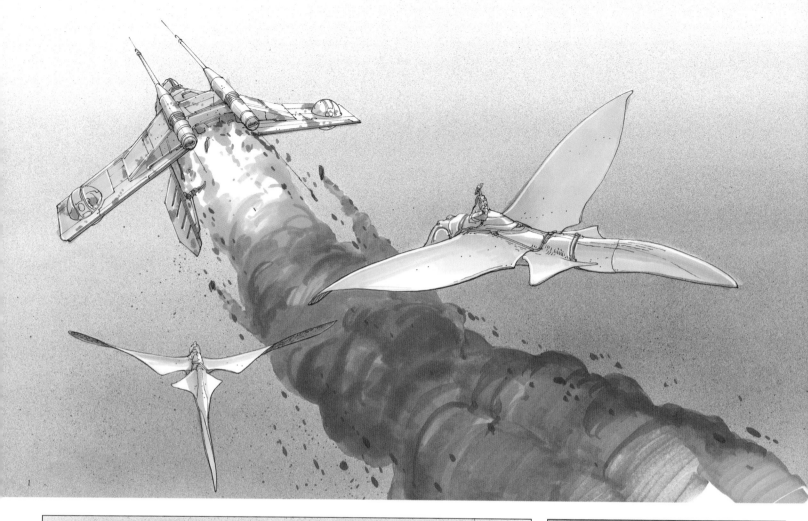

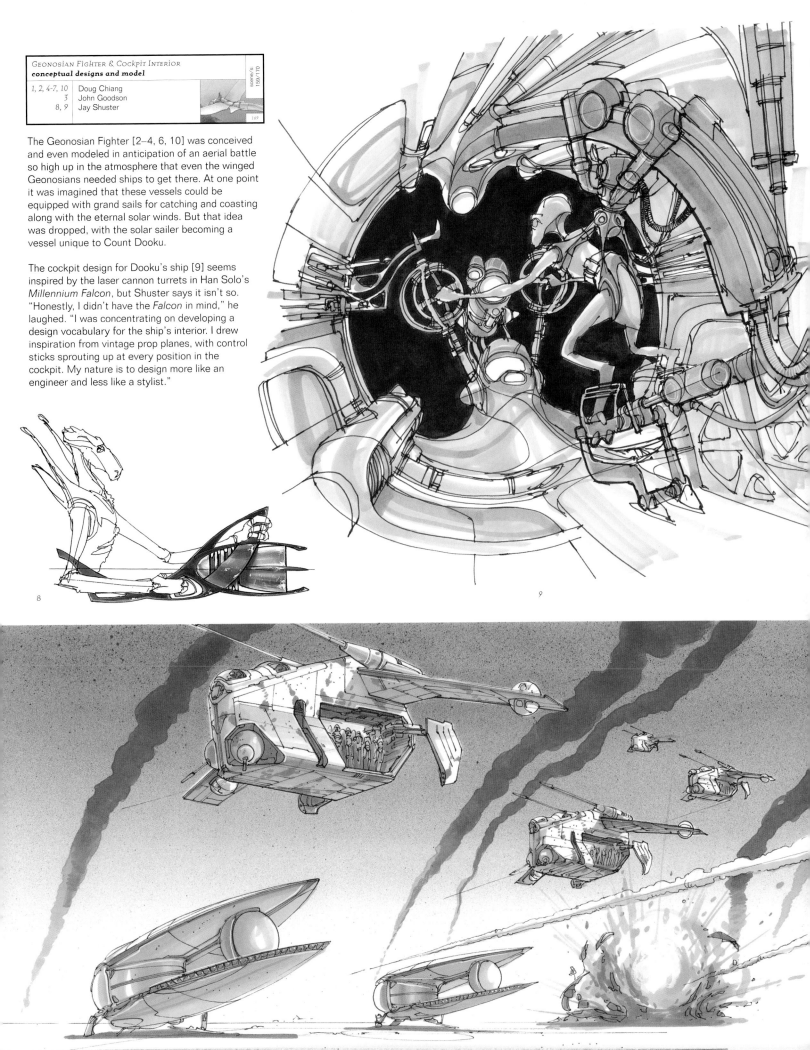

GEONOSIAN FIGHTER & COCKPIT INTERIOR
conceptual designs and model

1, 2, 4–7, 10	Doug Chiang
3	John Goodson
8, 9	Jay Shuster

scene/s:
159/170

169

The Geonosian Fighter [2–4, 6, 10] was conceived and even modeled in anticipation of an aerial battle so high up in the atmosphere that even the winged Geonosians needed ships to get there. At one point it was imagined that these vessels could be equipped with grand sails for catching and coasting along with the eternal solar winds. But that idea was dropped, with the solar sailer becoming a vessel unique to Count Dooku.

The cockpit design for Dooku's ship [9] seems inspired by the laser cannon turrets in Han Solo's *Millennium Falcon*, but Shuster says it isn't so. "Honestly, I didn't have the *Falcon* in mind," he laughed. "I was concentrating on developing a design vocabulary for the ship's interior. I drew inspiration from vintage prop planes, with control sticks sprouting up at every position in the cockpit. My nature is to design more like an engineer and less like a stylist."

8

9

10

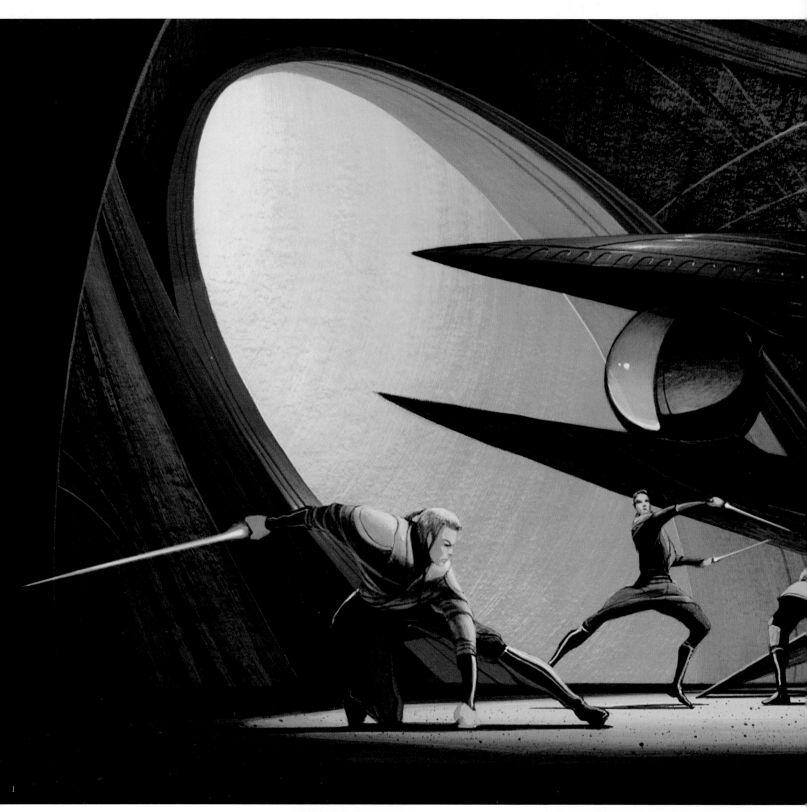

SOLAR SAILER HANGAR
conceptual designs

1, 3, 4	Doug Chiang
2	Edwin Natividad

scene/s: 170

This Chiang painting [1] depicts Obi-Wan and
Anakin in battle with Dooku in the Geonosian
hangar from which the count hopes to escape.
At the time he began the artwork, the hangar was
still being developed, but Chiang knew this would
be a critical image. "I wanted to explore dramatic
lighting in this film, and this image pushed my
skills," he explained. "This image worked because
it was the right design and texture and for a key
moment in the film." Note how Chiang further
explored his own concept by adding separately
rendered hangar structures [3, 4].

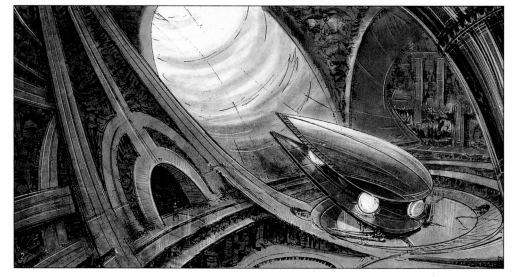

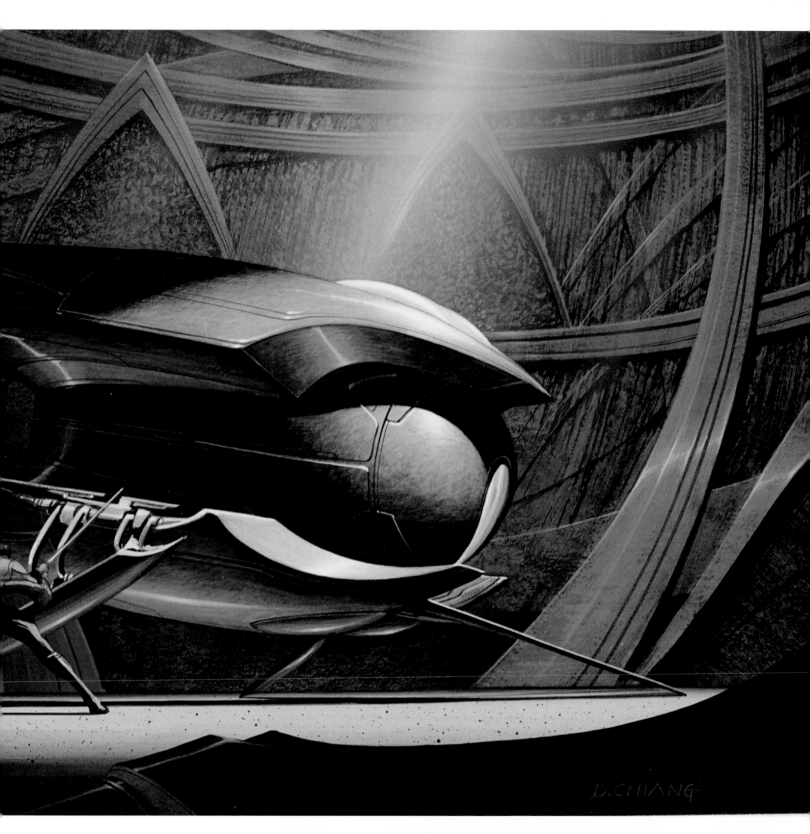

The crane pictured below was one of he elements added at Lucas's request. "When George was cutting this scene together using drawn storyboards, he felt more hangar props were needed—cranes and towers, fueling devices and servicing equipment—so Count Dooku could use the Force to knock them on to the Jedi he was battling, " Chiang explained.

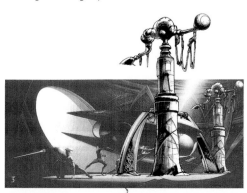

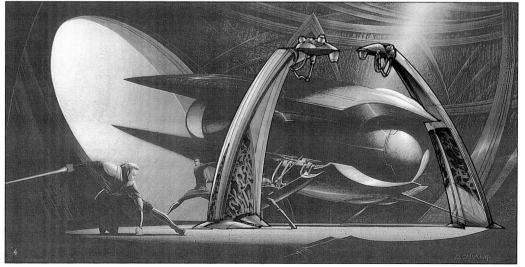

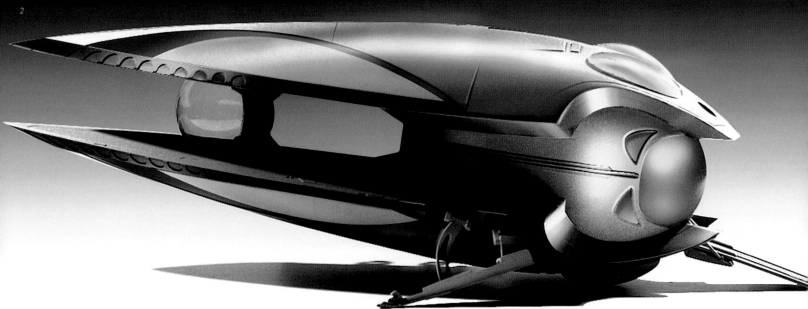

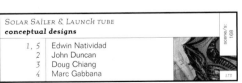

SOLAR SAILER & LAUNCH TUBE
conceptual designs

		scene/s: 168
1, 5	Edwin Natividad	
2	John Duncan	
3	Doug Chiang	173
4	Marc Gabbana	

"The idea of the count's ship is, it's closed up like a water beetle. When the wings are ready to deploy, they shoot out along tracks and the sails open up like parachutes, only horizontally. And then solar winds propel it."
—**Carol Bauman**

The artists rendered the top of Dooku's launch tunnel [1] and various sail ship concepts [3–5], which led to the final concept [2]. The cockpit detail on page 169, image 9, corresponds with the ball-shaped area at the front of the final craft, shown here.

For Carol Bauman, who worked with R. Kim Smith on the secret hangar, the original charge was to build a garage. When Bauman learned that Christopher Lee had been cast as the count, it helped her imbue the resulting hangar model with the elegant, menacing atmosphere she knew the actor would bring to the character of Dooku.

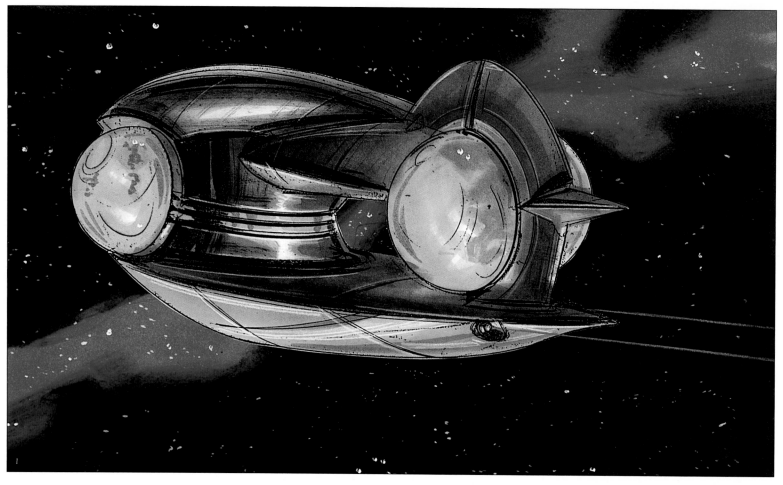

2

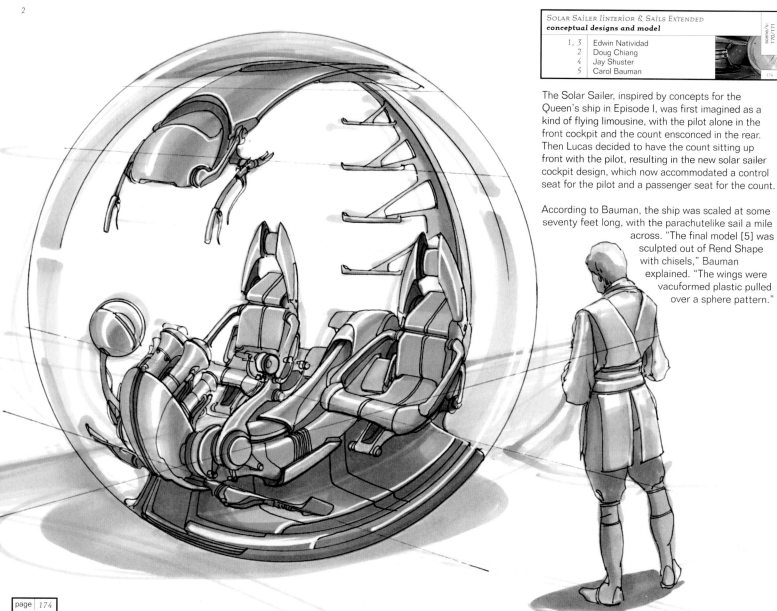

SOLAR SAILER IINTERIOR & SAILS EXTENDED
conceptual designs and model

scene/sc
170/171

1, 3	Edwin Natividad
2	Doug Chiang
4	Jay Shuster
5	Carol Bauman

174

The Solar Sailer, inspired by concepts for the Queen's ship in Episode I, was first imagined as a kind of flying limousine, with the pilot alone in the front cockpit and the count ensconced in the rear. Then Lucas decided to have the count sitting up front with the pilot, resulting in the new solar sailer cockpit design, which now accommodated a control seat for the pilot and a passenger seat for the count.

According to Bauman, the ship was scaled at some seventy feet long, with the parachutelike sail a mile across. "The final model [5] was sculpted out of Rend Shape with chisels," Bauman explained. "The wings were vacuformed plastic pulled over a sphere pattern."

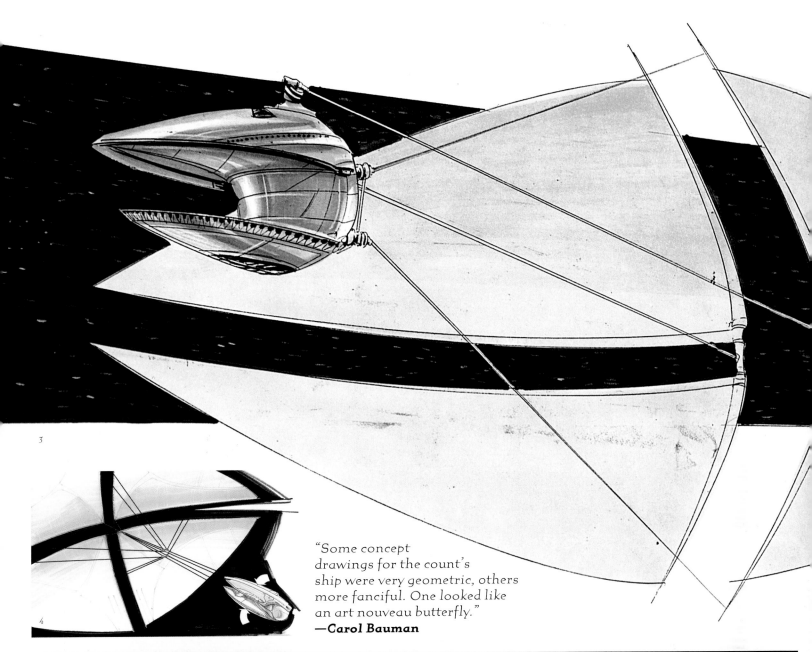

3

4

"Some concept drawings for the count's ship were very geometric, others more fanciful. One looked like an art nouveau butterfly."
—**Carol Bauman**

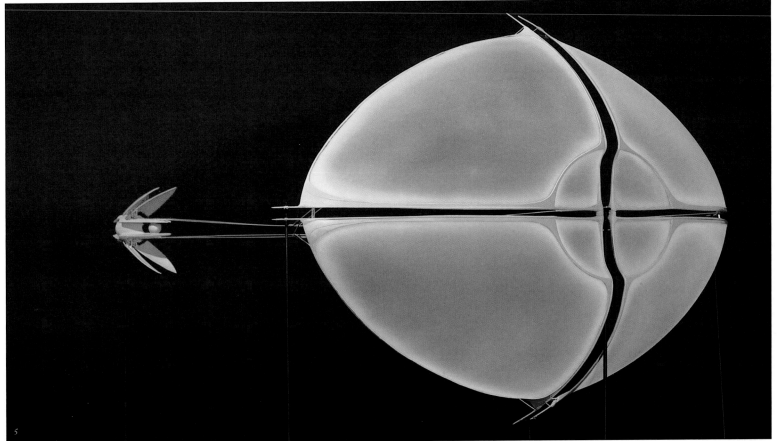

5

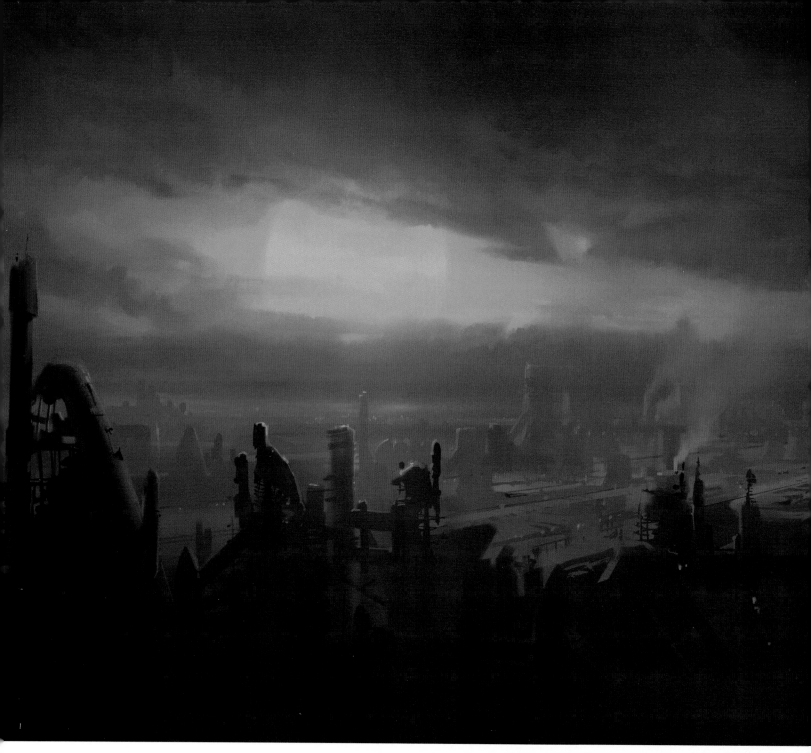

Back on Coruscant, in an industrial warehouse district, Count Dooku's own Master is revealed—Darth Sidious, the mysterious Master of Darth Maul from *The Phantom Menace*.

Marc Gabbana recalled that for the warehouse district, Lucas wanted a remote, lonely place for Darth Sidious to locate his hideout. The warehouse was imagined as abandoned, with conceptual designs working out the severity of the area's decay. The final approved artwork imagined the warehouse as a forgotten place, its mighty structures falling apart from age and neglect.

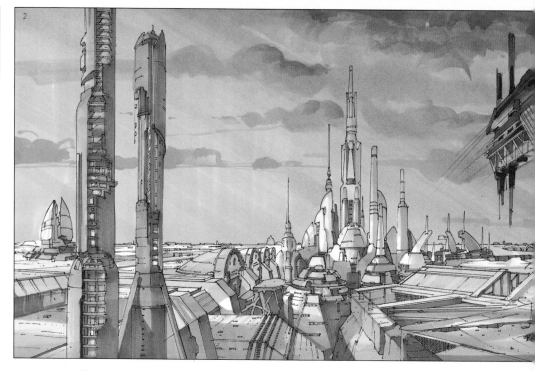

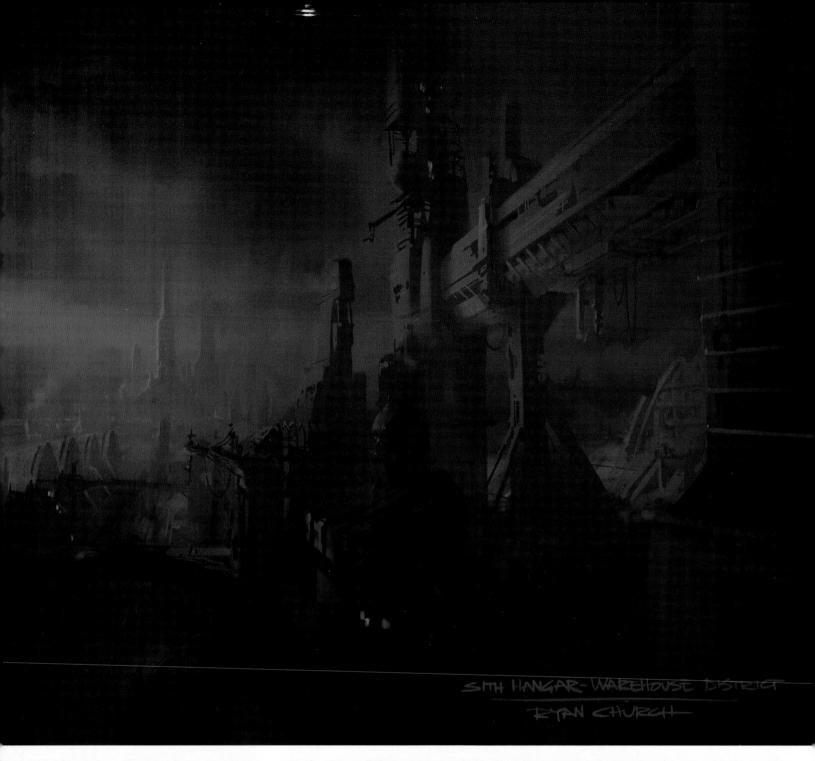

SITH HANGAR-WAREHOUSE DISTRICT
RYAN CHURCH

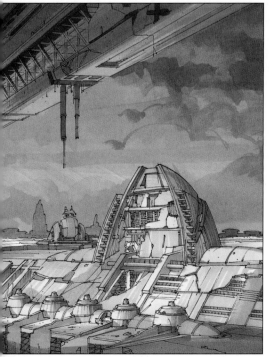

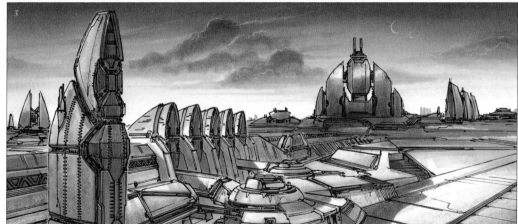

The Coruscant warehouse district was always planned as the secret hiding place for the film's mysterious Sith character. The look and mood of the district, however, was the great question to be explored and answered. "One concept for the warehouse district was a bombed-out wasteland, with skeletons of buildings in an ominous landscape,"

Marc Gabbana recalled. "Another approach was the area was abandoned, but with a few pockets of people living there. Another idea was this was a decrepit industrial district with infernal towers of ancient, decommissioned power plants looming high above the horizon."

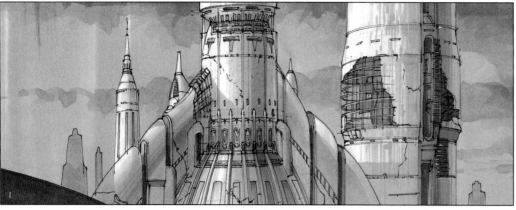

CORUSCANT WAREHOUSE DISTRICT: SECRET ENTRANCE
conceptual designs

1	Kurt Kaufman
2	Jay Shuster
3–5	Marc Gabbana

scene/s:
173/174

178

For the foreboding "secret entrance" [2] Jay Shuster was personally inspired by the moody theme of a hiding place. "I portrayed it with all the gothic baggage that goes with a secret lair; dark, creepy, a cathedral honoring the character's flawed traits. I drew from literal translations of gothic cathedrals, all the spindle and lightning rod–like fixtures characteristic of that architecture."

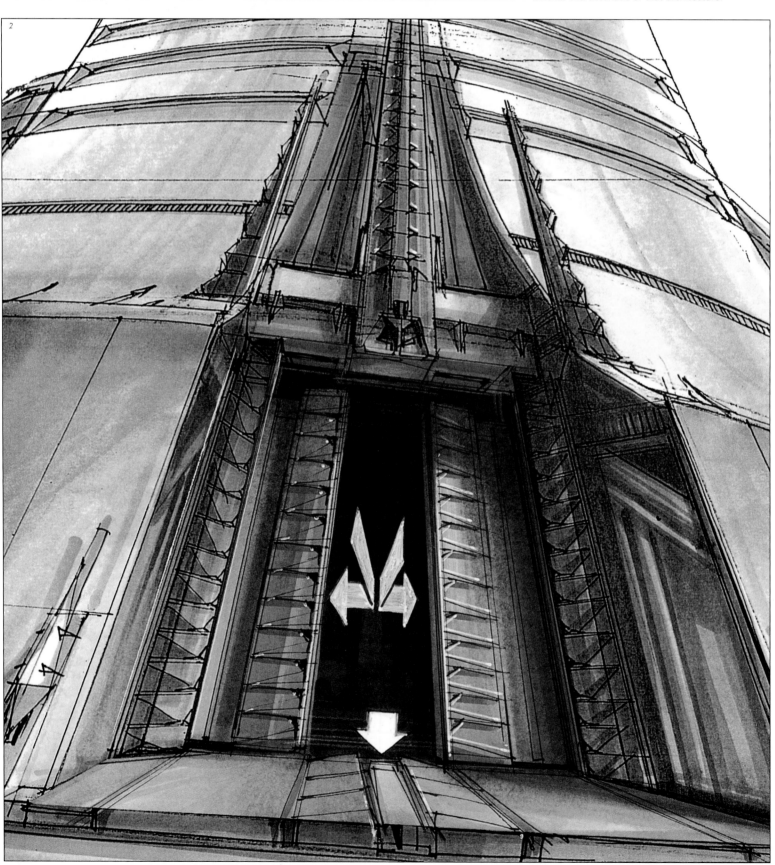

The design for Sidious's secret warehouse entrance allowed the count's solar sailer to fly in through a secret entrance. "Doug's first idea was for a sight gag, like the Batcave entrance," Gabbana noted. The idea evolved, including this Gabbana view of giant statuary [4], the statues themselves envisioned as hundreds of feet tall. Gabbana further experimented with scale by adding generic figures to the warehouse interior below [5].

Marc Gabbana's drawings for the abandoned warehouse district were "somber and dark," as he characterized them, underlining the intrigue, secrecy, and isolation required for the storypoint of a place serving as a secret lair. "I also tried to emphasize the desolate nature of the area to contrast with the vibrant, bustling downtown areas," Gabbana concluded.

"The warehouse district occupied several of us for several weeks of concept work," said Kurt Kaufman, whose own image of the secret warehouse area [1] depicts some of the ruin of the dilapidated structures.

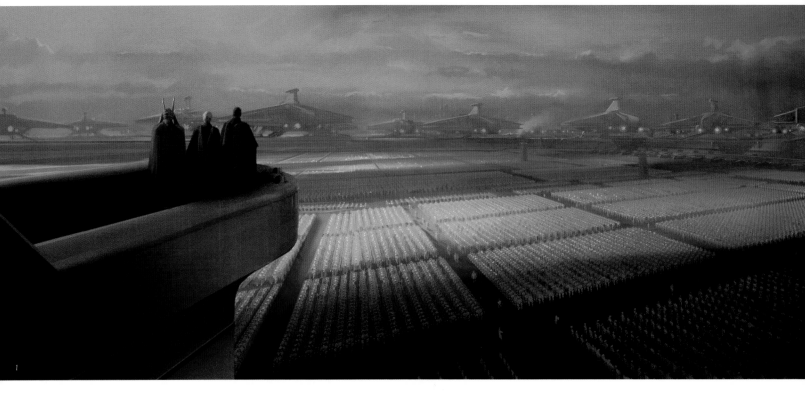

TROOP STAGING AREA		
conceptual designs		
1	Ryan Church	scene/s: 177
2-4, 6, 7	Erik Tiemens	
5	Jay Shuster	180

As Episode II ends, Palpatine is already reviewing the clone troopers produced on Kamino. As the final sentence of one version of the Episode II script dramatically stated: "The great Clone War has begun." For the troop staging area, concept artists considered references of marching crowds, particularly Hitler's Nuremberg Rallies and the fevered, impassioned masses immortalized in the chilling propaganda film _Triumph of the Will_.

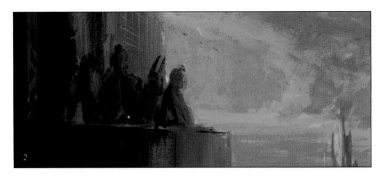

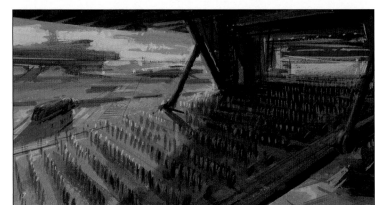

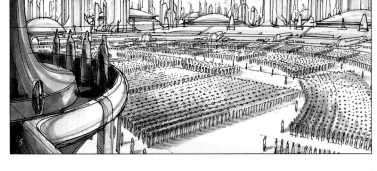

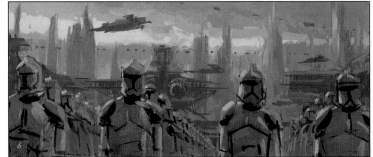

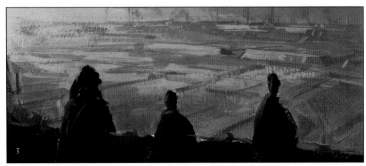

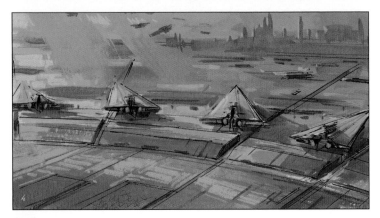

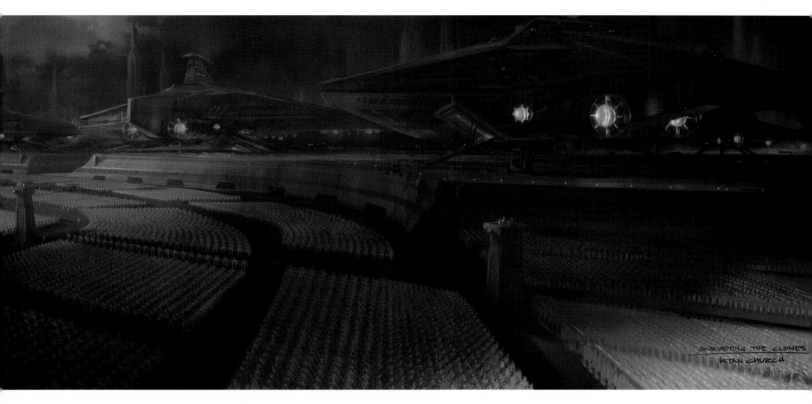

SURVEYING THE CLONES
RYAN CHURCH

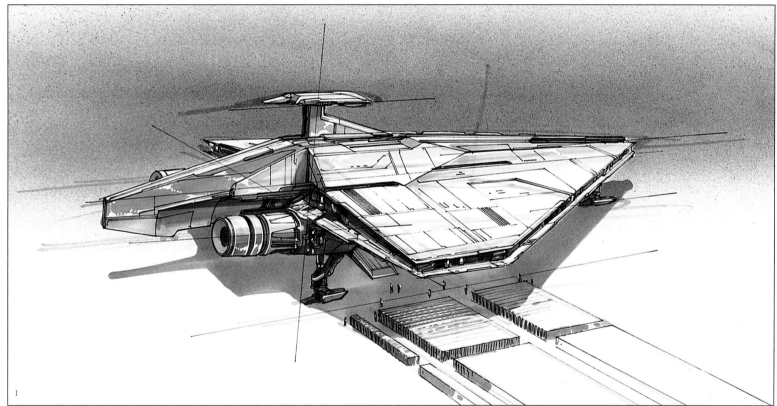

1

TROOP STAGING AREA
conceptual designs

scene/s: 174

1 Doug Chiang
2 Jay Shuster

181

This Doug Chiang sketch [1] was an early design imagining generic troops marching into a transport ship. This simple concept evolve into a grand troop staging area for the Episode II finale, as seen in this Jay Shuster storyboard image [2]. Additional troop staging designs, anticipating the Clone War, were imagined as sunset scenes of raking red light striking a mood of "impending doom, the sense that a storm is coming," Doug Chiang noted.

2

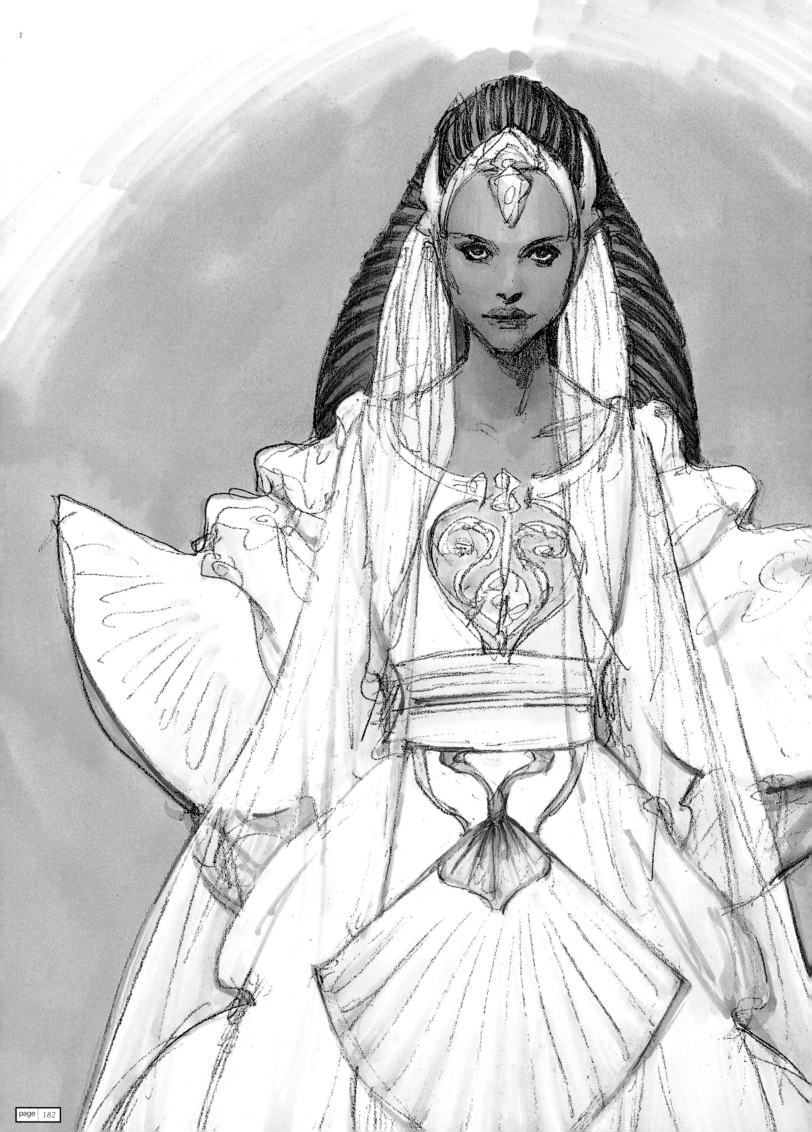

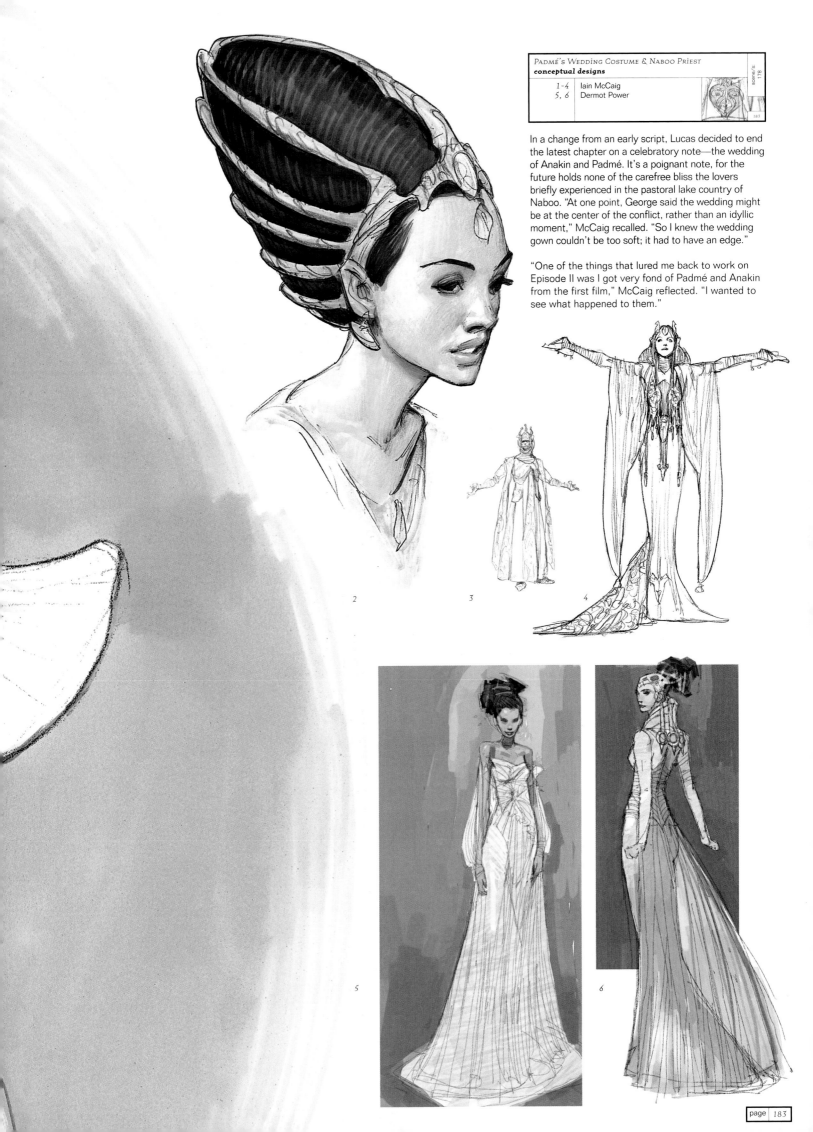

In a change from an early script, Lucas decided to end the latest chapter on a celebratory note—the wedding of Anakin and Padmé. It's a poignant note, for the future holds none of the carefree bliss the lovers briefly experienced in the pastoral lake country of Naboo. "At one point, George said the wedding might be at the center of the conflict, rather than an idyllic moment," McCaig recalled. "So I knew the wedding gown couldn't be too soft; it had to have an edge."

"One of the things that lured me back to work on Episode II was I got very fond of Padmé and Anakin from the first film," McCaig reflected. "I wanted to see what happened to them."

2

3

4

5

6

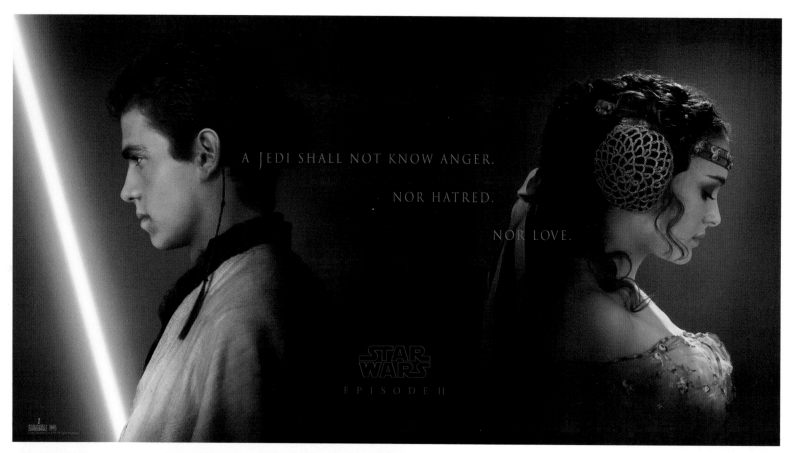

A JEDI SHALL NOT KNOW ANGER.

NOR HATRED.

NOR LOVE.

STAR WARS
EPISODE II

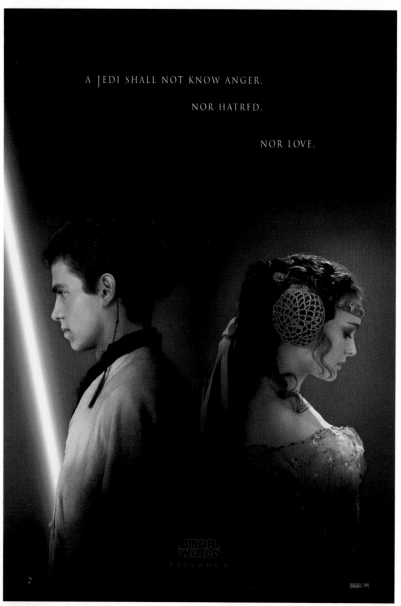

A JEDI SHALL NOT KNOW ANGER.

NOR HATRED.

NOR LOVE.

STAR WARS
EPISODE II

A JEDI SHALL NOT KNOW ANGER.

NOR HATRED.

NOR LOVE.

TEASER BANNER & POSTER (11/01) & ONE-SHEET (3/02)
final designs

1, 2	George Lucas, Jim Ward, Scott Erwert, Greg Bell, Paul Venables
3	George Lucas, Jim Ward, Scott Erwert, Drew Struzan

Star Wars Episode II
Attack of the Clones

184

The *Attack of the Clones* teaser and launch posters each reflect this episode's themes of forbidden love amidst turmoil in the *Star Wars* galaxy. Lucasfilm Vice President of Marketing Jim Ward worked with Art Director Scott Erwert to do initial explorations on these themes for both posters. The teaser evolved into a concept created by Art Director Greg Bell and Copywriter Paul Venables that used text and stunning images of Anakin and Padmé to suggest the fateful decision that Anakin must make between duty and forbidden love.

Veteran poster artist Drew Struzan painted the launch poster in the tradition of the existing *Star Wars* one-sheets. Struzan's illustration focuses on the young lovers, while the supporting characters and images display the mystery and intense conflict contained in *Attack of the Clones*.

STAR·WARS

EPISODE II

ATTACK OF THE CLONES

STAR WARS EPISODE II ATTACK OF THE CLONES

Starring EWAN McGREGOR NATALIE PORTMAN HAYDEN CHRISTENSEN

IAN McDIARMID SAMUEL L. JACKSON CHRISTOPHER LEE

Co-starring ANTHONY DANIELS KENNY BAKER FRANK OZ

Music by JOHN WILLIAMS Produced by RICK McCALLUM

Screenplay by GEORGE LUCAS and JONATHAN HALES

Directed by GEORGE LUCAS

STAR WARS

EPISODE II | ATTACK OF THE CLONES™

Screenplay by George Lucas and Jonathan Hales

ALIEN & GEONOSIAN INTERIOR conceptual designs		
1	Ryan Church	
2	Doug Chiang	

Star Wars Episode II
Attack of the Clones

186

ANIMATIC CREDITS

Brad Alexander
Brian Christian
Katie Cole
David Dozoretz
Simon Dunsdon
Daniel Gregoire
Robert Kinkead
Euisung Lee
Brian Pohl
Paul Topolos
Matthew A. Ward
Raymond Wong

Animatics can be as simple as videotaped story-boards and as complex as 3-D computer graphics. The goal has always been to provide a clear idea for the dynamics of a shot—its elements, pacing, and composition. For a *Star Wars* film, where every shot can be touched by effects magic, animatics are a necessity.

As with *The Phantom Menace*, low-resolution 3-D animatics for *Attack of the Clones* established a template for final shots created at Industrial Light + Magic. But while Episode I animatics focused on effects-heavy action set pieces, such as the Podrace and end battle, Episode II animatics covered the entire production.

The animatics ramped up from a staff of six for Episode I to some fourteen at the peak of Episode II production. Digital tools evolved from Electric Image 3-D animation software to Maya, a next generation modeling, animation, and rendering package allowing for more sophisticated work. Even the symbiosis with ILM advanced, with low-res animatics data files not merely serving as inspiration but able to be plugged into ILM's computers for truly virtual templates.

In the following section are images of animatics representing the final stage of the creative journey that was *Attack of the Clones* concept design. The images are snapshots of an evolving technological and artistic technique—and pieces of the dream that form the final film.

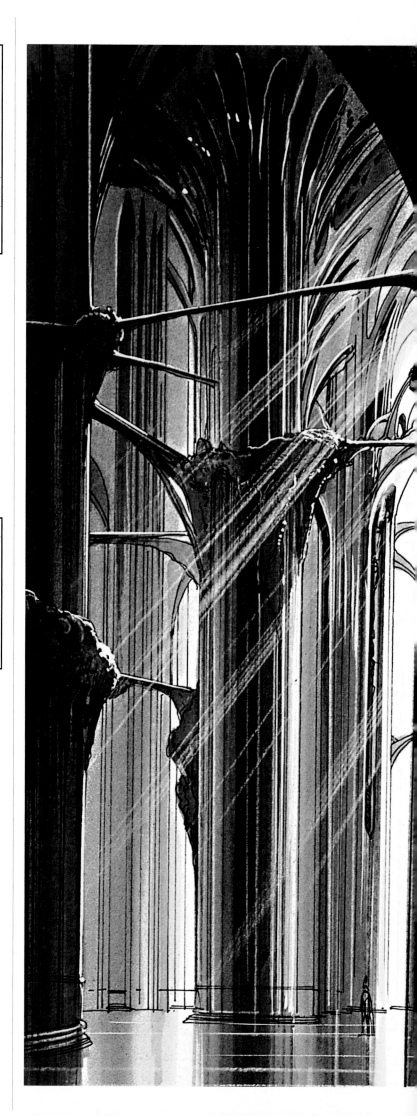

Scene 001 — EXTERIOR SPACE—TITLE CARD

A long time ago in a galaxy far, far away....

A vast sea of stars serves as a backdrop for the main title, followed by a rollup, which crawls into infinity.

There is unrest in the Galactic Senate. Several thousand solar systems have declared their intentions to leave the Republic.

This separatist movement, under the leadership of Count Dooku, has made it difficult for the limited number of Jedi Knights to maintain peace and order in the galaxy.

Senator Amidala, the former Queen of Naboo, is returning to the Galactic Senate to vote on the critical issue of creating an ARMY OF THE REPUBLIC to assist the overwhelmed Jedi…

PAN UP to reveal the amber city planet of Coruscant. Two yellow Naboo Fighters fly OVER CAMERA toward the planet, followed by a large Naboo Cruiser and one more Fighter.

Scene 002 — INTERIOR NABOO CRUISER—DAWN

The LIEUTENANT and two SECURITY OFFICERS address SENATOR AMIDALA as the Cruiser nears the planet.

Lieutenant: Senator, we're making our final approach in to Coruscant.
Senator Amidala: Very good, Lieutenant.

Scene 003 — EXTERIOR CITYSCAPE, CORUSCANT—DAWN

The ships skim across the surface of the city landscape. The sun glints off the chrome hulls of the sleek Naboo spacecraft as they navigate between the buildings of the capital planet.

Scene 004 — EXTERIOR CORUSCANT, LANDING PLATFORM—DAWN

Two Naboo Fighters land on one leaf of a three-leaf-clover landing platform. The Naboo Cruiser lands on the central leaf, and the third Fighter lands on the remaining platform.

A small GROUP OF DIGNITARIES waits to welcome the Senator.

One of the FIGHTER PILOTS jumps from the wing of his ship and removes his helmet. He is CAPTAIN TYPHO, SENATOR AMIDALA'S Security Officer. He moves over to a WOMAN PILOT.

Typho: We made it. I guess I was wrong, there was no danger at all.

The ramp lowers. TWO NABOO GUARDS appear. SENATOR AMIDALA, ONE HANDMAIDEN (VERSÉ), and FOUR TROOPERS descend the ramp. AMIDALA is more beautiful now than she was ten years earlier when, as Queen, she was freeing her people from the yoke of the Trade Federation.

The DIGNITARIES start to move forward. SENATOR AMIDALA reaches the foot of the ramp, when suddenly there is a blinding FLASH and a huge EXPLOSION. The DIGNITARIES and PILOTS are hurled to the ground as the starship is destroyed.

Klaxons blare, alarms sound! CAPTAIN TYPHO and the TWO ESCORT PILOTS get up and run to where SENATOR AMIDALA lies dying. Beyond, ARTOO-DETOO drops down from the Naboo Fighter and rolls toward the wreckage. The FEMALE ESCORT PILOT kneels by SENATOR AMIDALA and takes off her helmet, revealing SENATOR PADMÉ AMIDALA.

Padmé: Cordé…

She gathers her decoy double in her arms. Cordé's eyes open. She looks up at her.

Cordé: …I'm so sorry, M'Lady…I'm…not sure I…I've failed you, Senator.

CORDÉ dies. PADMÉ hugs her.

Padmé: No…!
Typho: M'Lady…You are still in danger here.

PADMÉ lowers CORDÉ to the ground. She gets up and looks around at the devastation. There are tears in her eyes.

Padmé: I shouldn't have come back.
Typho: This vote is very important. You did your duty—Cordé did hers. Now come. *(she doesn't respond)* Senator Amidala, *please!*

She turns. They walk away. ARTOO lets out a small whimper and rolls after them.

Scene 005 — EXTERIOR SENATE BUILDING—DAY

The massive Senate Building glistens in the afternoon sun. Small patches of fog have still to burn off.

Scene 006 — INTERIOR SENATE CHAMBER—DAY

The vast rotunda is buzzing with chatter. MAS AMEDDA, the Supreme Chancellor's majordomo, tries to quiet things down as PALPATINE confers with an AIDE, UV GIZEN, riding a small one-man floating scooter.

Mas Amedda: Order! We shall have order! The motion for the Republic to commission an army takes precedent, and that is what we will vote on at this time.

Everything quiets down. The AIDE disperses, and SUPREME CHANCELLOR PALPATINE steps to the podium.

Palpatine: …My esteemed colleagues, excuse me…I have just received some tragic and disturbing news. Senator Amidala of the Naboo system has been assassinated!

There is a shocked silence in the vast arena.

Palpatine: This grievous blow is especially personal to me. Before I became Chancellor, I served Amidala when she was Queen. She was a great leader who fought for justice, not only here in this honorable assembly, but also on her home planet. She was so loved she could have been elected Queen for life. She believed in public service, and she fervently believed in democracy. Her death is a great loss to us all. We will all mourn her as a relentless champion of freedom…and as a dear friend.

There is a moment of silence. ASK AAK, the SENATOR of MALASTARE, moves his pod into the center of the arena.

Ask Aak: How many more Senators will die before this civil strife ends! We must confront these rebels now, and we need an army to do it.

A second pod moves into the center of the arena with DARSANA, the AMBASSADOR of GLEE ANSELM.

Darsana: Why weren't the Jedi able to stop this assassination? We are no longer safe under their protection.

SENATOR ORN FREE TAA swings forward in his pod.

Orn Free Taa: The Republic needs more security now! Before it comes to war.
Palpatine: Must I remind the Senator from Malastare that negotiations are continuing with the separatists. Peace is our objective here...not war.

The SENATORS yell pro and con. MAS AMEDDA tries to calm things down. SENATOR PADMÉ AMIDALA, with CAPTAIN TYPHO, JAR JAR, and DORMÉ, maneuvers her pod into the center of the vast arena.

Padmé: My noble colleagues, I concur with the Supreme Chancellor. At all costs, *we do not want war!*

The Senate goes quiet, then there is an outburst of cheering and applause.

Palpatine: It is with great surprise and joy the chair recognizes the Senator from Naboo, Padmé Amidala.
Padmé: Less than an hour ago, an assassination attempt was made against my life. One of my bodyguards and six others were ruthlessly and senselessly murdered. I was the target but, more importantly, I believe this security measure before you was the target. I have led the opposition to build an army...but someone in this body who will stop at nothing to assure its passage...

Many of the SENATORS boo and yell at SENATOR AMIDALA.

Padmé: I warn you, if you vote to create this army, war will follow. I have experienced the misery of war firsthand; I do not wish to do it again.

There is sporadic yelling for and against her statements.

Padmé: Wake up, Senators...you must wake up! If we offer the separatists violence, they can only show us violence in return! Many will lose their lives. All will lose their freedom. This decision could very well destroy the very foundation of our great Republic. I pray you, do not let fear push you into a disastrous decision. Vote down this security measure, which is nothing less than a declaration of war! Does anyone here want that? I cannot believe they do.

There is an undercurrent of booing...and groaning. SENATOR ORN FREE TAA moves his pod next to AMIDALA.

Orn Free Taa: My motion to defer the vote must be dealt with first. That is the rule of law.

AMIDALA looks angry and frustrated. PALPATINE gives her a sympathetic look.

Palpatine: In view of the lateness of the hour and the seriousness of this motion, we will take up these matters tomorrow. Until then, the Senate stands adjourned.

Scene 007 | **EXTERIOR EXECUTIVE QUARTERS BUILDING—DAY**

The giant towers of the Republic Executive Building seem to reach the heavens. Traffic clogs the smoggy sky.

Scene 008 | **INTERIOR CHANCELLOR'S OFFICE—DAY**

CHANCELLOR PALPATINE sits behind his desk with TWO RED-CLAD ROYAL GUARDS on either side of the door. YODA, PLO KOON, KI-ADI-MUNDI, and MACE WINDU sit across from him. Behind them stand the Jedi LUMINARA UNDULI and her Padawan, BARRISS OFFEE.

Palpatine: I don't know how much longer I can hold off the vote, my friends. More and more star systems are joining the separatists.
Mace Windu: If they do break away—
Palpatine: I will not let this Republic that has stood for a thousand years be split in two. My negotiations will not fail!
Mace Windu: If they do, you must realize there aren't enough Jedi to protect the Republic. We are keepers of the peace, not soldiers.
Palpatine: Master Yoda, do you think it will really come to war?

Yoda closes his eyes.

Yoda: Worse than war, I fear...Much worse.
Palpatine: What?
Mace Windu: What do you sense, Master?
Yoda: The dark side clouds everything. Impossible to see, the future is. But this I am sure of—*(opens his eyes)* Do their duty, the Jedi will.

A muted BUZZER SOUNDS. A hologram of an AIDE, DAR WAC, appears on the Chancellor's desk.

Dar Wac: *(in Huttese)* The loyalist committee has arrived, my Lord.
Palpatine: Good. We will discuss this matter later. Send them in.

They all stand as SENATOR AMIDALA, CAPTAIN TYPHO, MAS AMEDDA, DORMÉ, and SENATORS (BAIL ORGANA, JAR JAR BINKS, AND HOROX RYYDER) and their ATTENDANTS enter the office. As YODA and MACE WINDU move to greet the SENATOR, YODA taps AMIDALA with his cane.

Yoda: Padmé, your tragedy on the landing platform, terrible. With you, the Force is strong...young Senator. Seeing you alive brings warm feelings to my heart.
Padmé: Thank you, Master Yoda. Do you have any idea who was behind this attack?
Mace Windu: Our intelligence points to disgruntled spice miners on the moons of Naboo.
Padmé: But I think that Count Dooku was behind it.

There is a stir of surprise. They look at one another.

Ki-Adi-Mundi: He is a political idealist, not a murderer.
Mace Windu: You know, M'Lady, Count Dooku was once a Jedi. He couldn't assassinate anyone. It's not in his character.
Yoda: In dark times nothing is what it appears to be, but the fact remains for certain, Senator, in grave danger you are.

PALPATINE gets up, walks to the window, and looks out at the vast city.

Palpatine: Master Jedi, may I suggest that the Senator be placed under the protection of your graces.
Bail Organa: Do you really think that is a wise decision during these stressful times?
Padmé: Chancellor, if I may comment, I do not believe the...
Palpatine: ..."situation is that serious." No, but I do, Senator.
Padmé: Chancellor, please! I don't want any more guards!
Palpatine: I realize all too well that additional security might be disruptive for you, but perhaps someone you are familiar with...an old friend like...Master Kenobi...

PALPATINE nods to MACE WINDU, who nods back.

Mace Windu: That's possible. He has just returned from a border dispute on Ansion.

Palpatine: You must remember him, M'Lady...he watched over you during the blockade conflict.
Padmé: This is not necessary, Chancellor.
Palpatine: Do it for me, M'Lady, please. I will rest easier. We had a big scare today. The thought of losing you is unbearable.

AMIDALA sighs as the JEDI get up to leave.

Mace Windu: I will have Obi-Wan report to you immediately, M'Lady.

Yoda leans into her ear.

Yoda: Too little about yourself you worry, Senator, and too much about politics. Be mindful of your danger, Padmé. Accept our help.

The JEDI leave the office.

Scene 009	**EXTERIOR APARTMENT BUILDING—TWILIGHT**

A graceful skyscraper twinkles in the evening light of Coruscant.

Scene 010	**INTERIOR APARTMENT BUILDING ELEVATOR—TWILIGHT**

ANAKIN and OBI-WAN ride in a windowed elevator attached to the outside of the Senate Building. They are on their way to SENATOR AMIDALA'S apartments. ANAKIN nervously rearranges his robes.

Obi-Wan: You seem a little on edge, Anakin.
Anakin: Not at all.
Obi-Wan: I haven't felt you this tense since we fell into that nest of gundarks.
Anakin: You fell into that nightmare, Master, and I rescued you, remember?
Obi-Wan: Oh yeah. *(they laugh)* You're sweating. Relax. Take a deep breath.
Anakin: I haven't seen her in ten years, Master.
Obi-Wan: She's not the Queen anymore, Anakin.
Anakin: That's not why I'm nervous.

Scene 011	**INTERIOR APARTMENT BUILDING— APARTMENT CORRIDOR—TWILIGHT**

The door to the apartment slides open. JAR JAR walks into the corridor, where TWO JEDI are exiting the elevator. He recognizes OBI-WAN and becomes extremely excited, jumping around, shaking his hand.

Jar Jar: Obi! Obi! Obi! Mesa sooo smilen to seein yousa. Wahooooo!

OBI-WAN smiles.

Obi-Wan: It's good to see you, too, Jar Jar.

JAR JAR notices OBI-WAN'S APPRENTICE.

Jar Jar: ...and this, I take it, is your apprentice...Nooooooo! Annie? Nooooooo! Little bitty Annie *(looks at Anakin)* Nooooooo! Yousa so biggen! Yiyiyiyyi! Annie!
Anakin: Hi, Jar Jar.

JAR JAR grabs hold of ANAKIN and envelops him in a big hug.

Jar Jar: Shesa expecting yousa. Annie...Mesa no believen!

Scene 012	**INTERIOR APARTMENT BUILDING, AMIDALA'S APARTMENT—TWILIGHT**

PADMÉ is in a conference with CAPTAIN TYPHO and DORMÉ. JAR JAR enters the room, followed by the TWO JEDI.

Jar Jar: Mesa here. Lookie...lookie...Senator. Desa Jedi arriven.

PADMÉ and TYPHO rise as OBI-WAN and ANAKIN stop before the SENA-TOR. OBI-WAN steps forward. ANAKIN stares at PADMÉ. She glances at him.

Obi-Wan: It's a pleasure to see you again, M'Lady.

PADMÉ walks over to OBI-WAN and takes his hand in hers.

Padmé: It has been far too long, Master Kenobi. I'm so glad our paths have crossed again...but I must warn you that I think your presence here is unnecessary.
Obi-Wan: I'm sure the Jedi Council has their reasons.

She moves in front of ANAKIN.

Padmé: Annie? *(stares)* My goodness, you've grown.

They look at each other for a long moment.

Anakin: *(trying to be smooth)* So have you...grown more beautiful, I mean...and much shorter...for a Senator, I mean.

OBI-WAN looks disapprovingly at his apprentice. PADMÉ laughs and shakes her head.

Padmé: Oh, Annie, you'll always be that little boy I knew on Tatooine.

This embarrasses ANAKIN, and he looks down. OBI-WAN and CAPTAIN TYPHO smile.

Obi-Wan: Our presence will be invisible, M'Lady, I can assure you.
Typho: I'm very grateful you're here, Master Kenobi. I'm Captain Typho, head of Her Majesty's security service. Queen Jamillia has informed you of your assignment. The situation is more dangerous than the Senator will admit.
Padmé: I don't need more security, I need answers. I want to know who is trying to kill me.
Obi-Wan: *(frowning)* We're here to protect you, Senator, not to start an investigation.
Anakin: We will find out who's trying to kill you, Padmé, I promise you!

He's done it again. He bites his lip in frustration and shame. OBI-WAN gives ANAKIN a dirty look.

Obi-Wan: We will not exceed our mandate, my young Padawan learner!
Anakin: I meant in the interest of protecting her, Master, of course.
Obi-Wan: We will not go through this exercise again, Anakin. And you will pay attention to my lead.
Anakin: Why?
Obi-Wan: What??!!
Anakin: Why else do you think we were assigned to protect her, if not to find the killer? Protection is a job for local security...not Jedi. It's overkill, Master. Investigation is implied in our mandate.
Obi-Wan: We will do exactly as the Council has instructed. And you will learn your place, young one.
Padmé: Perhaps with merely your presence the mysteries surrounding this threat will be revealed. Now, if you will excuse me, I will retire.

Everyone gives AMIDALA a slight bow as she and DORMÉ leave the room.

Typho: Well, I know I feel a lot better having you here. I'll have an officer situated on every floor and I'll be at the control center downstairs.

Jar Jar: Mesa busten wit happiness seein yousa again, Annie. Deesa bad times, bombad times.

CAPTAIN TYPHO leaves.

Anakin: She hardly recognized me, Jar Jar. I've thought about her every day since we parted...and she's forgotten me completely.
Jar Jar: Shesa happy. Happier den mesa seein her in longo time.
Obi-Wan: Anakin, you're focusing on the negative again. Be mindful of your thoughts. She was pleased to see us. Now let's check the security here.
Anakin: Yes, my Master.

Scene 013 **EXTERIOR SKYSCRAPER LEDGE—NIGHT**

An armor-clad bounty hunter, JANGO FETT, waits on the ledge of a sky-scraper as another bounty hunter, ZAM WESELL, a CHANGELING, steps from her hovering speeder and approaches FETT.

Zam Wesell: I hit the ship, but they used a decoy.

Jango Fett: We'll have to try something more subtle this time, Zam. My client is getting impatient.

FETT hands ZAM a transparent tube about a foot long containing centipede-like KOUHUNS.

Jango Fett: Take these. Be careful. They're very poisonous.

ZAM attaches her veil across the bottom of her face. She turns to leave, but FETT calls her back.

Jango Fett: Zam, there can be no mistakes this time.

She turns again, and walks toward her speeder.

Scene 014 **EXTERIOR JEDI TEMPLE—NIGHT**

The vast Jedi Temple sits on an endless flat plain, silhouetted against the traffic-filled sky.

Scene 015 **INTERIOR JEDI TEMPLE, CORRIDOR—NIGHT**

MACE WINDU and YODA walk down the long hallway, silhouetted by a lit room at the end.

Mace Windu: Why couldn't we see this attack on the Senator?
Yoda: Masking the future, is this disturbance in the Force.
Mace Windu: The prophecy is coming true, the dark side is growing.
Yoda: And only those who have turned to the dark side can sense the possibilities of the future.
Mace Windu: It's been ten years, and the Sith have yet to show themselves.
Yoda: ...out there, they are. A certainty, that is.

There is a long silence as they walk away. Only footsteps are heard.

Scene 016 **INTERIOR APARTMENT BUILDING, AMIDALA'S APARTMENT, MAIN ROOM—NIGHT**

ANAKIN is standing in the living room. He is in a meditative state. It is quiet. We hear DISTANT FOOTSTEPS in the corridor outside the apartment. Suddenly ANAKIN'S eyes pop open. His eyes dart around the room. He reaches for his lightsaber, then smiles and puts it back on his belt.

The door to the apartment slides open, and OBI-WAN enters.

Obi-Wan: Captain Typho has more than enough men downstairs. No assassin will try that way. Any activity up here?
Anakin: Quiet as a tomb. I don't like just waiting here for something to happen to her.

OBI-WAN checks a palm-sized view scanner he has pulled out of his utility belt. It shows a shot of ARTOO by the door, but no sign of PADMÉ on the bed.

Obi-Wan: What's going on?

ANAKIN shrugs.

Anakin: She covered the cameras. I don't think she liked me watching her.
Obi-Wan: What is she thinking?
Anakin: She programmed Artoo to warn us if there's an intruder.

Scene 017 **INTERIOR APARTMENT BUILDING, AMIDALA'S APARTMENT, BEDROOM—NIGHT**

PADMÉ is asleep in her bed, lit only by the light of the city outside her window coming through the blinds. ARTOO stands in the corner of the bedroom. His power is off.

Obi-Wan: (V.O.) It's not an intruder I'm worried about. There are many other ways to kill a Senator.
Anakin: (V.O.) I know, but we also want to catch this assassin. Don't we, Master?

Scene 018 **INTERIOR APARTMENT BUILDING, AMIDALA'S APARTMENT, MAIN ROOM—NIGHT**

ANAKIN and OBI-WAN continue their conversation.

Obi-Wan: You're using her as bait?
Anakin: It was her idea...Don't worry, no harm will come to her. I can sense everything going on in that room. Trust me.
Obi-Wan: It's too risky...besides, your senses aren't that attuned, my young apprentice.
Anakin: And yours are?
Obi-Wan: Possibly.

Scene 019 **EXTERIOR SKYSCRAPER LEDGE—NIGHT**

Standing on the skyscraper ledge, ZAM WESELL loads the cylinder carrying the deadly KOUHUNS into a PROBE DROID. She sends the PROBE DROID out into the Coruscant night.

Scene 020 **INTERIOR APARTMENT BUILDING, AMIDALA'S APARTMENT, MAIN ROOM—NIGHT**

ANAKIN and OBI-WAN continue their conversation, moving out onto the apartment's balcony.

Obi-Wan: You look tired.
Anakin: I don't sleep well anymore.
Obi-Wan: Because of your mother?
Anakin: I don't know why I keep dreaming about her now. I haven't seen her since I was little.
Obi-Wan: Dreams pass in time.
Anakin: I'd rather dream of Padmé. Just being around her again is... intoxicating.
Obi-Wan: Be mindful of your thoughts, Anakin, they betray you. You've made a commitment to the Jedi Order...a commitment not easily broken...and don't forget she's a politician. They're not to be trusted.

INTERIOR APARTMENT BUILDING, AMIDALA'S APARTMENT, BEDROOM—NIGHT

As PADMÉ sleeps, a PROBE DROID approaches outside her window. It sends out several small arms that attach to the window, creating sparks that shut down the security system. Then a large arm cuts a small hole in the glass. A FAINT SOUND is heard as the small section of glass is removed from the window.

ARTOO wakes up, and his lights go on. The PROBE DROID freezes. ARTOO looks around, makes a PLAINTIVE LITTLE SOUND, then shuts down again. The PROBE DROID attaches a little tube to the window. TWO DEADLY LOOKING CENTIPEDE-LIKE KOUHUNS exit the tube, crawl through the blinds, and head toward the sleeping PADMÉ.

Anakin: *(V.O.)* She's not like the others in the Senate, Master.
Obi-Wan: *(V.O.)* It's been my experience that Senators are only focused on pleasing those who fund their campaigns...and they are more than willing to forget the niceties of democracy to get those funds.
Anakin: *(V.O.)* Not another lecture, Master. Not on the economics of politics...

Scene 022 **INTERIOR APARTMENT BUILDING, AMIDALA'S APARTMENT, MAIN ROOM—NIGHT**

ANAKIN and OBI-WAN continue their conversation, walking back into the main room.

Anakin: ...and besides, you're generalizing. The Chancellor doesn't appear to be corrupt.
Obi-Wan: Palpatine's a politician.

Scene 023 **INTERIOR APARTMENT BUILDING, AMIDALA'S APARTMENT, BEDROOM—NIGHT**

ARTOO sounds an alarm and shines a light on the bed. The KOUHUNS are inches from PADMÉ's face. Their mouths are open, and wicked stinger tongues flick out.

Obi-Wan: *(V.O.)* I've observed that he is very clever at following the passions and prejudices of the Senators.

Scene 024 **INTERIOR APARTMENT BUILDING, AMIDALA'S APARTMENT, MAIN ROOM—NIGHT**

Anakin and Obi-Wan continue their conversation.

Anakin: I think he is a good man. My instincts are very positive about...

ANAKIN looks stunned. He looks sharply at OBI-WAN.

Obi-Wan: I sense it too.

Scene 025 **INTERIOR APARTMENT BUILDING, AMIDALA'S APARTMENT, BEDROOM—NIGHT**

OBI-WAN and ANAKIN burst into the room. The KOUHUNS stand on their hind legs and hiss as PADMÉ wakes up. ANAKIN throws himself in front of her, whacking in half the deadly creatures with his lightsaber.

OBI-WAN sees the DROID outside the window and races straight at it, crashing through the blinds as he goes through the window.

Scene 026 **EXTERIOR WINDOW LEDGE, APARTMENT BUILDING—NIGHT**

OBI-WAN flies through the glass window and flings himself at the PROBE DROID, grabbing onto the deadly machine before it can flee. The PROBE DROID sinks under the weight of OBI-WAN but manages to stay afloat and fly away, with the Jedi hanging on for dear life, a hundred stories above the city.

Scene 027 **INTERIOR APARTMENT BUILDING, AMIDALA'S APARTMENT—NIGHT**

ANAKIN and PADMÉ stare at the sight of OBI-WAN being carried off by the DROID. ANAKIN turns to her. She pulls her nightdress around her shoulders.

Anakin: Stay here!

CAPTAIN TYPHO, with TWO GUARDS and DORMÉ, enter the room as ANAKIN dashes out.

Dormé: Are you all right, M'Lady?

PADMÉ nods yes.

Scene 028 **EXTERIOR CITYSCAPE, CORUSCANT—NIGHT**

The PROBE DROID sends several protective electrical shocks across its surface, causing OBI-WAN to almost lose his grip. As they dart in and out of the speeder traffic, OBI-WAN disconnects a wire on the back of the DROID. Its power shuts off! OBI-WAN and the DROID drop like rocks. OBI-WAN realizes the error of his ways and quickly puts the wire back. The DROID'S systems light up again, and it takes off.

Scene 029 **EXTERIOR SENATE APARTMENTS— ENTRANCE—NIGHT**

ANAKIN charges out of the building and runs to a line of parked speeders. He vaults into an open one and takes off, gunning it fast toward the lines of speeder traffic high above.

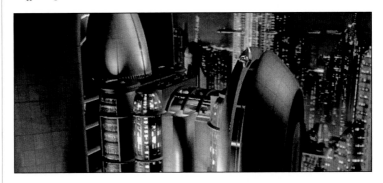

Scene 030 **EXTERIOR CITYSCAPE, CORUSCANT—NIGHT**

The DROID bumps against a wall, hoping to knock the Jedi loose. It moves behind a speeder afterburner to scorch him. It takes the JEDI wildly between buildings and finally skims across a rooftop as OBI-WAN is forced to lift his legs, then run across the roof, tenaciously hanging onto the DROID. The DROID heads for a dirty, beat-up speeder hidden in an alcove of a building about twenty stories up. When the pilot of the speeder, the scruffy Bounty Hunter, ZAM WESELL, sees the DROID approach with OBI-WAN hanging on, she pulls a long rifle out of the speeder and starts to fire at the JEDI. EXPLOSIONS burst all around OBI-WAN. ZAM runs to her speeder, jumps in, and takes off.

Obi-Wan: I have a bad feeling about this.

FINALLY the DROID suffers a direct hit and blows up. OBI-WAN falls fifty stories, until a speeder drops down next to him, and he manages to grab onto the back end of the speeder and haul himself toward the cockpit. The JEDI struggles to climb into the passenger seat of the open speeder and sits down next to the driver, ANAKIN.

Anakin: That was wacky! I almost lost you in the traffic.
Obi-Wan: What took you so long?
Anakin: Oh, you know, Master, I couldn't find a speeder I really liked, with an open cockpit...and with the right speed capabilities...and then you know I had to get a really gonzo color...

They zoom upward in hot pursuit of ZAM as she fires out the open window at them with her laser pistol.

Obi-Wan: If you'd spend as much time working on your saber skills as you do on your wit, young Padawan, you would rival Master Yoda as a swordsman.

Anakin: I thought I already did.

Obi-Wan: Only in your mind, my very young apprentice. Careful!! Hey, easy!!

As this conversation is going on, ANAKIN deftly moves in and out of the oncoming traffic, across lanes, between buildings, and miraculously through a construction site. ZAM WESELL continues firing at them.

Anakin: Sorry, I forgot you don't like flying, Master.

Obi-Wan: I don't mind flying...but what you're doing is suicide.

They barely miss a commuter train.

Anakin: Master, you know I've been flying since before I could walk. I'm very good at this.

Obi-Wan: Just slow down! There! There he goes!

ZAM WESELL and the JEDI race through a line of cross-traffic made up of giant trucks. The speeders bank sideways as they slide around right-angle turns between buildings. ZAM races into a tram tunnel.

Obi-Wan: Wait! Don't go in there! Take it easy...

Anakin: Don't worry, Master.

ANAKIN zooms into the tunnel after ZAM. They see a tram coming at them. They brake, turn around, and race out, barely ahead of the charging commuter transport.

Obi-Wan: You know I don't like it when you do that!

Anakin: Sorry, Master. Don't worry, this guy's gonna kill himself any minute now!

ZAM WESELL turns into oncoming traffic, deliberately trying to throw the JEDI off. Oncoming speeders swerve, trying to avoid ZAM and the JEDI. ZAM does a quick, tight loop-over and ends up behind the JEDI. She is now in a much better position to fire at them with her laser pistol. To avoid being hit by the laser bolts, ANAKIN slams on the brakes and moves alongside ZAM. She now fires point-blank at OBI-WAN.

Obi-Wan: What are you doing? He's gonna blast me.

Anakin: Right—this isn't working.

ANAKIN slides underneath Zam's speeder. They race along in traffic, one speeder right on top of the other. The BOUNTY HUNTER skims over the rooftops, causing ANAKIN to drop behind. ANAKIN goes through his gears, zooming around traffic. They race at high speed across a wide, flat surface of the city planet. A large spacecraft almost collides with them as it attempts to land.

Obi-Wan: Watch out for those banners!

They round a corner and clip a flag, which gets caught on one of the front air scoops.

Obi-Wan: That was too close!

Anakin: Clear that!

Obi-Wan: What?

Anakin: Clear the flag! We're losing power! Hurry!

OBI-WAN leans out of the speeder, then crawls out on the front engine and pulls the flag free of the scoop. The speeder lurches forward with a surge of power.

Obi-Wan: Whooooaaa! Don't do that! I don't like it when you do that!

Anakin: So sorry, Master.

They chase the BOUNTY HUNTER through a power refinery. ZAM shoots a power coupler causing voltage, like lightening, to jump across a gap from one coupler to another. ANAKIN stays on course, piloting the speeder directly through the arc. ANAKIN and OBI-WAN's bodies ripple with blue power.

Obi-Wan: Anakin! How many times have I told you to stay away from the power couplings! Slow down! Don't go through there!

Huge electrical bolts shoot between the buildings as the speeders pass.

Obi-Wan: Yiiii, what are you doing?

Anakin: Sorry, Master!

Obi-Wan: *(sarcastically)* Oh, that was good...

Anakin: That was crazy!!!

ZAM slides around a corner sideways, blocking an alley, firing point-blank as ANAKIN approaches.

Anakin: Ahh, damn.

Obi-Wan: Stop!!

Anakin: No, we can make it.

ANAKIN barely misses the BOUNTY HUNTER'S speeder as he dives under it, and through a small gap in the building, hitting several pipes and going wildly out of control. ANAKIN struggles to regain control of the speeder, narrowly missing a crane, barely clipping a pair of giant struts. A giant gas ball shoots up, causing ANAKIN to spin and bump a building, stalling the speeder.

Obi-Wan: I'm crazy...I'm crazy...I'm crazy.

Anakin: I got us through that one all right.

Obi-Wan: *(angrily)* No you didn't! We've stalled! And you almost got us killed!

Anakin: I think we're still alive.

ANAKIN works to get the speeder started. It races to life.

Obi-Wan: *(very angrily)* It was stupid!

Anakin: *(sheepishly)* I could have caught him...

Obi-Wan: *(furious)* But you didn't!!! And now we've lost him for good.

Suddenly, there is an ambush. Laser bolts are everywhere. EXPLOSIONS surround them. They look up and see ZAM WESELL take off.

Anakin: No we didn't...

Out of a cloud of smoke and ball of flames the JEDI tear after ZAM. They are smoking. OBI-WAN slaps out a small fire on the dashboard. ZAM goes up and down, through cross-traffic. There is a near miss as a speeder almost hits them. ZAM turns down and left between two buildings. ANAKIN pulls up and to the right.

Obi-Wan: Where are you going?!... He went down there, the other way.

Anakin: Master, if we keep this chase going, that creep's gonna end up deep fried. Personally, I'd very much like to find out who he is and who he's working for...This is a shortcut, I think.

Obi-Wan: *(sarcastic)* What do you mean, you "think?"

ANAKIN turns up a side street, zooms up several small passageways, then stops, hovering about fifty stories up.

Obi-Wan: Well, you lost him.

Anakin: I'm deeply sorry, Master.

ANAKIN looks around front and back. He spots something. He seems to start counting to himself as he watches something below approach.

Obi-Wan: Well, this is some kind of shortcut. He went completely the other way. Once again, Anakin...

Anakin: ...excuse me for a moment.

ANAKIN jumps out of the speeder. OBI-WAN looks down and sees ZAM'S speeder about five stories below them cruising past.

Obi-Wan: I hate it when he does that.

ANAKIN miraculously lands on top of the Bounty Hunter's speeder. The speeder wobbles under the impact. ZAM looks up and realizes what has happened.

ZAM takes off and ANAKIN slides to the back strut and almost slips off, but manages to hang on. ANAKIN works his way back to ZAM, who, caught off guard, briefly changes into her CLAWDITE form. ZAM stops suddenly, and ANAKIN flies forward to the left front fork. ZAM shoots at him with a laser pistol. There is a BLAST near ANAKIN'S hand, which breaks off a piece of the speeder. ANAKIN slides to the right fork of the speeder, where ZAM can't reach him, then he scrambles to the top, holding onto an air scoop.

OBI-WAN has jumped into the driver's seat of his speeder and is deftly gaining on the rogue speeder. The two speeders dive through oncoming traffic and then through cross traffic. Finally, ANAKIN is able to get hold of his lightsaber and starts to cut his way through the roof of the speeder. ZAM takes out her laser pistol and starts firing at the helpless JEDI, knocking the sword out of his hand. OBI-WAN races under the speeder and catches the Jedi weapon in the passenger's seat.

ANAKIN sticks his hand into the cockpit and, using the Force, pulls the gun out of ZAM'S hand. She grabs the JEDI'S hand, and they struggle for the weapon. It goes off, blowing a hole in the floor of the speeder. The speeder careens wildly out of control. ZAM struggles to pull the speeder out of its nosedive. OBI-WAN gets slowed down by traffic and loses sight of the Bounty Hunter's speeder.

Just as the speeder is about to nose dive into the ground, ZAM pulls it out, and it slides hard on the pavement in a shower of sparks. ANAKIN goes flying into the street.

Scene 031 | **EXTERIOR ENTERTAINMENT STREET—NIGHT**

ZAM exits the crashed speeder and runs. ANAKIN picks himself up off the pavement and runs after her down the very crowded street.

It's the seedy underbelly of the city. Broken sidewalks, garish lights reflected in filthy puddles. It's pretty crowded with various ALIEN LOW-LIFES, PANHANDLING DROIDS, and the occasional group of UPPERCLASS SLUMMERS.

ANAKIN barges into several of them as he chases after the fleeing ZAM. He loses the Bounty Hunter in the crowd, then sees her again. The young Jedi is having a very difficult time getting through the crowd. Ahead, ZAM turns in through a door and disappears. A nightclub sign is flashing over the door.

OBI-WAN lands the speeder in the nearby street. He gets out and runs through the crowd toward ANAKIN. ANAKIN is just about to follow ZAM into the nightclub when OBI-WAN catches up to him.

Obi-Wan: Anakin!
Anakin: She went into that club, Master.
Obi-Wan: Patience. Use the Force, Anakin. Think.
Anakin: Sorry, Master.
Obi-Wan: He went in there to hide, not run.
Anakin: Yes, Master

OBI-WAN hands ANAKIN the lightsaber.

Obi-Wan: Here. Next time try not to lose it.

ANAKIN reaches for the lightsaber.

Obi-Wan: A Jedi's saber is his most precious possession...
Anakin: Yes, Master.
Obi-Wan: He must keep it with him at all times.
Anakin: I know, Master.

OBI-WAN grabs holds of Anakin's lightsaber again.

Obi-Wan: This weapon is your life.
Anakin: I've heard this lesson before...

OBI-WAN finally holds out the lightsaber and ANAKIN grabs it.

Obi-Wan: But, you haven't learned anything, Anakin.

OBI-WAN releases hold of the lightsaber.

Anakin: I try, Master.

OBI-WAN walks ahead through the club entrance. ANAKIN follows him.

Obi-Wan: Why do I get the feeling you're going to be the death of me?!

Scene 032 | **INTERIOR NIGHTCLUB—NIGHT**

OBI-WAN and ANAKIN enter the nightclub bar, and everyone stares at them.

Anakin: Don't say that, Master...You're the closest thing I have to a father...I love you. I don't want to cause you pain.
Obi-Wan: Then why don't you listen to me?!
Anakin: I am trying.
Obi-Wan: Can you see him?
Anakin: I think he's a she...and I think she's a changeling.
Obi-Wan: In that case be extra careful... *(nods to the room)* Go and find her.

OBI-WAN goes away.

Anakin: Where are you going, Master?
Obi-Wan: For a drink.

OBI-WAN heads for the bar. ANAKIN blinks in surprise, then moves into the room, where ALIEN FACES look back at him with hostility, suspicion, and invitation as he moves among the tables. OBI-WAN arrives at the bar. He signals the BARMAN.

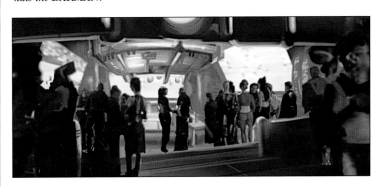

CLOSE—Somewhere in the room a HAND moves to a pistol in its holster and unsnaps the safety catch. At the bar, a glass is placed in front of OBI-WAN. A drink is poured. He lifts the glass.

Elan Sleazebaggano: You wanna buy some death sticks?

OBI-WAN looks at him. He moves his fingers slightly.

Obi-Wan: You don't want to sell me death-sticks.
Elan Sleazebaggano: I don't want to sell you death-sticks.

OBI-WAN moves his fingers.

Obi-Wan: You want to go home and rethink your life.
Elan Sleazebaggano: I want to go home and rethink my life.

He leaves. OBI-WAN lifts the drink and tosses it back.

CLOSE—The gun is drawn from its holster and held down out of sight. The BOUNTY HUNTER starts to move toward the bar.

The gun moves toward OBI-WAN's unsuspecting back. The gun is raised to aim directly at his back, and suddenly OBI-WAN turns fast. His lightsaber flashes. There is a shrill SCREAM and ZAM'S ARM hits the floor. The gun drops from its twitching fingers. Blood spreads.

The room is silent. ANAKIN is suddenly at OBI-WAN's side, his lightsaber glowing.

Anakin: Easy...official business. Go back to your drinks.

Slowly, the ALIENS sit. Conversation resumes. Onstage, THE PERFORMERS pick up their routine. OBI-WAN and ANAKIN lift ZAM and carry her out.

Scene 033	**EXTERIOR ALLEY OUTSIDE NIGHTCLUB—NIGHT**

OBI-WAN and ANAKIN carry ZAM into the alley and lower her to the ground. OBI-WAN attends to her wounded shoulder. She stares up hatefully at ANAKIN. She winces in pain, then nods.

Obi-Wan: Do you know who it was you were trying to kill?
Zam Wesell: The Senator from Naboo.
Obi-Wan: Who hired you?

ZAM glares at OBI-WAN.

Zam Wesell: It was just a job.
Anakin: Who hired you? Tell us!
Zam Wesell: That Senator's gonna die soon anyway, and the next one won't make the same mistake I did...
Obi-Wan: This wound's going to need treatment.
Anakin: Tell us...tell us now!

ZAM glares hatefully.

Zam Wesell: It was a bounty hunter called...

There is a sudden FTZZZ sound. ZAM twitches. She blinks in surprise and dies. As OBI-WAN lays Zam down on the street, she changes to her CLAWDITE form.

There is a WHOOSH from above. OBI-WAN and ANAKIN look up to see an ARMORED ROCKET-MAN taking off from a roof high above. He shoots up fast into the sky and disappears. OBI-WAN looks down at ZAM. He touches her neck and pulls out a small, wicked-looking dart.

Obi-Wan: Toxic dart...

Scene 034	**EXTERIOR JEDI TEMPLE—DAY**

The tall spires of the Jedi Temple stand out against the blue sky.

Scene 035	**INTERIOR JEDI TEMPLE, COUNCIL CHAMBER—DAY**

OBI-WAN and ANAKIN stand in the center of the Council Chamber. The members of the Jedi Council are seated in a circle surrounding the two Jedi.

Yoda: Track down this bounty hunter, you must, Obi-Wan.
Mace Windu: Most importantly, find out who he's working for.
Obi-Wan: What about Senator Amidala? She will still need protecting.
Yoda: Handle that, your Padawan will.
Mace Windu: Anakin, escort the Senator back to her home planet of Naboo. She'll be safer there. And don't use registered transport. Travel as refugees.
Anakin: As the leader of the opposition, it will be very difficult to get Senator Amidala to leave the Capital.
Yoda: Until caught this killer is, our judgment she must respect.

Mace Windu: Anakin, go to the Senate and ask Chancellor Palpatine to speak with her.

The two Jedi exit the Council Chamber.

Scene 036	**INTERIOR SENATE BUILDING, PALPATINE'S OFFICE—DAY**

ANAKIN and PALPATINE stand at the window of PALPATINE'S office and look out over the vast city.
Palpatine: I will talk to her. Senator Amidala will not refuse an executive order. I know her well enough to assure you of that.
Anakin: Thank you, your Excellency.
Palpatine: And so, my young Padawan, they have finally given you an assignment. Your patience has paid off.
Anakin: Your guidance more than my patience.
Palpatine: You don't need guidance, Anakin. In time you will learn to trust your feelings. Then you will be invincible. I have said it many times, you are the most gifted Jedi I have ever met.

PALPATINE and ANAKIN turn away from the window and walk through PALPATINE'S office towards the door.

Anakin: Thank you, your Excellency.
Palpatine: I see you becoming the greatest of all the Jedi, Anakin. Even more powerful than Master Yoda.

Scene 037	**INTERIOR JEDI TEMPLE, ATRIUM—DAY**

MACE WINDU and OBI-WAN walk along the Temple corridors. YODA accompanies them, riding in a small floating chair.

Obi-Wan: I am concerned for my Padawan. He is not ready to be given this assignment on his own yet.
Yoda: The Council is confident in this decision, Obi-Wan.
Mace Windu: The boy has exceptional skills.
Obi-Wan: But he still has much to learn, Master. His abilities have made him...well, arrogant.
Yoda: Yes, yes. It's a flaw more and more common among Jedi. Too sure of themselves they are. Even the older, more experienced ones.
Mace Windu: Remember, Obi-Wan. If the prophecy is true, your apprentice is the only one who can bring the Force back into balance.
Obi-Wan: If he follows the right path.

Scene 038	**INTERIOR APARTMENT BUILDING, AMIDALA'S APARTMENT—DAY**

ANAKIN looks on as PADMÉ and JAR JAR talk, standing near the door of the anteroom to PADMÉ's bedroom. DORMÉ moves about packing luggage.

Padmé: I'm taking an extended leave of absence. It will be your responsibility to take my place in the Senate. Representative Binks, I know I can count on you.
Jar Jar: Mesa honored to be taken on dissa heavy burden *(pompously)* Mesa accept this with muy muy humility and da...
Padmé: Jar Jar. I don't wish to hold you up. I'm sure you have a great deal to do.
Jar Jar: Of course, M'Lady.

JAR JAR bows and goes out. PADMÉ walks briskly to ANAKIN. She is in a very bad mood.

Padmé: I do not like this idea of hiding.
Anakin: Don't worry, now that the Council has ordered an investigation, it won't take Master Obi-Wan long to find this bounty hunter.
Padmé: *(frustrated)* I haven't worked for a year to defeat the Military Creation Act not to be here when its fate is decided!
Anakin: Sometimes we have to let go of our pride and do what is requested of us.
Padmé: Pride?!? Annie, you're young, and you don't have a very firm grip on politics. I suggest you reserve your opinions for some other time.
Anakin: Sorry, M'Lady. I was only trying to...
Padmé: Annie! No!
Anakin: Please don't call me that.
Padmé: What?
Anakin: Annie...
Padmé: I've always called you that...it is your name, isn't it?
Anakin: It's Anakin. When you say Annie it's like I'm still a little boy... and I'm not.
Padmé: I'm sorry, Anakin. It's impossible to deny. You've...*(looks him over)*...that you've grown up.

PADMÉ smiles at ANAKIN. He becomes a little shy.

Anakin: Master Obi-Wan manages not to see it...
Padmé: Mentors have a way of seeing more of our faults than we would like. It's the only way we grow.
Anakin: Don't get me wrong...Obi-Wan is a great mentor, as wise as Master Yoda and as powerful as Master Windu. I am truly thankful to be his apprentice. Only...although I'm a Padawan learner, in some ways...a lot of ways...I'm ahead of him. I'm ready for the trials. I know I am! He knows it too. But he feels I'm too unpredictable...Other Jedi my age have gone through the trials and made it...I know I started my training late...but he won't let me move on.
Padmé: That must be frustrating.
Anakin: It's worse...he's overly critical! He never listens! He just doesn't understand. It's not fair!

Padmé cannot suppress a laugh. She shakes her head.

Padmé: I'm sorry...You sounded exactly like that little boy I once knew, when he didn't get his way.
Anakin: I'm not whining! I'm not.

PADMÉ just smiles at him. DORMÉ laughs in the background.

Padmé: I didn't say it to hurt you.
Anakin: I know...

There is a brief silence, then PADMÉ comes over to ANAKIN.

Padmé: Anakin...

They look into each other's eyes for the first time.

Padmé: Don't try to grow up too fast.
Anakin: I am grown up. You said it yourself.

ANAKIN looks deep into PADMÉ's eyes.

Padmé: Please don't look at me like that.
Anakin: Why not?
Padmé: Because I can see what you're thinking.
Anakin: *(laughing)* Ahh...So, you have Jedi powers too?

DORMÉ is watching with concern.

Padmé: It makes me feel uncomfortable.
Anakin: Sorry, M'Lady.

ANAKIN backs away as PADMÉ turns and goes back to her packing.

| Scene 039 | **EXTERIOR CORUSCANT, SPACEPORT FREIGHTER DOCKS, TRANSPORT BUS—DAY** |

A small bus speeds toward the massive freighter docks of Coruscant's industrial area. The spaceport is bustling with activity. Transports of various sizes move supplies and passengers as giant floating cranes lift cargo out of the starships. The bus stops before a huge, intergalactic freighter starship. It parks in the shadows of an overhang.

| Scene 040 | **INTERIOR CORUSCANT, SPACEPORT FREIGHTER DOCKS, TRANSPORT BUS—DAY** |

ANAKIN and PADMÉ, dressed in Outland peasant outfits, get up and head for the door where CAPTAIN TYPHO, DORMÉ, and OBI-WAN are waiting to hand them their luggage.

Typho: Be safe, M'Lady.
Padmé: Thank you, Captain. Take good care of Dormé...The threat's on you two now.
Dormé: He'll be safe with me.

They laugh, and PADMÉ embraces her faithful handmaiden. DORMÉ starts to weep.

Padmé: You'll be fine.
Dormé: It's not me, M'Lady. I worry about you. What if they realize you've left the Capital?
Padmé: *(looks to Anakin)* Then my Jedi protector will have to prove how good he is.

DORMÉ and PADMÉ smile. ANAKIN frowns as OBI-WAN pulls him aside.

Obi-Wan: Anakin. Don't do anything without first consulting either myself or the Council.
Anakin: Yes, Master.
Obi-Wan: *(to Padmé)* I will get to the bottom of this plot quickly, M'Lady. You'll be back here in no time.
Padmé: I will be most grateful for your speed, Master Jedi.
Anakin: Time to go.
Padmé: I know.

PADMÉ gives DORMÉ a last hug, ANAKIN picks up the luggage, and the TWO PEASANTS exit the speeder bus, where ARTOO is waiting for them.

Obi-Wan: Anakin, may the Force be with you.
Anakin: May the Force be with you, Master.

They head off toward the giant Starfreighter.

Padmé: Suddenly, I'm afraid...
Anakin: This is my first assignment on my own. I am too. *(looking at Artoo)* But don't worry. We've got Artoo with us.

They laugh.

OBI-WAN and CAPTAIN TYPHO watch ANAKIN and PADMÉ disappear into the vastness of the spaceport with ARTOO trundling along behind them.

Obi-Wan: I hope he doesn't try anything foolish.

Typho: I'd be more concerned about her doing something, than him.

Scene 041 **EXTERIOR FREIGHTER DOCKS, CORUSCANT—DAY**

The freighter slowly takes off from the huge docks area of Coruscant. It soon moves into the crowded skies.

Scene 042 **INTERIOR JEDI TEMPLE, MAIN HALLWAY—LATE DAY**

From high above, light streams down from the lofty ceilings. OBI-WAN crosses the floor of the great hallway, heading for the Analysis Rooms.

Scene 043 **INTERIOR JEDI TEMPLE, ANALYSIS CUBICLES—LATE DAY**

OBI-WAN walks past several glass cubicles where work is going on. He comes to an empty one and sits down in front of a console. An SP-4 ANALYSIS DROID comes to life. A tray slides out of the console.

SP-4: Place the subject for analysis on the sensor tray, please.

OBI-WAN puts the dart onto the tray, which retracts into the console. The DROID activates the system, and a screen lights up in front of OBI-WAN.

Obi-Wan: It's a toxic dart. I need to know where it came from and who made it.

SP-4: One moment, please.

Diagrams and data appear on the screen, scrolling past at great speed. OBI-WAN watches as the screen goes blank. The tray slides out.

SP-4: Markings cannot be identified. As you can see on your screen, subject weapon does not exist in any known culture. Probably self-made by a warrior not associated with any known society. Stand away from the sensor tray please.

Obi-Wan: Excuse me? Could you try again please?

SP-4: Master Jedi, our records are very thorough. They cover eighty percent of the galaxy. If I can't tell you where it came from, nobody can.

OBI-WAN picks up the dart and looks at it, then looks to the DROID.

Obi-Wan: Thanks for your assistance! *(to himself)* I know who can identify this.

Scene 044 **EXTERIOR CORUSCANT, DOWNTOWN, BACK STREET—MORNING**

OBI-WAN walks down the street. It is a pretty tough part of town. Old buildings, warehouses, beat up speeders and transporter rigs thundering past. Above, the old elevated monospeed with occasional "shiny freighters" hissing through.

OBI-WAN comes to a kind of alien diner. On the steamed-up windows it says "DEX'S DINER," in alien lettering. He goes inside.

Scene 045 **INTERIOR CORUSCANT, DEX'S DINER—MORNING**

A WAITRESS DROID is carrying plates of half-eaten food. There is a counter with stools and a line of booths along the wall by the window. A number of CUSTOMERS are eating—TOUGH-LOOKING WORKERS, FREIGHTER DRIVERS, ETC. The WAITRESS DROID looks up as OBI-WAN comes in.

Waitress Droid: Can I help ya?

Obi-Wan: I'm looking for Dexter.

The WAITRESS DROID approches OBI-WAN.

Waitress Droid: Waddya want him for?

Obi-Wan: He's not in trouble. It's personal.

There is a brief pause, then the DROID goes to the open serving hatch behind the counter.

Waitress Droid: Someone to see ya, honey. *(lowering her voice)* A Jedi, by the looks of him.

Steam billows out from the kitchen hatch behind the counter as a huge head pokes through.

Dexter Jettster: Obi-Wan!

Obi-Wan: Hey, Dex.

Dexter Jettster: Take a seat! Be right with ya!

OBI-WAN sits in a booth.

Waitress Droid: You want a cup of ardees?

Obi-Wan: Oh yes, thank you.

The WAITRESS DROID moves off as the door to the counter opens and DEXTER JETTSTER appears. He is big—bald and sweaty, old and alien. Not someone to tangle with. He arrives, beaming hugely.

Dexter Jettster: Hey, ol' buddy!

Obi-Wan: Hey, Dex.

DEXTER eases himself into the seat opposite OBI-WAN. He can just make it.

Dexter Jettster: So, my friend. What can I do for ya?

Obi-Wan: You can tell me what this is.

OBI-WAN places the dart on the table between them. DEX's eyes widen. He puts down his mug.

Dexter Jettster: *(softly)* Well, waddya know...

DEXTER picks up the dart delicately between his puffy fingers and peers at it.

Dexter Jettster: I ain't seen one of these since I was prospecting on Subterrel beyond the Outer Rim!

Obi-Wan: Can you tell where it came from?

DEXTER grins. He puts the dart down between them.

Dexter Jettster: This baby belongs to them cloners. What you got here is a Kamino saberdart.

Obi-Wan: Kamino saberdart?...I wonder why it didn't show up in our analysis archive.

Dexter Jettster: It's these funny little cuts on the side that give it away...Those Analysis Droids you've got over there only focus on symbols, you know. I should think you Jedi would have more respect for the difference between knowledge and wisdom.

Obi-Wan: Well, Dex, if droids could think, we wouldn't be here, would we? *(laughing)* Kamino...doesn't sound familiar. Is it part of the Republic?

Dexter Jettster: No, it's beyond the Outer Rim. I'd say about twelve parsecs outside the Rishi Maze, toward the south. It should be easy to find, even for those droids in your archive. These Kaminoans keep to themselves. They're cloners. Damned good ones, too.

OBI-WAN picks up the dart, holding it midway between them.

Obi-Wan: Cloners? Are they friendly?
Dexter Jettster: It depends.
Obi-Wan: On what, Dex?

DEXTER grins.

Dexter Jettster: On how good your manners are...and how big your pocketbook is...

Scene 046	**EXTERIOR JEDI TEMPLE—DAY**

The main entrance at the base of the huge Temple is bustling with activity. All sorts of JEDI are coming and going.

Scene 047	**INTERIOR JEDI TEMPLE, ARCHIVE LIBRARY—DAY**

A bronze bust of Count Dooku stands among a line of other busts of Jedi in the Archive Room. OBI-WAN stands in front of it, studying the striking features of the chiseled face.

On the walls, lighted computer panels seem to stretch to infinity. Farther along the room in the background, FIVE JEDI are seated at tables, studying archive material.

After OBI-WAN studies the bust for a few moments, MADAME JOCASTA NU, the Jedi Archivist, is standing next to him. She is an elderly, frail-looking human Jedi. Tough as old boots and smart as a whip.

Jocasta Nu: Did you call for assistance?
Obi-Wan: *(distracted in thought)* Yes...yes, I did...
Jocasta Nu: He has a powerful face, doesn't he? He was one of the most brilliant Jedi I have had the privilege of knowing.
Obi-Wan: I never understood why he quit. Only twenty Jedi have ever left the Order.
Jocasta Nu: *(sighs)* The Lost Twenty...Count Dooku was the most recent and the most painful. No one likes to talk about it. His leaving was a great loss to the Order.
Obi-Wan: What happened?
Jocasta Nu: Well, Count Dooku was always a bit out of step with the decisions of the Council...much like your old Master, Qui-Gon Jinn.
Obi-Wan: *(surprised)* Really?
Jocasta Nu: Oh, yes. They were alike in many ways. Very individual thinkers...idealists...

JOCASTA NU gazes at the bust.

Jocasta Nu: He was always striving to become a more powerful Jedi. He wanted to be the best. With a lightsaber, in the old style of fencing, he had no match. His knowledge of the Force was...unique. In the end, I think he left because he lost faith in the Republic. He believed that politics were corrupt, and he felt the Jedi betrayed themselves by serving the politicians. He always had very high expectations of government. He disappeared for nine or ten years, then just showed up recently as the head of the separatist movement.
Obi-Wan: It's very interesting. I'm not sure I completely understand.
Jocasta Nu: Well, I'm sure you didn't call me over here for a history lesson. Are you having a problem, Master Kenobi?
Obi-Wan: Yes, I'm trying to find a planet system called Kamino. It doesn't seem to show up on any of the archive charts.
Jocasta Nu: Kamino? It's not a system I'm familiar with...let me see...

JOCASTA NU leans over OBI-WAN's shoulder, looking at the screen.

Jocasta Nu: Are you sure you have the right coordinates?
Obi-Wan: *(nodding)* According to my information, it should be in this quadrant somewhere...just south of the Rishi Maze.

JOCASTA NU taps the keyboard and frowns.

Jocasta Nu: No coordinates? It sounds like the sort of directions you'd get from a street tout...some old miner or Furbog trader.
Obi-Wan: All three, actually.
Jocasta Nu: Are you sure it exists?
Obi-Wan: Absolutely.
Jocasta Nu: Let me do a gravitational scan.

OBI-WAN and JOCASTA NU study the star map hologram.

Jocasta Nu: There are some inconsistencies here. Maybe the planet you're seeking was destroyed.
Obi-Wan: Wouldn't that be on record?
Jocasta Nu: It ought to be, unless it was very recent. *(shakes her head)* I hate to say it, but it looks like the system you're searching for doesn't exist.
Obi-Wan: That's impossible...perhaps the archives are incomplete.
Jocasta Nu: The archives are comprehensive and totally secure, my young Jedi. One thing you may be absolutely sure of—if an item does not appear in our records, it does not exist!

OBI-WAN stares at her, then looks back to the map. JOCASTA NU notices a young boy approach. She turns from OBI-WAN and leaves with the youngster.

Scene 048	**EXTERIOR SPACE, STARSHIP FREIGHTER**

The massive, slow-moving freighter moves through space.

Scene 049	**INTERIOR STARFREIGHTER, STEERAGE HOLD—DAY**

A great, gloomy hold is crowded with EMIGRANTS and their belongings. To one side ARTOO is coming to the head of a food line holding two bowls. With one of his little claw-arms, he grabs a chunk of something that looks like bread.

ARTOO slips a tube into a tub of mush and sucks up a large quantity. A SERVER sees him.

Server: Hey! No droids!

ARTOO takes one last big suck and heads away from the food line. The SERVER shouts after him angrily. The little droid moves past groups of eating or sleeping EMIGRANTS and comes to ANAKIN and PADMÉ's table where ANAKIN is sound asleep. The young Jedi seems to be having a nightmare. He is very restless.

Anakin: No, no, Mom, no...

He is sweating. PADMÉ leans over resting her hand on his arm. He wakes with a start, then realizes where he is. PADMÉ simply looks at him. He stares back, somewhat confused.

Anakin: What?
Padmé: You seemed to be having a nightmare.

ANAKIN looks at PADMÉ a little more closely, trying to see if he revealed any of his secrets. She hands him a bowl of mush and bread.

Padmé: Are you hungry?
Anakin: Yeah.

PADMÉ takes the food from ARTOO and sets it on a make-shift table. ANAKIN rises and takes a seat as she places a bowl in front of him.

Anakin: Thanks.
Padmé: We went to lightspeed a while ago.

ANAKIN looks into PADMÉ's eyes.

Anakin: I look forward to seeing Naboo again. I've thought about it every day since I left. It's by far the most beautiful place I've ever seen...

PADMÉ is a little unnerved by his intense stare.

Padmé: It may not be as you remember it. Time changes perception.
Anakin: Sometimes it does...Sometimes for the better.
Padmé: It must be difficult having sworn your life to the Jedi...not being able to visit the places you like...or do the things you like...
Anakin: Or be with the people I love.
Padmé: Are you allowed to love? I thought it was forbidden for a Jedi.
Anakin: Attachment is forbidden. Possession is forbidden. Compassion, which I would define as unconditional love, is central to a Jedi's life, so you might say we're encouraged to love.
Padmé: You have changed so much.
Anakin: You haven't changed a bit. You're exactly the way I remember you in my dreams. I doubt if Naboo has changed much either.
Padmé: It hasn't...

There is an awkward moment.

Padmé: (continuing; changing the subject) You were dreaming about your mother earlier, weren't you?
Anakin: Yes...I left Tatooine so long ago, my memory of her is fading. I don't want to lose it. Recently I've been seeing her in my dreams... vivid dreams...scary dreams. I worry about her.

PADMÉ gives ANAKIN a sympathetic look.

| Scene 050 | INTERIOR JEDI TEMPLE, MAIN HALLWAY—DAY |

OBI-WAN walks through the main hallway to the training area.

| Scene 051 | INTERIOR JEDI TEMPLE, TRAINING VERANDA—DAY |

OBI-WAN comes out onto the veranda and stops, watching TWENTY or so FOUR-YEAR-OLDS doing training exercises, supervised by YODA. They wear helmets over their eyes and try to strike little TRAINING DROIDS with their miniature lightsabers. The DROIDS dance in front of them.

Yoda: Don't think...feel...be as one with the Force. Help you, it will. (he sees Obi-Wan) Younglings—enough! A visitor we have. Welcome him.

The CHILDREN turn off their lightsabers.

Yoda: Master Obi-Wan Kenobi, meet the mighty Bear Clan.
Children: Welcome, Master Obi-Wan!
Obi-Wan: I am sorry to disturb you, Master.
Yoda: What help to you, can I be?
Obi-Wan: I'm looking for a planet described to me by an old friend. I trust him, but the system doesn't show up on the archive maps.
Yoda: Lost a planet, Master Obi-Wan has. How embarrassing...how embarrassing. Liam, the shades. An interesting puzzle. Gather, younglings, around the map reader. Clear your minds and find Obi-Wan's wayward planet, we will.

The reader is a small shaft with a hollow at the top. The CHILDREN gather around it. OBI-WAN takes out a little glass ball and places it into the bowl. The window shades close, the reader lights up and projects the star map holo-gram into the room. The CHILDREN laugh. Some of them reach up to try and touch the nebulae and stars. OBI-WAN walks into the display.

Obi-Wan: This is where it ought to be...but it isn't. Gravity is pulling all the stars in this area inward to this spot. There should be a star here...but there isn't.
Yoda: Most interesting. Gravity's silhouette remains, but the star and all of its planets disappeared, they have. How can this be? Now, younglings, in your mind, what is the first thing you see? An answer? A thought? Anyone?

There is a brief pause. Then a CHILD puts his hand up. YODA nods.

Jedi Child Jack: Master? Because someone erased it from the archive memory.
Children: That's right! Yes! That's what happened! Someone erased it!
Jedi Child May: If the planet blew up, the gravity would go away.

OBI-WAN stares; YODA chuckles.

Yoda: Truly wonderful, the mind of a child is. The Padawan is right. Go to the center of gravity's pull, and find your planet you will.

YODA and OBI-WAN move away from the children. With a hand movement, OBI-WAN causes the star map to disappear. OBI-WAN uses the Force to call the glass ball back to his hand as the two walk into an adjoining room.

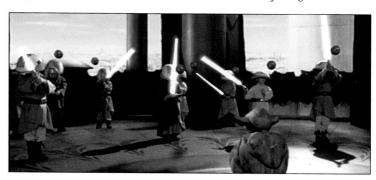

Obi-Wan: But Master Yoda, who could have erased information from the archives? That's impossible, isn't it?
Yoda: (frowning) Dangerous and disturbing this puzzle is. Only a Jedi could have erased those files. But who and why, harder to answer. Meditate on this, I will. May the Force be with you.

OBI-WAN leaves the room as YODA walks back toward the children.

| Scene 052 | EXTERIOR NABOO SPACEPORT—DAY |

The starfreighter lands in the giant port city of Theed.

PADMÉ, ANAKIN, and ARTOO are among the EMIGRANTS streaming from the starfreighter into the vast docking area. They exit onto the main plaza.

| Scene 053 | EXTERIOR NABOO PALACE, GRAND COURTYARD—AFTERNOON |

The speeder bus pulls up and stops. PADMÉ, ANAKIN, and ARTOO get out. The great courtyard stretches before them, and they see the rose-colored domes of the palace on the far side. ARTOO WHISTLES. They pick up their gear and start to cross the courtyard. ARTOO trundles behind them.

Anakin: If I grew up here, I don't think I'd ever leave.
Padmé: (laughing) I doubt that.
Anakin: No, really. When I started my training, I was very homesick and very lonely. This city and my mom were the only pleasant things I had to think about...The problem was, the more I thought about my mom, the worse I felt. But I would feel better if I thought about the palace—the way it shimmers in the sunlight—the way the air always smells of flowers...

Padmé: ...and the soft sound of the distant waterfalls. The first time I saw the Capital, I was very young...I'd never seen a waterfall before. I thought they were so beautiful...I never dreamed one day I'd live in the palace.

Anakin: Well, tell me, did you dream of power and politics when you were a little girl?

Padmé: (*laughing*) No. That was the last thing I thought of, but the more history I studied, the more I realized how much good politicans could do. After school, I became a Senatorial advisor with such a passion that, before I knew it, I was elected Queen. For the most part it was because of my conviction that reform was possible. I wasn't the youngest Queen ever elected, but now that I think back on it, I'm not sure I was old enough. I'm not sure I was ready.

Anakin: The people you served thought you did a good job. I heard they tried to amend the Constitution so you could stay in office.

Padmé: Popular rule is not democracy, Annie. It gives the people what they want, not what they need. And, truthfully, I was relieved when my two terms were up. So were my parents. They worried about me during the blockade and couldn't wait for it all to be over. Actually, I was hoping to have a family by now...My sisters have the most amazing, wonderful kids...So when the Queen asked me to serve as Senator, I couldn't refuse her.

Anakin: I agree! I think the Republic needs you...I'm glad you chose to serve. I feel things are going to happen in our generation that will change the galaxy in profound ways.

Padmé: I think so too.

ANAKIN and PADMÉ walk toward the palace. ARTOO continues to follow.

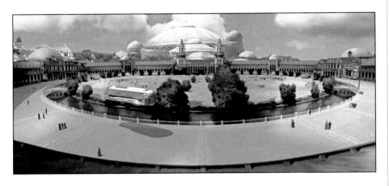

Scene 054 | **INTERIOR NABOO PALACE, THRONE ROOM – AFTERNOON**

QUEEN JAMILLIA is seated on the throne, flanked by SIO BIBBLE and a COUPLE OF ADVISORS. FOUR HANDMAIDENS stand close by, and GUARDS are at the doors.

Queen Jamillia: We've been worried about you. (*takes her hand*) I'm so glad you're safe, Padmé.

Padmé: Thank you, your Highness. I only wish I could have served you better by staying on Coruscant for the vote.

Sio Bibble: Given the circumstances, Senator, you know it was the only decision Her Highness could have made.

Queen Jamillia: How many systems have joined Count Dooku and the separatists?

Padmé: Thousands. And more are leaving the Republic every day. If the Senate votes to create an army, I'm sure it's going to push us into a civil war.

Sio Bibble: It's unthinkable. There hasn't been a full-scale war since the formation of the Republic.

Queen Jamillia: Do you see any way, through negotiations, to bring the separatists back into the Republic?

Padmé: Not if they feel threatened. The separatists don't have an army, but if they are provoked, they will move to defend themselves. I'm sure of that. And with no time or money to build an army, my

guess is they will turn to the Commerce Guilds or the Trade Federation for help.

Queen Jamillia: The armies of commerce! Why has nothing been done in the Senate to restrain them?

Padmé: I'm afraid that, despite the Chancellor's best efforts, there are still many bureaucrats, judges, and even Senators on the payrolls of the Guilds.

Sio Bibble: It's outrageous that, after all of those hearings, and four trials in the Supreme Court, Nute Gunray is still the Viceroy of the Trade Federation. I fear the Senate is powerless to resolve this crisis. Do those money mongers control everything?

Queen Jamillia: Remember, Counselor, the courts were able to reduce the Federation's armies. That's a move in the right direction.

Padmé: There are rumors, Your Highness, that the Trade Federation Army was not reduced as they were ordered.

Queen Jamillia: We must keep our faith in the Republic. The day we stop believing democracy can work is the day we lose it.

Padmé: Let's pray that day never comes.

Queen Jamillia: In the meantime, we must consider your own safety.

SIO BIBBLE signals. All the OTHER ADVISORS and ATTENDANTS bow and leave the room.

Sio Bibble: (*to Anakin*) What is your suggestion, Master Jedi?

Padmé: Anakin's not a Jedi yet, Counselor. He's still a Padawan learner. I was thinking....

Anakin: (*nettled*) Hey, hold on a minute.

Padmé: Excuse me! I was thinking I would stay in the Lake Country. There are some places up there that are very isolated.

Anakin: Excuse me! I am in charge of security here, M'Lady.

SIO BIBBLE and QUEEN JAMILLIA exchange a look. Something is going on here.

Padmé: Annie, my life is at risk, and this is my home. I know it very well... that is why we're here. I think it would be wise for you to take advantage of my knowledge in this instance.

Anakin: (*takes a deep breath*) Sorry, M'Lady.

Queen Jamillia: Perfect. It's settled then.

ANAKIN glares at PADMÉ. Then QUEEN JAMILLIA gets up, and they all start to leave.

Queen Jamillia: Padmé, I had an audience with your father yesterday. I told him what was happening. He hopes you will visit your mother before you leave...your family's very worried about you.

Padmé: Thank you, your Highness.

PADMÉ looks worried. They ALL exit down the main staircase.

Scene 055 | **EXTERIOR THEED, RESIDENTIAL AREA, SIDE STREET—AFTERNOON**

PEOPLE are passing through the little street, OLD MEN are sunning themselves, WOMEN are gossiping, KIDS are playing. ANAKIN, PADMÉ, and ARTOO turn onto a side street. ANAKIN is back in his Jedi robes. PADMÉ wears a beautiful simple dress. She stops, beaming.

Padmé: There's my house!

PADMÉ starts forward; ANAKIN hangs back.

Padmé: What? Don't say you're shy!

Anakin: (*untruthfully*) No, but I...

Suddenly, there are shouts from two little girls, RYOO (age 6) and POOJA (age 4). They come running toward PADMÉ.

Padmé: Ryoo!! Pooja!!

PADMÉ scoops up RYOO and POOJA and hugs them.

Padmé: Go wake up Artoo.
Ryoo & Pooja: Artoo!!!

As they see the droid, they hug him. ARTOO WHISTLES and BEEPS. PADMÉ laughs. ANAKIN and PADMÉ go on toward the house. The GIRLS stay and play with ARTOO.

Scene 056 **INTERIOR PADMÉ'S PARENTS' HOUSE, MAIN ROOM—AFTERNOON**

SOLA, PADMÉ'S beautiful older sister, comes in from the kitchen carrying a big bowl of food.

Sola: (over her shoulder) They're eating over at Jev Narran's later, Mom. They just had a snack. They'll be fine.

SOLA puts the bowl down on the table, where ANAKIN, PADMÉ, and RUWEE NABERRIE (Padmé's father) are coming into the room.

Sola: Padmé! (hugging her) You're late. Mom was worried.
Padmé: We walked. Anakin, this is my sister, Sola.
Sola: Hello, Anakin.
Anakin: Hello.

SOLA sits, as JOBAL NABERRIE (Padmé's mother) comes in with a heaped bowl of steaming food.

Padmé: …and this is my mother.
Jobal: You're just in time for dinner. I hope you're hungry, Anakin.
Anakin: A little.
Padmé: He's being polite, Mom. We're starving.
Ruwee: (grinning) You came to the right place at the right time.

EVERYONE sits and starts passing food.

Jobal: (to Padmé) Honey, it's so good to see you safe. We were so worried.

PADMÉ gives JOBAL a dirty look. RUWEE smiles as he watches.

Ruwee: Dear…
Jobal: I know, I know…but I had to say it. Now it's done.
Sola: Well, this is exciting! Do you know, Anakin, you're the first boyfriend my sister's ever brought home?
Padmé: (rolls her eyes) Sola!! He isn't my boyfriend! He's a Jedi assigned by the Senate to protect me.
Jobal: A bodyguard?! Oh, Padmé! They didn't tell us it was that serious!
Padmé: It's not, Mom, I promise. (glances at Jobal) Anyway, Anakin's a friend. I've known him for years. Remember that little boy who was with the Jedi during the blockade crisis?

They nod.

Padmé: He grew up.
Jobal: Honey, when are you going to settle down? Haven't you had enough of that life? I certainly have!
Padmé: Mom, I'm not in any danger.
Ruwee: (to Anakin) Is she?
Anakin: …Yes…I'm afraid she is.
Padmé: (quickly) But not much.

Scene 057 **EXTERIOR PADMÉ'S PARENTS' GARDEN—AFTERNOON**

ANAKIN and RUWEE are walking.

Ruwee: Sometimes I wish I'd traveled more…but I must say, I'm happy here.
Anakin: Padmé tells me you teach at the university?
Ruwee: (nodding) Yes, and before that, I was a builder. I also worked for the refugee relief movement when I was very young.

Scene 058 **INTERIOR PADMÉ'S PARENTS' HOUSE, MAIN ROOM—AFTERNOON**

PADMÉ, SOLA, and JOBAL are clearing the table.

Sola: Why haven't you told us about him?
Padmé: What's there to talk about? He's just a boy.
Sola: A boy? Have you seen the way he looks at you?
Padmé: Sola—stop it!
Sola: It's obvious he has feelings for you. Are you saying, little baby sister, that you haven't noticed?
Padmé: I'm not your baby sister, Sola. Anakin and I are friends…our relationship is strictly professional. (to Jobal) Mom, would you tell her to stop it?
Sola: (laughing) Well, maybe you haven't noticed the way he looks at you. I think you're afraid to.
Padmé: Cut it out.
Jobal: Sola's just concerned…we all are.
Padmé: Oh, Mom, you're impossible. What I'm doing is important.
Jobal: You've done your service, Padmé, It's time you had a life of your own. You're missing so much!

Scene 059 **EXTERIOR PADMÉ'S PARENTS' GARDEN—AFTERNOON**

ANAKIN and RUWEE are walking in the garden. RUWEE stops and faces ANAKIN directly.

Ruwee: Now tell me, son. How serious is this thing? How much danger is my daughter really in?
Anakin: There have been two attempts on her life. Chances are there'll be more. My Master is tracking down the assassins. I'm sure he'll find out who they are. This situation, won't last long.
Ruwee: I don't want anything to happen to her.
Anakin: I don't either.

Scene 060 **INTERIOR PADMÉ'S PARENTS' HOUSE, PADMÉ'S ROOM—AFTERNOON**

PADMÉ throws some things into a bag.

Padmé: Don't worry, this won't take long.
Anakin: I just want to get there before dark.

PADMÉ goes on packing. ANAKIN looks around the room.

Anakin: You still live at home.
Padmé: I move around so much, I've never had a place of my own. Official residences have no warmth. I feel good here. I feel at home.
Anakin: I never had a real home. Home was always where my mom was.

ANAKIN picks up a framed hologram.

Anakin: Is this you?

The hologram shows PADMÉ at age seven or eight surrounded by forty or fifty little green creatures. She is holding one in her arms. They are all smiling hugely.

Padmé: That was when I went with a relief group to Shadda-Bi-Boran. Their sun was imploding, and the planet was dying. I was helping to relocate the children. See that little one I'm holding? His name was N'a-kee-tula, which means sweetheart. He was so full of life. All those kids were. They were never able to adapt…to live off their native planet.

ANAKIN picks up another hologram. It shows PADMÉ at age ten or eleven. She is wearing official robes and standing between two robed legislators. Her expression is severe.

Padmé: My first day as an Apprentice Legislator. Notice the difference?

PADMÉ pulls a face. ANAKIN grins. She continues packing. ANAKIN sets the two holograms down side by side—the beaming little girl and the stern, unsmiling adolescent.

Scene 061 **EXTERIOR SPACE**

The view is just like the star map hologram, plus the storm-shrouded planet of Kamino, which is exactly where it ought to be. OBI-WAN'S Starship disengages from the hyperspace transport ring and flies OVER CAMERA and heads down toward the planet.

Obi-Wan: There it is, Arfour, right where it should be. Our missing planet, Kamino. Those files were altered.

Scene 062 **EXTERIOR TIPOCA CITY, KAMINO LANDING**
 PLATFORM (RAINSTORM)—DAY

Heavy rains and hard-driving winds lash the platform as OBI-WAN'S Starship approaches. The huge, ultra-modern city of Tipoca rests on great stilts that keep it above the pounding and ever-present waves that cover the surface of this watery world.

The Starfighter lands. OBI-WAN gets out and makes his way through the howling wind toward a tower on the far side of the platform. A door slides open. A shaft of brilliant light pierces the swirling rain. OBI-WAN passes through it and goes inside.

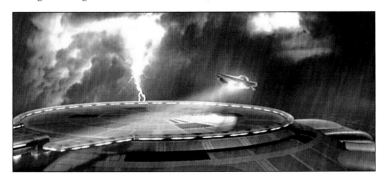

Scene 063 **INTERIOR TIPOCA CITY,**
 CORRIDOR ENTRANCE—DAY

Brilliant white light. OBI-WAN pushes the soaking hood from his face.

Taun We: Master Jedi, so good to see you.

OBI-WAN wipes the rain from his face and blinks in surprise at a tall, pasty-white alien named TAUN WE. She has large, almond-shaped eyes.

Taun We: The Prime Minister expects you.
Obi-Wan: *(warily)* I'm expected?
Taun We: Of course! He is anxious to meet you. After all these years, we were beginning to think you weren't coming. Now please, this way!

OBI-WAN masks his surprise as they move away along the corridor.

Scene 064 **INTERIOR TIPOCA CITY, PRIME MINISTER**
 OFFICE—DAY

The door slides open. OBI-WAN and TAUN WE enter and cross to where LAMA SU rises, smiling, from his chair, which, like all the furniture on Kamino, seems made out of pure light.

Taun We: May I present Lama Su, Prime Minister of Kamino...and this is Master Jedi...
Obi-Wan: Obi-Wan Kenobi.

LAMA SU indicates a chair. OBI-WAN remains standing. TAUN WE hovers. The room is bathed in brilliant white light. The whole place is ultra high-tech.

Lama Su: I trust you are going to enjoy your stay. We are most happy you have arrived at the best part of the season.
Obi-Wan: You make me feel most welcome.
Lama Su: Please...*(gestures to chair)* And now to business. You will be delighted to hear we are on schedule. Two hundred thousand units are ready, with another million well on the way.
Obi-Wan: *(improvising)* That is...good news.
Lama Su: Please tell your Master Sifo-Dyas that we have every confidence his order will be met on time and in full. He is well, I hope.
Obi-Wan: I'm sorry? Master—?
Lama Su: Jedi Master Sifo-Dyas. He's still a leading member of the Jedi Council, is he not?
Obi-Wan: Master Sifo-Dyas was killed almost ten years ago.
Lama Su: Oh, I'm so sorry to hear that. But I'm sure he would have been proud of the army we've built for him.
Obi-Wan: The army?
Lama Su: Yes, a clone army. And I must say one of the finest we've ever created.
Obi-Wan: Tell me, Prime Minister, when my Master first contacted you about the army, did he say who it was for?
Lama Su: Of course he did. This army is for the Republic. But you must be anxious to inspect the units for yourself.
Obi-Wan: That's why I'm here.

OBI-WAN and LAMA SU rise and walk toward the door.

Scene 065 **EXTERIOR NABOO LAKE RETREAT, WATER**
 SPEEDER, LANDING PLATFORM—
 LATE AFTERNOON

A water speeder driven by PADDY ACCU, the retreat caretaker, docks at the island landing platform. ANAKIN and PADMÉ disembark the water speeder at the base of a lodge rising on the beautiful island in the middle of the lake.

Scene 066 **EXTERIOR NABOO LAKE RETREAT, LODGE,**
 GARDEN TERRACE—LATE AFTERNOON

ANAKIN and PADMÉ walk up the stairs from where the water speeder is parked onto a terrace overlooking a lovely garden. Behind them, PADDY ACCU follows.

ANAKIN and PADMÉ stop at the balustrade. PADMÉ looks out across the garden to the shimmering lake and the mountains rising beyond. ANAKIN looks at her.

Padmé: When I was in Level Three, we used to come here for school retreat. See that island? We used to swim there every day. I love the water.
Anakin: I do too. I guess it comes from growing up on a desert planet.

PADMÉ becomes aware that ANAKIN is looking at her.

Padmé: ...We used to lie on the sand and let the sun dry us...and try to guess the names of the birds singing.
Anakin: I don't like sand. It's coarse and rough and irritating, and it gets everywhere. Not like here. Here everything's soft....and smooth...

He touches her arm. PADMÉ has become receptive to the way he looks at her but is nervous.

Padmé: There was a very old man who lived on the island. He used to make glass out of sand—and vases and necklaces out of the glass. They were magical.
Anakin: *(looks in her eyes)* Everything here is magical.
Padmé: You could look into the glass and see the water. The way it ripples and moves. It looked so real...but it wasn't.
Anakin: Sometimes, when you believe something to be real, it becomes real.

They look into each other's eyes.

Padmé: I used to think if you looked too deeply into the glass, you would lose yourself.
Anakin: I think it's true...

ANAKIN kisses PADMÉ. She doesn't resist. She comes to her senses and pulls away.

Padmé: No, I shouldn't have done that.
Anakin: I'm sorry. When I'm around you, my mind is no longer my own.

He looks at her.

| Scene 067 | EXTERIOR TIPOCA CITY, PARADE GROUND (RAINSTORM)—DAY |

OBI-WAN, LAMA SU, and TAUN WE come out onto a balcony. Below is a huge parade ground. The rain and wind are brutal. THOUSANDS OF CLONE TROOPERS, faces covered by helmets, are marching and drilling in formations of several hundred.

Lama Su: *(beaming)* Magnificent, aren't they?

OBI-WAN nods slowly.

| Scene 068 | INTERIOR TIPOCA CITY, CLONE CENTER, HATCHERY—DAY |

They enter a space filled with great racks of glass spheres, which are filled with fluid in which EMBRYOS are suspended.

Obi-Wan: Very impressive.
Lama Su: I hoped you would be pleased. Clones can think creatively. You'll find that they are immensely superior to droids.

OBI-WAN gazes at the nearest embryos.

| Scene 069 | INTERIOR TIPOCA CITY, CLONE CENTER, CLASSROOM—DAY |

The tour continues through a classroom filled with IDENTICAL YOUNG BOY CLONES.

Lama Su: We take great pride in our combat education and training programs. This group was created about five years ago.
Obi-Wan: You mentioned growth acceleration...
Lama Su: Oh yes, it's essential. Otherwise, a mature clone would take a lifetime to grow. Now, we can do it in half the time. Those items you saw on the parade ground were started ten years ago, when Sifo-Dyas first placed the order, and they're already mature.

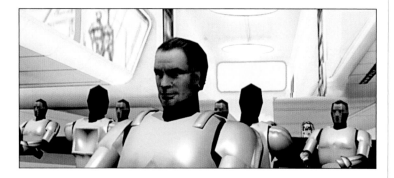

| Scene 070 | INTERIOR TIPOCA CITY, CLONE CENTER, COMMISSARY—DAY |

LAMA SU conducts OBI-WAN through a large eating area. TAUN WE follows as they walk by HUNDREDS OF CLONES who look exactly alike, all about twenty years old, dressed in black. They are seated at tables, eating.

Lama Su: You'll find they are totally obedient, taking any order without question. We modified their genetic structure to make them less independent than the original host.
Obi-Wan: Who was the original host?
Lama Su: A bounty hunter called Jango Fett. We felt a Jedi would be the perfect choice, but Sifo-Dyas hand-picked Jango Fett himself.
Obi-Wan: Where is this bounty hunter now?
Lama Su: Oh, we keep him here.

| Scene 071 | INTERIOR TIPOCA CITY, CLONE CENTER, BARRACKS—DAY |

The tour continues through a long corridor filled with narrow, transparent tubes into which CLONES are climbing. Once in the tube, the CLONE goes to sleep.

Lama Su: Apart from his pay, which is considerable, Fett demanded only one thing—an unaltered clone for himself. Curious, isn't it?
Obi-Wan: Unaltered?
Lama Su: Pure genetic replication. No tampering with the structure to make it more docile...and no growth acceleration.
Obi-Wan: I would very much like to meet this Jango Fett.
Taun We: I would be most happy to arrange it, for you.

TAUN WE bows, and leaves.

| Scene 072 | EXTERIOR NABOO, MOUNTAIN MEADOW— LATE AFTERNOON |

PADMÉ and ANAKIN are in the middle of an idyllic hilly meadow, its lush grasses sprinkled with flowers. At a distance, a herd of SHAAKS grazes contentedly.

Beyond is the shimmering expanse of waterfalls of the lake. Several other lakes stretch to the horizon. The warm air is full of little floating puffballs. They sit on the grass, in a playful, coy mood, talking. PADMÉ is picking flowers.

Padmé: I don't know...
Anakin: Sure you do...you just don't want to tell me.
Padmé: Are you going to use one of your Jedi mind tricks on me?
Anakin: They only work on the weak-minded. You are anything but weak-minded.
Padmé: All right...I was twelve. His name was Palo. We were both in the Legislative Youth Program. He was a few years older than I...very cute...dark curly hair...dreamy eyes.
Anakin: All right, I get the picture. Whatever happened to him?
Padmé: I went into public service. He went on to become an artist.
Anakin: Maybe he was the smart one.
Padmé: You really don't like politicians, do you?
Anakin: I like two or three, but I'm not really sure about one of them. *(smiling)* I don't think the system works.
Padmé: How would you have it work?
Anakin: We need a system where the politicians sit down and discuss the problem, agree what's in the best interests of all the people, and then do it.
Padmé: That is exactly what we do. The trouble is that people don't always agree. In fact, they hardly ever do.
Anakin: Then they should be made to.
Padmé: By whom? Who's going to make them?
Anakin: I don't know. Someone.
Padmé: You?
Anakin: Of course not me.
Padmé: But someone.
Anakin: Someone wise.
Padmé: That sounds an awful lot like a dictatorship to me.

A mischievous little grin creeps across his face.

Anakin: Well, if it works...

PADMÉ stares at ANAKIN. He looks back at her, straight-faced, but can't hold back a smile.

Padmé: You're making fun of me!
Anakin: *(sarcastic)* Oh no, I'd be much too frightened to tease a Senator.
Padmé: You're so bad!

PADMÉ picks up a piece of fruit and throws it at him. He catches it. PADMÉ throws two more pieces of fruit, and ANAKIN catches them.

Anakin: You're always so serious.
Padmé: I'm so serious?!

ANAKIN then starts to juggle the fruit. PADMÉ laughs and throws more fruit at him. He manages to juggle them too until there are too many, and he loses control and ducks, letting the food fall on his head. They both laugh.

ANAKIN stands in front of a SHAAK, yelling at it and waving his arms. PADMÉ starts laughing as ANAKIN runs in circles, chased by the SHAAK.

Scene 073 | **EXTERIOR NABOO, MOUNTAIN MEADOW—LATE AFTERNOON**

A SHAAK crosses in front of PADMÉ, with ANAKIN is riding it, facing the SHAAK's tail. ANAKIN attempts to stand on the galloping SHAAK's back, but the SHAAK bucks and ANAKIN loses his balance and falls off. PADMÉ laughs even harder. ANAKIN lies still. Concerned, PADMÉ jumps up and runs to where ANAKIN is face down in the grass.

Padmé: Annie, Annie! Are you all right?

She turns him over. He is pulling a stupid face at her and laughing. She yelps in mock fury and takes a swing at him. He catches her arm. She struggles. They roll over in the grass, embracing, and looking into each other's eyes. Suddenly, they become aware of the contact between them. They let go of each other quickly and sit up, looking away.

ANAKIN stands up and holds out his hand to her. She takes it. He pulls her up. And now they are easy together, not self-conscious any more. PADMÉ scrambles up onto the SHAAK behind ANAKIN. She puts her arms around his waist and leans against his back. ANAKIN digs his heels in. The SHAAK starts forward, and they ride away.

Scene 074 | **EXTERIOR TIPOCA CITY (RAINSTORM)—DAY**

Rain lashes the city. Below, mighty waves pound the stilts, breaking almost to the height of the platforms. A large avian carrying a rain-soaked rider flies above the water toward a floating city.

Scene 075 | **INTERIOR TIPOCA CITY, CORRIDOR—DAY**

TAUN WE and OBI-WAN stand in front of the door of Jango Fett's apartment. TAUN WE waves his hand, and a muted bell RINGS.

As they wait, OBI-WAN notes the door lock entry mechanism. Then the door opens, and ten-year-old boy, BOBA FETT, looks at them. He is identical to the boys in the classroom.

Taun We: Boba, is your father here?

There is a brief pause.

Boba Fett: Yep.
Taun We: May we see him?
Boba Fett: Sure.

Another brief pause, then BOBA FETT steps aside, and TAUN WE and OBI-WAN go through.

Scene 076 | **INTERIOR TIPOCA CITY, FETT APARTMENT—DAY**

OBI-WAN, TAUN WE, and BOBA FETT enter the apartment. OBI-WAN looks around the room.

Boba Fett: Dad! Taun We's here!

JANGO FETT comes in from the bedroom. He wears a jumpsuit. He is unshaven and mean looking, his face pitted with the scars of old wounds. There are a couple of weird tattoos on his muscular forearms. He eyes OBI-WAN with suspicion.

Taun We: Jango, welcome back. Was your trip productive?
Jango Fett: Fairly.

OBI-WAN and JANGO FETT size each other up. BOBA FETT studies both of them.

Taun We: This is Jedi Master Obi-Wan Kenobi. He's come to check on our progress.
Jango Fett: That right?

JANGO FETT's eyes fix OBI-WAN coldly.

Obi-Wan: Your clones are very impressive. You must be very proud.
Jango Fett: I'm just a simple man, trying to make my way in the universe, Master Jedi.
Obi-Wan: Aren't we all?

OBI-WAN eyes the half-open bedroom door, through which a couple of pieces of body armor can be seen on the floor. JANGO FETT registers OBI-WAN's look. He moves in front of him, blocking the view.

Obi-Wan: Ever make your way as far into the interior as Coruscant?
Jango Fett: Once or twice.
Obi-Wan: Recently?
Jango Fett: *(eyes Obi-Wan carefully)* Possibly...
Obi-Wan: Then you must know Master Sifo-Dyas?
Jango Fett: *(in Huttese)* Boba, close the door.

BOBA FETT moves to close the bedroom door. JANGO FETT smiles thinly at OBI-WAN.

Jango Fett: Master who?
Obi-Wan: Sifo-Dyas. Is he not the Jedi who hired you for this job?
Jango Fett: Never heard of him.
Obi-Wan: Really.
Jango Fett: I was recruited by a man called Tyranus on one of the moons of Bogden.
Obi-Wan: No? I thought...
Taun We: Sifo-Dyas told us to expect him. And he showed up just when your Jedi Master said he would. We have kept the Jedi's involvement a secret until your arrival, just as your Master requested.
Obi-Wan: Curious...
Jango Fett: Do you like your army?
Obi-Wan: I look forward to seeing them in action.
Jango Fett: *(grinning)* They'll do their job well, I'll guarantee that.
Obi-Wan: Thanks for your time, Jango.
Jango Fett: Always a pleasure to meet a Jedi.

OBI-WAN and TAUN WE go out. The door slides closed. JANGO FETT turns to his son. He is deep in thought.

Boba Fett: What is it, Dad?
Jango Fett: Pack your things. We're leaving.

EXTERIOR NABOO LAKE RETREAT, LODGE—LATE AFTERNOON

The setting sun touches the mountain peaks. The lake glows in the rose-tinted light. Floating lamps gleam softly like jewels at the lodge.

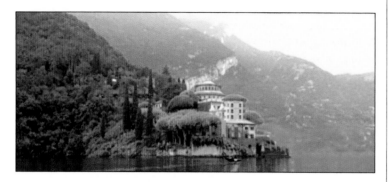

Scene 078 **INTERIOR NABOO LAKE RETREAT, DINING ROOM—LATE AFTERNOON**

NANDI places dessert in front of PADMÉ. TECKLA does the same for ANAKIN. The dessert is some kind of fruit.

Anakin: And when I got to them, we went into…aggressive negotiations.*(to Teckla)* Thank you.
Padmé: "Aggressive negotiations," what's that?
Anakin: Uh, well, negotiations with a lightsaber.
Padmé: *(laughing)* Oh.

PADMÉ picks up her fork and goes to spear a piece, but it moves! She frowns and tries again—the fruit moves. She looks up at ANAKIN. His eyes are on his plate.

Padmé: You did that?

ANAKIN looks up—wide-eyed innocence.

Anakin: What?

PADMÉ scowls at him. PADMÉ jabs at the fruit—ANAKIN subtly moves his hand and it lifts up from the plate and hovers in front of her!

Padmé: That! Now stop it!

PADMÉ laughs. ANAKIN laughs. She reaches out for the fruit—it loops.

Padmé: Anakin!!

ANAKIN moves his fingers. The fruit flies into his hand.

Anakin: If Master Obi-Wan caught me doing this, he'd be very grumpy.

ANAKIN is pleased. He cuts the fruit into several pieces and sends one back to PADMÉ. She bites it out of the air and laughs.

Scene 079 **INTERIOR NABOO LAKE RETREAT, LODGE, FIREPLACE ALCOVE—TWILIGHT**

A fire blazes in the open hearth. PADMÉ and ANAKIN are sitting in front of it, gazing into the flames. She looks up as ANAKIN leans in to kiss her.

Padmé: Anakin, no.
Anakin: From the moment I met you, all those years ago, a day hasn't gone by when I haven't thought of you. And now that I'm with you again, I'm in agony. The closer I get to you, the worse it gets. The thought of not being with you makes my stomach turn over—my mouth go dry. I feel dizzy. I can't breathe. I'm haunted by the kiss you should never have given me. My heart is beating, hoping that kiss will not become a scar. You are in my very soul, tormenting me. What can I do? I will do anything you ask…

Silence. The logs flame in the hearth. PADMÉ meets his eye, then looks away.

Anakin: If you are suffering as much as I am, tell me.
Padmé: …I can't. We can't. It's just not possible.
Anakin: Anything's possible. Padmé, please listen…
Padmé: You listen. We live in a real world. Come back to it. You're studying to become a Jedi Knight. I'm a Senator. If you follow your thoughts through to conclusion, they will take us to a place we cannot go…regardless of the way we feel about each other.
Anakin: Then you do feel something!
Padmé: Jedi aren't allowed to marry. You'd be expelled from the Order. I will not let you give up your future for me.
Anakin: You're asking me to be rational. That is something I know I cannot do. Believe me, I wish I could wish my feelings away…but I can't.
Padmé: I am not going to give in to this. I have more important things to do than fall in love.

There is silence as they stare at the fire. ANAKIN is thinking.

Anakin: It wouldn't have to be that way…we could keep it a secret.
Padmé: Then we'd be living a lie—one we couldn't keep up even if we wanted to. My sister saw it. So did my mother. I couldn't do that. Could you, Anakin? Could you live like that?

Silence for a moment.

Anakin: No. You're right. It would destroy us.

Scene 080 **INTERIOR TIPOCA CITY, CORRIDOR—DAY**

OBI-WAN stands with TAUN WE just inside the open door.

Lama Su: Tell your Council the first battalions are ready. And remind them that if they need more troops, it will take more time to grow them.
Obi-Wan: I won't forget. And thank you.
Taun We: Thank you.

Scene 081 **EXTERIOR TIPOCA CITY, KAMINO LANDING PLATFORM (RAINSTORM)—LATE DAY**

OBI-WAN comes out from the tower into the driving rain. The door closes behind him. He pulls his robe around him and stands braced against the gale. OBI-WAN glances back toward the closed door, confirming that LAMA SU has left.

Below, a huge wave crashes against the stilts. Spray flies high and whips across the platform to where OBI-WAN is standing. He walks over to his Starfighter, looks to see if anyone is watching, then addresses ARFOUR.

Obi-Wan: Arfour.

Scene 082 **EXTERIOR TIPOCA CITY LANDING PLATFORM, JEDI FIGHTER, (RAINSTORM)—LATE DAY**

R4-P17, OBI-WAN'S Astro-Droid, who is still sitting on top of OBI-WAN'S Starfighter, switches on and BEEPS.

Obi-Wan: Arfour, relay this, "scramble code five," to Coruscant: care of "the old folks home."

ARFOUR BEEPS and WHISTLES. The panels light up inside the cockpit. A transmitter disc emerges from the top of the starfighter and the message is transmitted.

Scene 083 **INTERIOR JEDI TEMPLE, YODA'S QUARTERS—LATE AFTERNOON**

YODA sits with MACE WINDU. Between the two Jedi, a hologram of OBI-WAN speaks.

Obi-Wan: *(V.O.)* I have successfully made contact with the Prime Minister of Kamino. The are using a bounty hunter named Jango Fett to create a clone army. I have a strong feeling that this bounty hunter is the assassin we're looking for.

Mace Windu: Do you think these cloners are involved in the plot to assassinate Senator Amidala?

Obi-Wan: *(V.O.)* No, Master. There appears to be no motive.

Yoda: Do not assume anything, Obi-Wan. Clear, your mind must be if you are to discover the real villains behind this plot.

Obi-Wan: *(V.O.)* Yes, Master. They say a Master Sifo-Dyas placed the order for a clone army at the request of the Senate almost ten years ago. I was under the impression he was killed before that. Did the Council ever authorize the creation of a clone army?

Mace Windu: No. Whoever placed that order did not have the authorization of the Jedi Council.

Yoda: Into custody, take this Jango Fett. Bring him here. Question him, we will.

Obi-Wan: *(V.O.)* Yes, Master. I will report back when I have him.

The hologram of OBI-WAN fades.

Yoda: Blind we are, if creation of this clone army we could not see.

Mace Windu: I think it is time to inform the Senate that our ability to use the Force has diminished.

Yoda: Only the Dark Lords of the Sith know of our weakness. If informed the Senate is, multiply our adversaries will.

Scene 084	INTERIOR NABOO LAKE RETREAT, ANAKIN'S BEDROOM—NIGHT

ANAKIN moves restlessly in his sleep. He mutters to himself. Sweat forms on his forehead. He turns violently. He cries out.

Anakin: No...No...No...Mom!..Don't, no, don't!

Scene 085	EXTERIOR NABOO LAKE RETREAT, LODGE, BALCONY OVERLOOKING GARDENS—MORNING

ANAKIN is on the balcony overlooking the gardens. After a moment, PADMÉ comes onto the balcony behind him. She sees he is meditating and turns to go.

Anakin: *(eyes closed)* Don't go.
Padmé: I don't want to disturb you.
Anakin: Your presence is soothing.

Brief pause.

Padmé: You had a nightmare again last night.
Anakin: Jedi don't have nightmares.
Padmé: I heard you.

ANAKIN opens his eyes at looks at her.

Anakin: I saw my mother. I saw her as clearly as I see you now. She is suffering, Padmé. They're killing her! She is in pain...I know I'm disobeying my mandate to protect you, Senator. I know I will be punished and possibly thrown out of the Jedi Order, but I have to go. I have to help her! I'm sorry, Padmé. I don't have a choice.
Padmé: I'll go with you. That way you can continue to protect me, and you won't be disobeying your mandate.
Anakin: What about Master Obi-Wan?

PADMÉ smiles and takes his hand

Padmé: I guess we won't tell him, will we?

Scene 086	INTERIOR TIPOCA CITY, CORRIDOR—DAY

OBI-WAN enters cautiously from outside. Ahead, the corridor is deserted. He moves down it.

Scene 087	INTERIOR TIPOCA CITY, CORRIDOR OUTSIDE FETT APARTMENT—DAY

OBI-WAN arrives at the door to JANGO FETT'S apartment. He reaches up and runs his fingers along the door, locating the locks. The door slides open.

Scene 088	INTERIOR TIPOCA CITY, FETT APARTMENT—DAY

OBI-WAN walks in to find the room in complete disorder. The bedroom door is wide open—clear signs of hurried departure. All of the FETTS' personal belongings are gone.

OBI-WAN goes to an ultra-thin computer screen. He punches up AN ONSCREEN PICTURE of JANGO FETT and BOBA FETT unhitching the lines securing their ship on the landing platform. JANGO FETT is wearing his armor and rocket pack.

Scene 089	EXTERIOR TIPOCA CITY, KAMINO LANDING PLATFORM, (RAINSTORM)—DAY

JANGO FETT's ship, SLAVE I, rests on the landing platform. JANGO and BOBA FETT are preparing to board. OBI-WAN rushes through the tower door and runs toward the ship.

Boba Fett: Dad!! Look!

JANGO FETT turns to see OBI-WAN charging out of the tower toward him. As he runs, OBI-WAN draws his lightsaber from his belt. It flashes on.

JANGO FETT draws his gun and fires at the charging JEDI. OBI-WAN deflects the blast and swings at JANGO FETT.

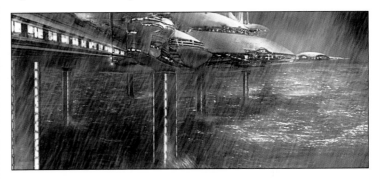

Jango Fett: Boba, get on board.

The bounty hunter rockets up and over OBI-WAN, landing on the top of a nearby tower. JANGO FETT fires down at OBI-WAN. The JEDI deflects the shots back, but JANGO FETT evades them. Then he fires an explosive sending OBI-WAN diving out of the way.

IN THE COCKPIT of JANGO FETT'S ship, BOBA FETT grabs the controls of a laser gun and swings it to aim at OBI-WAN, and fires.

The explosion of the ship's laser blasts throws OBI-WAN to the ground. His lightsaber skids across the wet surface of the landing platform. JANGO FETT drops from the tower landing in front of OBI-WAN. OBI-WAN rises and charges toward JANGO.

IN THE COCKPIT, BOBA FETT watches as:

OUTSIDE, OBI-WAN and JANGO FETT grapple and fight, punching, kicking, grabbing hold, and throwing each other around. OBI-WAN grabs JANGO FETT tightly, and JANGO FETT rockets up into the air and kicks OBI-WAN loose. OBI-WAN crashes to the deck and slides toward the edge. He grapples desperately for a handhold on the slick surface. OBI-WAN reaches out for his lightsaber, using the Force to bring it to him, but JANGO fires a thin wire from his wristpack. It wraps around OBI-WAN's wrists before he can retrieve the lightsaber.

JANGO rockets into the air, dragging OBI-WAN behind him along the platform surface. As OBI-WAN slides toward some columns he manages to maneu-

ver himself into a roll avoiding a collision by leveraging the wire against the structure and pulling himself to his feet. OBI-WAN pulls with all his weight against the momentum of the wire, causing JANGO to drop and crash into the ground. JANGO'S rocketpack breaks free from his back and explodes.

Still connected by the wire, OBI-WAN charges at JANGO kicking him over the platform edge. JANGO slides pulling OBI-WAN with him. Locked together, OBI-WAN and JANGO FETT plummet down toward the raging ocean. At the last moment, JANGO FETT sees the edge and digs his forearm claws into the surface. OBI-WAN slides past him as JANGO finally ejects the wire free from his wrist. OBI-WAN cannot stop the speed of his slide and shoots off the edge, falling...

OBI-WAN uses the Force and causes the wire to wrap around a pole, stopping his descent. He swings and drops onto a SMALL SERVICE PLATFORM just above the waves. He hauls himself to his feet. When JANGO looks down, the JEDI has disappeared. JANGO uses his forearm claws to climb back to the landing platform and runs toward his ship.

INSIDE THE COCKPIT, BOBA FETT settles into the pilot's seat. He punches buttons. The engines ROAR.

OBI-WAN comes running out onto the landing platform and spots his lightsaber laying on the ground. This time, he retrieves it successfully and turns it on just as JANGO'S ship engines roar. Realizing the ship is about to take off, OBI-WAN takes a small tracking device from his belt and throws it onto the hull of the ship.

JANGO FETT'S ship lifts off from the platform and heads up into the lowering sky. It disappears. Lightening flashes. Rain lashes the tower and streams across the surface of the platform where OBI-WAN stands, watching.

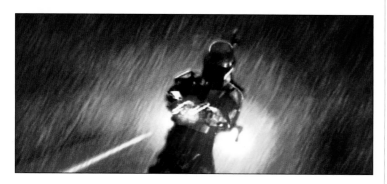

Scene 090 **EXTERIOR SPACE**

The Naboo Starship heads toward the desert planet of Tatooine.

Scene 091 **EXTERIOR TATOOINE, MOS ESPA STREETS AND WATTO'S SHOP—DAY**

The Naboo Starship lands in a large parking lot of Spaceships on the outskirts of Mos Espa. ANAKIN and PADMÉ ride a rickshaw through the streets. ANAKIN stares at sights he hasn't seen for years. Finally, they come to WATTO'S shop, and the rickshaw stops.

Anakin: (to the droid driver) Wait, please.

ANAKIN and PADMÉ get down. Sitting on a stool in front of the shop is WATTO. He is using a small electronic screwdriver on a fiddly DROID. THREE PIT DROIDS are chattering away and are trying to help him, but they seem only to make him madder.

Watto: (yelling, in Huttese) No, not that one—that one! [No chuba da wanga, da wanga.]
Anakin: (arriving) Excuse me, Watto. [Chut, chut, Watto.]
Watto: (in Huttese) What? [Ke Booda?]
Anakin: (in Huttese) I said excuse me. [Di nova, 'Chut, chut.']

WATTO turns to the chattering PIT DROIDS.

Watto: (in Huttese) Shut down. [Go ana bopa!]

The PIT DROIDS snap into their storage position.

Anakin: Let me help you with that. [Ding mi chasa hopa.]

ANAKIN takes the fiddly piece of equipment and starts to play with it. WATTO blinks in surprise.

Watto: (in Huttese) What? I don't know you...What can I do for you? You look like a Jedi. Whatever it is...I didn't do it. [Ke booda? Yo baan pee hota. No wega mi condorta. Kin chasa du Jedi. No bata tu tu.]

WATTO drops the screwdriver and curses loudly in Huttese.

Anakin: I'm looking for Shmi Skywalker. [Mi boska di Shmi Skywalker.]

WATTO looks at him suspiciously. He stares at PADMÉ, then back to ANAKIN.

Watto: Annie?? Little Annie?? Naaah!!

Suddenly, the fiddly piece of equipment in Anakin's hands WHIRS into life. WATTO blinks at it.

Watto: (continuing; in English) You are Annie! It is you! Ya sure sprouted! Weehoo! A Jedi! Waddya know? Hey, maybe you couldda help wit some deadbeats who owe me a lot of money...
Anakin: My mother...
Watto: Oh, yeah. Shmi...she's not mine no more. I sold her.
Anakin: Sold her...
Watto: Years ago. Sorry, Annie, but you know, business is business. Sold her to a moisture farmer named Lars. Least I think it was Lars. Believe it or not, I heard he freed her and married her. Can ya beat that?
Anakin: Do you know where they are?
Watto: Long way from here...someplace over on the other side of Mos Eisley, I think...
Anakin: I'd like to know.

ANAKIN's grim look means business; WATTO gets the hint quickly.

Watto: Yeah...sure...absolutely. Let's go look in my records.

ANAKIN and WATTO go into the shop.

Scene 092 **EXTERIOR SPACE, GEONOSIS**

The red planet of Geonosis is circled by a large asteroid field that forms rings. JANGO FETT'S ship appears, heading toward it. OBI-WAN's Starfighter, attached to the hyperspace transport ring, appears in space. The Starfighter disengages from the ring and follows JANGO FETT's ship.

Scene 093 **INTERIOR COCKPIT, FETT SHIP, SPACE, GEONOSIS**

JANGO FETT grins at BOBA FETT.

Jango Fett: Nearly there, son.

INSIDE THE COCKPIT, a small blip shows up on the ship's scan screen.

Boba Fett: Dad! I think we're being tracked...Look at the scan screen! Isn't that a cloaking shadow?

BOBA FETT checks the scan screen and reveals a small tracking device on the outer hull.

Jango Fett: He must have put a homing device on our hull during the fight...We'll fix that! Hang on, son! We'll move into the asteroid field. He won't be able to follow us there. If he does, we'll leave him a couple of surprises.

He pushes some buttons and the spot where the device was disappears. JANGO FETT guides his ship into the asteroid fields. OBI-WAN stops his ship.

Obi-Wan: That's interesting, Arfour. They seem to have discovered the tracker. Shut down...Shape scan their last coordinates.

JANGO FETT pilots his ship through the asteroids.

Boba Fett: He's gone.
Jango Fett: He must have gone on toward the surface.

BOBA sees OBI-WAN on the screen.

Boba Fett: Look, Dad! He's back!
Jango Fett: Hang on!

He releases a charge which drifts toward OBI-WAN. As the charge approaches OBI-WAN's Starfighter, ARFOUR beeps.

Obi-Wan: Whoa! Sonic charges...Stand by.

JANGO'S ship goes into a power climb to avoid an asteroid.

Boba Fett: Dad! Watch out!
Jango Fett: Stay calm, son. We'll be fine. That Jedi won't be able to follow us through this.

OBI-WAN'S ship dives into the asteroid belt behind them.

Boba Fett: There he is!
Jango Fett: He doesn't seem to be able to take a hint.

JANGO flies down a narrow tunnel in one of the larger asteroids.

Boba Fett: Watch out!

OBI-WAN passes over the asteroid and JANGO emerges, chasing after him.

Boba Fett: Get him, Dad! Get him! Fire!

JANGO FETT fires lasers at the Jedi Starfighter.

<hr>

Scene 094 **EXTERIOR SPACE, GEONOSIS**

The ships flip, roll, and turn at incredible speed, dodging, weaving, and firing. They tumble from near misses.

Obi-Wan: Oh, blast! This is why I hate flying.

Bits fly off OBI-WAN'S fighter as one of JANGO'S missiles gets through.

IN JANGO FETT'S COCKPIT, JANGO continues to bombard the JEDI Starfighter with laser fire. One bolt strikes OBI-WAN's ship causing a small explosion.

Boba Fett: You got him!
Jango Fett: We'll just have to finish him.

JANGO FETT pushes buttons to open an outer hull door and releases a guided aerial torpedo. The torpedo closely follows OBI-WAN'S Starfighter.

IN OBI-WAN'S COCKPIT, his skill is pushed to the limit as he throws the ship from side to side, avoiding great rocks and the torpedo. Then a huge asteroid tumbles across his path. There seems no way he can avoid it.

Obi-Wan: Arfour, Prepare to jettison the spare parts canisters. Release them now!

IN JANGO'S COCKPIT, they see a huge explosion as OBI-WAN'S ship appears to smash into the asteroid.

Boba Fett: Got him! Yeahhhhh!
Jango Fett: We won't see him again.

BOBA FETT laughs. JANGO FETT'S ship emerges from the asteroid belt and heads down toward the planet of Geonosis.

<hr>

Scene 095 **EXTERIOR SPACE, GEONOSIS RINGS**

A huge chunk of rock tumbles slowly through the asteroid belt. CAMERA CLOSES, to discover OBI-WAN'S Starship hidden in a blasted-out area on the pitted back side of the great rock.

<hr>

Scene 096 **INTERIOR COCKPIT, JEDI FIGHTER, SPACE, GEONOSIS RINGS**

OBI-WAN'S ship is sitting on an asteroid.

Obi-Wan: Well, Arfour, I think we've waited long enough...Follow his last known trajectory.

OBI-WAN'S fighter moves out from the back side of the asteroid and heads away from the asteroid field, descending toward Geonosis. OBI-WAN looks out toward Geonosis and sees in the distance a large fleet of Trade Federation ships hidden among the asteroids.

Obi-Wan: There's an unusual concentration of Federation ships over there, Arfour. We'd better stay clear.

<hr>

Scene 097 **EXTERIOR GEONOSIS, LANDING AREA—NIGHT**

OBI-WAN'S ship skims across the top of a small mesa along the edge of a rocky ridge. He maneuvers under a rock overhang and lands. He gets out of the Fighter and walks onto the mesa. The wind whips at him. He looks around.

Geonosis is a red rock planet, featureless apart from buttes and mesas, and occasional tall stalagmites that stand out dramatically on the arid plains.

The night is quiet, except for an occasional WEIRD CRY. OBI-WAN checks his bearings, then heads away.

<hr>

Scene 098 **EXTERIOR TATOOINE, BLUFF OVERLOOKING HOMESTEAD—LATE DAY**

The Naboo Starship descends, hovers, and lands on a bluff. ANAKIN and PADMÉ get out. They look down from the edge of the bluff to where the homestead is seen on the desert floor below.

Padmé: Stay with the ship, Artoo.

ARTOO WHISTLES as ANAKIN and PADMÉ start down the trail toward the homestead.

<hr>

Scene 099 **EXTERIOR TATOOINE, DESERT, HOMESTEAD MOISTURE FARM—LATE DAY**

C-3PO is working outside the homestead. He looks up as ANAKIN and PADMÉ arrive.

C-3PO: Oh, hello. How might I be of service? I am See

Anakin: Threepio?
C-3PO: Oh, my...Oh, my maker! Master Anakin! I knew you would return. I knew you would! And this must be Miss Padmé!
Padmé: Hello, Threepio.
C-3PO: Oh, my circuits! I'm so pleased to see you both!
Anakin: I've come to see my mother.
C-3PO: I think...I think...Perhaps we'd better go indoors.

<hr>

Scene 100 **EXTERIOR TATOOINE, HOMESTEAD, COURTYARD—LATE DAY**

ANAKIN, PADMÉ, and THREEPIO arrive in the courtyard. THREEPIO shuffles ahead.

C-3PO: Master Cliegg, Master Lars! Might I present two important visitors?

OWEN LARS and BERU WHITESUN come out into the courtyard.

Anakin: I'm Anakin Skywalker.
Owen: Owen Lars. This is my girlfriend, Beru.
Beru: Hello.
Padmé: I'm Padmé.
Owen: I guess I'm your stepbrother. I had a feeling you might show up some day.
Anakin: Is my mother here?
Cliegg: No, she's not.

CLIEGG LARS swings from the house on a small floating chair. One of his legs is heavily bandaged; the other is missing. He balances awkwardly and puts out a hand.

Cliegg: Cliegg Lars. Shmi is my wife...Come on inside. We have a lot to talk about...

Scene 101 | **INTERIOR TATOOINE, HOMESTEAD, KITCHEN—LATE DAY**

BERU puts several steaming cups of ardees on a tray and exits the kitchen...

Cliegg: (O.S.) It was just before dawn. They came out of nowhere. A hunting party of Tusken Raiders.

Scene 102 | **INTERIOR TATOOINE, HOMESTEAD, DINING AREA—LATE DAY**

CLIEGG, OWEN, PADMÉ and ANAKIN sit around the table, BERU brings the drinks in from the kitchen.

Cliegg: Your mother had gone out early, like she always did, to pick mushrooms that grow on the vaporators. From the tracks, she was about halfway home when they took her. Those Tuskens walk like men, but they're vicious, mindless monsters. Thirty of us went out after her. Four of us came back. I'd be with them, only...after I lost my leg I just couldn't ride any more...until I heal.

CLIEGG grimaces, easing his throbbing leg.

Cliegg: This isn't the way I wanted to meet you, son. This isn't how your mother and I planned it. I don't want to give up on her, but she's been gone a month. There's little hope she's lasted this long.

Silence. Then ANAKIN stands up.

Owen: Where are you going?
Anakin: To find my mother.
Padmé: No, Annie!
Cliegg: Your mother's dead, son. Accept it.
Anakin: I can feel her pain, and I will find her.
Owen: Take my speeder bike.
Anakin: I know she's alive.

ANAKIN turns abruptly.

Scene 103 | **EXTERIOR TATOOINE, HOMESTEAD, MOISTURE FARM—LATE DAY**

ANAKIN stands looking across the desert. PADMÉ comes running out of the homestead after him. ANAKIN turns to PADMÉ.

Anakin: You are going to have to stay here. These are good people, Padmé. You'll be safe.
Padmé: Anakin...

PADMÉ hugs him. ANAKIN walks to OWEN'S speeder bike, which is standing close by.

Anakin: I won't be long.

ANAKIN swings onto the bike. The engine fires. He takes off across the desert. PADMÉ watches him go.

Scene 104 | **EXTERIOR TATOOINE, LANDSCAPE—SUNSET**

THREE DIFFERENT SHOTS. ANAKIN rides the speeder bike through three exotic landscapes.

Scene 105 | **EXTERIOR TATOOINE, DESERT, JAWA CAMP—TWILIGHT**

ANAKIN stands in the middle of a crowd of JAWAS. He asks them for directions. The JAWAS confer excitedly, then the CHIEF JAWA points in a particular direction. ANAKIN gets on the bike and speeds off to where the JAWA pointed.

Scene 106 | **EXTERIOR TATOOINE, DUNE SEA, CAMPFIRE—TWILIGHT**

ANAKIN rides over a large dune toward a small flickering light in the distance.

He rides up and stops the bike in front of a campfire. There are bodies of THREE DEAD FARMERS lying beside the campfire. TWO EOPIES are tethered nearby, along with a burned and smoking speeder.

Scene 107 | **EXTERIOR TATOOINE, DESERT, HOMESTEAD (FULL MOON)—NIGHT**

The lights of the vaporators blink in the night sky. Somewhere close by, a night animal HOWLS.

Scene 108 | **EXTERIOR TATOOINE, HOMESTEAD, COURTYARD (FULL MOON)—NIGHT**

PADMÉ is pacing the courtyard restlessly. She stops, listening to the animal HOWLING nearby. She shivers slightly, then turns and goes into the garage at the side of the courtyard.

Scene 109 | **INTERIOR TATOOINE, HOMESTEAD, GARAGE (FULL MOON)—NIGHT**

PADMÉ enters the garage where C-3PO sits working.

C-3PO: Hello, Miss Padmé
Padmé: Hello, Threepio.
C-3PO: You can't sleep?
Padmé: No. I have too many things on my mind, I guess.
C-3PO: Are you worried about your work in the Senate?
Padmé: No, I'm just concerned about Anakin. I said things...I'm afraid I may have hurt him. I don't know. Maybe I only hurt myself. For the first time in my life, I'm confused.
C-3PO: I'm not sure it will make you feel any better Miss Padmé, but I don't think there's been a time in my life when I haven't been confused.
Padmé: I want him to know I care about him. I do care about him.
C-3PO: Don't worry about Master Annie. He can take care of himself. Even in this awful place.

Scene 110 | **EXTERIOR GEONOSIS, ROCK FACE TRAIL—NIGHT**

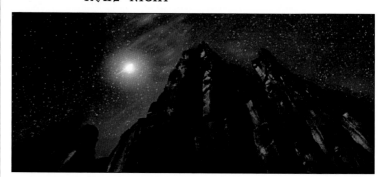

OBI-WAN climbs a steep, narrow trail. Suddenly, a CRY is heard close by. OBI-WAN stumbles slightly. His foot slips on the edge, sending a stream of pebbles skittering into the darkness.

OBI-WAN listens. Silence. He draws his lightsaber but does not ignite it.

He sets off again and works his way around a narrow corner, to confront a crouching MASSIFF (a dog-sized lizard) with slavering fangs! The beast leaps at him, and OBI-WAN ignites his lightsaber as the MASSIFF knocks him on his back. Its jaws open wide. OBI-WAN stabs the creature, throws it off of him, and jumps up.

A SECOND MASSIFF jumps him from behind. OBI-WAN swings around and cuts it in half. The MASSIFF flies over the cliff, HOWLING. It plummets to its death hundreds of feet below.

Scene 111 EXTERIOR GEONOSIS, ROCK FACE TRAIL— NIGHT

OBI-WAN arrives at the head of the trail. Far below, a flat plain stretches into the distance. He stops, peering into the darkness, where strange shapes loom indistinctly.

OBI-WAN takes a pair of electronic binoculars from his belt and puts them to his eyes. He sees a cluster of great towers like fantastic stalagmites rise from the plain below.

SLOW PAN with the binoculars, and suddenly a line of Battle Starships come into view. OBI-WAN touches the viewfinder. Between fifty and a hundred Federation Starships are in neat rows. Some are on platforms that are carrying the Starships down to an underground facility. Other platforms are rising to the surface. They carry THOUSANDS of BATTLE DROIDS that step off and file into waiting ships. A fully loaded Starship takes off. OBI-WAN swings the binoculars upward, to see more Trade Federation Starships.

Scene 112 EXTERIOR GEONOSIS, TOWER ENTRANCE— DAWN

Light grows on the clustering tower of fantastic stalagmites. OBI-WAN sneaks up to the main one. He climbs up the side of the tower to a small window-like opening. OBI-WAN looks around quickly, then sneaks inside.

Scene 113 INTERIOR GEONOSIS, CORRIDORS—MORNING

OBI-WAN makes his way along a narrow, pillared corridor. He comes to what looks like a large open well or vent shaft. He looks down and sees a huge underground facility below. In one area, machines are constructing BATTLE DROIDS. In another area, completed DROIDS are moving along a conveyor belt. GEONOSIS WORKERS, with no wings, drone away at the assembly line.

Scene 114 INTERIOR GEONOSIS, CENTRAL SQUARE— MORNING

OBI-WAN arrives at a vast expanse in the stalagmite interior. Immense pillars, soaring Gaudi-Gothic arches, vaulted roofs. The huge space is deserted—completely silent.

OBI-WAN starts to cross the square. Suddenly he hears voices.

He darts behind a pillar as POGGLE THE LESSER (Archduke of Geonosis), his aide, SUN FAC; COUNT DOOKU; and NUTE GUNRAY approach, closely followed by PASSEL ARGENTE and WAT TAMBOR. COUNT DOOKU is tall, elderly, and saturnine, with beautiful manners. OBI-WAN flattens himself against the pillar as they pass by.

Count Dooku: Now, we must persuade the Commerce Guild and the Corporate Alliance to sign the treaty.
Nute Gunray: What about the Senator from Naboo? Is she dead yet? I'm not signing your treaty until I have her head on my desk.
Count Dooku: I am a man of my word, Viceroy.
Poggle: With these new Battle Droids we've built for you, Viceroy, you'll have the finest army in the galaxy.

They move out of earshot. OBI-WAN peers around the pillar to see them going through an archway on the far side of the courtyard. There is a flight of stairs beside it.

OBI-WAN arrives at the stairs. He sneaks up them, to arrive at a narrow gothic archway. He looks down through it.

Scene 115 INTERIOR GEONOSIS, CONFERENCE ROOM— DAY

POGGLE THE LESSER and his TWO AIDES are at one end of a large round conference table.

Count Dooku: Now is the time, my friends. This is the moment when you have to decide between the Republic or the Confederacy of Independent Systems.

COUNT DOOKU is at the head of the table. JANGO FETT stands behind his chair.

In addition to the original group, there are also THREE OPPOSITION SENATORS: PO NUDO, TESSEK and TOONBUCK TOORA, and a COMMERCE GUILD DIGNITARY, SHU MAI and a MEMBER of the INTERGALACTIC BANK CLAN, SAN HILL.

Count Dooku: As I explained to you earlier, I'm quite convinced that ten thousand more systems will rally to our cause with your support, gentlemen. And let me remind you of our absolute commitment to capitalism...of the lower taxes, the reduced tariffs, and the eventual abolition of all trade barriers. Signing this treaty will bring you profits beyond your wildest imagination. What we are proposing is completely free trade (looks at Nute) Our friends in the Trade Federation have pledged their support. When their Battle Droids are combined with yours, we shall have an army greater than anything in the galaxy. The Jedi will be overwhelmed. The Republic will agree to any demands me make.

PASSEL ARGENTE, the Corporate Alliance Representative.

Passel Argente: I am authorized by the Corporate Alliance to sign the treaty.
Count Dooku: We are most grateful for your cooperation, Chairman.

SHU MAI, the Commerce Guild Representative.

Shu Mai: The Commerce Guilds do not at this time wish to become openly involved. But we shall support you in secret—and look forward to doing business with you.

There are chuckles around the table. COUNT DOOKU smiles.

Count Dooku: That is all we ask.

SAN HILL, the banker.

San Hill: The Intergalactic Banking Clan will support you wholeheartedly, but only in a non-exclusive arrangement.

WAT TAMBOR, *the Techno Union representative.*

Wat Tambor: The Techno Unions are at your disposal, Count.

Scene 116 | **INTERIOR GEONOSIS, STAIRS—DAY**

OBI-WAN pulls back from the archway.

Scene 117 | **EXTERIOR TATOOINE, CLIFF (FULL MOON)—NIGHT**

ANAKIN pulls up near the edge of a cliff. He gets off the bike and creeps to the edge. He looks over to see a Tusken camp in the oasis below. One of the huts at the edge of the camp has TWO TUSKEN GUARDS outside it. ANAKIN drops off the edge of the cliff to the camp below.

Scene 118 | **EXTERIOR TATOOINE, TUSKEN RAIDER CAMP, OASIS (FULL MOON)—NIGHT**

ANAKIN creeps through the camp, working his way from hut to hut, flattening himself against the walls, overhearing snatches of Tusken conversation from inside, using the shadows to hide him until he arrives at the hut with the TWO GUARDS. They are sitting a short distance from the door. ANAKIN wriggles around the back. He takes out his lightsaber and cuts into the base of the wall.

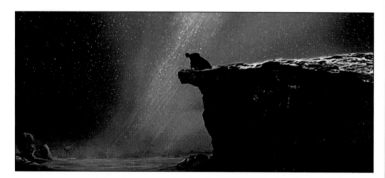

Scene 119 | **INTERIOR TUSKEN RAIDER HUT—NIGHT**

The lightsaber completes the hole in the wall. ANAKIN wriggles in. He pulls himself to his feet. There are candles everywhere.

A shaft of moonlight from a hole in the roof pierces the gloom of the hut. By its light, ANAKIN sees SHMI, hanging from a wooden frame in the middle of the hut.

He cuts her free, takes her into his arms, and lowers her gently to the ground. Her eyes are closed. Her face is bloodied. She has been terribly beaten. ANAKIN cradles her tenderly.

Anakin: Mom...Mom...Mom...

SHMI's eyelids flutter—and barely open. They are caked with blood.

Shmi: Annie...? Is it you...?

SHMI's eyes focus slowly. ANAKIN gives a little choking gasp.

Anakin: I'm here, Mom. You're safe. Hang on. I'm going to get you out of here...
Shmi: Annie? Annie? You look so handsome. My son...my grown-up son. I'm so proud of you, Annie...so proud...I missed you so much... Now...I am complete.
Anakin: Just stay with me, Mom. I'm going to make you well again. Everything's...going to be fine.
Shmi: I love...

SHMI dies. ANAKIN draws her to his breast. He reaches over and closes her eyes. There is silence for a moment. ANAKIN lifts his head, listening for a moment, then he sits on the floor of the Tusken hut, cradling his dead mother in his arms.

Scene 120 | **EXTERIOR TATOOINE, TUSKEN RAIDER CAMP, OASIS—DAWN**

The pale light grows. Thin tendrils of smoke rise slowly in the cold, clear air. Somewhere a dog BARKS. An OLD WOMAN comes out of one of the huts. She carries a pail. She swirls it and tosses the dirty water onto the ground.

As she goes back inside the hut, a TUSKEN CHILD runs past, dragging a stick in the sand. The CHILD runs through the line of huts, turns a corner, and stops suddenly, staring at the TWO TUSKEN GUARDS. Between them, ANAKIN stands outside the hut door. His face is a grim mask. The CHILD stares, then there is a FLASH OF LIGHT as Anakin's lightsaber switches on. He immediately kills the two TUSKENS guarding the door of the hut, and makes his way toward the others.

Scene 121 | **INTERIOR JEDI TEMPLE, YODA'S QUARTERS—LATE AFTERNOON**

YODA meditates and suddenly hears a familiar voice, as if from a great distance. It is the voice of QUI-GON JINN, filled with alarm.

Qui-Gon: *(V.O.)* No Anakin! No! Don't! No!

MACE WINDU enters the room and sits down. YODA opens his eyes and looks to MACE.

Mace Windu: What is it?
Yoda: Pain. Suffering. Death, I feel. Something terrible has happened. Young Skywalker is in pain. Terrible pain.

Scene 122 | **EXTERIOR GEONOSIS, LANDING AREA—DAY**

OBI-WAN examines the transmitter dish and speaks with ARFOUR.

Obi-Wan: The transmitter is working, but we're not receiving a return signal. Corusant's too far. Arfour, can you boost the power?

ARFOUR beeps a reply.

Obi-Wan: We'll have to try something else.

OBI-WAN jumps into the cockpit.

Obi-Wan: Maybe we can contact Anakin on Naboo. It's much closer. Anakin, Anakin, do you copy? This is Obi-Wan Kenobi. Anakin? He's not on Naboo, Arfour. I'm going to try and widen the search. I hope nothing's happened to him.

OBI-WAN sits in the Starfighter cockpit looking at a display. A GEONOSIAN spies OBI-WAN and his Starfighter from an overlooking cliff.

Obi-Wan: That's Anakin's tracking signal all right, but it's coming from Tatooine. What in the blazes is he doing there? I told him to stay on Naboo.

OBI-WAN exits the cockpit and jumps down to the ground. He speaks to ARFOUR.

Obi-Wan: All right. We're all set. We haven't much time. Anakin? Anakin, do you copy? This is Obi-Wan Kenobi.

Scene 123 | **INTERIOR COCKPIT, NABOO STARFIGHTER—DAY**

In the ship, ARTOO BEEPS as he receives the message.

Obi-Wan: *(V.O.)* Record this message and take it to your mistress, Padmé...and the Jedi Skywalker..."Anakin, my long range transmitter has been knocked out. Retransmit this message to Coruscant."

ARTOO dutifully listens to the desperate message. OBI-WAN'S voice cuts out. ARTOO WHISTLES in dismay.

| Scene 124 | **EXTERIOR TATOOINE, DESERT, HOMESTEAD MOISTURE FARM—MORNING** |

ANAKIN rides the speeder bike toward the homestead. SHMI'S BODY is tied to it. OWEN, followed by BERU and PADMÉ, comes out of the homestead to meet ANAKIN. THREEPIO follows. CLIEGG hobbles out of the homestead on his hovering chair.

ANAKIN arrives. They run to him as he steps away from the bike, carrying SHMI. He stops, face-to-face with CLIEGG. There is a brief pause. Then he carries SHMI into the homestead.

| Scene 125 | **INTERIOR TATOOINE MOISTURE FARM, KITCHEN—MORNING** |

PADMÉ prepares some food for Anakin. BERU helps her.

Beru: What's it like there?
Padmé: I'm sorry?
Beru: On Naboo...What's it like?

PADMÉ is completely preoccupied with her concern for ANAKIN, but she does her best to reply.

Padmé: Oh—it's...very green. With lots of water. And trees. Not like here at all.

She takes out a tray and starts to put the food on it.

Beru: I think I like it here better.
Padmé: Maybe you'll come and see it one day.
Beru: I don't think so. I don't like to travel.

They finish preparing the tray.

Padmé: (smiles) Thanks, Beru.

She goes out.

| Scene 126 | **INTERIOR TATOOINE, HOMESTEAD, GARAGE—DAY** |

PADMÉ comes in with a tray of food. ANAKIN is standing at a workbench, repairing a part off the speeder bike.

Padmé: I brought you something. Are you hungry?

PADMÉ puts the tray down.

Anakin: The shifter broke. Life seems so much simpler when you're fixing things. I'm good at fixing things...always was. But I couldn't...(stops working, tears in his eyes) Why did she have to die? Why couldn't I save her? I know I could have!
Padmé: Sometimes there are things no one can fix. You're not all-powerful, Annie.

ANAKIN turns and walks away from the bench.

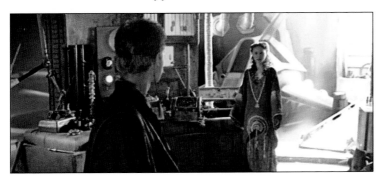

Anakin: (angry) I should be! Someday I will be...I will be the most powerful Jedi ever! I promise you, I will even learn to stop people from dying.

Padmé: Anakin...
Anakin: (furious) It's all Obi-Wan's fault. He's jealous! He knows I'm already more powerful than he is. He's holding me back!

ANAKIN hurls the wrench across the garage. It CLATTERS to the floor. He looks at his trembling hands. PADMÉ stares at him, shocked.

Padmé: Annie, what's wrong?
Anakin: I...I killed them. I killed them all. They're dead, every single one of them...

ANAKIN focuses on her like someone returning from far away.

Anakin: Not just the men, but the women and the children too. They're like animals, and I slaughtered them like animals...I hate them!

There is silence for a moment, then ANAKIN breaks down, sobbing. PADMÉ takes him into her arms.

Anakin: Why do I hate them? I didn't...I couldn't...I couldn't control myself. I...I don't want to hate them... but I just can't forgive them.
Padmé: To be angry is to be human.
Anakin: To control your anger is to be a Jedi.
Padmé: Ssshhh...you're human.
Anakin: No, I'm a Jedi. I know I'm better than this. I'm sorry, I'm so sorry!
Padmé: You're like everyone else...

PADMÉ rocks him, and ANAKIN weeps.

| Scene 127 | **EXTERIOR TATOOINE, HOMESTEAD, GRAVESITE—DAY** |

ANAKIN, PADMÉ, CLIEGG, OWEN, BERU, and THREEPIO are standing around Shmi's grave. Two other headstones, one smaller than the other, stand in the blazing suns.

Cliegg: I know wherever you are it's become a better place. You were the most loving partner a man could ever have. Goodbye, my dearest wife. And thank you.

Brief pause. ANAKIN steps forward and kneels at his mother's grave. He picks up a handful of sand.

Anakin: I wasn't strong enough to save you, Mom. I wasn't strong enough. But I promise I won't fail again...(he stands up) I miss you so much.

Silence. Then BEEPS and WHISTLES are heard. They turn as ARTOO rolls up.

Padmé: Artoo, what are you doing here?

ARTOO BEEPS and WHISTLES.

C-3PO: It seems that he is carrying a message from an Obi-Wan Kenobi. Master Annie, does that name mean anything to you?

| Scene 128 | **INTERIOR COCKPIT, NABOO STARSHIP—DAY** |

A rough hologram of OBI-WAN is projected in front of ANAKIN and PADMÉ. They watch the flickering image.

Obi-Wan: (V.O.) Anakin, my long range transmitter has been knocked out. Retransmit this message to Coruscant.

PADMÉ turns and reaches over to a control board and pushes a button to transmit the message.

Obi-Wan: (V.O.) I have tracked the bouny hunter Jango Fett to the droid foundries on Geonosis.

| Scene 129 | **INTERIOR JEDI COUNCIL ROOM—DAY** |

The members of the Jedi Council stand around a hologram of OBI-WAN.

Obi-Wan: (V.O.) The Trade Federation is to take delivery of a droid army here and it is clear that Viceroy Gunray...

Scene 130 — INTERIOR COCKPIT, NABOO STARSHIP—DAY

ANAKIN and PADMÉ continue to listen.

Obi-Wan: (V.O.) ...is behind the assassination attempts on Senator Amidala.

Scene 131 — INTERIOR JEDI COUNCIL ROOM—DAY

The Council members continue to listen to OBI-WAN.

Obi-Wan: (V.O.) The Commerce Guilds and Corporate Alliance have both pledged their armies to Count Dooku and are forming an...Wait!...Wait!!

Scene 132 — INTERIOR COCKPIT, NABOO STARSHIP—DAY

ANAKIN and PADMÉ watch as OBI-WAN is attacked by droidekas. The hologram cuts off. ANAKIN jumps up, agitated.

Scene 133 — INTERIOR JEDI COUNCIL ROOM—DAY

The Council members also see the attack on OBI-WAN. YODA looks to MACE WINDU.

Yoda: More happening on Geonosis, I feel, than has been revealed.
Mace Windu: I agree.

Scene 134 — INTERIOR COCKPIT, NABOO STARSHIP—SUNSET

ANAKIN and PADMÉ watch a hologram of MACE WINDU.

Mace Windu: (V.O.) Anakin, we will deal with Count Dooku. The most important thing for you is to stay where you are. Protect the Senator at all costs. That is your first priority.
Anakin: Understood, Master.

The hologram switches off. PADMÉ is looking at the readout on the ship's control panel.

Padmé: They'll never get there in time to save him. They have to come halfway across the galaxy. Look, Geonosis is less than a parsec away.

PADMÉ starts to hit buttons and flick switches. ANAKIN puts a hand over hers, stopping her. She stares at him.

Anakin: If he's still alive.
Padmé: Annie, are you just going to sit here and let him die?? He's your friend...your mentor...
Anakin: He's like my father, but you heard Master Windu. He gave me strict orders to stay here.
Padmé: He gave you strict orders to protect me...

PADMÉ pulls her hand free and flicks more switches. The engines fire.

Padmé: ...and I'm going to save Obi-Wan. So if you plan to protect me, you will have to come along.

ANAKIN grins and takes the controls. THREEPIO and ARTOO come forward from the back of the starship. THREEPIO straps himself into a seat behind PADMÉ.

Scene 135 — EXTERIOR TATOOINE, BLUFF OVERLOOKING HOMESTEAD—SUNSET

The Naboo Starship rises from the bluff and zooms away.

Scene 136 — EXTERIOR CORUSCANT, REPUBLIC EXECUTIVE BUILDING—DAY

LOW ANGLE. A line of reflecting pools with splashing fountains flanked by statues on each side leads to the main entrance to the awesome building.

Scene 137 — INTERIOR CORUSCANT, CHANCELLOR'S OFFICE—DAY

JEDI (YODA, MACE WINDU, and KI-ADI-MUNDI) and SENATORS (BAIL ORGANA, ASK AAK, and JAR JAR) along with PALPATINE and MAS AMEDDA discuss OBI-WAN's message with growing concern.

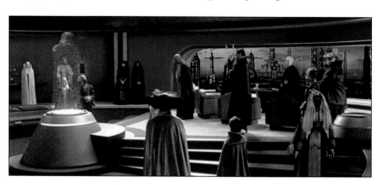

Bail Organa: The Commerce Guilds are preparing for war...there can be no doubt of that.
Palpatine: Count Dooku must have made a treaty with them.
Bail Organa: We must stop them before they're ready.
Jar Jar: Excueeze me, yousa honorable Supreme Chancellor, Sir. Maybe dissen Jedi stoppen the rebel army.
Palpatine: Master Yoda, how many Jedi are available to go to Geonosis?
Yoda: Throughout the galaxy, thousands of Jedi there are. To send on a special mission, only two hundred are available.
Bail Organa: With all due respect for the Jedi Order, that doesn't sound like enough.
Yoda: Through negotiation the Jedi maintains peace. To start a war, we do not intend.
Ask Aak: The debate is over! Now we need that clone army...
Bail Organa: Unfortunately, the debate is not over. The Senate will never approve the use of the clones before the separatists attack.
Mas Amedda: This is a crisis! The Senate must vote the Chancellor emergency powers! He could then approve the use of the clones.
Palpatine: But what Senator would have the courage to propose such a radical amendment?
Mas Amedda: If only Senator Amidala were here.

JAR JAR steps forward from the back of the group.

Jar Jar: Mesa mosto Supreme Chancellor...Mesa gusto pallos. Mesa proud to proposing the motion to give yousa Honor emergency powers.

Scene 138 — INTERIOR GEONOSIS, PRISON CELL—DAY

COUNT DOOKU walks into the cell holding OBI-WAN. OBI-WAN is suspended in a force field, turning slowly as blue electric bolts restrain him. COUNT DOOKU circles OBI-WAN as they talk.

Obi-Wan: Traitor!
Count Dooku: Hello, my friend. This is a mistake. A terrible mistake. They've gone too far. This is madness.
Obi-Wan: I thought you were their leader here, Dooku.
Count Dooku: This had nothing to do with me, I assure you. I promise you I will petition immediately to have you set free.
Obi-Wan: Well, I hope it doesn't take too long. I have work to do.
Count Dooku: May I ask why a Jedi Knight is all the way out here on Geonosis?
Obi-Wan: I've been tracking a bounty hunter named Jango Fett. Do you know him?

Count Dooku: There are no bounty hunters here that I'm aware of. Geonosians don't trust them.

Obi-Wan: Well, who can blame them. But he is here, I can assure you.

Count Dooku: It's a great pity that our paths have never crossed before, Obi-Wan. Qui-Gon always spoke very highly of you. I wish he were still alive. I could use his help right now.

Obi-Wan: Qui-Gon Jinn would never join you.

Count Dooku: Don't be so sure, my young Jedi. You forget that he was once my apprentice just as you were once his. He knew all about the corruption in the Senate, but he would never have gone along with it if he had known the truth as I have.

Obi-Wan: The truth?

Count Dooku: The truth. What if I told you that the Republic was now under the control of the Dark Lords of the Sith?

Obi-Wan: No, that's not possible. The Jedi would be aware of it.

Count Dooku: The dark side of the Force has clouded their vision, my friend. Hundreds of Senators are now under the influence of a Sith Lord called Darth Sidious.

Obi-Wan: I don't believe you.

Count Dooku: The Viceroy of the Trade Federation was once in league with this Darth Sidious. But he was betrayed ten years ago by the Dark Lord. He came to me for help. He told me everything. The Jedi Council would not believe him. I tried many times to warn them but they wouldn't listen to me. Once they sensed the Dark Lord's presence, it would then be too late. You must join me, Obi-Wan, and together we will destroy the Sith.

Obi-Wan: I will never join you, Dooku.

Count Dooku turns to leave.

Count Dooku: It may be difficult to secure your release.

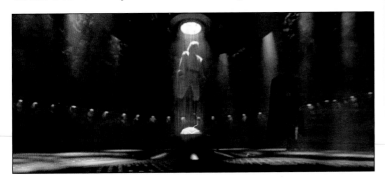

Scene 139 **EXTERIOR SPACE**

The Naboo Starship heads toward the rings of Geonosis.

Scene 140 **EXTERIOR GEONOSIS—DAY**

Anakin pilots the starship close to the ground, weaving around towering rock formations.

Padmé: See those columns of steam straight ahead? They're exhaust vents of some type.
Anakin: That'll do.

ANAKIN pilots the craft straight down into a column, flying through the steam, and landing at the bottom.

Scene 141 **INTERIOR COCKPIT, NABOO STARSHIP— DAY**

PADMÉ and ANAKIN prepare to leave the starship.

Padmé: Look, whatever happens out there, follow my lead. I'm not interested in getting into a war here. As a member of the Senate, maybe I can find a diplomatic solution to this mess.

Anakin: Don't worry. I've given up trying to argue with you.

ARTOO WHISTLES a plaintive sigh.

C-3PO: My sad little friend. If they had needed our help, they would have asked for it. You have a lot to learn about humans.

Scene 142 **INTERIOR GEONOSIS, CORRIDORS—DAY**

ANAKIN and PADMÉ enter the stalagmite city. They stop, looking around in wonder at the emptiness.

Scene 143 **INTERIOR COCKPIT, NABOO STARSHIP— DAY**

ARTOO stands in front of THREEPIO, who is fussing about.

C-3PO: For a mechanic, you seem to do an excessive amount of thinking. I'm programmed to understand humans.

ARTOO beeps a question.

C-3PO: What does that mean? That means I'm in charge here!

ARTOO trundles out of the starship and down the landing ramp. THREEPIO follows him out of the ship.

C-3PO: Wait! Where are you going? Don't you have any sense at all?

ARTOO makes a rude noise.

C-3PO: How rude! Please wait! Do you know where you're going?

ARTOO bleeps at THREEPIO.

Scene 144 **INTERIOR GEONOSIS, CORRIDORS—DAY**

ANAKIN and PADMÉ start forward. As they pass, the surface of the pillars seems to pulse slowly and move. High above, WINGED CREATURES grow from the pillars and detach themselves.

Anakin: Wait.

ANAKIN turns as one of the WINGED CREATURES attacks him. Lightsaber blazing, ANAKIN cuts down three creatures as PADMÉ exits through a far doorway. He reaches PADMÉ and they both stand on the edge of a short walkway extending over a deep crevasse. The door behind them closes, stranding the two. The walkway retracts and PADMÉ slips and then jumps down onto a conveyor belt leading into the droid factory.

Anakin: Padmé!

ANAKIN jumps down and slashes more WINGED CREATURES while attempting to reach PADMÉ. PADMÉ makes her way across stamping machines and welders as ANAKIN follows, beating back WINGED CREATURES.

Scene 145 **INTERIOR GEONOSIS, DROID FACTORY—DAY**

THREEPIO and ARTOO stop at the small walkway.

C-3PO: Oh my goodness! Machines creating machines. How perverse! (ARTOO bleeps) Calm down. What are you talking about? I'm not in your way!

ARTOO pushes THREEPIO off the small ledge and onto a flying Conveyor Droid. Flailing, THREEPIO falls from the droid and onto the conveyor belt below. ARTOO uses his rocket jets to fly up and into the factory.

C-3PO: Help!

ANAKIN continues to work his way toward PADMÉ, lightsaber flashing, WINGED CREATURES attacking from all directions. PADMÉ wrestles with one CREATURE and is thrown into a large empty vat moving down the assembly line. Mechanized arms carry the vat to a position where molten metal will be poured into it. PADMÉ struggles to find handholds for escape, but is unsuccessful. ARTOO flies towards PADMÉ.

SEE-THREEPIO is carried down the assembly line. He stands, only to find his head sliced from his body. His head lands in a line of Battle Droid heads and is welded to a Battle Droid body.

C-3PO: How ugly! Why would one build such unattractive droids?

THREEPIO's headless body continues down the assembly line, sandwiched between Battle Droids. A Battle Droid head is welded on THREEPIO's body.

C-3PO: I'm so confused.

Meanwhile, ANAKIN continues to battle CREATURES. He trips on the assembly line and his right arm becomes locked into a molding device. ANAKIN comes close to the cutting machine.

As PADMÉ continues her struggle to escape the vat, ARTOO finds the computer port controlling the vats and programs PADMÉ's to dump her onto a walkway. ANAKIN ignites his lightsaber in an attempt to free his arm. The cutter approaches. He maneuvers his body away from the cutter, but it slams down and cuts his lightsaber in half.

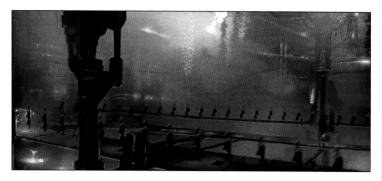

PADMÉ is surrounded by WINGED CREATURES and taken prisoner. ANAKIN is surrounded by DROIDEKAS and from above, JANGO FETT drops down, blaster in hand.

Jango Fett: Don't move, Jedi!

<hr>

Scene 146 **INTERIOR GEONOSIS, CONFERENCE ROOM— DAY**

COUNT DOOKU sits at a large conference table with PADMÉ on the far side. ANAKIN stands behind her with FOUR GEONOSIAN GUARDS standing behind him. JANGO FETT stands behind COUNT DOOKU, and SIX GEONOSIAN GUARDS stand behind him.

Padmé: You are holding a Jedi Knight, Obi-Wan Kenobi. I am formally requesting you turn him over to me, now.

Count Dooku: He has been convicted of espionage, Senator, and will be executed. In just a few hours, I believe.

COUNT DOOKU smiles.

Padmé: He is an officer of the Republic. You can't do that.

Count Dooku: We don't recognize the Republic here, Senator, but if Naboo were to join our Alliance, I could easily hear your plea for clemency.

Padmé: And if I don't join your rebellion, I assume this Jedi with me will also die?

Count Dooku: I don't wish to make you join our cause against your will, Senator, but you are a rational, honest representative of your people, and I assume you want to do what's in their best interest. Aren't they fed up with the corruption, the bureaucrats, the hypocrisy of it all? Aren't you? Be honest, Senator.

Padmé: The ideals are still alive, Count, even if the institution is failing.

Count Dooku: You believe in the same ideals we believe in! The same ideals we are striving to make prominent.

Padmé: If what you say is true, you should stay in the Republic and help Chancellor Palpatine put things right.

Count Dooku: The Chancellor means well, M'Lady, but he is incompetent. He has promised to cut the bureaucracy, but the bureaucrats are stronger than ever, no? The Republic cannot be fixed, M'Lady. It is time to start over. The democratic process in the Republic is a sham, no? A shell game played on the voters. The time will come when that cult of greed called the Republic will lose even the pretext of democracy and freedom.

Padmé: I cannot believe that. I know of your treaties with the Trade Federation, the Commerce Guilds, and the others, Count. What is happening here is not government that has been bought out by business...It's business becoming government! I will not forsake all I have honored and worked for and betray the Republic.

Count Dooku: Then you will betray your Jedi friends? Without your cooperation I can do nothing to stop their execution.

Padmé: And what about me? Am I to be executed also?

Count Dooku: I wouldn't think of such an offense. But there are individuals who have a strong interest in your demise, M'Lady. It has nothing to do with politics, I'm afraid. It's purely personal, and they have already paid great sums to have you assassinated. I'm sure they will push hard to have you included in the executions. I'm sorry, but if you are not going to cooperate, I must turn you over to the Geonosians for justice. Without your cooperation, I've done all I can for you.

Jango Fett: Take them away.

<hr>

Scene 147 **INTERIOR CORUSCANT, MAIN SENATE CHAMBER, UPPER CORRIDOR—EVENING**

MACE WINDU walks down an upper corridor and meets YODA, who is sitting on a ledge overlooking the Senate chamber.

Inside the great rotunda, the UPROAR is even louder. Opposing SENATORS yell furiously at one another.

Mas Amedda: Order! Order!!

Finally, the uproar dies.

Palpatine: In the regrettable absence of Senator Amidala, the chair recognizes the senior representative of Naboo, Jar Jar Binks.

Amid a conflicting storm of CHEERS AND BOOS, JAR JAR, with TWO GUNGAN AIDES, floats on his pod to the middle of the vast space. He looks at PALPATINE nervously. PALPATINE nods. JAR JAR clears his throat.

Jar Jar: Senators, dellow felagates...

Laughter. Jeers. JAR JAR blushes.

Mas Amedda: Order! The Senate will accord the representative the courtesy of a hearing!

Comparative quiet. JAR JAR grips the edge of the podium.

<hr>

Scene 148 **INTERIOR CORUSCANT, MAIN SENATE CHAMBER—EVENING**

JAR JAR stands in his pod as it floats in the middle of the vast space.

Jar Jar: In response to the direct threat to the Republic, mesa propose that the Senate give immediately emergency powers to the Supreme Chancellor.

Uproar. JAR JAR looks a little sheepish.

Brief silence, then a rolling wave of APPLAUSE. JAR JAR beams and bows.

PALPATINE rises.

Palpatine: It is with great reluctance that I have agreed to this calling. I love democracy...I love the Republic. But I am mild by nature, and I do not desire to see the destruction of democracy. The power

you give me I will lay down when this crisis has abated, I promise you. And as my first act with this new authority, I will create a grand army of the Republic to counter the increasing threats of the separatists.

Scene 149 **INTERIOR CORUSCANT, MAIN SENATE CHAMBER, UPPER CORRIDOR—EVENING**

Mace Windu: It is done then. I will take what Jedi we have left and go to Geonosis and help Obi-Wan.
Yoda: Visit I will the cloners on Kamino and see this army they have created for the Republic.

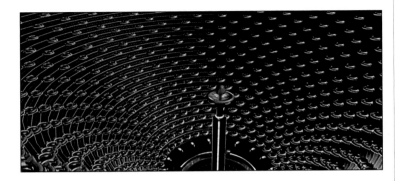

Scene 150 **INTERIOR GEONOSIS, HIGH AUDIENCE CHAMBER—DAY**

ANAKIN and PADMÉ are standing in the center of what looks like a courtroom. Seated before them in a tall boxed-off area is POGGLE THE LESSER, the Archduke of Geonosis. He is accompanied by his underling, SUN FAC. Off to one side sit Separatist Senators PO NUDO, TESSEK, and TOON-BUCK TOORA. Next to them are the Commerce Dignitaries, SHU MAI, NUTE GUNRAY, PASSEL ARGENTE, WAT TAMBOR, and SAN HILL of the Intergalactic Bank Clan. Along the wall about a HUNDRED GEONOSIANS wait for a verdict.

Sun Fac: You have been charged and found guilty of espionage.
Poggle: Do you have anything to say before your sentence is carried out?
Padmé: You are committing an act of war, Archduke. I hope you are prepared for the consequences.

POGGLE laughs. COUNT DOOKU simply smiles.

Poggle: We build weapons, Senator...that is our business! Of course we're prepared!
Nute Gunray: Get on with it. Carry out the sentence. I want to see her suffer.
Poggle: Your other Jedi friend is waiting for you, Senator. Take them to the arena!

FOUR GUARDS take hold of PADMÉ and ANAKIN. They are escorted out of the chamber to the sounds of chuckling.

Scene 151 **INTERIOR GEONOSIS, TUNNEL TO EXECUTION ARENA—DAY**

In the gloomy tunnel, ANAKIN and PADMÉ are tossed into an open cart. The murmur of a vast crowd is heard offscreen. GUARDS extend their arms along the framework and tie them so that they stand facing each other.

The DRIVER gets up onto his seat.

Anakin: Don't be afraid.
Padmé: I'm not afraid to die. I've been dying a little bit each day since you came back into my life.
Anakin: What are you talking about?
Padmé: I love you.
Anakin: You love me?! I thought we decided not to fall in love. That we would be forced to live a lie. That it would destroy our lives...

Padmé: I think our lives are about to be destroyed, anyway. My love for you is a puzzle, Annie, for which I have no answers. I can't control it...and now I don't care. I truly, deeply love you and before we die I want you to know.

PADMÉ leans toward ANAKIN. By straining hard, it is just possible for their lips to meet. They kiss.

The DRIVER cracks his whip over the ORRAY harnessed between the shafts. The cart jerks forward. Suddenly, there is a HUGE ROAR and blinding sunlight as they emerge into the arena.

Scene 152 **EXTERIOR GEONOSIS, EXECUTION ARENA— DAY**

The great stadium is packed with tier upon tier of yelling GEONOSIANS. The cart trundles to the center, where OBI-WAN is chained to one of four upright posts that are three feet in diameter. The cart stops. PADMÉ and ANAKIN are taken down, dragged to posts, and chained to them. ANAKIN is in the center. PADMÉ pulls a wire from her clothing and places it in her mouth.

Obi-Wan: I was beginning to wonder if you had gotten my message.
Anakin: I retransmitted it just as you requested, Master. Then we decided to come and rescue you.
Obi-Wan: Good job!

Their arms are pulled high above their heads, and the cart drives away. There is another ROAR as POGGLE THE LESSER, COUNT DOOKU, NUTE GUNRAY, THE FETTS, and DIGNITARIES arrive in the archducal box and take their places.

Sun Fac: The felons before you have been convicted of espionage against the Sovereign System of Geonosis. Their sentence of death is to be carried out in this public arena henceforth.

The crowd ROARS and CHEERS. In the box, POGGLE THE LESSER rises. The crowd becomes quiet.

Poggle: Let the executions begin!

The crowd goes wild.

From different gates around the arena, THREE MONSTERS are driven in. One is a REEK (bull-like), one is a NEXU (lion-like), and one is an ACKLAY (a kind of dino-lobster). They are driven in by PICADORS carrying long spears and riding ORRAYS. The PICADORS poke the MONSTERS toward the center, then retire to the perimeter.

Anakin: I've got a bad feeling about this.

The MONSTERS toss their heads, looking around, ROARING or SCREECHING. Then they catch sight of the THREE CAPTIVES and start moving toward them.

Obi-Wan: Take the one on the right. I'll take the one on the left.
Anakin: What about Padmé?

PADMÉ has used the wire she concealed to pick the lock on one of the hand restraints. She turns around and pulls herself up by the chain to the top of the post. Within a moment, she is standing on top of it, trying to pull the chain free.

Obi-Wan: She seems to be on top of things.

The REEK charges ANAKIN. He jumps up, and the beast hits the post hard. ANAKIN lands onto its back, wrapping part of his chain around its horn. The REEK backs off, shaking its head angrily, which tears the chain from the post.

OBI-WAN ducks around the post as the ACKLAY charges. It knocks the post flat, sending OBI-WAN sprawling. The ACKLAY crunches the post between its claws, freeing the chain. OBI-WAN leaps up and runs toward ONE of the PICADORS. The ACKLAY takes off after him.

The NEXU arrives at PADMÉ'S POST and rears on its hind legs. On top, PADMÉ struggles to tear the chain free. The NEXU ROARS, displaying wicked, dripping fangs.

In the archducal box, NUTE GUNRAY beams and rubs his hands.

In the arena, OBI-WAN runs at the PICADOR. The ORRAY rears up. OBI-WAN grabs the PICADOR's long spear and pole vaults over him. The chasing ACKLAY smashes into the ORRAY. It goes down. The PICADOR tumbles onto the sand, where he is grabbed by the ACKLAY and crunched.

ANAKIN's REEK starts to buck. It charges around the arena with ANAKIN hanging on for dear life. He whirls the free length of chain around his head and casts it into the REEK's mouth. Its jaws clamp hard on the chain. ANAKIN yanks hard on the chain, turning the REEK, beginning to ride it.

The NEXU's claws dig deep into the post. The cat-like creature reaches the top of the post and takes a swipe at PADMÉ. She turns and the claw barely catches her shirt, ripping it off, leaving superficial claw marks across her back. She hits the creature with her chain and it backs off down the pole. Then, PADMÉ jumps off the post into the air. She swings around on the chain and whacks the beast hard on the head with both her feet. It tumbles back onto the sand. PADMÉ climbs back up the pole, scrambling to the top.

In the archducal box, NUTE GUNRAY fumes.

Nute Gunray: Foul!! She can't do that...shoot her or something!

In the arena, OBI-WAN runs out from behind the fallen ORRAY and throws the spear at the ACKLAY, hitting it in the neck. It lets out a terrible SCREECH and turns on him. The NEXU springs up and makes to leap up at PADMÉ again. She finally manages to work the chain loose. ANAKIN comes charging up on the REEK.

Anakin: You okay?
Padmé: (nods, gasping) Sure!
Anakin: Jump!!!

The NEXU springs. PADMÉ leaps from the top of the post to land on the REEK behind ANAKIN. The REEK charges away, around the arena. The NEXU bounds after it. The REEK passes the wounded ACKLAY and OBI-WAN. OBI-WAN runs and jumps on the back of the REEK behind ANAKIN and PADMÉ.

In the archducal box, NUTE GUNRAY turns angrily to COUNT DOOKU.

Nute Gunray: This isn't how it's supposed to be! Jango, finish her off!

COUNT DOOKU motions for the bounty hunter to stay put. BOBA FETT is enjoying the spectacle.

Count Dooku: (smiling enigmatically) Patience, Viceroy...she will die.

Droidekas roll to the center of the arena where they transform and surround the REEK and contain the JEDI.

Scene 153 **EXTERIOR GEONOSIS, EXECUTION ARENA—DAY**

In the archducal box, amid the uproar, MACE WINDU ignites his lightsaber and holds it to JANGO FETT's neck. COUNT DOOKU turns to see MACE WINDU standing behind him. COUNT DOOKU masks his surprise elegantly.

Count Dooku: Master Windu, how pleasant of you to join us. You're just in time for the moment of truth. I would think these two new boys of yours could use a little more training.
Mace Windu: Sorry to disappoint you, Dooku. This party's over.

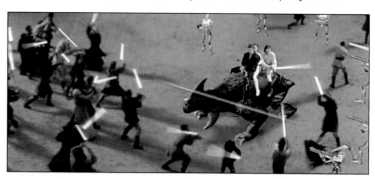

MACE WINDU signals, and at strategic places around the arena there are sudden flashes of light as about ONE HUNDRED JEDI switch on their lightsabers. The crowd is suddenly silent. COUNT DOOKU's lips curl in slight amusement.

Count Dooku: (to Mace Windu) Brave, but foolish, my old Jedi friend. You're impossibly outnumbered.
Mace Windu: I don't think so. The Geonosians aren't warriors. One Jedi has to be worth a hundred Geonosians.

COUNT DOOKU looks around the great theater. His smile grows.

Count Dooku: It wasn't the Geonosians I was thinking about. How well do you think one Jedi will hold up against a thousand Battle Droids?

Super Battle Droids come down the corridor toward MACE WINDU, firing their weapons. MACE deflects the blasts.

COUNT DOOKU signals. THOUSANDS OF DROIDS start to pour into all parts of the arena.

JANGO FETT fires his flamethrower at MACE WINDU, igniting MACE's robe. MACE WINDU jumps into the arena. The battle begins. GEONOSIANS fly away everywhere. DROIDS fire at JEDI, who deflect the bolts and cut down the DROIDS. The GEONOSIAN TROOPS fire ray guns that are more difficult for the JEDI to deflect. SEVERAL JEDI run to the center of the arena and throw lightsabers to OBI-WAN and ANAKIN.

The REEK and the NEXU are spooked by the battle. The REEK bucks the riders off of its back and stampedes around the arena, trampling DROIDS and JEDI that have moved into its path. PADMÉ picks up a discarded pistol and joins the fight.

Among the crowd, JEDI cut down swaths of GEONOSIANS and DROIDS. On the sand, JEDI fight, attacking DROIDS. OBI-WAN and ANAKIN swing their lightsabers, cutting DROIDS in half. PADMÉ blasts away at DROIDS and GEONOSIANS.

Scene 154 **EXTERIOR GEONOSIS, EXECUTION ARENA—DAY**

MACE WINDU runs to the center of the arena and fights back-to-back with OBI-WAN, as they swipe and mangle DROIDS.

Among the tiers, JEDI are slowly being driven back. They have killed heaps of GEONOSIANS and have knocked out piles of DROIDS, but sheer numbers are telling. Individual JEDI are being cut down or blasted. The rest are retreating into the arena.

ANAKIN and PADMÉ are back-to-back, fighting DROIDS and flying GEONOSIANS.

Anakin: You call this diplomacy?
Padmé: No, I call it aggressive negotiations.

THREEPIO's body with the Battle Droid head enters the arena. The droid is fired upon and knocked back. The Battle Droid head goes flying off THREEPIO's body.

PADMÉ jumps on top of the orray pulling the execution wagon. ANAKIN runs, jumps, and lands in the cart, deflecting laser blasts with his lightsaber. PADMÉ blasts Battle Droids as the two ride through the arena.

The Battle Droid body with THREEPIO'S head enters the arena, carrying a blaster rifle.

C-3PO: Where are we? A battle! Oh, no! I'm just a protocol droid. I'm not made for this. I can't do it. I don't want to be destroyed!

Jedi KIT FISTO uses the Force to knock the THREEPIO Battle Droid backward onto the arena floor. A downed Super Battle Droid falls on top of THREEPIO's Battle Droid body, pinning him to the ground.

C-3PO: Help! I'm trapped! I can't get up!

ANAKIN wields his lightsaber and PADMÉ uses a blaster rifle to defend themselves, using the fallen execution wagon for protection.

OBI-WAN and MACE WINDU fight back-to-back, lightsabers flashing. The REEK charges and separates the two. The REEK chases MACE WINDU across the arena. MACE WINDU slashes at the REEK but loses his lightsaber. JANGO FETT, watching from above, rockets down into the arena to battle with MACE WINDU.

MACE WINDU retrieves his lightsaber, and the REEK tosses JANGO FETT away. JANGO FETT ends up under the REEK, avoiding the creature's massive hoofs. Finally, FETT is free and kills the REEK. MACE WINDU fights fiercely with JANGO FETT. Finally, the bounty hunter falls. His helmet goes flying. The bounty hunter's body falls to the ground.

OBI-WAN is attacked by the ACKLAY and finally slays the beast with his lightsaber.

ARTOO finds the Battle Droid with THREEPIO'S head attached. He shoots a projectile from his body that attaches a suction device to THREEPIO'S head, and pulls the head away from the Battle Droid. ARTOO drags THREEPIO'S head across the arena and reattaches it to THREEPIO'S body, using an extendable welding arm.

C-3PO: Artoo, what are you doing here? Wait! No! How dare you! You're pulling too hard. Stop dragging me, you lead-head. Artoo, be careful! You might burn my circuits. Are you sure my head's on straight?

Scene 155 | **EXTERIOR GEONOSIS, EXECUTION ARENA—DAY**

MACE WINDU, OBI-WAN, ANAKIN, PADMÉ and an exhausted group of about TWENTY JEDI stand in the center of the arena surrounded by a ring of BATTLE DROIDS. The bloodied sand around them is strewn with the bodies of DEAD GEONOSIANS, SHATTERED DROIDS, and JEDI.

KI-ADI-MUNDI and the SURVIVORS from the raiding party are herded into the arena by SUPER BATTLE DROIDS. From the encircling tiers above, THOUSANDS OF BATTLE DROIDS level their weapons menacingly.

In the archducal box, COUNT DOOKU lifts his hand. The DROIDS lower their weapons. The COUNT calls out to the JEDI.

Count Dooku: Master Windu! You have fought gallantly. Worthy of recognition in the history archives of the Jedi Order. Now it is finished. *(pauses briefly)* Surrender—and your lives will be spared.
Mace Windu: We will not be hostages for you to barter with, Dooku.
Count Dooku: Then, I'm sorry, old friend. You will have to be destroyed.

The DROIDS raise their weapons. ANAKIN and PADMÉ look to each other. COUNT DOOKU raises his hand to give the order to fire. PADMÉ looks up suddenly.

Padmé: Look!

Above, SIX GUNSHIPS are descending fast through the open area in the arena ceiling. They land in a cluster around the handful of JEDI. CLONE TROOPERS spill out and start firing up at the DROIDS. There is a hellstorm of laserfire that bounces off the laser shields created by the Gunships. YODA appears at the door of one of the Gunships.

Yoda: Circle the Jedi. A perimeter, create, around the survivors.

The SURVIVING JEDI dash to the Gunships and scramble in. MACE WINDU hangs on tight as the Gunship, firing all its weapons, rises out of the arena up and over the topmost rim.

On the arena grounds, ARTOO beeps as THREEPIO tries to sit up.

C-3PO: What happened? I had the most peculiar dream.

In another part of the deserted arena, BOBA FETT finds his father's battered helmet. Kneeling down, he picks it up and lowers his head in sorrow.

Scene 156 | **EXTERIOR GEONOSIS, TERRAIN OUTSIDE EXECUTION ARENA—DAY**

The massed lines of parked Trade Federation Starships and the DROIDS surrounding the arena, are themselves surrounded by thousands of Republic Starships, disgorging TENS OF THOUSANDS OF CLONE TROOPERS. Beyond, more Republic Starships are landing and spewing out troops.

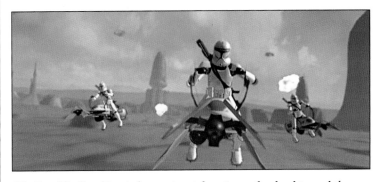

The Republic Gunships circle towering stalagmites as they head toward the assembly point. Winged GEONOSIANS fire laser cannons up at the Gunships.

Scene 157 | **INTERIOR GEONOSIS, COMMAND CENTER—DAY**

DOOKU, POGGLE, NUTE, and RUNE enter a huge command center. In the center of the room there is a large circular viewscreen and around the perimeter of the room GEONOSIAN SOLDIERS monitor the CLONE ARMY'S advances on large semitransparent maps. In one corner of the room there is a large monitor flashing a variety of images, like schematics to a familiar planet-sized mechanized weapon.

Poggle: All our communications have been jammed. We are under attack.
Nute Gunray: The Jedi have amassed a huge army.
Count Dooku: Where did they get them? That doesn't seem possible. How did the Jedi come up with an army so quickly?
Nute Gunray: We must send all available droids into battle.
Count Dooku: There are too many. They will soon have us surrounded.

Scene 158 | **INTERIOR GUNSHIP NUMBER TWO—DAY**

Ground fire and explosions rock the Gunship. PADMÉ, ANAKIN, and OBI-WAN steady themselves.

Obi-Wan: Hold on!

INTERIOR GEONOSIS, COMMAND CENTER—DAY

COUNT DOOKU, POGGLE THE LESSER, NUTE GUNRAY, and RUNE HAAKO stand around the viewscreen.

Nute Gunray: This is not going well at all.
Poggle: Order a retreat. I am sending all my warriors deep into the catacombs to hide.
Rune Haako: We must get the cores of our ships back into space.
Count Dooku: I'm going to Coruscant. My Master will not let the Republic get away with this treachery.

POGGLE crosses to the holographic schematic and downlads it into a cartridge. He gives it to COUNT DOOKU.

Poggle: The Jedi must not find our designs for the ultimate weapon. If they have any idea of what we are planning to create, we are doomed.
Count Dooku: I will take the designs with me. They will be much safer with my Master.

Scene 160 **INTERIOR GUNSHIP NUMBER ONE—DAY**

MACE WINDU stares at the incredible sight.

Mace Windu: Captain, land at that assembly point ahead.
Clone Captain: Yes, sir.

The Gunship lands. MACE WINDU, KI-ADI-MUNDI, and CLONE TROOPERS spill from the Gunship and join the ground battle. The Gunship lifts off with YODA on board.

Yoda: Capture Dooku, we must. If escapes he does, he will rally more systems to his cause.

The CLONE TROOPERS open fire with artillery. EXPLOSIONS wreck the parked Battle Starships. CLONE TROOPERS advance, firing at the massed DROIDS. FIGHTER DROIDS fly overhead, exchanging fire with the Gunships and JEDI fighters.

Yoda: More battalions to the left. Encircle them, we must, then divide.

Scene 161 **EXTERIOR BATTLEFIELD, GEONOSIS LANDSCAPE—DAY**

Gunship #2 skims the battlefield, firing down, deflecting answering fire from the droids.

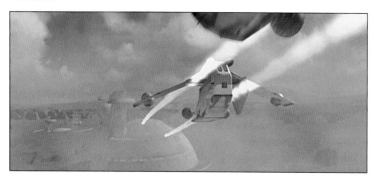

Scene 162 **INTERIOR GUNSHIP NUMBER TWO – DAY**

OBI-WAN, ANAKIN, and PADMÉ watch from the open Gunship.

On the battleground below, CLONE TROOPERS riding speeder bikes advance toward the battlefield. TRADE FEDERATION Spider Droids fire at the CLONE TROOPERS and Republic Gunships. Lightsaber-wielding Jedi slash though Battle Droids. The battle rages on.

Gunship #1 flies low toward TECHNO UNION starships.

Anakin: Aim right above the fuel cells.

Laser fire pelts the base of the TECHNO UNION ship. Rocked with explosions, it begins to tilt over and the Gunships split up, flying past.

Obi-Wan: Good call. Those Federation starships are taking off. Target them quickly.

One TRADE FEDERATION starship begins to rise from its docking port. Gunship #2 fires on the starship, with no apparent damage.

Anakin: They're too big, Master. The groundtroops will have to take them out.

Scene 163 **INTERIOR GUNSHIP NUMBER ONE—DAY**

The Gunship lands at the Command Center. YODA disembarks.

Clone Commander: Master Yoda, all forward positions are advancing.
Yoda: Very good. Very good.

Scene 164 **INTERIOR GUNSHIP NUMBER TWO—DAY**

The Gunship continues to fire on the TRADE FEDERATION starships. The starships continue to lift into the sky.

Scene 165 **EXTERIOR COMMAND CENTER—DAY**

Yoda: Concentrate all your fire on the nearest starship.
Clone Commander: Yes, sir.

The TRADE FEDERATION starship finally begins to weaken under the constant fire. The starship begins to fall and then explodes in a fireball.

Scene 166 **INTERIOR GUNSHIP NUMBER TWO—DAY**

OBI-WAN, ANAKIN, and PADMÉ are at the open sides of the Gunship. CLONES fire down at the DROIDS below.

The Gunship slows, circling a droid gun-emplacement. It blasts it, but suddenly the Gunship is rocked by a near miss. It lurches violently.

Obi-Wan: Look! Over there...
Anakin: It's Dooku! Shoot him down!

Through the other side of the Gunship, they see a Geonosian Speeder racing past. In the open cockpit is the unmistakable figure of COUNT DOOKU.

Clone Captain: We're out of ordinance, sir.
Anakin: Follow him!
Padmé: We're going to need some help.
Obi-Wan: No, there's no time. Anakin and I can handle this.

DOOKU signals the two fighters flanking his ship. They veer off left and right, loop around, and come up behind our heroes' Gunship. To avoid the BEAK-WING fire, the Gunship banks up a steep dune but is still hit. The ship lurches on its side, and PADMÉ and a CLONE OFFICER tumble out.

Anakin: Padmé!!!

ANAKIN stares down in horror as PADMÉ hits the ground below.

Anakin: *(continuing; to pilot)* Put the ship down! Down!
Obi-Wan: Don't let your personal feelings get in the way. *(to the pilot)* Follow that speeder.

The Gunship continues its pursuit of DOOKU's speeder, followed by the TWO BEAK-WING fighters.

Anakin: *(to pilot)* Lower the ship!
Obi-Wan: Anakin, I can't take Dooku alone. I need you. If we catch him we can end this war right now. We have a job to do.
Anakin: I don't care. *(to the pilot)* Put the ship down.
Obi-Wan: You'll be expelled from the Jedi Order.
Anakin: I can't leave her.
Obi-Wan: Come to your senses. What do you think Padmé would do if she were in your position?

Anakin: (resigned) She would do her duty.

Scene 167 **EXTERIOR COMMAND CENTER—DAY**

YODA stands next to the CLONE COMMANDER. He senses something is wrong with PADMÉ.

Yoda: Hmmmm…
Clone Commander: The droid army is in full retreat.
Yoda: Well done, Commander. Bring me my ship.

Scene 168 **EXTERIOR GEONOSIS DUNES—DAY**

On the ground, the CLONE TROOPER approaches PADMÉ.

Clone Trooper: Are you all right?
Padmé: I think so.
Clone Trooper: We better get you back to the Forward Command Center.
Padmé: No, no. Gather up what troops you can. We've got to get to that hangar. Get a transport. Hurry!

Scene 169 **INTERIOR GUNSHIP NUMBER TWO—DAY**

ANAKIN and OBI-WAN watch as COUNT DOOKU'S speeder parks outside the tower; the Gunship parks next to it. OBI-WAN and ANAKIN leap down and run inside the tower.

Scene 170 **INTERIOR GEONOSIS SECRET HANGAR TOWER—LATE DAY**

COUNT DOOKU throws switches on a control panel. His Interstellar Sail Ship is parked nearby.

Anakin: You're going to pay for all the Jedi you killed today, Dooku.
Obi-Wan: (to Anakin) We'll take him together—you go in slowly on the...
Anakin: No, I'm taking him now!
Obi-Wan: Anakin, no!

ANAKIN charges across the open space at COUNT DOOKU, who smiles faintly, watching him come. ANAKIN raises his lightsaber. At the last moment, COUNT DOOKU thrusts out an arm and unleashes a blast of Force lightning. ANAKIN is hurled across the room, and slammed into the opposite wall. He slumps to the foot of the wall, semi-conscious. COUNT DOOKU moves toward OBI-WAN.

Count Dooku: As you can see, my Jedi powers are far beyond yours.
Obi-Wan: I don't think so.

OBI-WAN lifts his lightsaber. COUNT DOOKU smiles and ignites his lightsaber.

OBI-WAN comes in fast, swinging at COUNT DOOKU's head. DOOKU parries the cut easily. As they fight, it quickly becomes clear that DOOKU is the complete swordsman—elegant, graceful, classical—a master of the old style.

Count Dooku: Master Kenobi, you disappoint me. Yoda holds you in such high esteem.

COUNT DOOKU parries another cut and then thrusts. OBI-WAN steps back quickly, panting for breath.

Count Dooku: Come, come, Master Kenobi. Put me out of my misery.

OBI-WAN takes a deep breath, gets a fresh grip on his lightsaber, and comes in again. For a moment, he drives COUNT DOOKU back. Then DOOKU'S superior skill begins to tell again, and he forces OBI-WAN to retreat.

COUNT DOOKU increases the tempo of his attack. OBI-WAN is pushed to the limit to defend himself. DOOKU presses. His lightsaber flashes.

OBI-WAN is wounded in the shoulder, then the thigh. He stumbles back against the wall, trips, and falls. His lightsaber goes skittering across the floor.

COUNT DOOKU raises his lightsaber. OBI-WAN looks up at him helplessly. Dooku's lightsaber flashes down and CLASHES against–Anakin's lightsaber! COUNT DOOKU and ANAKIN stare eyeball to eyeball.

Count Dooku: That's brave of you, boy—but foolish. I would have thought you'd have learned your lesson.
Anakin: I'm a slow learner.

And ANAKIN charges at COUNT DOOKU. The force of his attack catches the COUNT slightly off balance. ANAKIN'S lightsaber flashes. COUNT DOOKU draws back.

Count Dooku: You have unusual powers, young Padawan. But not enough to save you this time.
Anakin: Don't bet on it!
Obi-Wan: Anakin!

OBI-WAN uses the Force to catch his lightsaber and he tosses it to ANAKIN. With TWO LIGHTSABERS, ANAKIN attacks. COUNT DOOKU parries and ripostes. It's no contest. ANAKIN is driven back against the wall. He loses one lightsaber. Finally COUNT DOOKU, in one flashing move, sends Anakin's arm, cut off at the elbow, flying, still gripping his lightsaber. ANAKIN drops to the ground in agony. COUNT DOOKU draws himself up to deliver the coup de grace.

Suddenly, through the thick smoke, emerges the heroic figure of YODA. He stops on the smoke-filled threshold.

Silence. COUNT DOOKU steps away from ANAKIN to face the Jedi Grand Master.

Count Dooku: Master Yoda.
Yoda: Count Dooku.
Count Dooku: You have interfered with our plans for the last time.

COUNT DOOKU levitates machinery, hurling it at the tiny figure of the JEDI MASTER. YODA recovers and deflects the machinery. COUNT DOOKU then causes great boulders in the ceiling above YODA to fall, and again, YODA deflects the boulders which fall around him. YODA deflects Force lightning thrown at him by the enraged COUNT DOOKU.

Yoda: Powerful you have become, Dooku. The dark side I sense in you.
Count Dooku: I have become more powerful than any Jedi. Even you, my old Master.

COUNT DOOKU continues to hurl Force lightning at YODA, who deflects every blast.

Yoda: Much to learn you still have.
Count Dooku: It is obvious this contest will not be decided by our knowledge of the Force, but by our skills with a lightsaber.

COUNT DOOKU whirls his lightsaber in a formal salute. YODA draws his lightsaber. Suddenly, COUNT DOOKU charges across the space at YODA. He rains down blows upon the tiny figure. YODA doesn't budge an inch. For the first part of the contest, he parries every cut and thrust that COUNT DOOKU

aims. Nothing the great swordsman tries gets through. His energy drains. His strokes become more feeble, slower.

YODA attacks! He flies forward. COUNT DOOKU is forced to retreat. Words are insufficient to describe the range and skill of YODA'S speed and swordplay. His lightsaber is a humming blur of light. Finally, their blades cross and the fighting slows.

Yoda: Fought well, you have, my old Padawan.
Count Dooku: The battle is far from over. This is just the beginning.

Then, with all his might, COUNT DOOKU uses the Force to pull on one of the cranes in the hangar. It comes crashing down toward OBI-WAN and ANAKIN. ANAKIN wakes. But in the blink of an eye, ANAKIN and OBI-WAN attempt to hold up the crane, using the Force. YODA closes his eyes and concentrates, adding his strength to the two fallen JEDI and moves the crane aside. COUNT DOOKU runs up the ship's ramp, throwing a look back before going inside.

The sound of the Sail Ship's engines are heard starting up.

COUNT DOOKU'S Sail Ship takes off. OBI-WAN and ANAKIN struggle to the exhausted YODA, but it's too late. The Sail Ship rises into the air and flies away.

| Scene 171 | **EXTERIOR GEONOSIS SPACE** |

COUNT DOOKU pilots his ship through the asteroid field circling Geonosis and into deep space.

| Scene 172 | **INTERIOR GEONOSIS SECRET HANGAR TOWER—LATE DAY** |

PADMÉ runs to ANAKIN and throws her arms around him. ANAKIN is barely able to stand up.

| Scene 173 | **EXTERIOR CORUSCANT, OLD TOWN—DAWN** |

COUNT DOOKU'S Interstellar Sail Ship glides through a deserted, burned-out part of Coruscant. COUNT DOOKU maneuvers the ship into one of the empty buildings and lands.

| Scene 174 | **INTERIOR CORUSCANT, SECRET LANDING PLATFORM—DAWN** |

The ramp lowers. COUNT DOOKU emerges and walks to where the hooded figure of DARTH SIDIOUS stands waiting. COUNT DOOKU bows.

Count Dooku: The Force is with us, Master Sidious.

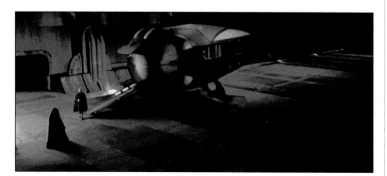

Darth Sidious: Welcome home, Lord Tyranus. You have done well.
Count Dooku: I bring you good news, my Lord. The war has begun.
Darth Sidious: Excellent. *(smiling)* Everything is going as planned.

| Scene 175 | **EXTERIOR CORUSCANT, JEDI TEMPLE—SUNSET** |

The beautiful temple basks in the red glow of the setting sun.

| Scene 176 | **INTERIOR JEDI TEMPLE, COUNCIL CHAMBER—SUNSET** |

OBI-WAN and MACE WINDU are standing, looking out through the tall windows at the great plaza below. YODA sits in his chair.

Obi-Wan: Do you believe what Count Dooku said about Sidious controlling the Senate? It doesn't feel right.
Yoda: Become unrealiable, Dooku has. Joined the dark side. Lies, deceit, creating mistrust are his ways now.
Mace Windu: Never the less, I feel we should keep a closer eye on the Senate.
Yoda: I agree.
Mace Windu: Where is your apprentice?
Obi-Wan: On his way to Naboo. He is escorting Senator Amidala home. I have to admit, without the clones, it would not have been a victory.
Yoda: Victory? Victory, you say?

OBI-WAN turns and looks at the sad little JEDI sitting in the Council Chamber.

Yoda: Master Obi-Wan, not victory. The shroud of the dark side has fallen. Begun, this Clone War has!

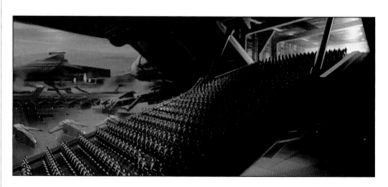

| Scene 177 | **EXTERIOR CORUSCANT, MILITARY STAGING AREA, BALCONY—SUNSET** |

PALPATINE, BAIL ORGANA, and MAS AMEDDA stand looking down at the square below.

TENS OF THOUSANDS OF CLONE TROOPS are drawn up in strict formation or move forward in neat files to climb the ramps of the Military Assault Ships.

On the balcony, PALPATINE's expression is deeply sad. Everyone watches somberly as, in the square, loaded Assault Ships take off. Others land immediately in their place. The sky above is thick with transports. CLONE TROOPS march and board the Ships.

The Great Clone War has begun...

| Scene 178 | **EXTERIOR NABOO LAKE RETREAT, LODGE, GARDEN—LATE DAY** |

In a rose-covered arbor overlooking the sparkling lake, ANAKIN and PADMÉ stand before a NABOO HOLY MAN.

THREEPIO and ARTOO stand by, watching, as the HOLY MAN blesses the happy couple and, amid gently falling rose petals, ANAKIN and PADMÉ kiss.

IRIS OUT: The End

NABOO SUMMER HOUSE
conceptual color schemes

1-4 | Gavin Bocquet

Star Wars Episode II
The Next Adventure

221

1

2

3

4

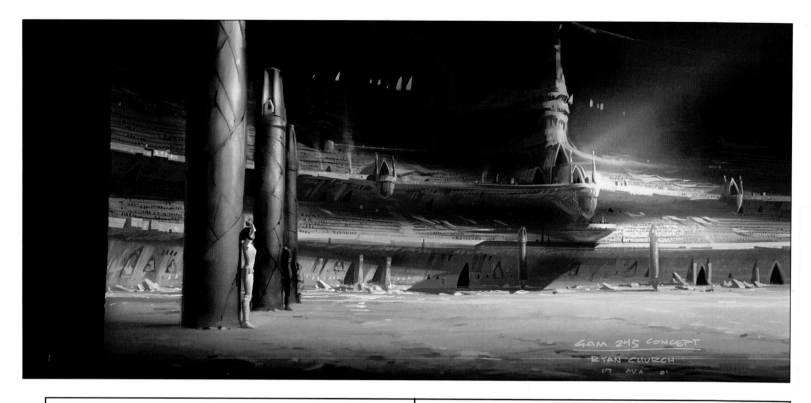

Art Department

Production Designer
Gavin Bocquet

Concept Design Supervisors
Erik Tiemens, Ryan Church,
Doug Chiang

Costume Designer
Trisha Biggar

Supervising Art Director
Peter Russell

Art Directors
Ian Gracie, Phil Harvey, Fred Hole,
Jonathan Lee, Michelle McGahey,
David Lee

Concept Artists
Iain McCaig, Dermot Power,
Jay Shuster, Edwin Natividad,
Marc Gabbana, Kurt Kaufman,
Phil Shearer, Ravi Bansal

Storyboard Artists
Mark Sexton, Rodolfo Damaggio

Pre-Visualization/Effects Supervisors
Daniel D. Gregoire & David Dozoretz

Pre-Visualization/Effects Artists
Euisung Lee, Bradley Alexander,
Matthew A. Ward, Robert Kincaid,
Paul Topolos, Raymond Wong,
Simon Dunsdon, Brian Christian,
Brian Pohl, Gary Lee, Katie Cole

Assistant Art Directors
Jacinta Leong, Clive Memmott

Concept Sculptors
Robert E. Barnes, Michael Patrick
Murnane, Tony McVey

Sculptor
Tony Lees

Concept Modelmakers
John Goodson, John Duncan,
Carol Bauman, R. Kim Smith

Set Model Makers
Ben Collins, Kerryane Jensen,
Michael Kelm

Graphics/3D modeller
Pheng Sisopha

Draftspeople
Andrew Powell, Edward Cotton,
Peter Milton, Damien Drew

Junior Draftspeople
Mark Bartholomew, Andrew Chan,
Cindi Knapton, Paul Ocolisan

Art Department Supervisor
Fay David

Conceptual Researcher
David Craig

Art Department Coordinator
Colette Birrell

Art Department Assistants
Bethwyn Garswood, Ryan Mendoza,
Roel Robles, Matthew Saxon,
Michael Smale, Sarah Stuart

Art Department Runners
Roderick England, Chris Penn

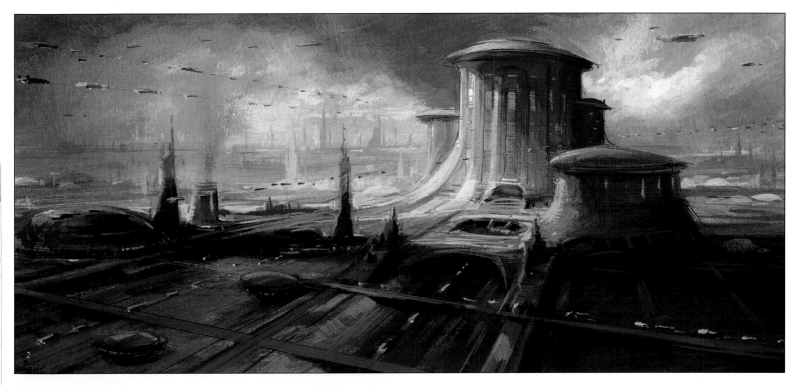

ARENA BATTLE, PALPATINE'S OFFICE QUARTERS & AUTHORS
conceptual designs and portraits

1 & 5 (OVER)	Ryan Church
2	Erik Tiemens
3	Lisa Tomasetti
4	Sue Adler

Star Wars: Episode II
Attack of the Clones

223

George Lucas *is the creator of the phenomenally successful STAR WARS saga and INDIANA JONES series and the Chairman of the Board of Lucasfilm Ltd., LucasArts Entertainment Company LLC, Lucas Digital Ltd. LLC., Lucas Licensing Ltd. and Lucas Learning Ltd. In 1992, George Lucas was honored with the Irving G. Thalberg Award. The Award was given by the Board of Governors of the Academy of Motion Picture Arts and Sciences for achievement in producing.*

Jonathan Hales *was born in London. He was one of the writers of* The Young Indiana Jones Chronicles, *for which he wrote the opening episode, "Egypt & Mexico," and several more, including "Tales of Innocence," "New York 1920," and "Hollywood Follies." He lives with his wife, Sarah, in Devon, England.*

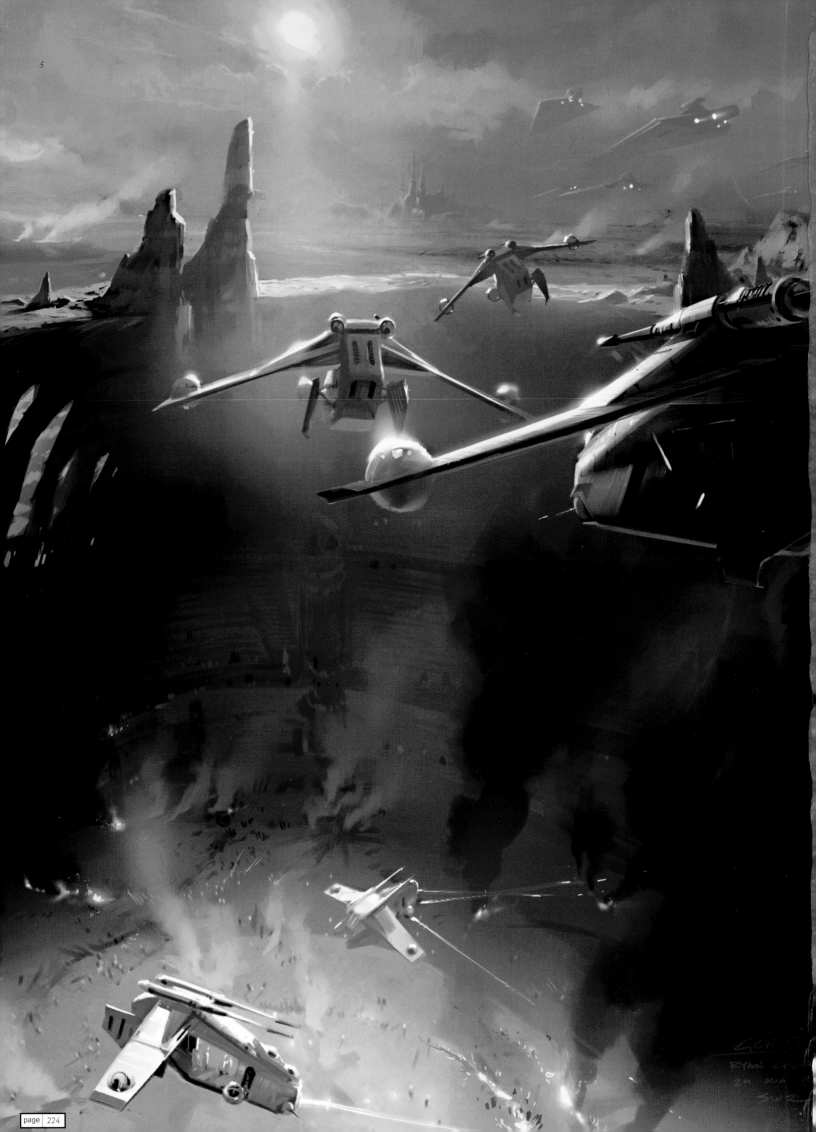